The National Gallery

COMPANION GUIDE

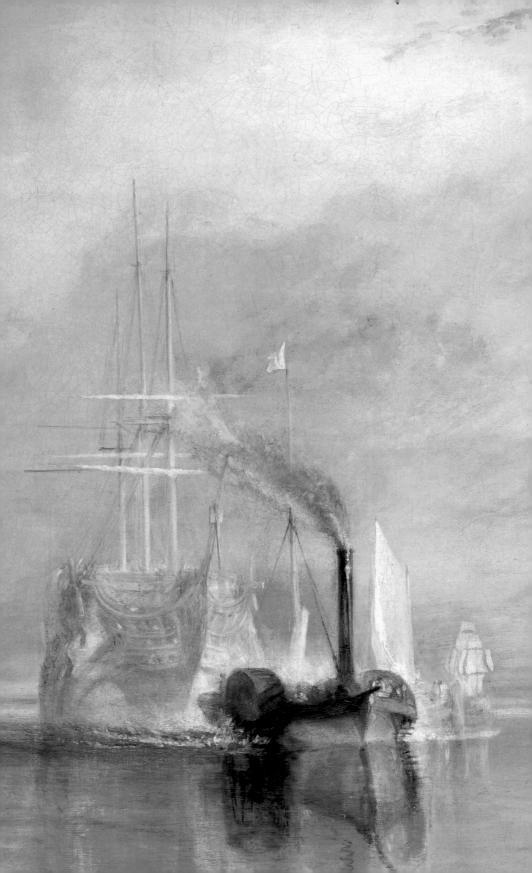

The National Gallery COMPANION GUIDE

Erika Langmuir

National Gallery Company, London
DISTRIBUTED BY YALE UNIVERSITY PRESS

In memory of my parents

© National Gallery Company Limited 2006 First edition 1994; Revised edition 1997 10 9 8 7 6 5 4 3

Henri Matisse, *Portrait of Greta Moll*, 1908. © Succession H. Matisse/DACS 2004 Pablo Picasso, *Bowl of Fruit, Bottle and Violin*, about 1914. © Succession Picasso/DACS 2004

All rights reserved. No part of this publication may be transmitted in any form or by any means, electronic or mechanical, including photocopy, recording, or any storage and retrieval system, without prior permission in writing from the publisher.

First published in Great Britain in 1994 by National Gallery Company Limited 30 Orange Street, London wc2H 7HH

ISBN: 978 1 85709 399 5 525349

British Library Cataloguing-in-Publication Data A catalogue record is available from the British Library

Library of Congress Catalog Card Number: 2003114450

PROJECT EDITOR (revised edition) Jane Ace
EDITORS Diana Davies, Felicity Luard and Helen Robertson
DESIGN LewisHallam
PRODUCTION Jane Hyne and Penny Le Tissier

Printed and bound in Hong Kong by Printing Express Ltd. Origination by D.L. Repro

FRONT COVER Giovanni Bellini, The Doge Leonardo Loredan (detail), about 1501–4
FRONTISPIECE Joseph Mallord William Turner, The Fighting Temeraire
tugged to her Last Berth to be broken up, 1838 (detail), 1838–9
PAGE 6 Leonardo da Vinci, The Virgin and Child with Saint Anne and
Saint John the Baptist (detail), 1499–1500
BACK COVER
Titian, Bacchus and Ariadne, 1520–3
Francisco de Zurbarán, A Cup of Water and a Rose on a Silver Plate, about 1630
The Wilton Diptych, between 1395 and 1399
Claude-Oscar Monet, The Beach at Trouville, 1870

CONTENTS

Preface 7
Acknowledgements 8
Foreword by Charles Saumarez Smith 9
A Short History of the National Gallery 10
Plan of the Main Floor Galleries 12
Introduction 13

Paintings 1250–1500
THE SAINSBURY WING

Paintings 1500–1600
THE WEST WING

Paintings 1600-1700 174 THE NORTH WING

Paintings 1700–1900 266 THE EAST WING

Index 346

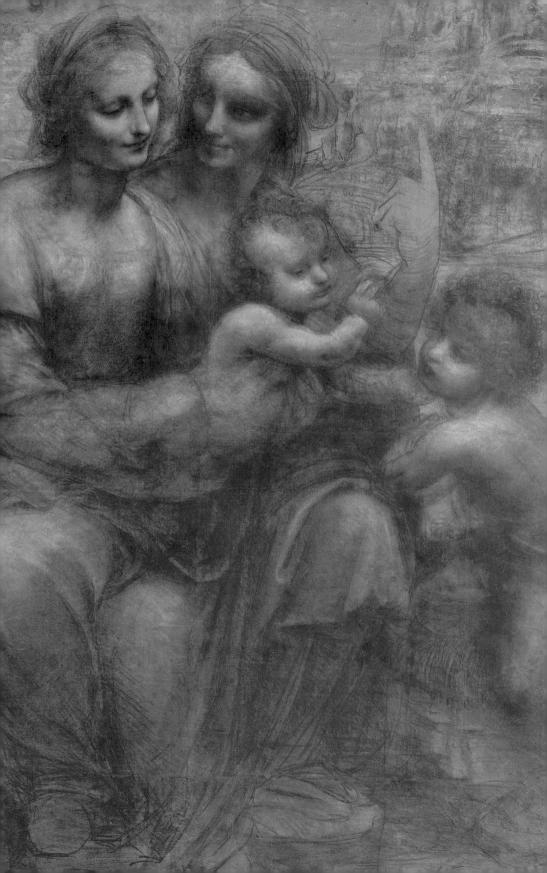

PREFACE

ABN AMRO has enjoyed a long and exciting association with the National Gallery. In 1991, when the Sainsbury Wing was opened, we became one of the Gallery's first Corporate Members. Then, in 1994, we were delighted to sponsor the publication of the first *Companion Guide*. This book was the first publication that not only served as a handbook for visitors to the Gallery but also told the story of Western European painting through the Gallery's collection. Since 1994 the *Companion Guide* has sold over 200,000 copies in seven different languages.

As a leading international bank with a Dutch heritage, ABN AMRO has a long tradition of supporting art. In 1998 we were again pleased to assist the National Gallery in a project to transform the display of their great collection of Dutch paintings. The results of this may be viewed in the ABN AMRO Room in the North Galleries.

We are, therefore, very proud to continue our close relationship with the Gallery by supporting the publication of this revised and expanded edition of the *Companion Guide*. This version includes the very latest information on works within the collection, together with new entries on some of the great works of art acquired by the Gallery over the last ten years.

This guide illustrates the National Gallery's continued pursuit of quality and excellence.

ACKNOWLEDGEMENTS

The National Gallery's former director, Neil MacGregor, and publisher, Patricia Williams, are the true begetters of this book, and were its first readers. I cannot thank them enough for their encouragement and their perceptive and challenging comments. To Neil MacGregor I am indebted also for art-historical information and insights, as I am to all those Gallery members of staff, past and present, on whose research, publications and generous help I have relied so heavily. I hope they will bear in mind the old adage that plagiarism is the sincerest form of flattery. It has also been a privilege to work with Diana Davies, the most scrupulous and caring of editors; with Felicity Luard, who ably steered the original manuscript through to production, and with Jane Ace, who managed the daunting project of revision with tireless dedication. Needless to say, I alone am responsible for any errors that remain (many have been eliminated over the years thanks to kind readers, and I am especially grateful to this book's Japanese translator, the art historian Hiroko Takahashi, for her corrections). Gillian Greenwood's subtle design of the first edition accommodated larger plates and more words, in a readerfriendly format, than I had dared hope, and Philip Lewis has tactfully undertaken the revision.

My debts to others – teachers and friends – are hardly less great. The late Sir Ernst Gombrich was an inspiration for most of my adult life, and I owe him many acts of great kindness; Lorenz Eitner made possible my career as an art historian. Their influence is reflected throughout these pages, as is that of Jennifer Fletcher, Enriqueta Harris Frankfort, Charles Hope, Martin Kemp, Norbert Lynton, Elizabeth McGrath, Linda and Peter Parshall, Paula Rego, Catherine Reynolds, Bridget Riley, and others too numerous to name.

Valerie Langmuir continues to provide a vital computer helpline, while it is literally true that without the unfailing support of Charles McKeown this book could neither have been written nor revised. My loving thanks to both of them.

FOREWORD

The National Gallery houses one of the greatest collections of Western European painting in the world, with works ranging from as early as 1250 to 1900. However well you may know the collection, it is often helpful to have a well-informed guide at your side. Erika Langmuir was Head of Education at the National Gallery from 1988 to 1995 and during that time she introduced thousands of visitors, young and old, to this beautiful and extraordinarily varied collection. Approaching the works with a broad interest in all periods of art and a deep knowledge of the circumstances in which they were painted. the author communicates her expertise with unique clarity and skill. The life stories of artists such as Leonardo and Rembrandt are intertwined with fascinating details regarding subject matter, medium and style. Whether read in front of the pictures or at home, this extraordinarily useful guide provides a wealth of information on over two hundred paintings from the collection.

The National Gallery was established in 1824 to give every person in the country the opportunity to experience these great pictures. The *Companion Guide* aims to enhance that pleasure, and we are extremely grateful to ABN AMRO Bank, whose great generosity helped us to produce the very first *Companion Guide* in 1994 and also this revised and expanded edition.

Charles Saumarez Smith
DIRECTOR
THE NATIONAL GALLERY, LONDON

A Short History of the National Gallery

The National Gallery is exceptional among the great public museums of Europe in not having as its nucleus a royal or princely collection. Nor, to the occasional surprise of visitors from abroad, does it exhibit mainly works by British artists; these are concentrated at Tate Britain. The National Gallery houses the nation's collection of Western European paintings of all schools, from the late thirteenth to the early twentieth century – in other words, from Margarito of Arezzo (page 67) to Monet (page 315).

Founded in 1824, the Gallery is also a latecomer to the ranks of comparable institutions. The collections of the Medici in Florence had been presented to the State of Tuscany in 1737, and other major repositories of art opened to the public shortly afterwards: in Vienna in 1781, in Paris in 1793, in Amsterdam in 1808, in Madrid in 1809, in Berlin in 1823. While the British Museum had been founded in 1753, it was above all a collection of antique sculpture, coins and medals, growing to include books, prints and drawings; there were few paintings. The Royal Academy, established in 1768, was a teaching institution and held regular exhibitions, but it had no Old Master pictures for the modern painters to copy. Although Constable, for one, deplored the idea of a National Gallery – writing in 1822, 'there will be an end of the art in poor old England . . . the manufacturers of pictures are then made the criterion of perfection, instead of nature' - other academicians, public-minded connoisseurs and politicians joined together to urge on Parliament 'a Plan. . . for the establishing a National Gallery of painting & for encouraging Historical Painting' (Joseph Farington, Royal Academician, diary entry of 1805). In 1823, as an incentive to an impecunious government, Sir George Beaumont, Constable's patron and a chief proponent of a national gallery, promised his own collection of paintings to the nation, provided a suitable building could be found for their proper display and conservation. His generous offer was matched soon afterwards by the Reverend Holwell Carr, who pledged his pictures on the same conditions. They were the earliest, and among the greatest, of the many benefactors of the Gallery. Rubens's Autumn Landscape with a View of Het Steen (page 244) and Canaletto's 'The Stonemason's Yard' (page 271) are two of the pictures donated by Beaumont, while the Holwell Carr Bequest includes, among others, Tintoretto's Saint George and the Dragon (page 161) and Rembrandt's Woman bathing in a Stream (page 235).

As it turned out, the government was persuaded by the surprising conjunction in 1824 of two events: the offer for sale of the Old Master collection built up by John Julius Angerstein (1735–1823), a self-made financier, philanthropist and collector born in St Petersburg, and the unexpected repayment by the Austrians of a war debt. The latter being used to purchase the former, the National Gallery came into being. Sebastiano del Piombo's great altarpiece, *The Raising of Lazarus* (page 156), was an Angerstein picture and bears the accession number '1' in the Gallery's collection.

Opened first in Angerstein's private town house, 100 Pall Mall, the Gallery did not move into purpose-built premises until 1838. Even then for the next thirty years it had to share William Wilkins's much-criticised Trafalgar Square building (not yet the

'much-loved friend' of the 1980s) with the Royal Academy. By gift, bequest and purchase, the collection grew rapidly, necessitating the enlargements of the 1870s by E. M. Barry, which comprise the whole of the block lying behind the east half of the original building. More galleries were added to the north of the portico in 1887; in 1911 the building was extended westwards. Rooms were added and courtyards roofed in the late 1920s, early 1930s and in 1961. The North Galleries, providing an additional entrance from Orange Street, were completed in 1975. In 1991 the Sainsbury Wing, built through private donations and specially designed by Robert Venturi to house the earliest paintings in the collection, was inaugurated on the site of a bombed-out furniture store to the west of the main Gallery complex.

The latest major building project, initiated in 2003, was planned to take advantage of the grand civic space created by the pedestrianisation of Trafalgar Square's north side. To improve access from the redesigned square to the Gallery, this project makes available for the first time a public entrance on the ground level of the main building, east of Wilkins's portico. Designed to cater for growing numbers of visitors, it also provides more generous spaces for visitor services and better links between the ground floor and the main floor picture galleries.

From the beginning, it was intended that the Gallery be opened not only to artists and copyists but to the public at large. Parliament even insisted that children be allowed in, because otherwise the poor, who had no servants or nursery maids, would not be able to come at all. Calls to remove the Gallery to a less polluted neighbourhood were resisted, in order that in 'the very gangway of London' the collection should best fulfil the needs of people who could not themselves own great paintings – that 'large class of persons very moderately acquainted with art, very desirous of knowing more, very much occupied in business, who have occasionally an half-hour or hour of leisure, but seldom a whole day. . .' as Mr Justice Coleridge wrote to the 1857 National Gallery Site Parliamentary Commission.

The modern National Gallery, a more complex institution than its nineteenth-century predecessor, continues to honour its original aims. The Scientific and Conservation Departments ensure that pictures are shown in good condition, and preserved for future generations - as, in a different way, do the Security staff, who are responsible for the well-being and safety of both the paintings and visitors. Admission to the permanent collection is still free, and children are encouraged to come, not only in family groups but also in school parties. Information about the paintings is presented to those 'desirous of knowing more' through various media - lectures and tours, books and other publications, videos and CDs - so that all visitors may share in the fruits of scholarly research, the main responsibility of Curatorial staff. The Gallery also mounts temporary exhibitions of paintings not normally on view in London, and of pictures from the collection in new contexts. Despite continuous change, as of any living institution, no better statement of the National Gallery's purpose, past or present, can be made than that set before the Parliamentary Commission of 1857: 'The existence of the pictures is not the end [purpose] of the collection, but the means only to give the people an ennobling enjoyment.'

Plan of the Main Floor Galleries

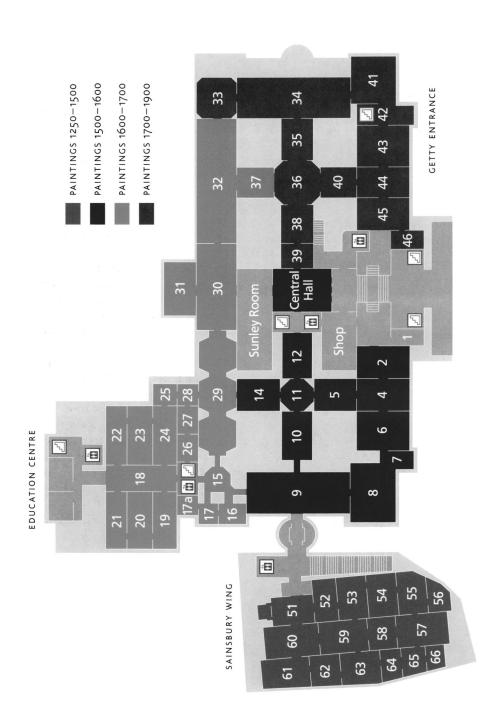

Introduction

This Guide is intended to be both useful to visitors in the National Gallery and readable at home. It is divided into four sections, corresponding to the chronological display of paintings on the main floor of the Gallery: 'Paintings 1250-1500' in the Sainsbury Wing, 'Paintings 1500-1600' in the West Wing, 'Paintings 1600-1700' in the North Wing and 'Paintings 1700-1900' in the East Wing. Each section opens with a brief text introducing the major artists represented in the wing and discussing the main types of paintings, their original functions and locations, technique, medium, subject and style. Readers are alerted to topics - such as the evolution of landscape painting or of the 'state portrait' - which they may wish to trace for themselves in the galleries, and warned against 'pitfalls' - many Early Renaissance paintings in the Sainsbury Wing, for example, are fragments, and painted for particular viewing conditions. About fifty of the most important or best-known pictures in each wing - more than two hundred in all - are illustrated and discussed; they are arranged in alphabetical order by artist's name within each section. When two or more paintings by an artist are included, they are normally discussed in the order of acquisition. Each entry is self-contained, but the uniquely well-balanced nature of the National Gallery Collection and its chronological display across national schools, the variety of topics covered in the text, and copious cross-references, make it possible to read the Guide as an introduction to the main themes of the history of Western painting. There is an index of names and places at the back of the book.

The reader interested in learning more about the whole collection may wish to consult the National Gallery's *Complete Illustrated Catalogue*, compiled by Christopher Baker and Tom Henry. Detailed information on the techniques and social background of Early Renaissance painting in Italy and Northern Europe, on the other hand, can be found in *Giotto to Dürer: Early Renaissance Painting in the National Gallery*, which provides an extensive discussion of pictures in the Sainsbury Wing. The High Renaissance is discussed in *Dürer to Veronese: Sixteenth-Century Painting in the National Gallery*. Themes of particular interest to both artists and Gallery visitors are addressed in the *Pocket Guides series*.

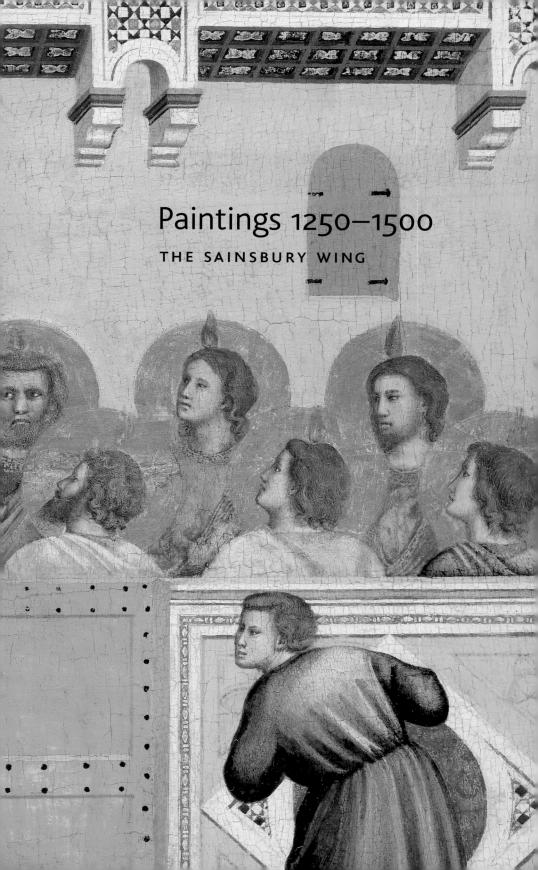

The Sainsbury Wing, opened in July 1991, was designed to house the earliest paintings in the National Gallery. Instead of being strictly segregated by national schools, pictures from Southern and Northern Europe are integrated, hung in broad chronological order in adjoining rooms, reminding us as we move through the wing that in this period works of art, artists and their clients travelled widely, and ideas and ideals were freely exchanged. Frontiers were in any case different from what they are now: neither Italy nor Germany nor the Netherlands existed as nation states. The map of Europe was largely a patchwork of principalities and city-states, some with allegiances to feudal lords, including kings and the Holy Roman Emperor. Courts, great consumers of art, communicated with each other and often had interests in more than one part of Europe.

All Western European rulers recognised the spiritual authority of the pope, head of the Roman Catholic Church for which the greatest number of important works of architecture, painting and sculpture were created. In the same period, however, local art traditions were forged, promoted through craft associations and family ties. Both trends – to internationalism on the one hand, and to the formation of local styles on the other – can be traced through the arrangement of paintings in this wing. More rooms are devoted to Italian painting, reflecting the bias of the National Gallery's Collection, and this is in turn reflected in the architectural style of the Sainsbury Wing, which evokes the cool interiors of Italian Renaissance churches.

Most of the paintings in the wing are devotional – either Christian altarpieces or altarpiece fragments from churches and chapels, or images intended to serve as the focus of pious meditation or prayer at home or while travelling. Sometimes, especially with later fifteenth-century works, it is difficult to tell where the line between piety and a love for painting was drawn, as for example in the delicious little picture of *Saint Jerome in his Study* by Antonello da Messina. Of the non-religious pictures the majority are portraits, and one of the themes which can be followed through the wing is the evolution of more lifelike portraiture, a type of painting which Northern European artists pioneered. Other secular paintings formed part of the decoration of furniture or of room panelling, and here the subjects may be fancifully drawn from history, as in Uccello's *Battle of San Romano*, or from Ancient Greco-Roman myth, as in Botticelli's *Venus and Mars*.

Throughout the whole period, successive generations of painters in both Northern and Southern Europe seem to have been striving to achieve greater and greater versimilitude – that is, to make their painted worlds resemble the three-dimensional world we inhabit – without, however, sacrificing abstract order and beauty. But it would be wrong to conclude that the search for greater lifelikeness was part of a creeping secularisation, a turning away from spiritual values. Like contemporary preachers and poets, painters also sought to move the human heart, to convince viewers of the urgent truth of their message, to make them weep or rejoice with the painted personages, seek consolation or draw assurance.

Previous page: Attributed to Giotto di Bordone, Pentecost (detail), about 1306-12

Most surviving non-mural paintings from this period are on wooden panels. The frame is frequently an integral part of the structure of the panel. Many pictures were executed on lightweight fabric supports of silk or linen, as ephemeral decorations, to be carried in processions or sent to clients abroad. Of these fragile works, few survive, one of the greatest being Bouts's solemn <code>Entombment</code>. Like many such paintings, it is executed in a glue-based paint. Italian panel pictures in this period were painted mainly in tempera, pigments hand-ground to powder suspended in an emulsion of egg yolk or whole egg, applied over a smooth white surface. In Northern Europe, on the other hand, drying oils, especially linseed oil, were the preferred medium for panel painting; under the influence of Northern art, the use of oils became wide-spread in Italy after about 1500. Cosimo Tura's <code>Allegorical Figure</code> from the later 1450s is perhaps the earliest known Italian work to use an oil medium in the accomplished Early Netherlandish technique. Both oils and egg tempera required meticulous preplanning and great precision, necessitating the use of underdrawings, now visible in infra-red photographs and reflectograms.

Artists both north and south also used gold leaf, beaten out thinly from gold coins, either as a background or applied to the paint surface as luminous lines. The gold was also often incised or punched to increase surface interest and distinguish, for example, haloes from the gilded background. To recapture some of their original effect, we must imagine the gilded altarpieces in the Sainsbury Wing as resembling precious solid gold

and enamelled objects, gleaming in the winking light of flickering candles.

ANTONELLO DA MESSINA (active 1456-died 1479)

Saint Jerome in his Study about 1475-6

Oil on limewood, 46 × 36 cm NG 1418

Antonello was active in Messina in Sicily, then part of the Kingdom of Naples, by 1456. In 1475–6 he was in Venice, working on a large altarpiece. It was once thought that he taught the Venetians the technique of building up colours in glazes – thin translucent layers of pigment suspended in a drying oil medium – having learned it himself on a trip to Bruges. This tradition can now be discounted, since we know that accomplished paintings in this technique were being produced near Venice by the 1460s (see page 92).

Saint Jerome (AD?347-420) was a monk and a scholar who compiled the standard Latin translation of the Bible, the Vulgate. Although the office of cardinal was not instituted in his day, as a papal adviser he was posthumously 'promoted' to it, and is sometimes

shown in a cardinal's red robes, as here, and nearly always with a cardinal's broad-brimmed red hat beside him. Since he was also a penitent hermit, in the fifteenth century he is often portrayed in front of a crucifix in the wilderness, striking his breast with a stone (see page 45). Here, however, we see him as a dignified scholar, in a snug wooden carrel erected in a Gothic building, something between a church and a palace. Legend attributed to him the miraculous good deed of another saint, the extracting of a thorn from a lion's foot, and a tame lion is shown padding in the shadows to the right.

The painting was in a Venetian collection in 1529, when it was described as by Antonello or possibly by Jan van Eyck or another 'old master from the Netherlands'. It is a marvel of minute description, especially of the effects of light as it streams in from the viewer's space through the opening in the foreground, and through the windows behind the saint, casting sharp or graduated shadows, reflecting from different surfaces, and illuminating the landscape beyond the lower windows and the distant sky above. In its original, domestic setting, where the picture could be viewed from very near, it must indeed have seemed as if the artist had painted everything as far as the eye can see: birds wheeling in the sky and settling on the window ledges, figures in a rowing boat on the river, trees, a walled city with gentle mountains rising behind.

The active life outside the scholar's study contrasts with the contemplative life within, yet it is tempting to think of Jerome resting from his labours on the window seat to the left, watching the boatmen going home. The partridge and the peacock in the foreground are probably symbolic: the one of truth (because partridges were thought always to recognise their true mother's voice), the other of immortality (because the flesh of the peacock was thought never to decay).

ALESSO BALDOVINETTI (about 1426-1499)

Portrait of a Lady in Yellow about 1465

Egg tempera and oil on wood, 63×41 cm $\,$ NG $\,758$

As well as painting on panel, and directly on the freshly plastered wall in fresco, Baldovinetti also designed stained-glass windows, mosaics and wood inlay. The sitter for this portrait remains unidentified; despite the three palm leaves and two others (or feathers?) on her sleeve, which may be an armorial device, we do not even know whether, like Baldovinetti, she was Florentine or from another Italian city.

Although the three-quarter view of the face was preferred in Northern Europe at this time, in some parts of Italy the profile portrait continued in favour until about 1500. Its disadvantages are obvious here: the sitter appears remote and impassive, making no contact with the viewer. On the other hand, profile portraits evoked venerable associations: with Ancient Greek and Roman coins, which were much collected, and the contemporary medals imitating them, and perhaps even with the legendary origins of painting itself, when a maiden traced the outline of her lover's shadow on the wall.

Baldovinetti reinforces the metallic sharpness of the silhouette with a thin white line within the darker edge. Unlike the graduated blue in the background of Bellini's portrait of Doge Loredan (page 21), which evokes the sky, the flat blue around the lady, contrasting and complementing the blond tonality of the figure, lends the entire painting the semblance of a heraldic coat of arms. Paradoxically, however, counteracting the two-dimensional effect, tiny white strokes mould the volumes of her face and body, and the roundness and lustre of the pearls in her hair, the folds of her dress, are all lovingly recreated. The frame, although not integral with the panel, is original.

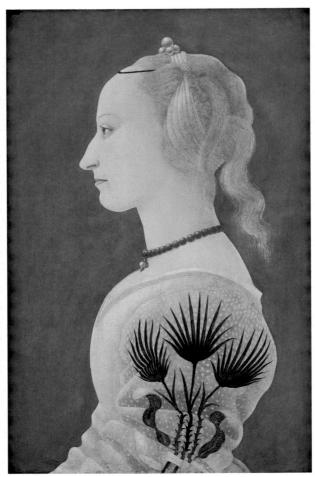

NG 758 Portrait of a Lady in Yellow

GIOVANNI BELLINI (about 1435-1516)

The Doge Leonardo Loredan about 1501-4

Oil, probably with some egg tempera, on poplar, 62×45 cm NG 189

Giovanni Bellini was the son of one painter, Jacopo, and the brother of another, Gentile. They formed the leading artistic dynasty of Venice, charged with many official commissions. In 1453 the family firm forged links with the rising young artist Andrea Mantegna (page 64) by marrying Giovanni and Gentile's sister Niccolosia to him. Giovanni's first known painting in oils, the *Coronation of the Virgin* in Pesaro, dates from about 1475. In addition to large-scale public pictures and portraits, he is also noted for his many devotional images of the Virgin and Child.

This famous portrait was probably made soon after the election of Leonardo Loredan (1436–1521) as Doge, that is, head of state of the Venetian Republic. He is shown

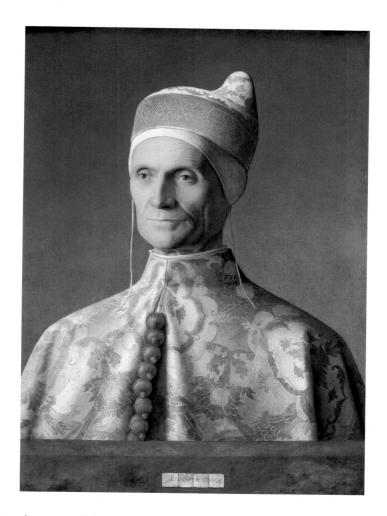

wearing the cape and the horned cap of his ceremonial dress, in the novel material of damask woven with gold thread, the lustrous effect of which Bellini has represented by deliberately roughing the paint. This thickening of the paint layer, and the transparency of the shadows, are only possible with an oil medium. Partly inspired by the sculpted portrait busts of Ancient Rome, partly by Netherlandish painted portraits, the picture is both a static official image and an intimation of a personality; perhaps even a meditation on old age.

To achieve these complex ends, Bellini manipulates the sitter's features and the representation of light. The expression of the face is asymmetrical: the right, lit side, more severe, the left side, in shadow, more benevolent. By graduating the blue of the background, more intense towards the top and lighter at the bottom, Bellini evokes the sky, in contrast to Baldovinetti in the *Portrait of a Lady in Yellow* (opposite). The strong directionality of the light and the catchlights (reflections of the light source) in Loredan's eyes suggest that he is looking towards the sun. To be reflected like this the sun must be fairly low in the sky – although, judging by its colour, not yet setting. But this hint of time passing, combined with Loredan's aged face, recalls the old comparison between the duration of a day and the span of human life, and the inevitable coming of the night.

GIOVANNI BELLINI (about 1435-1516)

The Agony in the Garden about 1465-70

Egg tempera on wood, 81 x 127 cm NG 726

This episode from the life of Christ, traditional in art, is recorded in all the Gospels. After the Last Supper, Jesus went with the disciples to the Mount of Olives (or Gethsemane, the garden 'over the brook Cedron') near Jerusalem. Taking Peter, James and John with him, he asked them to watch with him while he prayed to God the Father to 'let this cup pass from me: nevertheless not as I will, but as thou wilt'. Luke writes: 'There appeared an angel unto him from heaven, strengthening him' (22:43). Peter and the others fell asleep. As Christ woke them, Judas arrived with the soldiers to take him prisoner.

Bellini's painting owes much to Mantegna's of the same subject (page 66). Yet, although he seems to have revered his brother-in-law, Bellini departs decisively from Mantegna's example in his treatment of space and, most notably, of light. Perhaps for the first time in Italian painting, the artist has represented a real, observed sunrise, which tints the undersides of clouds rose-orange, reflects from the walls of distant towns, glitters on armour, its warm colour dispersed as through air bathing the whole broad countryside. (Like Mantegna, and following an old convention, Bellini in this early painting records the highlights on Christ's blue cloak in fine lines of gold leaf ground to powder and used as a pigment.) By specifying the time of day, the picture reminds us of Christ's long night of agony – with his final acceptance of the Passion, symbolised by the chalice held out by the angel like a priest officiating at Mass – and helps us to empathise with the human weakness of the sleeping disciples, out of scale yet inhabiting the landscape more comfortably than do Mantegna's figures. And since the distant view resembles vistas familiar to Bellini's viewers, unlike Mantegna's fantastical rock formations and imaginary ancient city, the painting also urges the

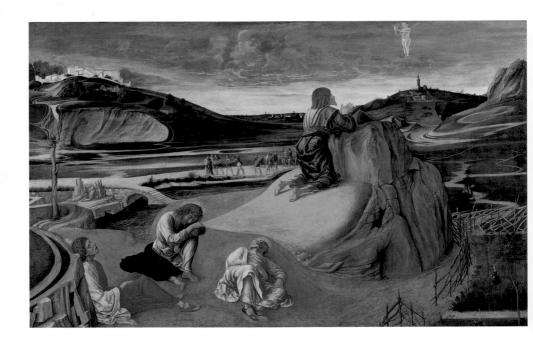

beholder to recall that the unique historic event of Christ's Passion is through our sins re-enacted daily among us.

Yet Bellini's new powers of description enable him to transcend this penitential note with a message of hope. For, he seems to say, just as the sun rises over the hill towns of Northern Italy, so will the Saviour rise from the dark tomb, that the prophecy of Isaiah (60:20) may be fulfilled: 'Thy sun shall no more go down... for the Lord shall be thine everlasting light, and the days of thy mourning shall be ended.'

BARTOLOMÉ BERMEJO (documented 1468–1495) Saint Michael triumphant over the Devil with the Donor Antonio Juan 1468

Oil and gold on wood, 180 \times 82 cm NG 6553

The most famous red-haired painter in history is the sixteenth-century Italian nick-named Rosso Fiorentino, 'the Florentine redhead'. A closely run second would be the Spaniard Bartolomé de Cardenas, were it not that only some twenty pictures by him survive. Called Bartolomé Bermejo in Spanish, he proudly signed the Latin equivalent, bartolomeus rubeus ('Red Bartholomew') on the fictive parchment cartellino in the foreground of this splendid panel, one of the Gallery's most important acquisitions of recent years. He was an early, and the most accomplished, exponent of the so-called Hispano-Flemish style, adopting the oil-glazing techniques developed by the Netherlandish painters Campin, Jan van Eyck, Rogier van der Weyden (pages 30, 46, 94) and their successors. Born in Córdoba in Andalucía, the seemingly restless Bermejo is recorded in Valencia, Daroca, Zaragoza and Barcelona in the kingdom of Aragón; he may have been partly trained in the Netherlands.

Saint Michael triumphant over the Devil with the Donor Antonio Juan is the earliest painting in Bermejo's œuvre, its authenticity vouched for by documents as well as signature. It was the central panel of a composite altarpiece commissioned for the church of San Miguel in Tous, near Valencia, by Antonio Juan, the town's feudal lord. Juan, who fought with John II of Aragón against the French in 1473, is portrayed, small in scale but assertively corporeal, in a luxuriously velvet-collared tunic of violet-grey damask, wearing the chain and sword of a knight. He kneels on the bare ground at the feet of Saint Michael, holding a psalter open at the opening lines of two penitential psalms: 'Have mercy upon me, O God, according to thy loving kindness' (Psalm 51) and 'Out of the depths have I cried unto thee, O Lord' (Psalm 130).

The defeat of the devil-dragon by Michael and his angels, as recounted in the Book of Revelation (12:7), was a subject especially popular in fifteenth-century Catholic Spain, where it was associated with the *reconquista*, the reconquering of territory from the Moors, who continued to rule Granada until 1492. This is why Bermejo (unlike Perugino, see page 80) has shown God's lieutenant in the very act of slaying the demon, omitting the scales on which the archangel weighs souls at the Last Judgement. Like Perugino, however, he has exploited the technical potential of oil paint to depict Michael's polished metal armour, here apparently made not of steel but of gold: its convex breastplate mirrors the Gothic towers of the Heavenly Jerusalem. In a passage of even greater bravura, Bermejo shows a crystal-domed shield, at once reflective and translucent. A priestly gold brocade cope, lined in crimson and fastened with a jewelled morse, flies about the holy warrior with brittle vehemence, emphasising the suave grace with which he wields his heavy sword, the composure of his angel's wings

and the impassive beauty of his youthful face, and detaching his slender silhouette from the much-worn gold-leaf background, tooled in ornamental patterns.

The demon on whom Michael treads in jewelled sollerets is a fantastical chimera – part reptile, bird, moth, bat, shell, hedgehog, unruly child – with gleaming eyes/nipples, a lascivious tongue and self-devouring teeth, as suggestive as any monster invented in later decades by Hieronymus Bosch. Would donor and artist have been horrified to know how irresistible he looks to me, a twenty-first-century viewer weaned on comics and cartoons – or was ridicule part of Bermejo's strategy?

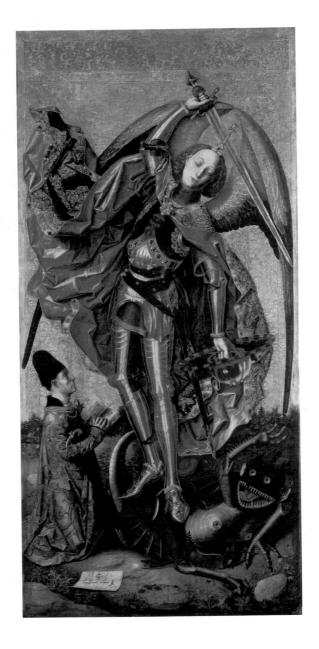

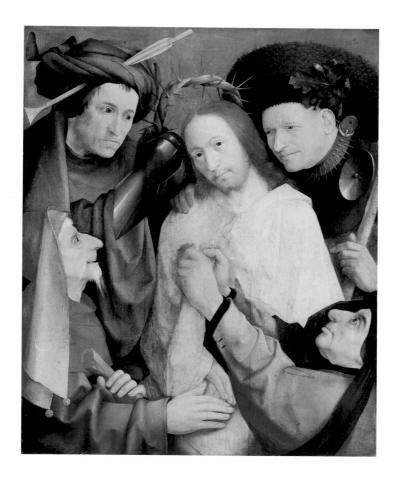

HIERONYMUS BOSCH (active 1474-died 1516)

Christ Mocked (The Crowning with Thorns) about 1490-1500

Oil on oak, 74 × 59 cm NG 4744

The painter worked in the Dutch town of 's Hertogenbosch. He is celebrated for his pictures of fantastical and demonic subjects, much admired by Italian and Spanish collectors in the sixteenth century, but he is also the author of more conventional moralising and devotional works such as this one.

The episode of the Mocking of Christ and Crowning with Thorns is told, with variations, in all four Gospels. It occurs just before the Crucifixion and is thus often included in narrative representations of the Passion. But the treatment here is not narrative: like a freeze-frame close-up in a film, it halts the action and concentrates the focus, compelling the viewer into an intimate relationship with what is shown. The technique evolved in fifteenth-century painting as an aid to devotion, an adjunct to the manuals which urged laymen and women to meditate on the sufferings of Christ and the Virgin Mary and to identify with them. It is significant that only Christ, the gentle victim in the white garment of innocence, looks out of the picture to meet the beholder's eye. The spiny crown about to be forced down on his head resembles a halo. The four brutal tormentors, like grisly caricatures of the four Evangelists surrounding

the deity (compare, for instance, page 67), are dressed in more or less contemporary costume, but with symbolic attributes. The Islamic crescent and the star on the headdress of the man lower left label him an unbeliever; the man in the upper right wears a spiked dog collar, recalling the frequent comparison of Christ's torturers with savage dogs.

Because oil paint becomes more translucent with age, we can see changes to Bosch's original ideas in thinly painted areas: Christ's robe, for example, was originally going to be a cloak, fastened with a large clasp. Other areas have been executed with many layers of paint: the sprig of oak with acorns, 'pinned' to the fur hat of the tormentor at the upper right, seems almost to lie on the surface of the picture, like the lifelike fly on the coif of the woman portrayed by a Swabian artist some twenty or thirty years earlier (page 90).

SANDRO BOTTICELLI (about 1445–1510)

Venus and Mars about 1480-90

Egg tempera and oil on poplar, 69 × 174 cm NG 915

Alessandro Filipepi, called Botticelli, the son of a Florentine tanner, probably acquired his name from his elder brother, a beater of gold leaf nicknamed *botticello*, 'little barrel', who may have brought him up. Perhaps through his brother's connections among painters and frame makers, he trained as an artist, almost certainly with Filippo Lippi (page 60), whose son Filippino he in turn taught after Filippo's death. In 1481–2 he worked on the wall paintings in the Sistine Chapel in Rome, but otherwise remained chiefly in Florence, where he ran a large workshop specialising in devotional pictures of the Virgin and Child.

This painting is one of a small number of secular works for which Botticelli is now famous. Its shape and subject suggest that it was a backboard for a bench or chest, and formed part of the decoration of a room in a Florentine town house on the occasion of a marriage. Venus, goddess of Love and Beauty, watches while her lover Mars, god of War, sleeps; not even the conch shell blown in his ear by the mischievous baby satyrs – half-child, half-goat – can wake him, nor the wasps buzzing near. (These wasps, *vespe* in Italian, may be a punning allusion to the Vespucci family, for whom Botticelli is known to have worked.) The picture refers to ancient myth, and perhaps even to

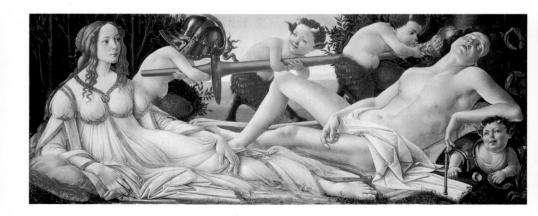

specific passages in ancient literature, but Botticelli's treatment owes little to ancient art: the armour, gown, jewels and hairstyles, even the proportions of the figure, conform to contemporary fashion. Contemporary also, and a source of humour in marriage celebrations, is the notion that making love exhausts a man while it invigorates a woman; although the more serious message – love conquers all; make love, not war – is timeless.

The remarkable translucent effect of Venus' gown is achieved through fine hatching characteristic of tempera painting, over the even finer hatching used to model the flesh. A firm, sinuous black line defines the contours, even in the shadows, and Botticelli's use of this old-fashioned Florentine convention at this date seems a wilful subordination of observed reality to decorative effect.

SANDRO BOTTICELLI (about 1445-1510)

'Mystic Nativity' 1500

Oil on canvas, 108 × 75 cm NG 1034

It has been suggested that this picture, the only surviving work signed by Botticelli, was painted for his own private devotions, or for someone close to him. It is certainly unconventional, and does not simply represent the traditional events of the birth of Jesus and the adoration of the shepherds and the Magi or Wise Men. Rather it is a vision of these events inspired by the prophecies in the Revelation of Saint John. Botticelli has underlined the non-realism of the picture by including Latin and Greek texts, and by adopting the conventions of medieval art, such as discrepancies in scale, for symbolic ends. The Virgin Mary, adoring a gigantic infant Jesus, is so large that were she to stand she could not fit under the thatch roof of the stable. They are, of course, the holiest and the most important persons in the painting.

The angels carry olive branches, which two of them have presented to the men they embrace in the foreground. These men, as well as the presumed shepherds in their short hooded garments on the right and the long-gowned Magi on the left, are all crowned with olive, an emblem of peace. The scrolls wound about the branches in the foreground, combined with some of those held by the angels dancing in the sky, read: 'Glory to God in the highest, and on earth peace, goodwill toward men' (Luke 2:14). As angels and men move ever closer, from right to left, to embrace, little devils scatter into holes in the ground. The scrolls held by the angels pointing to the crib once read: 'Behold the Lamb of God, which taketh away the sin of the world' – the words of John the Baptist presenting Christ (John 1:29). Above the stable roof the sky has opened to reveal the golden light of paradise. Golden crowns hang down from the dancing angels' olive branches. Most of their scrolls celebrate Mary: 'Mother of God', 'Bride of God', 'Sole Queen of the World'.

The puzzling Greek inscription at the top of the picture has been translated: 'I Sandro made this picture at the conclusion of the year 1500 in the troubles of Italy in the half time after the time according to the 11th chapter of Saint John in the second woe of the Apocalypse during the loosing of the devil for three and a half years then he will be chained in the 12th chapter and we shall see [...] as in this picture.' The missing words may have been 'him burying himself'. The 'half time after the time' has been generally understood as a year and a half earlier, that is, in 1498, when the French invaded Italy, but it may mean a half millennium (five hundred years) after a millennium (one thousand years): 1500, the date of the painting. Like the end of the

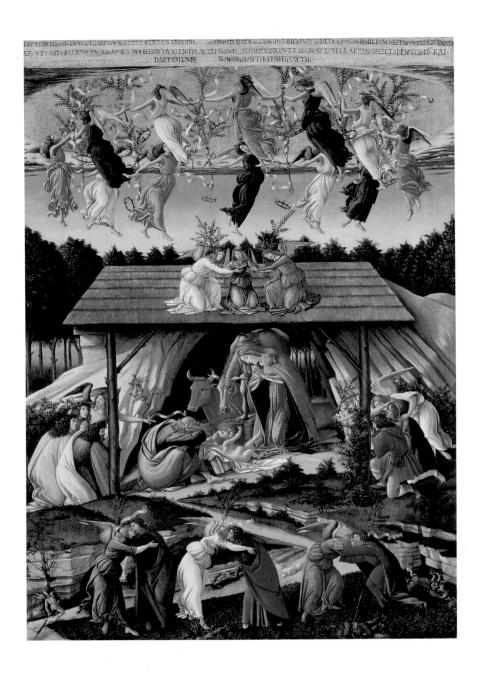

millennium in the year 1000, the end of the half millennium in 1500 also seemed to many people to herald the Second Coming of Christ, prophesied in Revelation.

At a time when Florentine painters were recreating nature with their brush, Botticelli freely acknowledged the artificiality of art. In the pagan *Venus and Mars* on the previous page he turned his back on naturalism in order to express ideal beauty. In the 'Mystic Nativity' he went further, beyond the old-fashioned to the archaic, to express spiritual truths – rather like the Victorians who were to rediscover him in the nineteenth century, and who associated the Gothic style with an 'Age of Faith'.

DIRK BOUTS (1400?-1475)

The Entombment about 1450-60

Glue size on linen, 88 × 74 cm NG 664

One of the leading Netherlandish artists of his time, Bouts lived in Louvain, where he furnished paintings for the town hall, and executed both private devotional pictures and altarpieces.

The Entombment is one of the most moving works in the Sainsbury Wing and repays long contemplation. It is remarkably well preserved considering its fragile technique. The picture was probably part of a series of scenes from the life of Christ forming a large shuttered altarpiece, and may have been painted on a lightweight cloth support, rolled like a carpet for export to Italy, where it was recorded in the nineteenth century. Like many such works, it has painted borders, which would have served as a guide to re-stretching the picture once it reached its destination.

The paint layers, composed of pigment mixed in a water-soluble glue medium, were applied directly onto the fabric, so that they sank into it. The retention of moisture by the canvas enabled the painter to blend the brushwork to achieve smooth transitions, an effect which Bouts has used with greatest subtlety in the landscape. Details, however, had to be added with a light touch so as not to redissolve the first paint layers, and the modelling of the faces, for example, is reinforced with rapid hatching. Although the colours would never have had the brilliance of oils, some pigments have discoloured: parts of the sky which were protected by an earlier frame can be seen to be more blue than those below, which have accumulated surface grime.

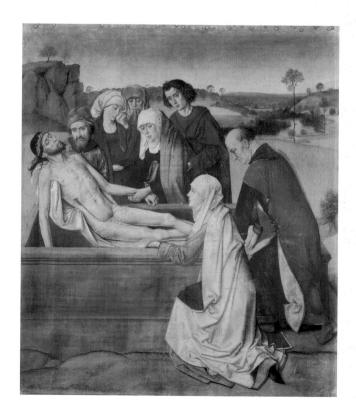

The burial of Christ after the Crucifixion is described in the Gospels and retold in more pathetic detail in the devotional literature of the time. For greater immediacy, the figures are dressed in contemporary clothes. Bouts carefully differentiates the grief of each one. The three Maries are shown from the front, from the left and from the right, their eyes all downcast. One wipes her tears, another covers her mouth, the third holds Christ's arm to place it gently in the tomb. She is supported by John, who casts a lingering last look at his Master. Joseph of Arimathea holds Christ's shoulders, reverently touching the body only through the linen cloth, like a priest at Mass holding up the host. Nicodemus, a secret follower of Jesus, lowers the feet into the tomb, while the repentant sinner, Mary Magdalene, looks up into the face of Christ – the only one of the women to lift her eyes. Christ's body is carefully turned so that we may see the wound in his side and the blood, which also refers to the Eucharist. The artist's intentions are clear. He sought to arouse, in a viewer kneeling at the altar preparing to receive the body of the Saviour, those same feelings of grief and wonder which we can still see in the painted figures.

ROBERT CAMPIN (1378/9-1444)

Portraits of a Man and a Woman 1430-5

Oil, with some tempera, on oak; each portrait 41 × 28 cm NG 653.1–2

These pictures are among the earliest surviving examples of paired portraits. They belong to a group of unsigned and undocumented Netherlandish works attributed to a painter whom scholars have called the 'Master of Flémalle', after three panels thought to have come from that locality. Robert Campin was an artist recorded in the

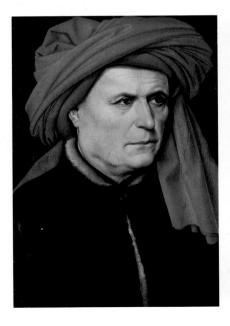

archives of Tournai, where he had numerous pupils, held civic office, got into trouble for leading a dissolute life and enjoyed the protection of the daughter of the Count of Holland. Most people now believe that he and the Master of Flémalle are the same person. Under either name, the artist who portrayed these prosperous townspeople was a major painter.

It is especially interesting to see how Campin/Flémalle approached the task of depicting a married couple individually yet together. Although their glances do not meet, husband and wife turn towards each other. While the woman's face is smaller than the man's, and more brightly lit from the opposite direction to his, their features are aligned and the compositions appear subtly symmetrical. The symmetry is all the more pleasing and surprising for encompassing such obvious differences of gender, age, complexion, probable character, even colour and texture of headdress. Nor does the pattern-making make the sitters look less lifelike. Because they take up more of the picture space than the figures of van Eyck's bust-length portraits (see page 48) and stand out more decisively from the background, they have a more assertive and potentially animated air.

WORKSHOP OF ROBERT CAMPIN (JACQUES DARET?) (1378/9-1444) The Virgin and Child in an Interior before 1432

Oil on oak; with frame, 23×15 cm NG 6514

Before its purchase by the Gallery in 1987 this tiny picture was hardly known and had never been reproduced for publication. Like *The Virgin and Child before a Firescreen* (also in the collection) it shows the Virgin Mary in a cosy domestic setting. She has either just bathed, or is about to bathe, the Christ Child in front of the fire. The scene corresponds to no passage in the Gospels, but is inspired by the devotional literature that was widely current in the Netherlands at the time. We are invited to marvel at the humility of Mary, a modest – if surprisingly well-to-do – townswoman; at her maternal devotion – she does not rely on a nursemaid to care for her child – and at the tender affection between her and her son. More profoundly, we are led to reflect on the Incarnation: Christ has truly become man, touching his genitals like any baby boy. His mother is without doubt the Virgin, for she wears her hair loose like an unmarried girl or a queen at her coronation. Haloes radiate from both their heads. The lighted candle may symbolise the marriage candle, for she is not only the Mother, but also the Bride of Christ.

Through the refined manipulation of thin layers of translucent oil paint, the artist is able to depict three light sources – the window, the sparking fire and the steadily burning candle – and the surface textures of many different materials, from the gleaming metal of the water basin to the velvet brocade of cushions and bench covering. Almost more magically, he is able to evoke the distant sky through the open window and through the small leaded glass panes above. These wonderful details were surely meant to capture and hold the close attention of the viewer, and lead him or her (and perhaps more particularly her) effortlessly to meditate on the spiritual values embodied here.

The frame and support are carved from a single piece of wood, and come from the same plank as the small portrait of a monk painted in Robert Campin's workshop, also in the collection.

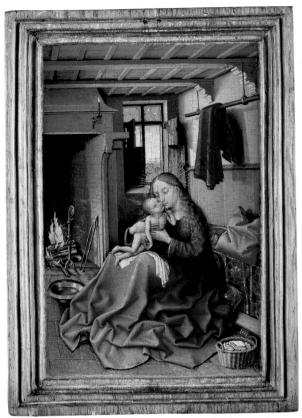

NG 6514 The Virgin and Child in an Interior

GIOVANNI BATTISTA CIMA DA CONEGLIANO (1459/60–1517/18) The Incredulity of Saint Thomas about 1502–4

Oil on poplar, transferred to synthetic panel, 294 × 199 cm NG 816

The visitor entering the Sainsbury Wing across the bridge from the main building of the National Gallery, or climbing to the top of the grand staircase in the wing and turning left, faces a breathtaking diminishing perspective of columns and arches enframing, and terminating in, Cima's *Incredulity of Saint Thomas*. This is the only example in the collection of a great Venetian altarpiece from the first decade of the sixteenth century. Cima, a painter from Conegliano, a small town north of Venice, may have been trained by Giovanni Bellini (page 20). He was active in Venice from 1492 to 1516.

The altarpiece was commissioned in 1497 by the penitent confraternity of Saint Thomas for their altar in the church of San Francesco in Portogruaro, east of Venice. It shows the most significant moment in the life of Thomas (John 20:24–9). On the day of the Resurrection, Jesus appeared to the disciples gathered in a closed room, but Thomas was not with them and refused to believe in the miracle without the evidence of his senses. Eight days later Jesus appeared again, showed Thomas the print of the nails in his hands and invited him to touch the wound in his side. The story ends in Christ saying, 'blessed are they that have not seen, and yet have believed'.

The figure of Christ is included in this scene primarily so that we can identify Thomas, the confraternity's patron saint. Cima, however, has placed the miraculously risen Saviour in the centre of the composition and has additionally focused our attention on him by making him taller than the others, by virtually bleaching him of all colour, and through linear perspective. All the vanishing lines of the tiled floor and the ceiling have been carefully incised into the white gypsum of the ground to meet at a point slightly left of Christ's exposed knee. Through these devices a narrative scene is made to serve the functions of an altarpiece: to act as a focus for the consecration of the bread and wine of the Eucharist, the body and blood of Christ.

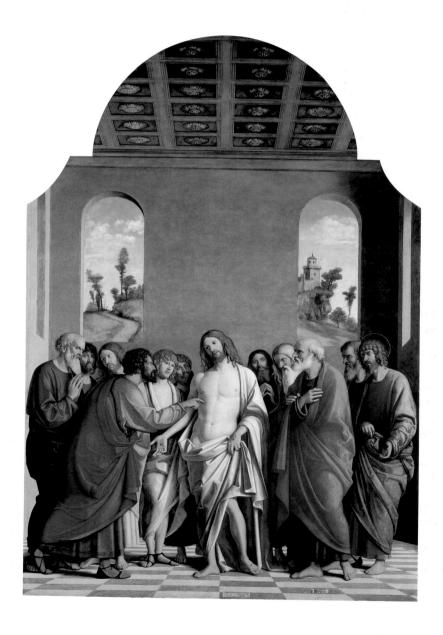

In addition to the illusion of perspective in the architecture, much of the striking effect of three-dimensionality in the painting is due to Cima's use of brilliant colour contrasts. The range of pigments is exceptionally wide, reminding us that Venice was the centre of the European pigment trade in this period, and the painter well placed to procure even the most rare colours.

The picture, crudely restored in 1745 and in poor condition, was sent in about 1820 for further conservation treatment in Venice. There, a sudden flood-tide inundated the ground-floor room where it was stored. After the painting was acquired by the National Gallery many attempts at consolidation were made. Eventually it was found necessary to transfer the ground and paint layers from the original panel onto a new support to prevent the remaining paint from blistering and flaking off, as a result of long submersion in salt water.

CIMABUE (about 1240-1302)

The Virgin and Child enthroned with Two Angels about 1280-5

Egg tempera on panel, 25.7 × 20.5 cm NG 6583

Cenni di Peppo, known as Cimabue (literally, ox-head), is seen as one of the 'founders' of Italian art. Having worked in fresco and mosaic in Rome, where a document of 1272 describes him as a 'Florentine painter', he absorbed the new eclectic style of the contemporary Roman school, and transmitted it along with his own contributions to his fellow Tuscans Duccio (page 41) and Giotto (page 52). The latter, according to legend, became his pupil. Poignantly, they are cited as exemplifying the transience of worldly fame in Dante's great fourteenth-century poem, *The Divine Comedy*:

Cimabue thought to hold the field in painting, and now the clamour is all for Giotto, so that the fame of the other is obscured. ('Purgatory', xi, 94–6)

This little panel, one of the rarest pictures to enter the Gallery, displays in miniature all the characteristics of Cimabue's monumental works, such as the large altarpiece of the Virgin in Majesty now in the Uffizi Gallery, Florence. The solemn pictorial schemata derived from ancient, Early Christian and Byzantine art are here translated into a more naturalistic and more affecting idiom. The Virgin Mary is still the Queen of Heaven, but although she still stares out at the spectator, she now also inclines her head to her child and raises one foot on a step to accommodate him more comfortably in her lap. Rather than holding a scroll or blessing the viewer, the infant Christ – the Word of God made flesh (John 1:14) – plays with his mother's hand like a real baby. One angel seems to steady the massive throne, while the other appears solicitously to plump up Mary's cushion. Painted on the same scale as the Virgin, both are more like affectionate attendants than other-worldly witnesses to God's glory. The panel is backed with gold leaf, but the diagonal placing of the throne and the slight turn of the figures create a new sense of three-dimensional space. The stylised folds and highlights of Byzantine drapery painting have given way to more delicate shading; a gentle flutter animates the ends of the angels' cloaks.

One of only two small-scale panels by Cimabue known to survive, this picture matches in handling and materials a little scene of the *Flagellation* now in the Frick Collection, New York. Red-painted borders show that the *Flagellation* comes from the bottom right-hand corner and the *Virgin and Child* from the upper left-hand corner of a dismembered ensemble, whose remaining panels have been lost or not identified.

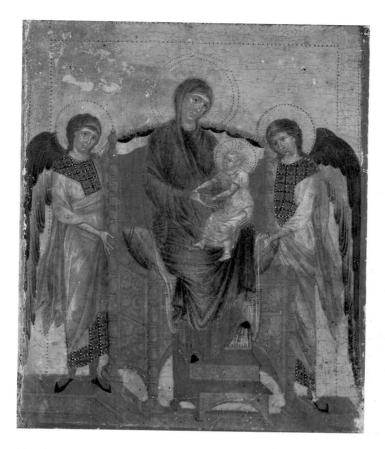

Along with other scenes from the life of Christ, they may have made up the wings of a diptych. But this diminutive relic of thirteenth-century piety reconciles innovation with conservatism, grandeur with refined sentiment, and needs no companion pictures to move the attentive viewer.

LORENZO COSTA (about 1459/60-1535)

A Concert about 1485-95

Oil on poplar, 95 × 76 cm NG 2486

Costa was a native of the Northern Italian city-state of Ferrara, and much influenced by Cosimo Tura (page 91). By 1483 he had settled in Bologna, working for the ruling Bentivoglio family. After the death of Mantegna (page 64) in 1506, Costa succeeded him as court painter in Mantua, where he died.

This painting is dated to Costa's Bolognese period, but may equally reflect performances at the court of Ferrara, where secular music evolved earlier than in other Italian centres. It is unlikely, however, to be a portrait commissioned by the sitters. Most probably it was one of a series decorating a room: whether other pictures would have represented more musicians with different instruments, or the 'sister arts' of poetry, dance and so on, we do not know.

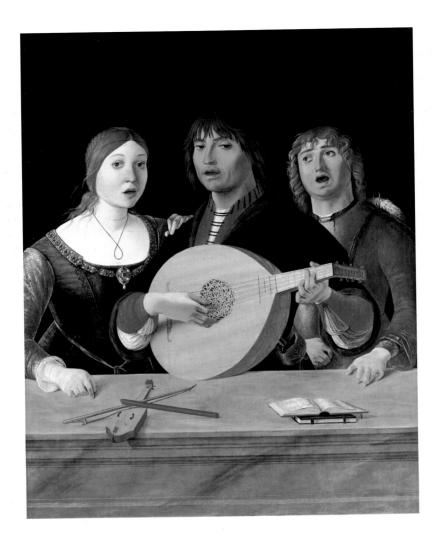

Costa captures faithfully the effect of making music in concert. The singer-lutenist in the centre leads, his eyes on the music book on the ledge before him. The others join him in polyphonic song – we can tell they are sounding different notes by the different shapes formed by their open mouths – beating time to keep together. The man on the right looks at the leader carefully, the woman on the left places her arm on his shoulder the better to follow. At some stage during the performance, these two musicians might accompany the lead singer on the fiddle and recorder in the foreground.

While *The Concert* is rare for the period in having no religious or symbolic connotations, it is by no means the only instance of a late fifteenth-century artist seeking to suggest polyphonic sound – see, for example, the angels singing in Piero della Francesca's *Nativity* (page 84). Costa was later to adopt a softer painting manner, but this work, like his bust-length portraits, tries to emulate the meticulous realism of Netherlandish painting.

CARLO CRIVELLI (14305-1494?)

La Madonna della Rondine ('The Madonna of the Swallow') about 1490-2

Tempera, with some oil, on poplar; main panel 150 \times 107 cm NG 724.1–2

Born in Venice, Crivelli was forced to spend most of his life away from the city after being imprisoned in 1457 for seducing a sailor's wife. He finally settled in the Marches where he became one of the main painters of altarpieces, many of them for Franciscan churches.

This altarpiece is one of the very few in the National Gallery to remain complete in what is probably its original frame. The restoration of both painting and frame was completed in 1989, and uncovered the original gaudy ornamentation of the predella frame with its bands of pink, green, red and maroon, speckled and flecked to imitate porphyry and other coloured stones. The swallow that gave the painting its title occupies a prominent place on the Virgin's throne. Because it was thought that swallows

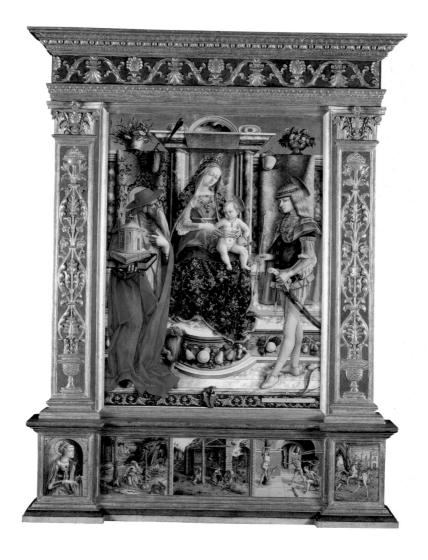

hibernated in the mud during the winter, they were a symbol of the Incarnation – God made flesh – and also of the Resurrection – a rebirth. Either significance makes the bird a suitable attribute here.

The Virgin as Queen of Heaven, with the Christ Child on her knee holding an orblike apple, is flanked by Saint Jerome and Saint Sebastian in their best court apparel. The venerable Jerome supports the Church – neatly symbolised by an architectural model – with his writings, the customary lion by his side (for a description of his history and attributes, see pages 18–19). Sebastian, by contrast, is a youthful knight, as befits an officer of the Roman Emperor Diocletian's bodyguard. On discovering that he was a Christian, the emperor had him shot with arrows, hence the arrow in his hand, tipped with metallic silver foil, and the bow at his feet.

In the predella, beneath this timeless scene in Heaven, are stories from the saints' lives on earth. Thus below his image in the main panel Jerome reappears in penitence in the desert; under the Virgin and Child we see the Nativity; and beneath Sebastian we find the Emperor's archers in action. An arrow has pierced the saint's foot, which he raises in agony, just as the thorn has made Jerome's lion lift his paw in the principal panel. In contrast to the shallow space above, heavy with gold and ornament, these lively and naturalistic little narratives are set in deep perspective. On either side are Saint Catherine with her wheel (see page 61) and Saint George, the name saint of the 'guardian' of the Franciscan monastery for whose church in Matelica the altarpiece was commissioned, with help from the city's lord. The latter's coat of arms is displayed over a painted decorative band under the Virgin's throne, along with an inscription giving the artist's name.

It is worth recalling that an altarpiece such as this was never meant to be seen under electric lights, but gleaming out of reach beyond flickering altar candles, a tribute of human craft to the divine splendour of which it is an emblem.

CARLO CRIVELLI (14305-1494?)

The Annunciation, with Saint Emidius 1486

Egg tempera, with some oil; transferred from wood to canvas, 207 \times 146 cm $\,$ NG 739

This altarpiece is an outstanding example of the inseparability of political and religious spheres in the fifteenth century. Painted for the Franciscan church of the Annunciation in Ascoli Piceno, one of the Papal States in the Marches, it celebrates the granting of limited self-government to the citizens, under the general control of their bishop, by the Franciscan Pope Sixtus IV in 1482. News of the privilege reached the city on 25 March, the Feast of the Annunciation, and thereafter a procession went every year on that day to the church in celebration. This is why Crivelli's painting includes Saint Emidius, a local bishop-martyr and the town's patron saint, holding a model of the city, and, below, the inscription LIBERTAS ECCLESIASTICA, the title of the papal edict which granted the city its freedom. The three coats of arms are those of the city, the pope (by 1486 it was Innocent VIII) and the bishop, Prospero Caffarelli.

The Annunciation has probably never taken place in so public a setting, with the Archangel Gabriel alighting in the street instead of in the Virgin's chamber. Onlookers, such as the Franciscan friar and the little boy – still dressed in baby's skirts – at the top of the stairs and the man shading his eyes in the distance, seem to see the golden ray which marks the flight path of the dove of the Holy Spirit from Heaven to Mary's room. A providential opening in the wall has admitted it to her presence. On the bridge a

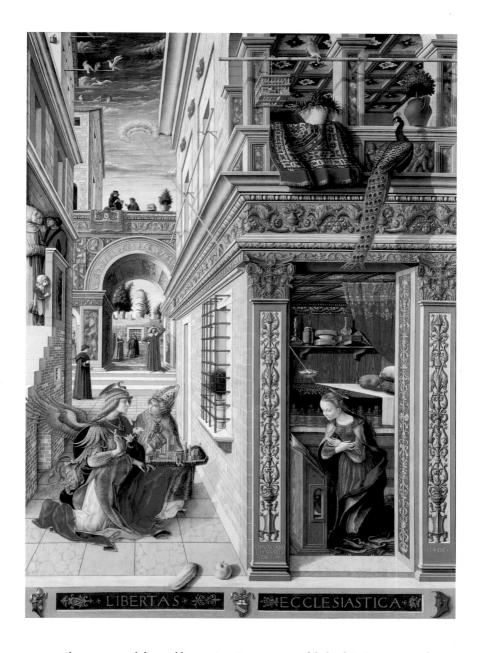

man reads a message delivered by carrier pigeon, now safely back in its cage nearby – a reference to the papal message and a witty secular counterpart to the spiritual event of the Annunciation. Oriental carpets are draped over parapets, as they would have been to celebrate a real-life public festival.

The town is depicted in great detail, down to masonry and brick courses and the dribbled mortar where the battlemented wall has been repaired. Crivelli, influenced by the work of Mantegna (page 64), pictures Ascoli Piceno as an ideal Renaissance city: all brick, stone and marble, with relief ornaments in the new style copied from the Ancient Romans. Particularly splendid is the Virgin's town house, with its potted

plants, commodious loggia in which to take the air, and tame birds, one of them a peacock, a symbol of immortality as its flesh was thought not to decay. The 'eyes' in its tail were sometimes also used to refer to the 'all-seeing Church'. To find room within the vertical format of the altarpiece for his extensive urban vista, the artist has relied on deep perspective, which also enables him to demonstrate his skill in the modern science of foreshortening, particularly remarkable in the little apertures of the dovecote in the top left corner.

GERARD DAVID (active 1484-died 1523)

The Virgin and Child with Saints and Donor about 1510

Oil on oak, 106 x 144 cm NG 1432

Born in Holland, David was the leading painter in Bruges after the death of Memling (page 78) and a member of the Antwerp guild from 1515. He was the last major painter to work in the Early Netherlandish tradition of Jan van Eyck (page 46) and Rogier van der Weyden (page 94) as opposed to the new Italianate idiom being forged in Antwerp by Quinten Massys (page 132). This altarpiece, almost certainly from the altar of Saint Catherine in the chapel of Saint Anthony in St Donatian's at Bruges, is a wonderful example of his mature style.

Translucent layers of oil paint create the illusion of a richly coloured yet meticulously ordered world. We can in pious meditation join the serene circle around the Virgin and Child, breathe in the rich odour of the flowers, bask in the mild sunshine. But the painter and his patron would have wished us to notice more. The altarpiece may have been commissioned by Richard de Visch de la Chapelle, cantor of St Donatian's, kneeling on the left, to mark his restoration of the chapel in which his mother was buried. Perhaps in her honour and that of the tutelary saint, Catherine, only female saints

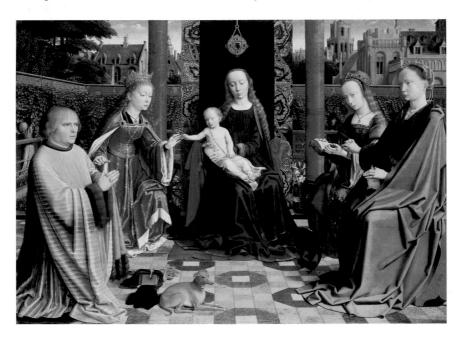

keep the Virgin company. Mary is enthroned in a walled garden, the 'garden enclosed' of the Song of Solomon (4:12), a metaphor of her virginity, alluded to also in the pure white lilies. An angel behind the donor is picking grapes, a reference to the Eucharist on the altar. The Christ Child puts a ring on the finger of Saint Catherine, in the place of honour on his right: Catherine of Alexandria was martyred for refusing to marry the emperor, saying she was already the Bride of Christ (see also page 61). On the Virgin's left Saint Barbara is reading a book. This holy martyr succeeded in converting to Christianity despite having been immured in a tower by her possessive father. Her attribute, the tower, forms part of her jewelled headdress, and a 'real' tower rises in the model city behind her. Saint Mary Magdalene, holding the pot of ointment with which she anointed Christ's feet, is impassively turning the page in Barbara's book. The artist added this gesture only as an afterthought in the final layers of paint. Saint Anthony Abbot, the saint to whom the chapel was dedicated, can be seen standing in the background to Barbara's right.

Richard de Visch de la Chapelle, identified by the coat of arms on his whippet's collar, his cantor's staff, prayer book and black hat at his feet, is slightly detached from the holy personages. It is his vision which David has embodied, and through the painter's craft Richard himself survives so that we may remember him, forever kneeling in that holy garden where it is always summer, adoring the Christ Child, venerating the Virgin and her saints, and commemorating his mother.

DUCCIO DI BUONINSEGNA (active 1278-died 1318/19)

The Virgin and Child with Saints about 1315

Tempera on poplar; central panel including framing, 61 × 39 cm NG 566

One of the greatest and most influential painters of the fourteenth century in Italy, Duccio worked mainly in Siena, although the *Rucellai Madonna*, one of his two documented pictures, was commissioned for a Florentine church. Like Margarito of Arezzo (page 67) he was largely influenced by medieval Greek painting, bringing to this rigidly schematic Byzantine manner, however, the grace and liveliness of Gothic art, known to him through ivories and manuscripts imported from France (see also Cimabue, page 34). He must have also looked closely at the sculpture of Nicola and Giovanni Pisano (active in Siena in the late thirteenth century), itself dependent both on Gothic sources and on Ancient Roman remains.

This beautifully preserved little triptych was intended as a portable altarpiece. When closed it could be easily moved, and when opened up it formed a miniature chapel for use in private devotions. The complete wooden structure was probably designed by Duccio before being made by the joiner, prior to the application of gypsum ground, gold leaf and pigment. Painting and frame were thus conceived together as a three-dimensional whole, drawing the viewer subtly into the inner harmony which Duccio has imparted to it. For example, the circle implied by the curve of the arch above the Virgin is optically completed by the positioning of the feet of the Christ Child and Mary's hands.

While the little figures of King David and Old Testament prophets in the gable speak to us, through their inscribed scrolls, of the Virgin and her role in the history of Salvation, the saints in the shutters provide a clue to the original owner of the triptych; the presence of Saint Dominic on the left suggests that he was a Dominican. The seldom-represented saint on the right is Aurea, martyred by being drowned at Ostia with a

millstone around her neck. Their combined presence may point to Duccio's patron having been the Dominican Niccolò da Prato, Cardinal Bishop of Ostia (died 1321).

A luxury object such as this would not have been available to everybody. The Virgin's brilliant blue robe, for example, is painted in the best ultramarine, a mineral extracted from the semi-precious stone lapis lazuli, whose only source at the time was from quarries in Afghanistan, and which was more expensive than pure gold. Duccio, however, tempers sumptuousness with tenderness in the relationship of Mother and Child, and his modelling is more naturalistic than that of Margarito a generation earlier. The green undermodelling of the Virgin's face now shows through more than it would have done originally.

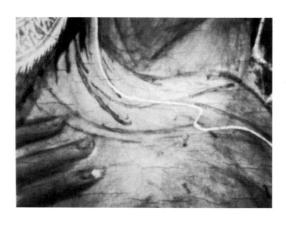

Fig. 1 Infra-red reflectogram of Duccio's Virgin and Child with Saints. Detail showing the quill-pen underdrawing of the Child's drapery.

An exciting discovery was made in 1989 when the painting was examined by infra-red reflectography. Under the plum-coloured drapery across the Child's legs is an underdrawing, which can convincingly be attributed to Duccio himself and whose individual characteristics can be recognised also in panels from Duccio's *Maestà* (see next page). The abrupt, emphatic lines are sketched with a slightly scratchy quill, whose split nib creates a double contour clearly visible when magnified (fig. 1).

DUCCIO DI BUONINSEGNA (active 1278-died 1318/19)

The Annunciation 1311

Tempera on poplar, 43 × 44 cm NG 1139

This small panel and the other two pictures by the artist hanging nearby, Jesus opens the Eyes of a Man born Blind and the Transfiguration, come from the predella of a huge double-sided altarpiece painted in Duccio's workshop and carried from there in triumph to the high altar of Siena Cathedral in 1311. Most of it survives in the Siena Cathedral museum, although after the complex structure was dismantled and sawn apart in 1771 some of the panels were lost and others, such as those in the National Gallery, sold abroad. The predella, a box-like supporting structure under the main panel, was, like the whole altarpiece, painted on both the front and the back. The front of the

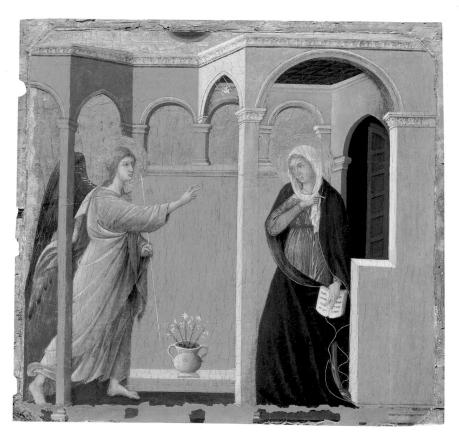

altarpiece faced the congregation, and the back was visible only to the cathedral clergy. The main front panel shows the Virgin, to whom the city of Siena was dedicated, enthroned in majesty as the Queen of Heaven and surrounded by angels and saints – hence the name given to the entire work, the <code>Maestà</code>, Italian for 'majesty'. Set originally underneath this timeless scene, the predella represented important moments in the earthly life of the Virgin, beginning on the left with the <code>Annunciation</code> (see fig. 2). The other two National Gallery pictures come from the rear predella painted with stories of the Ministry of Christ, which once supported a main panel depicting twenty-six episodes from the Passion, Entombment and Resurrection of Christ.

The Annunciation shows the Archangel Gabriel, striding in with the staff of a royal messenger, greeting the Virgin: 'Hail, thou that art highly favoured, the Lord is with thee: blessed art thou among women' (Luke 1:28). Her book is inscribed with the prophecy of Isaiah (7:14): 'Behold, a Virgin shall conceive and bear a son. . .' Between Mary and Gabriel stands a vase of white lilies, symbolic of her purity. Mary is putting her hand to her heart, a gesture usually read as submission: 'Behold the handmaid of the Lord; be it unto me according to thy word' (Luke 1:38). Alternatively, she may have just lowered her book and may be drawing away from Gabriel in disquiet and reflection, the two successive emotions in Luke's description of her reaction: 'And when she saw him, she was troubled at his saying, and cast in her mind what manner of salutation this should be' (1:29). Whatever Duccio's precise intention, his treatment of this key scene in the divine plan of Salvation invites our meditative empathy. The newly complex architectural setting plays an important role in this effect: mortal woman and angel meet in a real space which extends beyond the confines of the painting. The verticals of walls and pillars, the semicircular and lancet arches offset the unstable diagonals of the figures, lending them a semblance of motion. The Virgin is isolated yet sways in response to Gabriel.

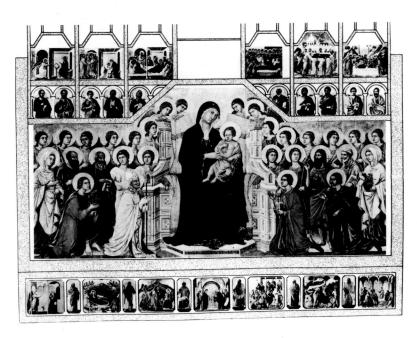

Fig. 2 Reconstruction of Duccio's Maestà (front, after John White). The Annunciation panel at the bottom left is tinted blue.

Infra-red photography reveals the presence of a quill-pen underdrawing by the same hand as that of fig. 1 (page 42). The space below Gabriel's wing to the left of the pillar was probably intended for gilding, like the area above the wing, since a layer of red bole, the clay undercoat of gold leaf, lies beneath the orange paint. Duccio, or more likely a workshop assistant, forgot to gild it, and finally painted it over, carrying the orange paint over to the right side of the pillar for the sake of completion.

ALBRECHT DÜRER (1471–1528)

Saint Jerome about 1495

Oil on wood, 23 x 17 cm NG 6563

Fruitful discordance marks the character and career of Albrecht Dürer. The diligent son and pupil of a Nuremberg goldsmith, he jettisoned his father's craft to train anew as a painter (continuing, however, to exploit his goldsmith's skills in the discipline of metal engraving). An artisan with rudimentary book learning, he longed to become a gentleman and scholar. Having willingly acquiesced to an arranged marriage and set up a workshop with his bride's dowry, he abandoned wife and shop within months of the wedding in 1494 and crossed the Alps into Northern Italy. The escapade must

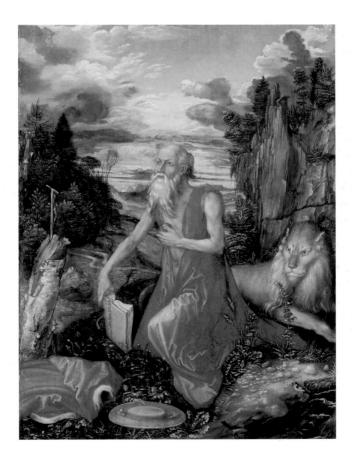

have been prompted by Willibald Pirckheimer, son of the Dürer family's landlord and Albrecht's childhood friend, who was reading law at Pavia. This picture, the first undisputed painting by the artist to be acquired by a British public gallery, is dated to just after Dürer's return home in late 1495. From this time onward the young Nuremberger, so richly endowed with the empirical individualism which he himself ascribed to 'the German mentality', strove to discover the Italians' secret of universal harmony.

The artistic Mecca of Northern Italy at this period, however, was not Pavia, nor even, despite the presence of Leonardo da Vinci (page 56), neighbouring Milan, but the Venice of Mantegna and Bellini (pages 64, 20). Dürer copied Mantegna's pioneering engravings, exotic with the *nackete Bilder* ('naked figures'), the rhythms and the stylised violence and pathos of Ancient Greco-Roman art. He responded with equal vigour to Giovanni Bellini's poetic use of colour and light. In contrast to the 'topographical inventories' executed during his apprenticeship, the watercolour landscape drawings he made on his way northward through the Alps subsume details to an overall conception, and modulate the colour of individual objects to accord with atmospheric and light conditions.

The minute panel of *Saint Jerome* (for the saint's history and imagery, see pages 18–19) transmutes these Alpine drawings into a marketable devotional oil painting. In later life Dürer was to write that he could 'make a pile in a year' of such works, but this youthful picture seems as elaborate and deeply felt as the engravings on which he lavished immense care and time. In its synthesis of Northern and Italian styles and motifs, Dürer must have wished the viewer to trace the momentous journey he himself had undertaken.

On the reverse is a swiftly painted comet – perhaps a heavenly portent of the Last Judgement, whose trumpets Jerome is said to have heard in the wilderness.

JAN VAN EYCK (active 1422-died 1441)

The Portrait of Giovanni(?) Arnolfini and his Wife ('The Arnolfini Portrait') 1434

Oil on oak, 82 x 60 cm NG 186

The 'invention' of painting in oils was long attributed to the Netherlandish artist Jan van Eyck. We now know the tradition to be untrue: oil may have been the original panel painting medium in Northern Europe, and had been used elsewhere since the eighth century or earlier for painting on stone and glass. What cannot be doubted is that van Eyck exploited the technique to its full representational potential. As we can see in this famous double portrait, he was able to imitate convincingly any surface texture – the silky hairs of the little dog, the polished brass of the chandelier, the convex silvered glass of the mirror and the amber rosary beads hanging on the wall. More astonishingly, by patiently working his slow-drying oil paints – sometimes with his fingertips, as demonstrated by fingerprints on the green gown – he was able to depict not just the effects of light on individual objects, but light itself, as it seems to enter the room through the window in the picture and either through a second, invisible window to our left or by the door reflected in the mirror.

The light casts shadows, flows behind and between the figures, and appears as omnipresent as air, like daylight in the real world. One device which aids this illusion is the constant variation of tonal relationships throughout the painting. Nearest the window, for example, Arnolfini's right shoulder stands out light against the dark

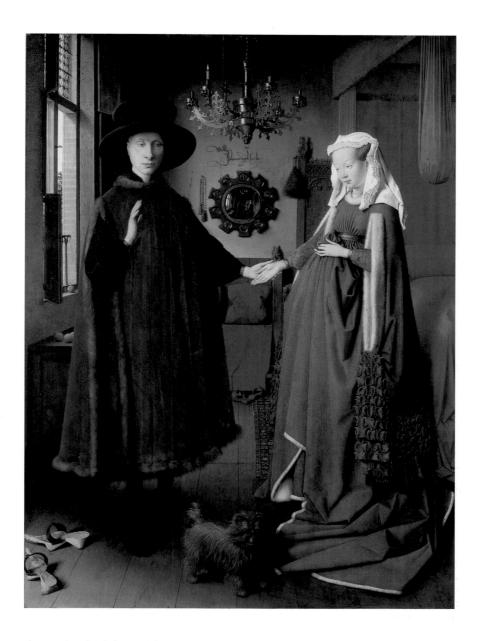

shutter, but his left shoulder and arm are silhouetted dark against the light wall. Such subtle changes, logically justified by the direction of light, serve to 'prise apart' foreground from background, figures from their surroundings. It is van Eyck's ability to match the appearance of light-in-air which enables him to evoke space, not linear perspective, which he employs only approximately. The illusion is so potent that not even the elongated proportions and tiny heads of the figures dispel our belief in the reality of this scene.

The picture is extremely unlikely to depict an actual marriage ceremony, as many have supposed. We are not even sure of the identity of the sitters. The Latin inscription on the back wall, 'Jan van Eyck was here/1434', probably simply attests to the artist's

authorship of the painting, his creation of 'here'. It is surely true, however, that the painting portrays a married couple, and in this context the dog might symbolise fidelity. The couple's piety is certainly attested by the beads and the mirror, whose frame is decorated with scenes of the Passion of Christ. The carving on the bench represents Saint Margaret, patron saint of women in childbirth (see pages 67–8), although the wife is fashionably round-bellied rather than pregnant. The gesture of Arnolfini's right hand – altered by the artist from a more upright position – might be welcoming the artist or the viewer; it is not, as has often been thought, the affirmation of marriage vows. What we see before us is the portrait of a prosperous and God-fearing bourgeois couple – and only the painter's invention and descriptive genius lends it the semblance of a significant moment in a particular place.

JAN VAN EYCK (active 1422-died 1441)

Portrait of a Man (Self Portrait?) 1433

Oil on oak, 33 × 26 cm NG 222

In this painting light is depicted to suggest volume and surface texture rather than, as in 'The Arnolfini Portrait', to evoke the illusion of space. It is one of the few fifteenth-century portraits to survive in its original frame. The inscription at the top, partly in Greek letters, reads in Flemish 'As I can', the one along the bottom, in Latin, 'Jan van

Eyck made me 1433 21 October'. Both inscriptions appear to have been chiselled in the wood but have in fact been painted. The former occurs in other works by the artist and seems to be taken from a Flemish proverb; a pun on the word 'IXH' – 'I' and 'Eyck' – may be intended: 'As I (Eyck) can but not as I (Eyck) would wish.' The mock modesty of the motto and the direction of the sitter's gaze, as if towards a mirror, have led to the identification of the picture as a self portrait, but there is no way now of knowing whether this is true.

Remarkable though it is, the description of the sitter – with the stubble on his chin prickly against the soft fur collar, and his bloodshot left eye – is less arresting than the depiction of his headdress. Van Eyck is noted for the impassivity of his figures, and it is instructive to compare this portrait with that by Campin of a man wearing a similar red hat (page 30). There, the scarf ends hang down, serving to frame a face in which we read force of character and upon which we can project an inner emotional life. Van Eyck's personage gives much less away. A greater area of the picture is taken up by his red hat than by his face, its three-dimensional bulk is more assertive, its folds and tucks more dramatic. I suspect that the hat was studied at greater length, perhaps on a stand, independently of the sitter and, like a studio still life, arranged by the painter, knotted and tweaked to present its most picturesque aspect. It seems less dependent on pictorial conventions than the three-quarter view of the face. Van Eyck's ability to depict it in such a realistic manner relies greatly on his control of the oil medium, which unlike tempera enables him to represent dark shadows and paler highlights without losing the glowing overall red hue.

GEERTGEN TOT SINT JANS (1455/65-1485/95)

The Nativity, at Night about 1490

Oil on oak, 34 x 25 cm NG 4081

There are no contemporary records of this Haarlem artist, whose name means 'Little Gerard of the brethren of Saint John'. This picture is attributed to him by analogy with works given to him in seventeenth-century sources. It may derive from a lost altarpiece; at this period large-scale compositions were frequently adapted for domestic devotions.

The subject of this magical little panel is vision: first, the mystic vision recounted by a fourteenth-century saint, Bridget of Sweden, in which she witnessed the painless birth of Christ, the Virgin's adoration of her son and the baby's radiance eclipsing Joseph's candle; secondly, the ocular vision of dazzled shepherds shielding their eyes as the angel appears, like a shooting star, to announce the birth of the Messiah; thirdly, the marvelling gaze of childlike angels, ox and ass, Mary and Saint Joseph upon the Light of the World naked in the manger. And, finally, it makes evident a new vision of piety current in the Northern Netherlands, in which humility is the key to holiness, and a new artistic vision.

The divine radiance is not embodied in costly expanses of gold and rare pigments crafted into a precious object (see page 42). It is made visible to us through Geertgen's patient modulation of darkness, the winter's night barely pierced by distant stars, hardly warmed by fire, only faintly lit by the candle Joseph once held (probably lost when the panel was trimmed at some time in the past). Through Geertgen's mastery of naturalistic description, with only a shorthand notation of thin rays of real gold beaming from the holy infant, this winter's night as it was before the birth of Christ can

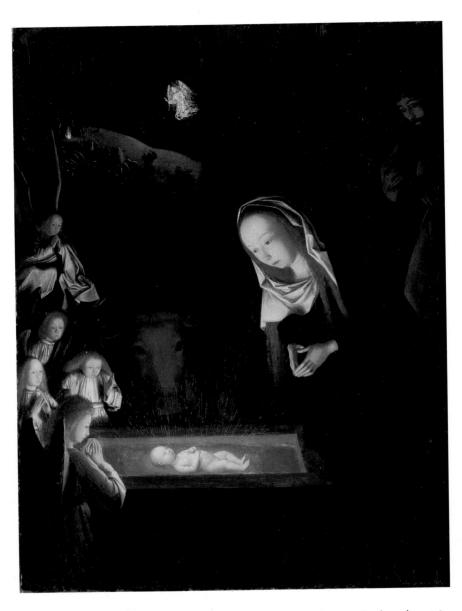

now be seen to have truly been, as is written in the Gospel of Saint John (11:10), a night in which 'if a man walk...he stumbleth, because there is no light in him'.

GENTILE DA FABRIANO (about 1385-1427)

The Virgin and Child (The Quaratesi Madonna) 1425

Tempera on poplar, 140 × 83 cm L37

Gentile is now known as a great painter on panel, although in his lifetime he was mainly celebrated for wall painting. A native of Fabriano in the Marches, he became

an itinerant artist, employed by the most distinguished patrons of Italy: the Venetian Republic, the lord of Brescia, Florentine magnates, the notaries of Siena, Orvieto Cathedral. He died in Rome, working for the pope.

Despite being the pre-eminent painter of his day, able to combine elaborate medieval technique with novel experiments in lifelike representation, Gentile remained flexible and open to influences – including that of his younger contemporary Masaccio (page 68), originally influenced by him. Ironically, within a generation Masaccio's rigorous application of observations from nature and after antique sculpture succeeded in eclipsing

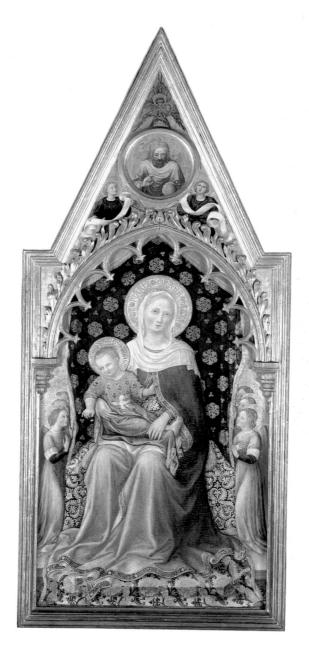

Gentile's fame in Florence. On loan to the National Gallery from the Royal Collection, the *Quaratesi Madonna* – named after the family who commissioned the altarpiece of which it was the central panel – is shown near Masaccio's *Virgin and Child* painted a year later. Art historians from all over the world come to compare and contrast the two works, usually to Masaccio's advantage. Gentile's beautiful picture, however, deserves to be viewed on its own terms.

The Quaratesi altarpiece was painted for the high altar of San Niccolò Oltrarno, Florence. Dismembered in the nineteenth century, it originally consisted of the Virgin and Child flanked by Saints Mary Magdalene and Nicholas of Bari on the left, and Saints John the Baptist and George on the right, each on a separate gabled panel. The saints (now in the Uffizi, Florence) stood on a continuous painted pavement, the edges of which are just perceptible on either side of the step of Mary's throne, like figures viewed through the slender columns of an open balcony or loggia. In the same way that Christ with his foreshortened halo leans out of the little roundel in the gable above the Virgin, other figures looked out of roundels above the saints of the main storey. Below, in the predella (now in the Vatican), were lively little scenes of the legendary deeds of Saint Nicholas, titulary saint of the church. All these elements were further harmonised through subtle adjustments of composition and colour. Gentile's sumptuous decorative effects can now best be appreciated in the gold brocade, for the once brilliant cloth of honour behind the Virgin and Child, painted translucent red over silver leaf and green over gold, has darkened and blotched with age.

Despite its regal magnificence, the central group retains a graceful intimacy. The Virgin, an ideal beauty of her day with fair hair, broad forehead and rosebud mouth, looks out gravely as the Christ Child smiles contentedly, showing his tiny milk teeth. Keeping firm hold of his mother's cloak, he turns from her to the adoring angel, with a daisy – symbol of his innocence, picked in heaven, the garden of eternal spring – held daintily between his pudgy finger and thumb.

ATTRIBUTED TO GIOTTO DI BONDONE (1266/7-1337)

The Pentecost about 1306-12

Tempera on poplar, 46 × 44 cm NG 5360

Giotto's contemporaries recognised that he had changed the course of art. Unlike earlier painters (but see also his presumed master, Cimabue, page 34), he stressed the three-dimensional reality of his personages and their settings, and sought to involve viewers as witnesses in the unfolding drama of the Christian story. Later Florentines, Michelangelo (page 134) among them, continued to draw on his example. Undisputed works by him are mural cycles in churches in Florence and Padua, and it is against these that panel paintings such as this one, attributed to him and his busy workshop, must be measured. Although the uneven quality of the figures suggests the collaboration of assistants, the two men in the foreground, solidly planted on the ground and psychologically alert despite the decorative symmetry of their poses, are almost certainly by Giotto himself.

Scientific examination has established that this little panel is the seventh, and last, of a series of scenes from the life of Christ originally painted on one plank and forming a long low altarpiece of exceptional width. Other panels are now scattered in museums in the United States and Europe, and comprise, from left to right, the Nativity, the Presentation in the Temple, the Last Supper, the Crucifixion, the Entombment and

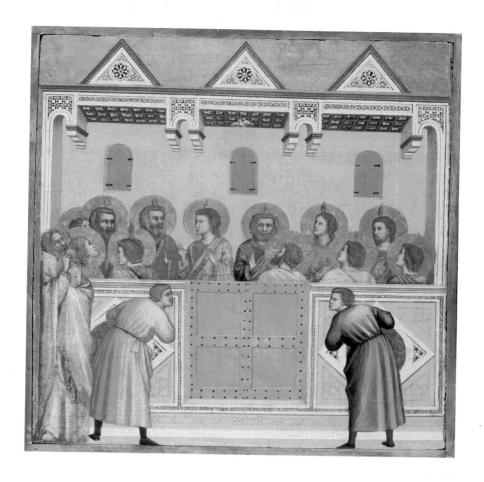

Christ's Descent into Limbo. The panels are united not only through their stories, scale and style, and the pattern of wood grain made visible through X-radiographs, but also in their unusual gilding. To give their golden backgrounds and haloes the warm gleam of the solid metal, artists normally laid gold leaf over a sticky red clay called bole. In all these panels, however, the gold has been applied over a layer of green earth, a pigment chiefly used under flesh tones by Italian painters of the time. This enhances the naturally greenish tone of the gold leaf and gives a distinctive cool tonality to the pictures.

The Pentecost, last in the series, is the only scene in which Christ himself does not appear. It is described in the Acts of the Apostles (2:1–13), and initiates the universal mission of Christ's disciples. Gathered together after Christ's Ascension, the twelve apostles were filled with the Holy Spirit in its form of 'cloven tongues like as of fire [that] sat upon each of them' and 'the multitude...were confounded, because that every man heard them speak in his own language'. In addition to the flames on the apostles' heads, the Holy Spirit is represented in the usual guise of a dove, with rays emanating from it. Giotto has designed the scene with the pithy clarity of his mural cycles, showing both the inside of the apostles' room, with its receding coffered ceiling, and the outside. Only three figures stand in for the exotic crowds in the text: one man meditating on the apostles' words, and the two men who listen and communicate, to each other and to the viewer, their wonderment at both the miracle and the message.

GIOVANNI DI PAOLO (active 1417-died 1482)

Saint John the Baptist retiring to the Desert $_{1454}$

Tempera on poplar; excluding borders, 32 × 38 cm NG 5454

Together with Sassetta (page 88), Giovanni di Paolo was one of the leading Sienese painters in the fifteenth century. So strong was the hold on Sienese art of its great fourteenth-century masters – Duccio (page 41) and his followers – that both Giovanni di Paolo and Sassetta consistently harked back to earlier models. Giovanni's dual allegiance to the modern and the old can clearly be seen in the four predella panels of Scenes from the Life of Saint John the Baptist at the National Gallery, of which Saint John retiring to the Desert is likely to have been the second from the left. The other panels represent the saint's birth, the Baptism of Christ, and the Feast of Herod at which Salome's dance and Herod's reward for it brought about the decapitation of the saint. The predella – a box-like supporting element for the main painting – may have originally formed the base of an altarpiece now in New York.

The story of Saint John the Baptist is told in the Gospels and in legend, and its pictorial tradition was well established by the fifteenth century. In 1427 bronze reliefs by the Florentine sculptors Ghiberti and Donatello, of *The Baptism of Christ* and *Herod's Feast* respectively, were delivered to Siena as part of a new font for the baptistery. Giovanni di Paolo has adapted these artists' compositions for the analogous scenes of his predella, but had no innovative Florentine sources for his depiction of the child Saint John leaving home and slipping off into the wilderness through a crevice in the mountain. He imparts a sense of movement to the scene by the poetic device of combining two episodes, John at the gate of the city and again in the mountains, shown

both times in profile as if driving the story onwards from left to right. Equally unrealistic, although traditional, is the large size of the figure in contrast to the small scale of the setting, and the very high bird's-eye viewpoint from which we see the landscape as it recedes abruptly away from the city wall to the right and to the top of the picture. It is this high viewpoint which enables us to perceive the curvature of the earth at the horizon and the neat patchwork of fields and woods. The mountains are painted in a convention inherited from medieval Greek art, and the whole picture, with its soft colour scheme punctuated with bright pink and the gleaming gold of John's halo, has the charm of a fairy tale.

Equally charming but for quite different reason, are the borders of roses painted entirely realistically on either side. Curiously, these are seen from below, as by a viewer at eye level with the lower bud on each branch.

ATTRIBUTED TO JACOPO DI CIONE (active 1362-died 1398/1400)

The Coronation of the Virgin with Adoring Saints (The San Pier Maggiore Altarpiece) 1370-1

Tempera on poplar; central panel 206 \times 114 cm, side panels each 169 \times 113 cm $\,$ NG 569.1-3

The Coronation of the Virgin and its flanking Adoring Saints were the main tier of one of the largest and most elaborate altarpieces commissioned in Florence in the second half of the fourteenth century. It was erected on the high altar of the church of San Pier Maggiore; the accounts show that a hoist was required to set it in place. Sometime

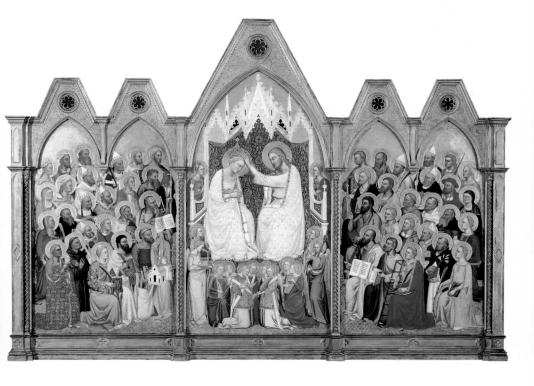

after the church was destroyed in the eighteenth century, the altarpiece was dismembered, the frame destroyed, all the panels altered in shape and the predella panels dispersed in various museums. Although the National Gallery owns the paintings of the main tier and the pinnacles, their original arrangement cannot be replicated because of its great height. The present frame is modern.

A complex structure of this kind was the work of many hands. While the painting is in the style of Jacopo di Cione, the youngest of four Florentine artist-brothers, the overall design was the responsibility of his collaborator, Niccolò di Pietro Gerini. A third master may have been charged with the gilding and its elaborate decoration. So closely and efficiently did the three masters and their assistants work together that from the initial design to the final installation took little longer than a year.

The central subject was extremely popular in Florence at this time (see page 63) and provides a pretext for assembling a celestial orchestra and a large number of spectator saints. There are forty-eight of them, the most prominent being the titular saint of San Pier Maggiore, Saint Peter. He is shown in the most honorific place to the right of the throne in the front row, holding the key to heaven and a model of his church, a symbol also of the universal Church. Although at first sight the heads of all the figures seem individually characterised, they are unlikely to have been painted, or drawn, from life, but were almost certainly derived from an appropriate pattern book (see also page 85). Some in fact are mirror images, so that the features of the young deacon Saint Stephen in the front row of the left panel (on his head is one of the stones with which he was martyred) reappear, reversed, on the face of the young deacon Saint Lawrence (with the grill of his martyrdom) on the right panel. Much of Giotto's naturalism and sense of drama (page 52) has been diluted through such reliance on stereotype. Although the figures are reasonably solid and kneel or stand in ranks behind each other, and the throne has been drawn in a freehand approximation of perspective, the general effect is two-dimensional.

A new interest in rich decoration, however, particularly in the splendid fabrics whose designs are scratched through the paint layer to reveal the gold leaf beneath, works to offset the impassivity of individual figures and the severity of the composition as a whole. Seen by candlelight, the tooled gold and rhythmically repeated colours might even have lent a semblance of movement to the scene – saints and angels swaying gently to the solemn music of harp and organ, bagpipe and cittern, played before the Virgin and her son.

LEONARDO DA VINCI (1452-1519)

The Virgin of the Rocks about 1492–1508

Oil on wood, 190 x 120 cm NG 1093

Even his contemporaries were in awe of that legendary genius, Leonardo da Vinci. Trained in Florence as an artist/engineer, he both traduced and transcended his profession, incessantly active but by the standards of the day achieving little. Unable or unwilling to work systematically from commission to completion, he relied on stipends from princes, dying in a château on the Loire, esteemed 'as a very great philosopher' by the King of France. Collectors pleaded in vain for pictures by his hand 'made with that air of sweetness and suavity which is peculiar to you', as Isabella d'Este, Marchioness of Mantua, wrote to him. He seems to have kept in his own possession famous and much coveted paintings such as the *Mona Lisa* and left them to a rascally pupil. His precious

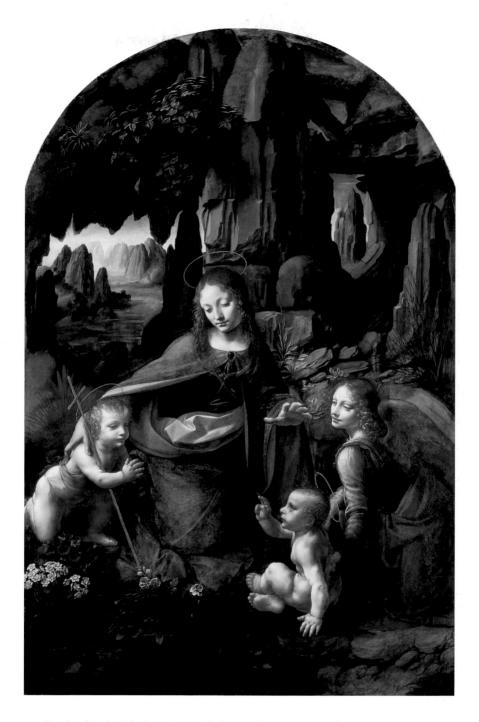

notebooks, filled with drawings and observations on art, architecture, engineering, optics, geometry, anatomy and other natural sciences, were never made public but were bequeathed to Giovanni Francesco Melzi, another member of his workshop, who compiled from them a fragmentary *Treatise on Painting* avidly studied for centuries. Yet

each of Leonardo's known compositions, completed or not, was influential throughout Europe. *Mona Lisa* has never lost her fascination and the ruined mural of the *Last Supper* remains the most compelling and widely known visualisation of a Christian narrative. It is almost impossible now to view his work afresh, or to recapture a convincing sense of how it would have appeared to its original spectators.

The Virgin of the Rocks was begun in 1492 for a lay brotherhood, the Confraternity of the Immaculate Conception, of San Francesco in Milan; parts of it remain unfinished, while others, especially the rocks in the background, were completed by one of the artist's associates. Leonardo may have planned the picture before he received the commission on his arrival in Milan in 1483 – an earlier version, probably sold to the French king, is now in the Louvre, Paris. The National Gallery picture substitutes a motif popular in Florence for the image normally required by Franciscan patrons promoting the doctrine of Mary's Immaculate Conception: a Virgin without the Child, shown standing among prophets holding texts taken to refer to her exemption from Original Sin. In The Virgin of the Rocks the infant Baptist, sheltering under Mary's cloak, venerates the Christ Child in a cool, watery wilderness. The artist's Milanese clients must have worried about confusing the two infants, for a later hand has given John an identifying scroll and a cross clumsily rooted in one of Leonardo's exquisite studies of plants.

The panel was inserted into a pre-existing frame, elaborately decorated with carving, gilding and painted shutters. In the candlelit chapel the glittering frame and the painted rocks from whose shadows the figures emerge would have combined to suggest a mysterious cavern. In his notebooks Leonardo records a moment, when standing before the mouth of a cave, 'Suddenly two things arose in me... fear of the menacing darkness... [and] desire to see if there was any marvellous thing within'. The contrast between the unfinished areas of the picture – such as the hand of the angel on Christ's back – and the finished passages would not have been as disturbing as it is now. Leonardo's intentions in this deeply emotional yet strangely uncommunicative work were perhaps most fully carried out in the angel's head and diaphanous veil, where the shimmering brushstrokes are of miraculous firmness and delicacy.

LEONARDO DA VINCI (1452-1519)

The Virgin and Child with Saint Anne and Saint John the Baptist about 1499-1500

Charcoal, with white chalk heightening, on paper, 142 × 106 cm NG 6337

In a specially built recess in the wall of a darkened little room behind the *Virgin of the Rocks* (page 57) hangs one of the most precious and fragile works in the National Gallery: Leonardo's 'cartoon' – a drawing of the Virgin's mother, Saint Anne, with the Virgin on her knee and the Christ Child in Mary's arms leaning across to bless the infant Baptist and chuck him under the chin. The drawing covers eight sheets of paper glued together. A reduced light level is necessary to prevent the chalk and charcoal from fading, but the reverential atmosphere it creates seems appropriate. As in the *Virgin of the Rocks* Leonardo has represented four figures in rapt communion charged with theological significance and intense human emotion. Shared glances and introspective smiles play across their faces, enigmatic expressions which Leonardo made famous.

The open triangle formed by the figures in the *Virgin of the Rocks* is here condensed into a pyramid of interlocking forms; the figures increase in scale and the rocky landscape recedes into the distance, leaving only pebbles in the foreground. Despite the gain in

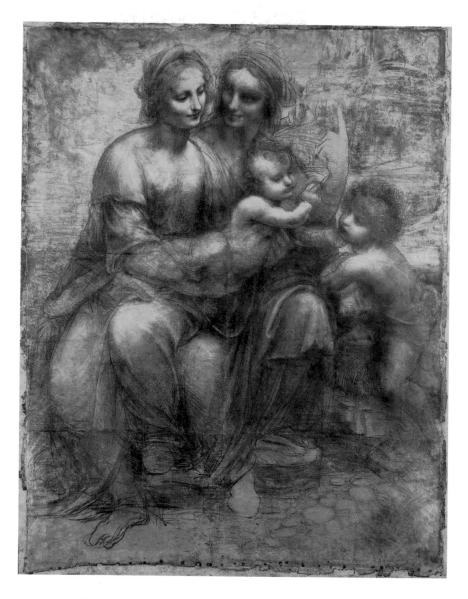

monumentality, nothing is conclusively resolved. Potentially awkward areas where the bodies touch and overlap were left blurred and smudged. Saint Anne's forearm, prophetically raised to Heaven, is barely sketched in. We begin to see why Leonardo found such great difficulty in bringing projects to completion, for the indeterminacy of the design and the lack of finish are integral to the significance of the work, pictorial mystery evoking divine mystery: God made flesh in the womb of a woman herself conceived without sin, the Passion foretold and accepted with melancholy joy.

Cartoons were full-size drawings made to be transferred to panel, wall or canvas to serve as a guide to painting. The National Gallery drawing was surely preparatory for a painting, but was never used for transfer, since the outlines are neither pricked nor incised. Like *The Virgin of the Rocks*, it is a variation on a theme which occupied Leonardo for some years. In 1501 Florentine 'men and women, young and old, as if they were

going to a solemn festival', had flocked to see a drawing by Leonardo of similar size on a similar subject, probably made for an altarpiece to Saint Anne, one of the patrons of republican Florence, for the church of Santissima Annunziata. That altarpiece was never executed, and the drawing for it was lost.

Sometime later Leonardo was commissioned to revise the composition for King Louis XII of France, whose second wife's name, Anne, would have made the subject especially attractive. The French king's painting, begun in about 1508, was left unfinished at Leonardo's death and is now in the Louvre, Paris. It shows Anne smiling down at the Virgin on her lap, who bends over to restrain the Child playing with a lamb, symbol of Christ's sacrifice and attribute of Saint John the Baptist. Both the Paris painting and the National Gallery 'cartoon' demonstrate what an eyewitness marvelled at in the lost drawing of 1501: 'And these figures are all as large as life, but they exist within a small cartoon, because they are either seated or in curved poses and each is a certain amount in front of the other...' It was Leonardo's supreme gift to resolve a formal problem in many different, but equally evocative, ways.

FRA FILIPPO LIPPI (about 1406-1469)

The Annunciation about 1448-50

Tempera on wood, 68 x 152 cm NG 666

An orphan placed in the convent as a child, Fra Filippo took his vows at Santa Maria del Carmine in Florence in 1421, in time to observe Masaccio and Masolino (pages 68–72) at work on the famous frescoes there. He was more suited to the life of a painter than to that of a Carmelite, for in 1456, while chaplain to a convent in Prato, he induced a nun to elope with him. She was to bear him a child, Filippino, who grew up to be an excellent painter of outstandingly chaste morals; there is a beautiful altarpiece by him in the Sainsbury Wing. Filippo was employed as an artist by the Medici, and through their intercession obtained a special dispensation to marry Filippino's mother.

The Annunciation is one of a pair of panels originally from a Medici palace in Florence; the other, hanging nearby, depicts seven saints of special significance to the family. The shape and subject matter of both panels suggest that they were part of the furnishings of two separate but related rooms, either as bed-heads or as panels situated above a bed

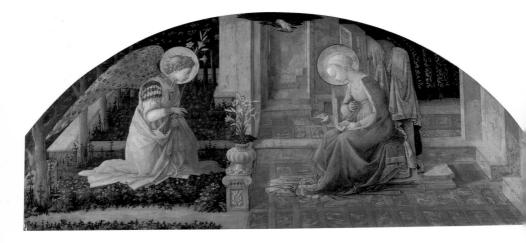

or door. While the Seven Saints illustrates a dynastic theme through the male members of the family, the Annunciation would have been more suitable for a woman's room.

The Medici device of three feathers within a diamond ring is 'sculpted' in relief on the edge of the parapet which separates the Virgin's 'garden enclosed' (see page 41) from her bedchamber. Mary's purity is further alluded to in the lilies held by the Archangel Gabriel and those growing in the urn between them. From the centre of the arched top of the panel the hand of God the Father has launched the dove of the Holy Spirit. Its spiralling flight path, outlined in glittering gold, is about to end in the Virgin's womb, from which emanates a small scattering of gold rays. In Mary's submissive pose Lippi illustrates the moment in the Gospel of Saint Luke (1:38) when she says: 'Behold the handmaid of the Lord; be it unto me according to thy word.'

All the qualities for which the Medici prized Fra Filippo's art are demonstrated in this image. The austerity of the centralised perspective (the slope of the floor is exaggerated to account for the angle at which the panel was originally to be viewed) and of the strict geometry inherited from Masaccio is tempered by the artist's sublimely delicate use of line, colour and ornament. The Virgin's transparent veil gently softens the curve of her neck and shoulders, Gabriel's peacock wings echo the curve of the arch. But the greatest beauty of the painting resides in the meeting of angel and Virgin, virtual mirror images of each other. The one inclines his profiled head and bends his arm in gentle deference, the other responds with grave humility.

STEPHAN LOCHNER (active 1442—died 1451)

Saints Matthew, Catherine of Alexandria and John the Evangelist about 1450

Oil on oak, 69 × 58 cm NG 705

Lochner was the leading painter of his day in Cologne, where in 1520 Dürer (page 45) paid to be shown his altarpiece of the Adoration of the Magi. This panel of saints is the inside of the left-hand shutter from a small altarpiece of which the central panel is lost; the outside of the shutter, also depicting three standing figures of saints, is badly damaged. The right-hand shutter, now in a museum in Cologne, was sawn apart so as to make two panels. While the National Gallery shutter was trimmed at the top and bottom, the inner panel in Cologne which once matched this picture still shows carved tracery above and below the figures. On it are painted Saints Mark, Barbara and Luke, so that the two shutters together, when opened, would have shown all four Evangelists and two of the most popular female saints. They can be identified through their attributes, those of the Evangelists being the four beasts of Revelation (4:6-8). Here Matthew, writing his Gospel, is accompanied by his angel. John holds a chalice containing a serpent to recall his miraculous feat of drinking from a poisoned cup without harm, and is accompanied by his eagle; his pen case hangs from his belt, and he is depicted in the act of blessing. Catherine of Alexandria holds the sword with which she was beheaded; at her feet are the fragments of the spiked wheel on which she was first tortured, and which has given her name to a kind of firework. All three are standing on stony ground against a gold-leaf background, tooled to catch the light and to suggest a sumptuous cloth of gold.

Lochner's painting style combines sharp outline with smooth-licked generalised volume, particularly striking in Catherine's fashionably rounded forehead. Just as the figures are united through the repetition in each of the same colours – green, red and

white – so their poses call to mind a pattern of the slow-paced dances of the time: three partners, symmetrically arranged by gender, all stepping forward with the same foot. The analogy must have been even more compelling when the altarpiece was still complete. For while the London figures stand with their right foot extended, it is their left foot which the three saints in Cologne put forward.

LORENZO MONACO (before 1372-1422/4)

The Coronation of the Virgin and Adoring Saints 1407-9

Tempera on poplar; left section 182 \times 105 cm, central section 217 \times 115 cm, right section 179 \times 102 cm $\,$ NG 215 / NG 1897 / NG 216

Piero di Giovanni became 'Lorenzo the Monk' upon taking his vows in 1391 at the Camaldolese monastery of Santa Maria degli Angeli, Florence. This ascetic order had been founded in 1012 by a Benedictine monk, Saint Romuald, shocked at the decadent laxity of his own monastery, and named by him after the mountain locality of Camaldoli in Tuscany where he built a hermitage. Legend has it that he dreamed of a

ladder stretching from earth to heaven, on which men in white robes were ascending, and thereupon decreed that the monks of his new order would dress in white. For this reason, Camaldolese altarpieces such as this one always show Saint Benedict, the sixth-century founder of the Benedictines, dressed in white rather than Benedictine black.

In this altarpiece from San Benedetto fuori della Porta Pinti, Florence, Benedict is shown on the extreme left. His book is inscribed with the opening words of the Prologue of his Rule, which the Camaldolites, as reformed Benedictines, observed. In his left hand is the birch he used to chastise errant monks. At his side sit Saint John the Baptist and Saint Matthew with his Gospel. Equally venerable on the extreme right is Saint Romuald in his white habit, with no lesser personages than Saint Peter and Saint John the Evangelist beside him. These and other saints are witnessing the Coronation by Christ of the Virgin after her Assumption to Heaven, a scene first depicted in thirteenth-century France and at this period extremely popular in Florence, although it is not mentioned in the Gospels. Since the Virgin sometimes personifies the Church, Christ vesting her with a regal crown confirms the authority of Church and Pope, a suitable subject in this city politically allied with the Papacy. Angels make music below.

In its original form the altarpiece was not divided as a triptych but presented a single surface with a three-arched top, with gables and a predella. It was probably dismembered during the siege of Florence in 1529, and almost certainly by 1568. The main panel was divided into three parts sometime after 1792 and the side pieces and central scene entered the National Gallery at different times. They are now shown in a modern frame.

Viewing this attractive work in its present state and location, it is easy to forget its solemn liturgical function and institutional self-promotion – the way the founding saints of the Benedictine and Camaldolese orders are installed in Heaven on equal terms with Evangelists, apostles and the Baptist. It is even harder to remember that the artist who painted these calligraphic lines, delicious colour combinations – the Virgin's robe has faded from its original pinkish mauve – and courtly mannered angels was himself a member of that austere, white-clad community.

ANDREA MANTEGNA (1430/1-1506)

The Introduction of the Cult of Cybele at Rome 1505-6

Glue size on linen, 74 × 268 cm NG 902

'Andrea would have done far better,' sneers Mantegna's estranged teacher, the Paduan Squarcione, in Vasari's account, 'if he had painted his figures not in various colours but just as if they were made of marble, seeing that his pictures resembled ancient statues ... rather than living creatures'. One cannot help but feel, looking at this painting or at Mantegna's other fictive relief sculptures in the National Gallery, that he took up Squarcione's challenge. He had separated from his former master in 1448 and in 1452/3 had allied himself through marriage with the rival firm of the Bellini, the foremost painters in the Veneto. Using his bride's dowry to annul all legal connection with Squarcione, Mantegna did not, however, bind himself to the Bellini workshop. In 1459 he settled at the Mantuan court, in whose service he was to die one of the most celebrated artists in Italy. His paintings influenced many, not least his brother-in-law Giovanni Bellini (page 20), and his prints many others, the great German artist Dürer (page 45) among them.

In the university town of Padua, Mantegna had become an amateur archaeologist and friend of classical scholars, interests which he continued to pursue at the learned court of Mantua. But the relatively small picture discussed here, as complex an evocation of Roman antiquity as any of his wall-size paintings, was commissioned in 1505 for the family palace of Francesco Cornaro, a Venetian nobleman. The Cornaro claimed descent from the Roman clan of Publius Cornelius Scipio Nasica, designated in 204 BC the man most worthy to welcome to Rome from Asia Minor the Mother of the Gods, Cybele. The goddess had manifested herself on Mount Ida in the form of a meteorite, and her removal to Rome was a precondition of expelling the Carthaginians from Italy

during the Punic Wars. As recounted by ancient historians and poets, the ship carrying the divine stone ran aground. A Roman matron accused of adultery, Claudia Quinta, pulled it free with her girdle, thus proving her chastity.

Mantegna's picture was to be one of a series (never completed) of related tales which, when affixed around the walls of a room, would have resembled a sculptural frieze. Rather than marble relief, however, he imitated the appearance of cameos – the works of ancient art most prized in the Renaissance – in which figures were cut out of one coloured layer of a stone to reveal another in the background. Even the largest Roman cameos barely compare in size with Mantegna's picture, making it seem especially rare and precious.

Cybele's meteorite, a bust of her (modelled on an Ancient Roman sculpture) and a lamp are shown carried on a litter by the goddess's rhythmically loping priests, preceded by one of her acolytes in oriental trousers. The wild-haired kneeling figure may be Claudia Quinta, or one of Cybele's self-castrated male worshippers. Scipio may be the man gesturing to wary fellow senators. To the right a turbaned seer expounds the exotic cult to a Roman soldier, while a young Phrygian plays a fife and drum, answered by trumpets from within the portal.

The perspective of the stairs is calculated for a low viewpoint, as is the placing of the figures. The 'stone' colours, graduated from gold-grey through cooler shades in the figures to the brilliantly variegated background, and the movement reverberating throughout the painting, combine to create the illusion of sculpture that has come vibrantly alive.

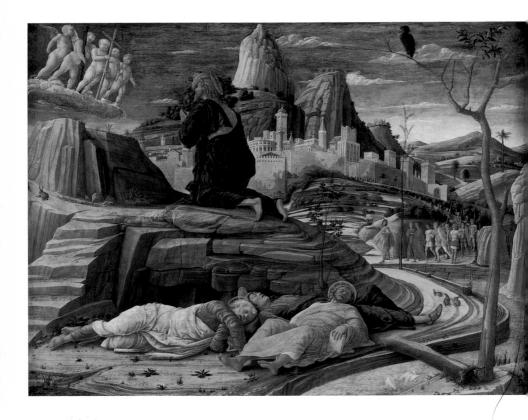

ANDREA MANTEGNA (1430/1-1506)

The Agony in the Garden about 1460

Tempera on wood, 63 × 80 cm NG 1417

Mantegna's passionate study of ancient ruins must have aroused his interest in stone itself. Not only did he paint fictive stone reliefs and cameos (see page 65), he even pictured quarrymen at work in the background of a small image of the Virgin and Child (Uffizi, Florence). Where magnificence was wanted he depicted marble floors, columns and walls in alabaster, porphyry, serpentine and other exotic stones prized in imperial Rome and medieval Venice. The keynote of this *Agony in the Garden*, however, is the bruising asperity of the bare rock of the Mount of Olives and the hardness of the dressed stone of Jerusalem, of which Christ predicts 'there shall not be left...one stone upon another' (Matthew 24:2).

The city is represented as doubly infidel. Crescent moons, the emblem of Islam, crown its towers; a gilded equestrian monument on a sculpted column and a round Colosseum-like building recall pagan Rome. A gate in the newly repaired walls opens only to let out a column of soldiers, Judas at their head. For this is the episode, recorded in all the Gospels, before the capture of Jesus. After the Last Supper, he went out of Jerusalem with the disciples to pray, saying, 'My soul is exceeding sorrowful unto death...' (Mark 14:34). Rather than watch with him, Peter, James and John sprawl in sleep. Where Bellini, in a version of this composition also in the National Gallery (page 22), shows the angel appearing to Christ 'from heaven, strengthening him' (Luke 22:43), Mantegna illustrates the bitter moment when Christ must resign himself to

God the Father's will. Before him five angels, naked like the athletic babes of ancient art, hold up Instruments of his Passion: the column of the Flagellation, the cross of the Crucifixion, the sponge which was dipped in vinegar and offered to him, the lance used to pierce his side. A vulture, sensing the approach of death, watches from a withered branch.

Yet it is not feelings of pity and desolation which Mantegna seems to wish to evoke from the viewer of this small devotional work with its wiry lines and bold colours. The hares (or rabbits) on the path, themselves defenceless, symbolise those who put the hope of their salvation in Christ, and the snow-white egrets in the water allude to the purification of baptism. Trees have been felled, but saplings sprout from the very rock. In his own stern way Mantegna enjoins courage. And perhaps it is not too far-fetched to recall here that 'stone' is a metaphor which runs through the Bible and which the apostle Peter applies to Christ (1 Peter 2:6): 'Behold, I lay in Sion a chief corner stone... and he that believeth on him shall not be confounded.'

MARGARITO OF AREZZO (active 1262)

The Virgin and Child Enthroned, with Scenes of the Nativity and the Lives of Saints 1260s

Tempera on wood, 93 × 183 cm NG 564

One of the earliest Italian paintings in the National Gallery, this panel was almost certainly made as an altarpiece rather than to decorate the front of the altar table, as the shape might suggest.

By the 1260s the figure of the Virgin Mary with the infant Christ, reflecting the Christian doctrine of the Incarnation, had become the most popular religious image, along with the Crucifix commemorating the sacrifice of Christ on the cross. Mary and her son are represented here in the traditional Byzantine (that is, medieval Greek) manner – she as Queen of Heaven, seated on a lion-headed throne like that of Solomon (1 Kings 10:19), Christ in turn enthroned upon his mother. He is shown not as a lifelike baby but as the Word of God, according to the Gospel of Saint John, draped in the garments of ancient philosophers, statesmen and judges, scroll in the left hand, blessing with the right. On either side, angels swing censers, like altar boys at Mass. These figures are contained within a mandorla, the almond-shaped glory signifying the heavens. At the four corners are the symbols of the four Evangelists, also traditional but originally derived from the Revelation of Saint John, the last, prophetic book of the Bible.

In contrast to this timeless and symbolic image, the four square compartments on either side depict moments in sacred history: the Birth of Christ in the upper left-hand corner, to its right Saint John the Evangelist being freed by an angel from a cauldron of boiling oil. To the right of centre in the upper tier Saint John is shown again, raising Drusiana from the dead, and to his right Saint Benedict fights the temptations of the flesh by rolling naked in thorny bushes. In the bottom left-hand corner Saint Catherine is beheaded and her body carried to Mount Sinai by angels, and to the right Saint Nicholas warns pilgrims that they have been given deadly oil by the devil. He reappears to save three youths from execution, and in the bottom right-hand corner Saint Margaret, behind prison bars, is also seen twice: being swallowed by a dragon and bursting out from his belly. Latin captions above each scene describe what is shown. Beneath the feet of the Virgin a Latin inscription declares 'Margarito of Arezzo made me'.

The painting stands both at the end and at the beginning of a pictorial tradition. Margarito is dependent, as we have seen, on Byzantine pictures imported into Italy. They, in turn, relied on representational schemes derived from Ancient Greco-Roman art: using shadow and highlight to indicate the folds of drapery, for example, and to show the roundness of forms or the jagged edges of rocks. Margarito employs these devices like a form of handwriting, not modifying them according to observation: notice for instance that the 'shadows' on Christ's legs fall on the left, while those on the Virgin's hands fall on the right. The division of the altarpiece into 'image' and 'stories', however, and the use of the window-like frames behind which the stories unfold – and on one of which the Virgin rests her feet, which project into our space – are rudiments of a new pictorial language, to be developed by later generations of Italian painters.

MASACCIO (1401-1428?)

The Virgin and Child 1426

Tempera on poplar, 139 × 76 cm NG 3046

Tommaso di Giovanni, known as Masaccio ('big bad Tom'), is the youthful hero of the Italian Renaissance. A century after his untimely death, Leonardo (page 56), Michelangelo (page 134) and a host of other Florentine artists cut their teeth copying his frescoes in the Brancacci Chapel, painted in collaboration with Tommaso da Panicale – Masolino, or 'little Tom' (page 71). Vasari wrote: 'Masaccio can be given the credit for originating a new style of painting...he produced work that is living, realistic, and natural.'

Masaccio's innovations were rooted in the Florentine tradition founded by Cimabue (page 34) and Giotto (page 52). Conventional in his subject matter and in his use of materials, he dedicated himself to maximising the expressive power of art. To this end, and with help from his friends the architect-sculptor Brunelleschi (inventor of single-vanishing-point perspective) and the sculptor Donatello, he drew both on Roman antiquity and on the direct observation of nature. In this painting the lutes of the two

angels at the Virgin's feet demonstrate Masaccio's understanding of the joint effects of foreshortening and directional illumination. Strong light shining from the upper left defines volume and surfaces, and the shadows and penumbras cast by the angels' hands look so natural that we almost take them for granted.

This scene was the central panel of a large altarpiece, commissioned in 1426 by a notary for his family chapel in Santa Maria del Carmine in Pisa, and dismembered before 1640. Its surviving fragments are scattered in museums around the world. Figure 3 shows the most probable reconstruction of the whole, halfway between an old-fashioned polyptych and a 'modern' unified surface. A strip of shadow belonging to one of the missing saints on the Virgin's right can be seen behind the angel seated on the throne step.

The painting is very damaged. Cut down at the base, it has lost its original frame, although the arch at the top, firmly locating the throne behind it, is Masaccio's. The silver-leaf backing of the Virgin's red robe has tarnished; her cloak is disfigured by discoloured retouchings, perhaps with Prussian blue, a pigment introduced in the eighteenth century. The flesh tones are abraded, revealing more than Masaccio intended of the green-earth modelling beneath. An old reconstruction of the missing parts of the Child's feet and the Virgin's hand has darkened. The wings and the haloes of the angels kneeling behind the throne are entirely the work of an unknown restorer.

The damage has compromised the appearance of the panel, yet Masaccio's novel pictorial strategy remains clear. He depicts Heaven as an idealised extension of the viewer's space, of the world perceived through our senses. Weighty as a Roman statue, the Virgin sits on a massive throne incorporating the three 'orders' of ancient architecture. The Child wears an elliptical halo; its foreshortening defines the space he occupies on his mother's lap. Naked and plump like a sculpted Roman *putto*, he nonetheless behaves like a living infant – though the grape juice he eagerly sucks from his fingers prefigures the wine of the Eucharist, the blood he will shed at the Crucifixion, painted directly above (see fig. 3). The theme of death is carried downward to the step, whose wavy pattern is copied from Roman sarcophagi.

Endowed with ancient grandeur yet subject to the laws of nature, poignant in its allusions, Masaccio's Virgin and Child renews one of the oldest themes of Christian art –

and simultaneously ennobles our view of reality.

Fig. 3 Reconstruction of Masaccio's Pisa altarpiece (by Jill Dunkerton and Dillian Gordon, drawing by Jim Farrant).

MASOLINO (about 1383-about 1436)

A Pope (Saint Gregory?) and Saint Matthias about 1428-9

Tempera with some oil, and oil on poplar, 126 × 59 cm NG 5963

Tommaso di Cristofano Fini da Panicale, called Masolino ('little Tom'), is probably best remembered as the collaborator of Masaccio (page 68). He was, however, a distinctive painter in his own right, famous enough to have been employed at the court of Hungary between 1425 and 1427. His graceful figure style is likely to have been influenced by the sculptor Ghiberti, with whom he may have worked in the early 1400s, and by Lorenzo Monaco (page 62). His extravagant use of the new science of perspective and his interest in details of everyday life give his surviving independent fresco cycles in Rome and in Castiglione Olona, near Como, an extraordinary fascination.

This picture and Masaccio's Saints Jerome and John the Baptist, exhibited nearby, were once the front and back of a panel in a double-sided triptych painted for the church of Santa Maria Maggiore, which may have served as an altarpiece in the canons' choir.

Probably completed by Masolino after Masaccio's death, it had been sawn apart by 1644. The two sides of the other wing, depicting Saints Martin and John the Evangelist and Saints Peter and Paul, are now in Philadelphia. The central scenes are in Naples; they represent the Assumption of the Virgin and the Miracle of the Snow — the fourth-century foundation of the church. According to legend, the Virgin ordered Pope Liberius to build a church dedicated to her on a site miraculously covered with snow in August; Masolino shows him tracing the ground plan with a hoe. This is the scene that presumably faced the nave and was seen by the congregation. Masaccio's Saints probably stood on its left, with Masolino's to the right of the otherworldly Assumption venerated by the canons.

Matthias, a rarely depicted saint, is included here because his body is one of Santa Maria Maggiore's most precious relics. He holds the blood-stained axe with which he was martyred by having his head hacked in half. His companion in the papal 'triple crown', formerly thought to represent Liberius, is now believed to be Saint Gregory the Great, also associated with the church. The identification is uncertain because Gregory is normally pictured with the dove of the Holy Spirit whispering inspiration into his ear (sharp-eyed viewers will find him near the top of the right-hand wing in Lorenzo Monaco's Coronation of the Virgin, page 63).

The painting has suffered in much the same way as Masaccio's Virgin and Child (page 69), with tarnished silver leaf and darkened red glazes. Masolino's technique, however, was in some respects more modern than that of his younger colleague. Whereas the latter underpainted flesh tones with old-fashioned Tuscan green-earth pigment, Masolino used a layer of lead white with a trace of red lead, giving the faces a ruddier appearance. He built up the colour in these areas with pigments bound with egg and oil rather than pure egg, and painted Matthias's olive-green robe and the pope's pinkish-cream robe in pure oils. As a result of this use of a slower-drying medium, his brushstrokes are more blended than Masaccio's, the modelling more delicate. But the lifelike effect of these technical advances is offset by more traditional aspects: the stereotypic portrayal of dignified old age, Matthias's stilted pose with both feet parallel to the picture plane, and the decorative pattern of curves that runs across both figures as they stare intently into each other's eyes.

THE MASTER OF LIESBORN (active second half of the 15th century)

The Annunciation 1470-80?

Oil on oak, 99 × 70 cm NG 256

Like so many large altarpieces from this period, the grand structure behind the high altar of the Benedictine abbey at Liesborn was broken up long ago. Several fragments from what must have been one of the most imposing of German altarpieces are now in the National Gallery; others are in Münster, and others still have been lost or destroyed. Its anonymous painter, the leading master in Westphalia at this period, has been named after the altarpiece; even in its dismembered state his gifts of description, his gentle and poetic narrative style, and his distinctive use of colour are evident.

The Annunciation was one of probably two panels making up the shutter on the left-hand side of the central scene. Both shutters depicted episodes in the life of Christ corresponding to feasts of the Church. This panel illustrates the event narrated in the Gospel of Saint Luke (1:27–35) and celebrated on 25 March, when the Archangel Gabriel announced to the Virgin Mary that she would give birth to Jesus. The fresh bright light

of early spring seems to fall on the angel and the Virgin through the stone arch framing her deep bedchamber, itself illuminated by windows looking out at a broad landscape. As in Early Netherlandish painting, which influenced the artist, symbolic attributes are realistically depicted side by side with everyday objects. The very room alludes to a metaphor drawn from Psalm 19:5, 'Which is as a bridegroom coming out of his chamber', used to describe both the Virgin's womb and her role as the Bride of Christ. The ewer and basin near the bed refer to her purity, while the candle recalls the eucharistic candles on the altar. The writing implements beside them may have a traditional meaning; or perhaps they were intended to suggest that the Virgin herself composed the prayer which hangs on a tablet under the window, as it might in any prosperous home. The heraldic devices on the tapestry and embroidered velvet cushions, their texture so minutely rendered that one can hardly refrain from touching them, and the coats of arms in the stained-glass windows, may provide clues to the identity of lay patrons.

Obviously symbolic are the statues on the stone arch of Old Testament prophets who foretold the birth of Christ and the stone statue of God the Father inside the room, while the patterns on the floor tiles and on the furniture are just what they seem: decorations. It is as if sacred and profane were mixed together in the world as it appears to us, a puzzle waiting to be deciphered – which is indeed how people of the time viewed reality.

Against this background the Annunciation itself looks like a theatrical performance, and such performances were in fact often put on in churches on the feast day of the Annunciation. The angel resembles an altar boy dressed up in the liturgical vestments of alb (the white linen tunic) and cope (the gold brocade cloak). He points to the scroll wound about his royal messenger's staff, which carries his salutation to Mary, 'blessed among women'. The Virgin, seated at her lectern, is dressed in a sumptuous gown and regal blue cloak, reflected in the shadows of the angel's tunic. She reacts to Gabriel as Luke describes, 'troubled at his saying, and cast in her mind what manner of salutation this should be'.

THE MASTER OF THE MORNAUER PORTRAIT (active about 1460–1480) Portrait of Alexander Mornauer about 1470–80

Oil on softwood, 44 × 36 cm NG 6532

The anonymous painter is named after his sitter in this arresting portrait, Alexander Mornauer, the Town Clerk of Landshut in Bavaria, who is identified by the letter, addressed to him, which he holds. Translated, this reads: 'To the honourable and wise Alexander Mornauer...scribe of Landshut, my (?true) patron.' Further evidence of his identity is furnished by the punning device of the Moor's head on his seal ring.

When this picture first entered the collection in 1991, Mornauer was depicted against an intensely blue background. Analyses carried out by the National Gallery's scientists, however, revealed that the background was painted in Prussian blue – a synthetic pigment first made in the eighteenth century – and therefore could not be

original. At the same time it was discovered that the skullcap shape of the sitter's hat was also a later alteration. It was then decided to restore the portrait to its original appearance and uncover the brown 'wood-bark' background and tall hat.

The picture, which in the eighteenth and nineteenth centuries was believed to be a likeness of Martin Luther by Holbein, may have been altered to make it more attractive to English collectors; it was in this country well before 1800. The painting in fact anticipates Holbein's sixteenth-century portraits (pages 122–5) through the uncompromising frontality of the pose, and in the way the sitter's massive bulk has been emphasised by being extended beyond the painting's edge. The discomfort experienced in directly confronting a full-face likeness has been slightly mitigated, however, by placing the head off-centre and turned slightly to one side, and by stressing the angle at which the light falls from outside the picture – to the extent of providing a painted shadow for the frame.

THE MASTER OF THE SAINT BARTHOLOMEW ALTARPIECE

(active about 1470 to about 1510)

The Deposition about 1500-5

Oil on oak, 75 × 47 cm NG 6470

The outstanding painter in Cologne at the turn of the century, this unknown artist is named after the *Saint Bartholomew Altarpiece*, now in Munich, and is also the author of a much larger version of the Deposition, now in the Louvre, Paris. In both the Paris and the National Gallery pictures the scene appears to take place within a carved and gilded shrine, mimicking the sculpted German tabernacles of the fifteenth century with their Gothic tracery and painted statues.

The theme is by these means set before our eyes in Cologne (or so it would have seemed to a contemporary viewer, kneeling before this picture in private devotion). The rocks and skull of the foreground, however, specify the historic location of the Crucifixion: Calvary or Golgotha ('place of a skull' in the languages of the Gospels). Like a medieval schoolmaster, the artist sets out to teach us the steps to Christian spirituality. Attracting us by pattern, gold and rich colour, he leads us on to sensory empathy, first of a pleasurable kind, with the rich textures of the worldly Magdalen's brocade and the gorgeous pearls and tassel of old Joseph, the 'rich man of Arimathea' (Matthew 27:57). Then he takes us beyond pleasure, to the hard wood of ladder and cross, to physical pain and mortal sorrow. Huge beads of blood spring from the open wounds of Christ and oversize tears glisten on the cheeks of the other figures; their eyes are red-rimmed from weeping. Christ's arms are locked in rigor mortis and his body is turning grey with death. As the vivid devotional manuals of the time taught, we must impress his message on our hearts, reliving in meditation this most sorrowful moment of the Passion. Only then can we succeed in the mystics' goal of the Imitation of Christ and his saints.

The figures are carefully differentiated: Nicodemus on the ladder lowers the body of Christ to Joseph of Arimathea, who has donated his own tomb for Christ's burial. Saint John supports the fainting Virgin. Mary Magdalene at the foot of the cross clutches her head, almost doubled up with grief. A young helper has hooked his leg around the crosspiece and the two other Maries stand in the back, the one praying, the other contemplating the crown of thorns as she comforts the Magdalen. Men and women, young and old, rich and poor, find their place before their crucified Saviour.

NG 6470 The Deposition

THE MASTER OF SAINT GILES (active about 1500)

The Mass of Saint Giles about 1500

Oil and tempera on oak, 62 × 46 cm NG 4681

The painter, named after his pictures in the National Gallery, must have been trained in the Netherlands but worked in Paris at the turn of the fifteenth century. This panel was once part of a larger altarpiece which it has not been possible to reconstruct, although it must have included the Saint Giles and the Hind shown nearby, and probably two other paintings of similar size now in Washington, one depicting the lower chapel of the Sainte-Chapelle, the other the square in front of Notre-Dame in Paris. The scene painted here has been set before the high altar of the Abbey of St-Denis near Paris,

whose interior as it appeared around 1500 it documents with great accuracy, although the miracle shown is said to have taken place in 719, possibly in Orléans.

The story is told in the *Golden Legend*, a thirteenth-century compilation of saints' lives. The Frankish King Charles Martel had committed a sin which he dared not confess. He asked Saint Giles to pray for him. On the following Sunday, while Saint Giles was celebrating Mass on behalf of the king, shown kneeling at a *prie-dieu* on the left, an angel placed a paper on the altar; on it was written the king's sin and a pardon obtained through the saint's prayers, conditional upon the king's repentance.

The gold gem-studded altarpiece in front of which Saint Giles officiates was presented to the Abbey by King Charles the Bald (823–877); it is mentioned in an inventory of 1505 and remained in existence until the French Revolution. First used to decorate the front of the altar, it would have been moved to the back of the altar table in the thirteenth century, when a change in the liturgy made it desirable to provide a backdrop for the elevation of the host – the bread of the Eucharist – which we see Saint Giles holding up for the king, and us, to adore. Above the altarpiece is a cross made by

Saint Eloy, seventh-century Bishop of Noyon, goldsmith and patron of goldsmiths. The small reliquary at its foot contained a fragment of the True Cross. The copper angels holding candlesticks, and standing on brass pillars that support the green curtains around the altar, were also listed in the inventory of 1505.

Behind the altar we glimpse the gilt brass coffin of Saint Louis mounted on tall columns, constructed in 1398 and given to the Abbey by King Charles VI. On the right, half cut off at the edge of the picture, is the mid-thirteenth-century tomb of King Dagobert I (died 639) which is still in situ, albeit heavily restored. Even the crown worn by Charles Martel may depict an actual object stored at St-Denis, the Sainte Couronne used to crown every king of France until it was destroyed in the late sixteenth century. We can be sure that the precious oriental carpet in front of the altar, the patterned textiles of altar front and vestments, the book bags and cushions, record real accessories. While many Netherlandish paintings give the appearance of truthfulness, it is extremely unusual in this period to find such an accurate description of an actual site. It would be pleasing to think that the sharp-eyed ecclesiastic holding back the curtain behind the king was the anonymous Master of Saint Giles, inviting our admiration as well as our prayers.

HANS MEMLING (active 1465-died 1494)

The Virgin and Child with Saints and Donors (The Donne Triptych) about 1478

Oil on oak; central panel 71×70 cm, shutters each 71×30 cm NG 6275.1–3

A native of Germany, Memling became the leading painter in Bruges. Many pictures from his large workshop were exported to Italy, where his mode of painting landscape backgrounds, with hazy distant hills and individual leaves highlighted on the trees, influenced, among others, Perugino (page 80). Just such a background can be seen in this small altarpiece painted for the Welsh nobleman and courtier Sir John Donne. who is shown kneeling to the Virgin's right in the centre panel. The Christ Child on her lap is blessing him, and his two name saints - John the Baptist, holding a very realistic Lamb of God, and John the Evangelist - are pictured on the shutters. In the somewhat less honorific position at the Virgin's left kneel his wife Elizabeth and their oldest child. Anne. The two female saints are Catherine, presenting Sir John to the Virgin, and Barbara. behind Lady Donne (for the saints' stories, see page 41). Catherine's identifying wheel and Barbara's tower wittily appear as realistic incidents in the distant landscape behind them, the former as a millwheel in the water, with the miller loading a sack of flour on his donkey nearby. Angels play music and amuse the Child, who is crumpling the pages of his mother's book, by offering him fruit - motifs often used in paintings from the Memling shop. The mood is at once homely and grand, in keeping with the architecture, part-Netherlandish domestic and part-Italianate palatial, and simultaneously pious and sunny.

Sir John and Lady Donne are shown wearing Yorkist collars of gilt roses and suns, from which hangs the Lion of March pendant of King Edward IV. The altarpiece may have been commissioned when Sir John was in Bruges in 1468 for the marriage of Margaret of York, Edward's sister, to Charles the Bold, Duke of Burgundy, or possibly on a later trip to nearby Ghent.

The reverses of the shutters depict Saint Christopher and Saint Anthony Abbot painted in tones of grey to resemble stone statues.

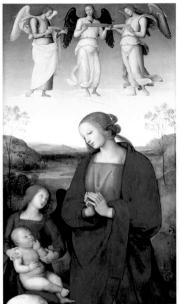

PIETRO PERUGINO (about 1452-1523)

The Virgin and Child with an Angel, the Archangel Michael and the Archangel Raphael with Tobias late 1490s

Oil, with some tempera, on poplar; central panel 127 \times 64 cm (cut down), side panels 126 \times 58 cm each (cut down) NG 288.1–3

In old age Perugino – Pietro Vannucci from Perugia – yielded in esteem to younger artists, notably his one-time assistant Raphael (page 148) and Michelangelo (page 134), because at a period of rapid artistic evolution he continued to repeat himself. An anecdote has him respond to criticism of a new painting, 'I have used in this work figures which you've other times praised... If they now displease you and earn no praise, what can I do?' The altarpiece of which these panels form a part, however, was commissioned at the height of Perugino's powers and reputation for the Charterhouse of Pavia, a Carthusian monastery patronised by the Duke of Milan. Some ten years earlier Perugino had supervised a team painting the walls of the Sistine Chapel in Rome, and had himself executed the most important scenes. At this time, in the 1490s, he was again in demand in Florence, where as a youth he had trained with Verrocchio.

The altarpiece originally comprised six parts: God the Father at the top, with on either side the Archangel Gabriel and the Virgin of the Annunciation, and, below, the three panels in the National Gallery showing the Virgin adoring the Christ Child flanked by two other archangels, Michael and Raphael. Michael, as commander of the celestial host who vanquished Lucifer, is customarily shown in armour – in this case, contemporary plate armour for which there is a careful preparatory drawing now in the Royal Collection at Windsor. Perugino's use of oil paint has enabled him to depict light reflected from the metal, and objects – such as the pommel of the sword and the red strap – mirrored in it. Michael's scales for weighing souls hang from a tree behind him. The devil at his feet was trimmed off when all three panels were cut.

The Archangel Raphael is the mysterious benefactor of Tobias in the Book of Tobit of the Apocrypha. He escorts Tobias on his journey to collect a debt for his blind old father and bids him extract from a fish the heart and liver, and the gall with which his father's sight will be restored. Little Tobias with his fish, his dog – also trimmed – and the box with the fish's organs are included here to enable us to recognise Raphael. Although these figures, like all the others, have been given the rosebud mouth and wispy hair which contemporaries so admired, they too were studied from life. Two workshop assistants in working gear were posed by Perugino and painstakingly drawn in metalpoint (on a sheet now in the Ashmolean, Oxford), with a separate drawing on the same page magnifying the detail of their joined hands, and another of Tobias' doubly foreshortened head.

In the painting, the figures' sweet angelic air is as characteristic of Perugino's idealised world as the graceful landscape with its feathery trees. But the only sign of the labour-saving devices that were later to spell the artist's decline is in the three angels of the central panel. They seem to have been transferred to the painting at a late stage from a full-scale drawing (cartoon) not designed for this composition, and appear in at least one other picture by Perugino from this period.

PIERO DI COSIMO (about 1462-after 1515)

A Satyr mourning over a Nymph about 1495

Oil on poplar, 65 x 184 cm NG 698

Piero di Cosimo, the son of a goldsmith, was the pupil of the Florentine painter Cosimo Rosselli after whom he was named. Writing a generation after Piero's death, the artist and chronicler Vasari recounts his eccentric love of nature: he never let his vines or his fruit trees be pruned, and often took himself off to see curious animals and plants. Much of his sympathy for animals, and the fantastical imagination for which he was also noted, can be seen in this painting and in the Fight between the Lapiths and the Centaurs also in the National Gallery. Both must have adorned the backboards of benches or chests in Florentine town houses, like Botticelli's Venus and Mars (page 26).

The subject of this picture has never been identified but may relate to the mythological tale of Cephalus and Procris. As told by the Latin poet Ovid in the *Metamorphoses*, Cephalus wrongly doubted his beloved wife Procris' fidelity. After their reconciliation,

81

Procris in turn believed false reports of Cephalus' unfaithfulness. She spied on him when he was resting in the woods after the hunt; hearing a noise in the undergrowth, and supposing it to have been made by a wild animal, Cephalus threw the magical spear Procris had given him, and mortally wounded her. The dog by her side may be the hound which she had also given to Cephalus. The mourning satyr, half-goat half-man, is not mentioned by Ovid but is included in a fifteenth-century play on this theme. The story, as a warning against jealousy between man and wife, would have been appropriate for a bedchamber decoration constructed, as was traditional, at the time of a wedding.

Piero admired Leonardo da Vinci (page 56), whose influence may be discerned in the fading of the colours to pale blue in the distance. Much of the sky was worked with the fingers. As the paint has become translucent with age, Piero's underdrawing can be seen: the dog in the foreground, for example, was originally intended to have an open jaw.

PIERO DELLA FRANCESCA (about 1415/20-1492)

The Baptism of Christ 1450s

Tempera on poplar, 167 × 116 cm NG 665

We like to think that our age is the first properly to appreciate Piero della Francesca. He has been hailed, for example, as the earliest 'cubist' painter. Yet in most ways he was a child of his time and place of birth in Borgo San Sepolcro, in those years a fief of Florence – like Uccello (page 92), an impassioned student of geometry and perspective, anticipating Leonardo (page 56) in his interest in the behaviour of light and in the problems of depicting it. He seems to have worked in Florence itself only once, as an assistant to Domenico Veneziano, but he enjoyed a high reputation throughout the Italian peninsula, and was employed at the princely courts of Urbino and Rimini and by the pope in Rome. His many frescoes, now almost all lost, influenced the succeeding generation of artists. We know his achievements in that difficult medium primarily through the much-damaged cycle of the True Cross in San Francesco at Arezzo. Although Piero's fame was eclipsed after his death, he was never forgotten, and from the early 1800s foreign artists in Italy copied the Arezzo paintings in watercolour or oils. Just such copies in the chapel of the Ecole des Beaux-Arts in Paris influenced Seurat (page 333). The Baptism was bought by an English collector in 1859 and acquired for the National Gallery in 1861. Probably painted for the altar of a chapel dedicated to Saint John the Baptist in the Camaldolese abbey of Borgo San Sepolcro, it had been moved to the cathedral in 1808, together with wings and a predella executed by another artist.

The Baptism of Christ is the key event in the life of Saint John and identifies the saint, in the same way as Christ's miraculous appearance is the crucial moment in the life of Saint Thomas (see Cima's Incredulity of Saint Thomas, page 32). Like Cima, Piero has placed Christ in the very centre of the picture. A line from the apex of the arched top runs through the beak of the foreshortened white dove of the Holy Spirit, through the trickle of water from the equally foreshortened bowl held by John, its rim catching the sunlight, down the middle of Christ's face, and through his reverently clasped hands, ending in the heel of his right foot, on which his weight is supported. The limpid waters of the River Jordan, winding its way calmly through the familiar patchwork of eastern Tuscany, with Borgo San Sepolcro nestling in its folds, reflect the hills behind Christ. But just where we (or perhaps he) may be supposed to look directly down into the water in the shadow of the tree, the reflections cease and we see the river bed. (This must be the earliest representation in Italian art of that optical phenomenon,

although it also appears in a painting of 1444, now in Geneva, by the German-trained Konrad Witz.)

The conventional elements of the image, such as the three angels on the left waiting to dry and clothe Christ, must have been eclipsed for contemporaries by its novelties: the assured foreshortenings, not only of dove and bowl but also of the feet, so that the figures stand as firmly as those of Masaccio (page 68); and above all Piero's cool light, defining the large simplified forms and the exquisite fall of the drapery, and uniting figures and setting in the fresh morning of a new dawn.

PIERO DELLA FRANCESCA (about 1415/20-1492)

The Nativity 1470-5

Oil on poplar, 124 x 123 cm NG 908

The *Baptism of Christ* was executed by Piero in the traditional Italian medium of egg tempera in a technique unchanged since the days of Duccio (page 41). As early as the mid-1450s, however, Piero seems to have become interested in Netherlandish art. The *Nativity* is painted in oils, and brown modelling of the flesh has replaced the green undermodelling still evident in the *Baptism*. It is clearly visible in the faces of the shepherds who have come to adore the newborn Child, all the more so because the picture, which may in any case be unfinished, was damaged through overcleaning in the nineteenth century. Piero's grasp of Netherlandish techniques was only approximate; a wrinkled paint surface shows a faulty use of the oil medium, and he used translucent glazes mainly to reinforce the deepest shadows. While there is more contrast in the modelling, the overall tone of the picture is thus almost as light as that of his works in tempera.

The *Nativity* actually represents an Adoration of the Christ Child. Having placed her newborn son on her outspread mantle, the Virgin kneels at his feet – a scene inspired by the vision of the fourteenth-century mystic Saint Bridget of Sweden. Mary's dress,

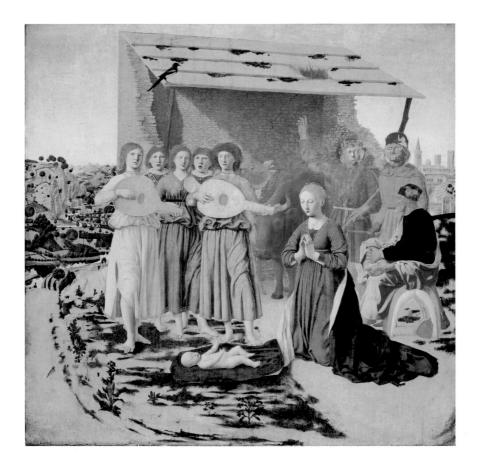

with its gleaming pearls and the now effaced veil, her face and the elongated infant all recall Early Netherlandish prototypes. These exotic figures, however, are attended by five wingless angels in Renaissance imitations of ancient dress, playing stringed instruments and singing in harmony. They are reminiscent of the marble musicians carved by Luca della Robbia for a famous singing gallery in Florence Cathedral and installed in 1438, a year before Piero is known to have been working in the city.

Abruptly different again are the dignified but realistic shepherds. One is pointing upwards, perhaps at the star which will guide the Magi to the stable, or in explanation of the angel who brought him and his companion there. Piero originally planned to leave his right arm and shoulder naked, so part of his sleeve was painted over the wall. The most surprising figure is that of Saint Joseph. Seated on a foreshortened saddle, the old man crosses one leg over his knee, showing us the sole of his foot in an unprecedentedly indecorous pose. Perhaps taking advantage of the freedom of his new medium, Piero has improvised the folds of his cloak, which bear no relation to the underdrawing now showing through.

Much else in this enigmatic picture has been improvised and would presumably have been changed, such as the ox's horn seemingly growing out of the lute peg box in front of it. In its dissonances, its bare ground and stringless lutes, the translucent ass braying or tugging invisible hay from the manger, this imperfect and damaged Nativity seems as humanly vulnerable as the body of the Saviour whose birth as the Son of Man it recounts.

PISANELLO (about 1395-1455?)

The Vision of Saint Eustace mid-15th century

Tempera on wood, 54 × 66 cm NG 1436

Pisanello (whose name derives from his father's birthplace, Pisa) was celebrated for his bronze medals, but also painted large murals and small easel pictures such as this one. He was almost certainly the pupil of Gentile da Fabriano (page 50), whom he assisted and whose Roman works he completed after Gentile's death. Most of his independent career, however, was spent in princely courts throughout Italy. In common with other artists of his time, particularly those employed by aristocratic clients who shared a love of hunting and exotica, he compiled model-books of drawings. These were detailed and accurate studies - both from life and from other model-books - of animals and birds, plants, costumes, records of works of art, ready to be transferred directly to paintings or medals. Pisanello was among the first to transcend this rather impersonal form of drawing for a more imaginative and exploratory kind, rapidly jotting down momentary poses or expressions, sketching compositional ideas as they occurred to him, using drawing as an aid to invention rather than as a substitute for it.

This painting, however, is probably compiled from Pisanello's more conventional stock patterns. The majority of the animals are represented in profile, a few in other equally clearly defined poses, with a minimum of overlapping, much as they would appear on the pages of a model-book - despite the joke of the hound sniffing the greyhound. The story and the setting seem at first sight only a pretext for a decorative compilation of 'noble' beasts: the horse, hunting dogs and their various quarries, the bear, the stag, the hare, waterfowl of different kinds. And, of course, the noblest creature of all: a fashionable courtier, as clearly delineated as on a medal. Real gold (modern, but probably replacing original gold) has been used for his harness, hunting horn, spurs

and tunic. But among all these secular delights there appears the emblem of another realm of experience: the Crucifix. The legend is told of Saint Eustace (equally of the courtier Saint Hubert, more frequently represented in Northern art) that one day while out hunting he had a vision of the crucified Christ between the antlers of a stag, and was converted to Christianity.

The scroll in the foreground shows no traces of inscription, and perhaps the patron never supplied the motto. Even a motto, however, might not have explained to us today how this curious and delightful painting was viewed by its original owner: as a souvenir of the active life, or for contemplative devotion to Eustace, patron of huntsmen, and to the miraculous occasion of his conversion?

ANTONIO DEL POLLAIUOLO (about 1432–1498) AND PIERO DEL POLLAIUOLO (about 1441–before 1496)

The Martyrdom of Saint Sebastian completed 1475

Oil on poplar, 292 x 203 cm NG 292

Sons of a Florentine poulterer (pollaiuolo), Antonio, trained as a goldsmith and sculptor, and Piero, primarily a painter, worked as a team on most of their major projects. Their joint careers culminated, around 1484, in a papal summons to Rome, where they

collaborated on the bronze tombs of Popes Sixtus IV and Innocent VIII. But perhaps more influential than even these unprecedented monuments, or the brothers' prestigious Florentine commissions, were Antonio's bronze statuettes in imitation of Ancient Roman work and his engraving, the *Battle of Ten Nudes*. As Vasari wrote nearly a century later, Antonio 'understood about [representing] nudes in a way more modern than that of previous masters, and he dissected many bodies to view their anatomy'. The battle print, pirated many times, provided generations of artists throughout Europe with a pattern or model-sheet of male bodies in vigorous action.

The modernity of the Pollaiuolo firm's approach is fully demonstrated in this altarpiece for the Oratory of Saint Sebastian in Florence, one of whose precious relics was the martyred Roman centurion's arm bone. Even its format was modern, a single rectangular panel replacing the many arched painted areas, enclosed within elaborate Gothic framing, of traditional polyptychs (see, for example, page 70). It is fluidly painted in a walnut oil medium, although in this early experiment the Florentine artists show that they did not fully understand the Netherlandish technique. Instead

of carefully building up the paint layers in thin translucent glazes, they premixed the colours, as in tempera, and applied them thickly with bold, sweeping strokes of the brush. As a consequence, slow-drying pigments such as the bituminous browns in the foreground have bubbled, and the green glazes in the distance, unsupported by opaque underpainting, have discoloured. We can still see, however, that the panoramic landscape, growing paler towards the horizon like the vistas of Northern pictures, resembles the Arno valley around Florence and must have been studied from nature.

Antonio's interest in the ancient world is demonstrated in the Roman triumphal arch, crumbling as the old order is vanquished by the new faith (a Moor's head, the emblem of the Pucci family, who built the Oratory which housed the altarpiece, appears in the roundels), and in the figure of Sebastian himself. He is raised on a tree stump, not merely in reference to the crucified Christ, but also to imitate the nude statues put up to youthful athletes in Ancient Greece and Rome. In contrast, the knights on horseback in the middle ground show off the latest in plate armour, and the equally contemporary figures of the archers, disposed around the martyr to suggest the pure geometrical form of a cone, realistically demonstrate the effects of muscular exertion. Antonio's statuettes must have suggested showing the same figures from different viewpoints, as in the Battle of Ten Nudes engraving.

Sebastian did not die from the archer's arrows, but was nursed back to health by holy women, only to be beaten to death with clubs. From antiquity, however, bubonic plague had been likened to God's arrows, and by association Sebastian became one of the chief saints invoked against that horrible disease. He is usually depicted at this phase of his martyrdom.

SASSETTA (1392?-1450)

The Stigmatisation of Saint Francis 1437-44

Tempera on poplar, 88 x 52 cm NG 4760

Stefano di Giovanni, known as Sassetta, was among the leading Sienese artists of the century. In 1437 he received one of the most extensive, and expensive, commissions in Sienese fifteenth-century painting: a double-sided polyptych for the church of San Francesco in Borgo San Sepolcro (the native town of his younger contemporary, Piero della Francesca; page 82). The figures and the scenes were to be specified by the friars. The altarpiece was painted in sections for easy transport from Siena to Borgo San Sepolcro, where it was delivered in 1444. It was dismembered in the 1500s; in the nineteenth century surviving fragments were sold to various collections.

As far as its original appearance can now be reconstructed, this great Franciscan altarpiece, like Duccio's *Maestà* in Siena Cathedral (see page 44), showed the Madonna and Child enthroned in the front main tier facing the congregation in the nave. The back, facing the friars in the choir, depicted *Saint Francis Triumphant* standing on Insubordination, Luxury and Avarice and surrounded by eight smaller scenes from his life ranged in two tiers on either side. Seven of these scenes are now in the National Gallery. The panel illustrated here is one of the best preserved. It shows one of the key events of Francis's life, cited in the process of his canonisation: the impression on his body of the five wounds of Christ. The miracle occurred on 14 September 1224 on La Verna. This forest-covered mountain near Arezzo, where he founded an eremitical convent, had been given to Francis in 1213; it is still a site of pilgrimage.

There are many textual sources for Francis's biography; Sassetta, however, almost certainly based his interpretation on artistic tradition. For example, the saint was alone when Christ appeared to him, but it had become customary in painting and sculpture to show his follower Brother Leo witnessing the event, as he is doing here, looking up in wonder from his book of devotions. Giotto (page 52) had already depicted Saint Francis in the same pose, kneeling and raising his arms to the six-winged seraph-Christ. Sassetta is in many ways a paradoxical painter. Like Giovanni di Paolo (page 54) and all other Sienese artists, he was deeply in thrall to his great Sienese predecessors of the fourteenth century, the followers of Duccio. He had studied Florentine art of the same period as well as of his own time. Around 1432 he became acquainted with French and Northern Italian miniatures. Something of all these sources is evident here, in the ornamental forms of the trees, the unrealistic ledge-like rocks of the foreground and the oblique angle at which he sets the chapel nestling in the mountain – a fourteenth-century method of suggesting perspective.

At the same time as Sassetta emulated the decorative effects of archaic styles, he could not help but be influenced by the artistic advances of his day. Thus the supernatural light flooding La Verna from the seraph is virtually consistent throughout the painting. Mountain shadows darken the stuccoed façade of the chapel, with its Virgin and Child above the door; Saint Francis's cord belt casts a shadow on his habit, and his parted fingers on the ground behind his shoulder. The miracle – which has caused the wooden cross in the makeshift oratory to bleed and makes of Francis an *alter Christus*, a second Christ – is felt throughout the natural world, a red sunset staining the Umbrian hills.

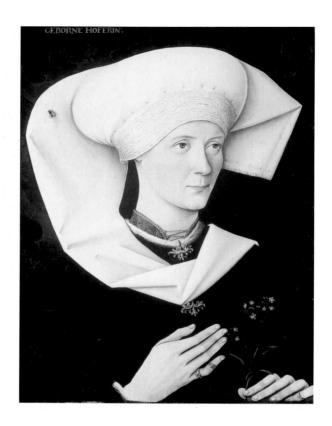

SWABIAN SCHOOL, UNKNOWN ARTIST (15th century) Portrait of a Woman of the Hofer Family about 1470

Oil on silver fir, 54×41 cm NG 722

The unknown artist worked in Swabia, an area of Southern Germany of which the main town was then Ulm. The inscription states that the sitter was born into the Hofer family. She wears a padded, ruched and pinned headdress – surely freshly laundered and pressed – which the painter invites us to admire, just as he invites our admiration for the meticulous distinction he makes between the fur of her collar and the metal clasps of her dress. But the most telling sign of the artist's ability to imitate appearances is the fly, which casts a shadow either on the lady's coif or on the surface of the painting, tempting us to brush it away, and lending the picture a paradoxical sense of momentariness which the sitter's static pose and faraway look belie. She holds a sprig of forget-me-not, a symbol of remembrance in German as in English. While her right hand points to her heart, the left is poised partly behind, partly on, the bottom edge of the picture, as if a ledge cut off the rest of her body from view.

As well as volume and texture, the painting also stresses line and pattern: for example, the diagonals formed by the fingers are echoed throughout. The sitter must have chosen to be painted in that particular headdress, but the way it is draped ensures that the greatest area of light is concentrated on and around her face, preventing the light areas of the hands from competing for our attention.

COSIMO TURA (before 1431–1495)

An Allegorical Figure about 1455-63

Oil on poplar, 116 x 71 cm NG 3070

Cosimo Tura was the first important Ferrarese painter (see also Costa, page 35), and served as court artist to Borso d'Este and to Borso's successor Ercole from 1458 to 1486. Few paintings by him survive, but the National Gallery is fortunate in owning four. Influenced by the youthful works of Mantegna (page 64), and by Rogier van der Weyden (page 94), who had supplied panel paintings (also lost) to Borso's brother and predecessor Lionello d'Este, Tura became one of the most original and sophisticated artists of his time. Despite his fantastical effects and the 'confectionary brilliance' of his colours, he was also capable of great solemnity and pathos.

This figure almost certainly comes from the *studiolo* begun for Lionello d'Este in the Villa Belfiore near Ferrara. Fifteenth-century villas revived the Ancient Roman idea of a place of escape from urban cares, especially in the stifling Italian summer, where one could be refreshed through cultivated leisure. A *studiolo*, as its name implies, was a small room to which the prince could retire to read, listen to poetry or music, admire beautiful objects and, free of court protocol, entertain learned men as friends. Such rooms were appropriately decorated – for example, with personifications of the Liberal Arts (see page 220) – but the *studiolo* of Belfiore was the first since antiquity to include a series of paintings of the Nine Muses who, in Greek and Roman myth, presided over the arts.

This panel may originally have been intended to depict Euterpe, Muse of Music, for X-radiographs have revealed that beneath the present image is an earlier version, not necessarily by Tura himself, showing a woman seated on a throne constructed of organ pipes. As completed by Tura the figure holds a branch of cherries and is seated on a marble throne decorated with metalwork dolphins. A reference to the legendary origins of music is retained, however, in the tiny vignette of a smith - either mythological Vulcan or biblical Tubalcain (Genesis 4:22) - sonorously hammering metal in a cave at the bottom right. But the riddle of the main figure's present significance is only part of her fascination. Analysis by the National Gallery's scientists has also shown that the image beneath, which never progressed beyond an underpainting, was executed in egg tempera. The lady now visible is painted in oils using a two-phase system of opaque underlayers modelled with translucent glazes, like that employed by Early Netherlandish artists. The effect is particularly sumptuous in the cloth-of-gold sleeves, which resemble the costume of one of the Three Kings in an altarpiece by Rogier van der Weyden, of about the same date as the lost Ferrarese pictures. Tura even used the paler, less yellowing walnut oil for the light colours and linseed oil for the dark glazes, a distinction later recommended by Vasari. There are none of the drying defects seen in the work of Piero or in many other early attempts by Italian painters to use oils (for example the Pollaiuolo, page 87).

Tura's command of this technique, so different from traditional Italian practice, must have been acquired at first hand, whether from van der Weyden or another Netherlandish artist in Ferrara, or through an Italian painter sent by the d'Este to the Netherlands. We have no record of Tura himself travelling abroad; the precise circumstances in which an egg-tempera Muse was transformed into an oil painting remain, for the time being, an enigma.

PAOLO UCCELLO (1397-1475)

The Battle of San Romano about 1438-40

Tempera on poplar, 182 x 320 cm NG 583

By the mid-sixteenth century, when the artist and chronicler Giorgio Vasari wrote his Lives of the Artists, Uccello was a byword for his excessive interest in perspective: 'He left... a wife who told people that Paolo used to stay up all night in his study, trying to work out the vanishing points of his perspective, and that when she called him to come to bed he would say: "Oh, what a lovely thing this perspective is!"' Unlike other great Florentine artists of his generation, however, Uccello did not use perspective in the service of narrative focus, or for symbolic ends, or to foster the total illusion of reality.

Three panels – one now in the National Gallery, another in Florence and the third in Paris – record a minor skirmish of 1 June 1432, when Florentines led by Niccolò da

Tolentino (shown here wearing a red and gold damask hat) defeated Sienese troops. The victory effectively ended a ruinous war waged by Florence against Lucca and its allies Genoa, Milan and Siena for access to the port of Pisa.

Art historians have long assumed that Uccello's battle scenes were painted for the Medici, in whose possession they were recorded from 1492. In 2000, however, new research revealed that they had been commissioned for his own town house by Lionardo Bartolini Salimbeni, supervisor of Florence's Council of Ten which conducted the Lucchese war. Lorenzo de' Medici appropriated them in 1483–4 from Lionardo's heirs. Originally arched to fit under a vaulted ceiling, the panels were cut down into rectangles and relocated in Lorenzo's chamber on the ground floor of the Medici palace.

Though celebrating an actual event, the paintings were designed as festive decoration. The hedge of roses, pomegranates and oranges behind the combatants, the real gold and silver leaf of the horse trappings and armour, the rhythmic lines of lances, the arabesques of curling pennants and rearing horses, even the disposition of the battle – all these relate Uccello's pictures to costly tapestries depicting the chivalric tournaments of Arthurian romance. The field armour is accurately represented, but plume-crested helmets were in reality only parade and jousting wear. Niccolò's gorgeous hat, a soldier's dead body, a fallen helmet, a shield and broken lances – the kind of irregular objects that Uccello stayed up nights to study from different angles – are shown in foreshortening on a shallow stage. As the sculptor Donatello is said to have told Uccello when he saw such 'oddities', 'These things are no use except for marquetry' (designs in inlaid wood, used for panelling and furniture). The obsessively rendered perspective excludes the background beyond the hedge, and is reduced to ornament.

Yet before time tarnished the silver leaf and nineteenth-century cleaning transformed chargers into rocking-horses and wiped the colour from fields and faces, this charmed world would have seemed more real than it does now. Through Uccello's paradoxical art Lionardo Bartolini Salimbeni could have seen his government's victory as a bloodless contest fought by valorous knights to the sound of trumpets and the scent of roses. Lorenzo de' Medici, banker, statesman and lyric poet, Florence's *de facto* ruler who organised a courtly joust for his own wedding, must have found the paintings irresistible.

ROGIER VAN DER WEYDEN (about 1399-1464)

The Magdalen Reading before 1438

Oil, transferred from its original wood to mahogany, 62×55 cm NG 654

Rogier van der Weyden (under the French version of his name, 'Rogelet de la Pasture') was almost certainly apprenticed to Robert Campin (page 30). Appointed Town Painter in Brussels and also employed at the Burgundian court, van der Weyden became an internationally celebrated artist. His influence long outlived his death in 1464, since his compositions remained in use in Brussels and Antwerp until the mid-sixteenth century in the workshops of his son, his grandson and his great-grandson.

Parallels can be found in Campin's work for setting sacred scenes in contemporary domestic interiors like the one depicted here. This beautiful figure seated on a cushion reading a devotional book can be identified as Mary Magdalene by the jar at her side, in reference to the ointment with which she anointed Christ's feet (Luke 7:37–8). When the painting was cleaned in 1956 it was discovered that its dark uniform background

(applied probably in the nineteenth century) had concealed the body of Saint Joseph holding a rosary, part of a window with a landscape view, and the foot and crimson drapery of another figure, identified as Saint John the Evangelist by reference to a late fifteenth-century drawing of a similar composition showing the Virgin and Child surrounded by saints. The altarpiece from which this picture was cut has been partially reconstructed with the help of that drawing and two other surviving fragments: one of them the head of Saint Joseph and the other the head of a female saint, both now in Lisbon. The whole picture is estimated to have been about one metre high and at least one and a half metres wide.

Van der Weyden's mastery of exquisitely painted naturalistic detail is here as apparent in the nailheads of the floor and Joseph's crystal rosary beads as it is in the gold brocade of the Magdalen's underskirt. In later paintings, however, he combined realistic details with the expression of intense pathos or deep piety, in contrast to his ever-impassive older contemporary, Jan van Eyck (page 46).

The Wilton Diptych about 1395-9

Tempera on oak, each wing 53 × 37 cm NG 4451

This little folding altarpiece with its integral frame, not much bigger than the illuminated manuscripts it resembles, was presumably commissioned for his private devotions by King Richard II of England. The left wing incorporates his kneeling portrait, with three saints of particular significance to him presenting him to the heavenly assembly in the right wing: King Edmund, King Edward the Confessor and John the Baptist. Edmund holds the Danish arrow which killed him in 869. Edward the Confessor holds a ring which, according to legend, he once gave to a poor pilgrim who turned out to be Saint John the Evangelist. This unusual imagery recalls Richard's birth on 6 January, the feast day on which Christians celebrate both Epiphany, when the Christ Child was adored by three kings, and the baptism of the adult Christ; John the Baptist, as his patron saint, is shown touching Richard's shoulder.

We do not know the identity, or even the nationality, of the artist. In style the picture is indebted to Sienese art, and the medium, egg tempera, is associated with Italy. The panel support, on the other hand, is oak and the white ground chalk, both of which are typical of Northern painting. No precisely comparable work survives in England, France or elsewhere in Europe.

One of the most puzzling features of the imagery has, however, recently been clarified: the significance of the banner. Is it the traditional symbol of the Resurrection, the Saviour's victory over death, or the flag of Saint George, patron saint of England? When the diptych was cleaned in 1992 there was discovered, within the minute orb surmounting the banner, the image of a green island with a white castle, set in a silverleaf sea, now sadly tarnished. In a lost altarpiece once in Rome, Richard and his first wife, Anne of Bohemia, were shown offering the orb of England to the Virgin, with the inscription: 'This is your dowry, O holy Virgin, wherefore O Mary, may you rule over it.' The Christ Child in the diptych, it becomes clear, has received the banner with its 'globe or patterne of England' on behalf of the Virgin, and handed it to an angel in order to free his hand to bless the king. The banner is thus revealed as signifying both the realm of England, ruled by Richard as the Virgin's viceroy, and the hope of Resurrection. (Minute nails and a crown of thorns incised in the gold of the Christ Child's halo point forward to his Passion, the ransom paid to deliver sinful humanity from eternal death.)

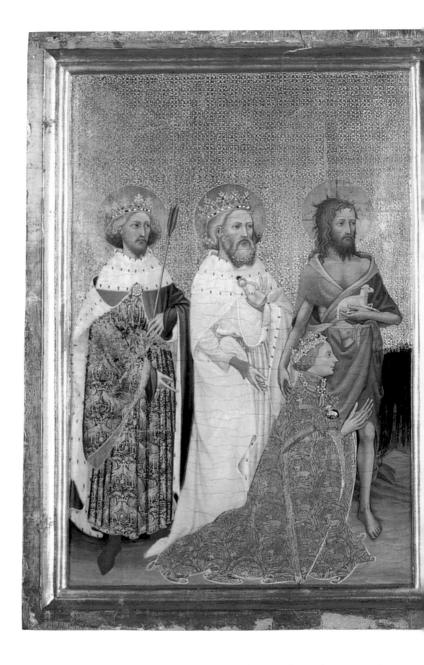

Richard's regal status is asserted in other ways also. The angels at the court of Heaven wear the king's livery, the white hart, which was his personal device, pinned as a gold and enamel jewel at his breast, embroidered on his robe, and portrayed on the exterior of the diptych. The broomcod is another heraldic reference. The pods of the broomplant, *Planta genista*, although an emblem of Richard's family the Plantagenets, were originally used as livery by the king of France, whose daughter Richard married in 1396 after the death of Anne. Collars of broomcods are worn by king and angels, and encircle the hart in the pattern of his robe.

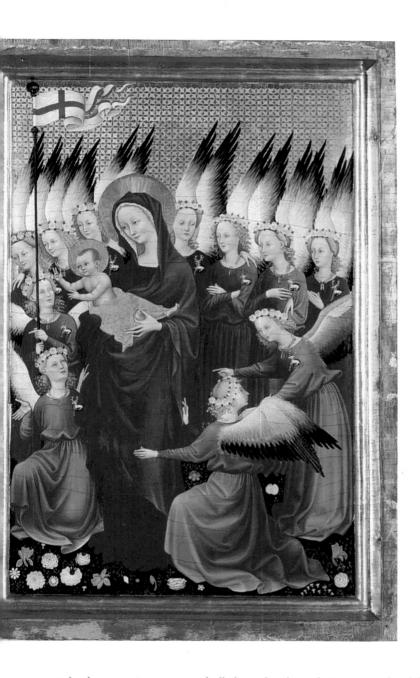

Only close scrutiny can reveal all these details or do justice to the delicacy and refinement of the unknown artist's technique. Almost all the gold is finely stippled, even the modelling of the Child's robe. The rose chaplets worn by the angels, the blooms in the heavenly garden, the Virgin's fluted white veil – these are only some of the exquisite consolations the king might find at prayer, shielded from the popular discontent and the baronial conspiracies which finally ended his reign in 1399, and cost him his life in 1400.

Crossing the bridge from the Sainsbury Wing into the West Wing of the National Gallery, we leave behind the 'cartoon' and *Virgin of the Rocks* by Leonardo da Vinci. Leonardo is both the last master of the Italian Early Renaissance and the first great artist of the High Renaissance. His influence was incalculable, not only among Italians but also north of the Alps. His exploration of natural phenomena, his narrative and symbolic inventiveness and his technical and formal experiments all extended the descriptive range of Italian painting. At the same time, his search for ideal beauty tempered the sometimes harsh and laboured realism of older contemporaries, such as the Pollaiuolo brothers. Combined with the vestiges of Greco-Roman antiquity then being excavated and studied with increased vigour, notably in Rome, his example set new standards of elegance and monumentality. Raphael, Michelangelo, Bronzino, Correggio – all High Renaissance artists represented in the West Wing – demonstrate their debt to Leonardo in the new breadth and scale of their figures, in complexity of pose and composition, in suavity of facial type and expression and in a new delicacy of modelling, in which gradual transitions 'veil' the steps from darkest shadow to highlight.

Leonardo achieved his subtlest effects in oils, but his art remained faithful to Tuscan traditions of fresco and tempera painting by being founded on line and tone. Colour is added after the composition, with its disposition of light and dark, has been determined; it is an ornament, not an integral part of the creative process. This method of building up a painting can be followed clearly in Michelangelo's unfinished *Entombment* and 'Manchester Madonna' in the West Wing. Venetian painting, on the other hand, developed differently. Following the lead of Giovanni Bellini and his probable pupil Giorgione, Venetian artists of the sixteenth century – of whom the greatest, Titian, is particularly well represented here – took colour as the primary and essential constituent of visual experience, although their paintings came to use fewer hues, and be less colourful, than those of Central Italian artists. Forms are defined in their pictures by transitions from one colour to another, broken by reflections and mingling in the shadows, rather than by linear contour. Tonal differences are translated directly into colour, rather than being first defined in black and white.

The compositions of Venetian sixteenth-century artists evolved throughout the process of painting, for they depend on the continuous adjustment of colour relationships. Venice, a great maritime power, had a highly developed shipbuilding industry, and her artists increasingly turned from panel to canvas, the cloth used for sails. As Titian matured, his oil technique became bolder and more expressive: the texture of paint, the track of the painter's gesture with brush and finger, enliven the surface of the picture and enhance its emotional charge. We can follow Titian's development in the West Wing, from his early works to the late, possibly unfinished, *Death of Actaeon*, with its streaks and dabs and patches that from a distance, miraculously unite to form an image. Titian's influence, like Leonardo's, was to extend across Europe and through the centuries.

Previous page: Titian, The Vendramin Family venerating a Relic of the True Cross (detail), about 1540–5, reworked perhaps about 1555

The range of Titian's subject matter is an index to still other developments in sixteenth-century art. Religious paintings, for churches and for private devotions, continued to be commissioned. Great pictures in this genre by sixteenth-century painters from all over Europe attest to the vitality of this tradition. With the growing strength of the secular nation state and the rise of centralised monarchies, however, portraiture became increasingly important as an instrument of statecraft and diplomatic exchange. Portraits tended to grow in size to the scale of life, and from bust-length to half-length, three-quarter-length and full-length. Famous portraits, official and domestic, by Titian, Raphael and other great Italian artists can be admired in the West Wing, as well as likenesses by the Germans Cranach and Holbein, and the Northern Italian portrait specialists Moretto and Moroni. But Titian's Death of Actaeon, like his Bacchus and Ariadne and Venus and Adonis, and Correggio's 'School of Love', demonstrate the new importance of mythological subjects in this period. No longer relegated to furniture decoration, mythological paintings brought the tales of antiquity to life on the walls of princely apartments. A new sensuality pervaded the art of European courts. Even when a moralising message offset the image, as in Bronzino's spectacular Allegory with Venus and Cupid and Cranach's small Cupid complaining to Venus, antique nudity was an occasion for erotic display as well as a test of an artist's sophistication and poetic powers.

Collecting pictures for aesthetic and sensuous pleasure, and to demonstrate the patron's cultural aspirations, created a demand for still other kinds of imagery. A generation earlier, devotional pictures and portraits were the only easel paintings to find a place in the home, and 'collecting' meant accumulating objects in precious materials or of great rarity. Now painters' specialised skills came to be prized for their own sake. Alerted by their reading of Pliny, the first-century Roman writer on art, cultivated collectors, mindful of the Northern painters' ability to create naturalistic landscape backgrounds in religious pictures, encouraged them to develop landscape as an independent theme. The West Wing contains works attributed to the workshop of the Netherlandish landscape specialist Patinir, and an autonomous landscape by the rare German artist Altdorfer.

A related development can be traced in the beautiful small pictures on copper by Elsheimer, a child of the sixteenth century but a pioneer of seventeenth-century art. Exemplifying the international current from North to South, and from South to North, demonstrated throughout the Gallery, Elsheimer trained in Germany, where he came under the influence of a landscape specialist, spent two years in Venice absorbing the colourism of Titian, and in 1610 finished his short life in Rome. He evolved a new theme, combining figure painting and landscape, the devotional and the antique: the Northerner's nostalgia for the South, the modern longing for a Golden Age. We will find the heirs to Elsheimer's influential vision in the following section, Paintings 1600–1700 (page 175).

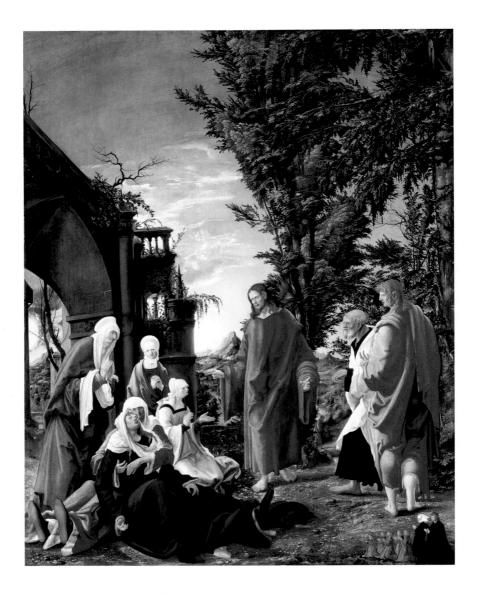

ALBRECHT ALTDORFER (about 1480-1538)

Christ taking Leave of his Mother about 1520?

Oil on limewood, 141 × 111 cm NG 6463

Painter and printmaker, Altdorfer belongs to a small group of German artists (Cranach, page 112, and Huber, page 126, among them) for whom landscape assumed great importance, both for helping to set the emotional tone of a narrative scene, as here, and for its own sake, as in the small *Landscape with a Footbridge* also in the National Gallery. Paintings by Altdorfer are comparatively rare, and there are very few by him in Great Britain.

The subject of Christ taking leave of his mother is probably more frequent in prints than in painted form. It derives from the devotional literature of the late Middle Ages, and from religious theatrical performances, the popular 'miracle plays' of the time,

rather than from the Gospels. Christ bids farewell to his mother in the village of Bethany before returning to Jerusalem to die on the cross. The Virgin, Mary Magdalene (the young woman dressed in pale blue) and the disciples plead with him not to go. But Christ instructs Peter (the old man in white and black) and John (the youth in red) to make preparations for the Passover meal in Jerusalem, which will become the Last Supper. On the column above the head of the Magdalen, Altdorfer has inserted, as if carved in the stone, a tiny scene of the Flagellation, prophetic of Christ's future sufferings. The Virgin swoons and is supported by one of the Maries. Their disproportionately large feet, sticking indecorously out of their gowns, accentuate the pathos of the scene.

Altdorfer relies on the expressive potential of distortion in other ways: the holy personages are unnaturally tall for the size of their heads, and diminish in scale abruptly as they recede in the distance. In the right-hand corner a family of donors, a man and wife and their five children, are painted no larger than dolls. All the hands move in 'speaking' gestures: blessing, commanding, pleading, calming, comforting, prayerful. But it is above all the acid and intense colour contrasts and the untamed landscape which give the painting its extraordinary emotional power. Through the arch, fiery clouds echo the lurid reds of garments, and black branches paraphrase mortality. Azurite, an ore of copper mined principally in Germany, is responsible for the peculiarly green-tinged blues. The thickest and most elaborate layers of paint were reserved for the luxuriant foliage of the trees, closely observed and realistically differentiated, reaching out with vigorous new life from behind Christ and the disciples to beyond the edges of the panel.

JACOPO BASSANO (active 1535—died 1592)

The Way to Calvary about 1540

Oil on canvas, 145 x 133 cm NG 6490

Jacopo was the best known of the da Ponte family of painters in Bassano, a small provincial town in the Veneto. Between 1545 and 1560 he became one of the most influential artists in Venetian territory after Titian (page 163). In his later years his workshop, in which his four sons were employed, came to specialise in bucolic scenes and nocturnes. Prints played an important part in forming his style, and the Way to Calvary may have been influenced by an engraving of 1519 of Raphael's painting of the same subject which, in turn, was dependent on a woodcut by Dürer (page 45). The crowded composition (an effect exaggerated by the picture having probably been cut down on the left side) contrasts the brawny musculature of the executioners – characteristic of Central Italian painting – with the Düreresque pathos of Christ, Saint John and the Holy Women.

Much of the impact of the composition derives from its dynamic organisation along the main diagonals. We 'enter' the scene from the bottom right corner, where Saint Veronica in her Venetian gown strains forward to wipe the sweat and blood off Christ's face; follow the lines of the wooden upright of the cross, Christ's body collapsed under the weight, the tormentor's brutal blows, to the furthest point in the upper left, where the executioner pulls on the rope around Christ's waist, urging him on to Golgotha in the distance. His windblown cloak picks up the red of Veronica's dress. Alternatively, we can scan the picture from upper right, from the mounted officers pointing to and discussing the events below; follow the wooden lance shaft to where John's green cloak, seized by a soldier, seems to flow around the headdresses and shoulders of the Maries

into Veronica's out-thrust veil. The Virgin's dark mantle isolates her as she stands, becalmed in the jostling crowd, wiping the tears from her eyes.

However we read the painting, we are inexorably drawn to Christ, crowned with thorns. Although his eyes turn to Veronica, his is the only figure depicted virtually in full face, the Man of Sorrows of devotional imagery.

JOACHIM BEUCKELAER (active 1563-75)

The Four Elements: Earth.

A Fruit and Vegetable Market with the Flight into Egypt

in the Background 1569
Oil on canvas, 157.3 × 214.2 cm NG 6585

Together with his uncle by marriage, teacher and probable business partner Pieter Aertsen (1507/8–1575), Beuckelaer pioneered the painting of still life in the Low Countries. Sent abroad or transmitted via engravings, compositions such as this, one of a set of four acquired by the National Gallery in 2001, influenced artists as far afield

as Italy and Spain (see Velázquez, page 256). It is indeed probable that the large *Four Elements* were originally made for an Italian client, since Beuckelaer painted them on easily transportable canvas rather than on his more customary wood panels. Though their earlier location is not known, the pictures were in Florence by 1884.

A better painter than Aertsen, Beuckelaer adopted a formula invented by his teacher: a profusion of raw foodstuffs (justified by the fiction of a market or kitchen setting) in the foreground, with a small biblical scene in the background. Such pictures were inspired by the recent translation from Latin of Pliny the Elder's history of Ancient Greek and Roman art, which recounted how Peiraikos gave 'the keenest delight' and acquired glory and riches with *rhyparography*, the 'painting of sordid subjects' such as 'barbers' shops and cobblers' stalls, asses, foodstuffs and the like' (see the *Still Life Pocket Guide*). This imagery of idyllic abundance also celebrated modern advances in agriculture, animal husbandry and commerce, although Antwerp, where Aertsen and Beuckelaer worked, was under Spanish occupation in 1569, with food in short supply. The biblical scenes in the background were introduced both to 'elevate' the 'sordid subjects' to the more highly prized genre of religious art, and to contrast Christian values with materialism. They were meant to remind viewers of the brevity of life on earth and the futility of worldly riches and sensuous gratification.

Beuckelaer goes one step further in making still life respectable: he wittily relates it to cosmology. According to a theory evolved in Ancient Greece, the universe is made up of four elements: Earth, Water, Air and Fire. The artist interprets them by picturing vegetables and fruits grown in *Earth*, fish that swim in *Water*, fowl that fly through the *Air*, and *Fire* used for cooking. Some of the paintings also allude to the human temperaments once associated with the elements.

Earth is set in the countryside. The background includes the Flight into Egypt in the upper left-hand corner, with a beggar reclining on the earth to look upon the Holy Family, and to remind us of our duty of charity. By the well near which the produce is washed, a man sits idle with his hands folded in the traditional pose of Melancholy, the earth-bound temperament.

The well-dressed servant women in the foreground have rolled up their sleeves. They are choosing to buy from among cabbages, cauliflower, carrots and radishes – some sixteen varieties of vegetables and fruit are on display, overflowing from baskets and bowls and toppling from a wheelbarrow. This bravura arrangement never existed in reality; most of these items are reproduced from individual studies made at different times by the artist and reused in other paintings. Chemical changes to the blue pigment smalt have caused areas of sky and the women's aprons to lose colour and tonal definition; some red glazes have faded, notably from the now pink cabbages. The steeply tilted perspective is patently artificial, yet it seems reality itself that holds our gaze. Dazzled by this panoply of the sensory and the everyday, we barely attend to the Christ Child passing by.

BRONZINO (1503-1572)

An Allegory with Venus and Cupid about 1540-50

Oil on wood, 146 x 116 cm NG 651

The Allegory with Venus and Cupid has fascinated and troubled visitors to the National Gallery since its acquisition in 1860. The most frankly erotic painting in the collection, it nonetheless arouses and chills in equal proportions. Perhaps the nearest modern equivalent of its emotional range can be found among the pages of our glossy fashion magazines, where 'cool' is equated with 'style', and nature subsumed to artifice.

Agnolo di Cosimo, called Bronzino, worked at the court of Florence's first absolute ruler, Duke Cosimo de' Medici. The well-loved pupil and assistant of Pontormo – who included his likeness in the panel of *Joseph with Jacob in Egypt* (page 147) – Bronzino became famous mainly as the official portraitist of the duke and duchess, their many children and members of the court. He also painted altarpieces and religious narratives, but even in these he usually maintained the aristocratic aloofness and formal beauty which we associate with his adult portraits.

Like the world of high fashion, the court of a despotic ruler prizes artifice above nature. Style assumes a disproportionate importance because it masks the brutal realities of power and dependence. Spontaneity is stifled and protocol governs daily behaviour. Intellectual enquiry is devalued, but a veneer of learning is the hallmark of the élite. Bored courtiers must learn to pass the time in solemn frivolity. Hence this work, probably created at the Tuscan court for presentation to the King of France, was designed as a puzzle and incorporates symbols and devices from the worlds of

mythology and emblematic imagery.

It would have made the perfect present for the French king, known for his lusty appetites, yearning after Italianate culture and magnificence, and with a liking for heraldry and obscure emblems. Unravelling the symbolism would have been an excuse for admiring at length the alluring bodies of Venus and Cupid and the lubricious details of their embrace. The goddess of love and beauty, identified by the golden apple given to her by Paris, and by her doves, has drawn Cupid's arrow. At her feet, masks, perhaps the symbols of sensual nymph and satyr, seem to gaze up at the lovers. Foolish Pleasure, the laughing child with a Morris dancer's anklet of bells, throws rose petals at them, heedless of the thorn piercing his right foot. Behind him Deceit, fair of face but foul of body, proffers a sweet honeycomb in one hand, concealing the sting in her tail with the other. On the other side of the lovers is a dark figure, formerly called Jealousy but recently plausibly identified as a personification of the effects of syphilis,

a disease probably introduced into Europe from the New World and reaching epidemic proportions by 1500.

The symbolic meaning of the central scene is thus revealed to be unchaste love, presided over by Pleasure and abetted by Deceit, and its painful consequences. Oblivion, the figure on the upper left who is shown without the physical capacity for remembering, attempts to draw a veil over all, but is prevented by Father Time – possibly alluding to the delayed effects of syphilis. Cold as marble or enamel, the nudes are deployed against the costliest ultramarine blue, and the whole composition, flattened against the picture plane, recalls Bronzino's contemporaneous designs for the duke's new tapestry factory. But a more compelling analogy is with another luxury product for which the courts of Italy became notorious. Like one of the Borgias' fabled poison rings, a jewel alluring to the sight, deadly when unlocked, the image conceals, and reveals, its bitter moral.

PIETER BRUEGEL THE ELDER (active 1550/1-died 1569)

The Adoration of the Kings 1564

Oil on oak, 111 x 83 cm NG 3556

Pieter Bruegel was a pioneer of landscape painting, and this picture is unusual in being so tightly focused on the Adoration as to exclude the countryside and the kings' cortège. The panel may have been cut down at the sides and at the top, but this is unlikely to have radically changed the composition. Instead of the magnificent horses and courtly riders of tradition, we are shown foot soldiers and three townsmen, one of whom whispers conspiratorially in Saint Joseph's ear, crowding in upon the Holy

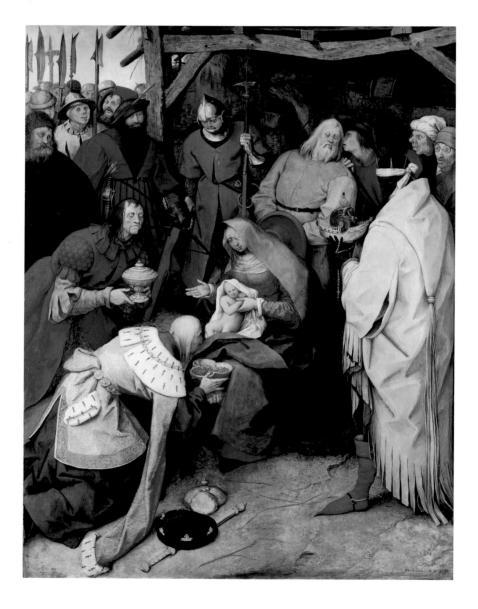

Family. Bruegel was much influenced by Hieronymus Bosch (page 25) and both the format and the cruel caricatures are probably indebted to him.

Despite specialising in scenes from peasant life, for which he became known as 'Peasant Bruegel', the artist was no Flemish rustic but a highly educated man who travelled to Italy recording views of cities and landscapes. He began his career working for a publisher designing popular satirical engravings and prints after Bosch. When he began to paint around 1560 he found his patrons among the leading intellectuals and rich bankers of Antwerp. Many of his pictures reflect the farces, allegorical plays and processions presented by the literary societies to which such people belonged and which were central to the intellectual and festive life of Netherlandish cities. It is difficult to believe that a theme like the Adoration could be conceived in a satirical spirit, yet the caricatural element may have a serious moral point. As the kings offer or wait to offer their gold, frankincense and myrrh to the Christ Child, the crowd has eyes only for the rich presents. The townsman in glasses on the right seems to look at the Moorish king Balthazar's magnificent censer with open-mouthed greed. (It is indeed a splendid example of contemporary goldsmith's art, a golden ship constructed around a precious nautilus shell surmounted by a crystal orb.) The soldier at the Virgin's shoulder stares wide-eved at the vessel containing myrrh. And the Child smiles but shrinks back from the gold held out by the oldest king.

We know from the Bible, and from pictorial tradition, that at the Passion Christ was tormented by soldiers, reviled by the people and led to execution. Is Bruegel hinting at this in a scene of the Adoration? Are these men who surround the Virgin and Child seeing not their heavenly king but only earthly riches, the same ones who will later mock and kill him? The ass of Isaiah's prophecy (1:3) is eating at the manger in the background, for he 'knoweth...his master's crib: but Israel doth not know, my people doth not consider.' And Isaiah is echoed by Jeremiah and Ezekiel (12:2): 'Son of man, thou dwellest in the midst of a rebellious house, which have eyes to see, and see not...'

CORREGGIO (about 1494-1534)

Venus with Mercury and Cupid ('The School of Love') about 1525

Oil on canvas, 155 x 92 cm NG 10

Born in Correggio, a small town equidistant between Mantua and Parma in Northern Italy from which he takes his name, Antonio Allegri is now perhaps the least familiar of the great painters of the Italian Renaissance. His most important works - innovative vault and dome frescoes and many altarpieces - remain in Parma, the native city of his follower, Parmigianino (page 143). Only a relatively small number of other religious images, two allegorical pictures, and the artist's six erotic paintings on mythological themes - including 'The School of Love' - for Federigo II Gonzaga, Lord of Mantua, have entered major European museums. Had a painter as accomplished and influential as Correggio been employed in a more self-conscious and self-publicising artistic centre, such as Florence or Rome, he would surely have been better documented in his lifetime. Were Parma still on the tourist trail, as it was in the more leisurely century of Grand Tourism (see pages 271 and 305), he might be better known today. Few of the millions of visitors to Rome now realise, for example, that the great Baroque dome and vault decorations of the city's churches, flooded with heavenly light and dizzying crowds of saints and angels, emulate Correggio's frescoes of a hundred years earlier, through the agency of Lanfranco, a painter from Parma. Equally, the playful sensuality

of eighteenth-century Rococo art (see, for example, Fragonard, page 288) owes much to Correggio's easel paintings in French royal collections.

Correggio's artistic formation, however, was unusually dependent on his geographical origins. Working within the larger triangle of Venice, Milan and Rome, he drew on the disparate pictorial traditions of these cities as well as on the Mantuan works of Mantegna (page 64) and on prints from across the Alps. The blurred contours, veiled transitions from rosy shadow to gold and white highlight and from flesh to feather, and the elusive mood of 'The School of Love' recall Giorgione (page 116), but Leonardo's influence is also evident in the exquisitely silky hair, the dreamy smiles, the complex pose of Venus (page 56). X-rays reveal major alterations: Mercury and Venus may even have exchanged places. This method of working directly on the canvas derives from Venice (see page 100). Yet Correggio draws these various elements together

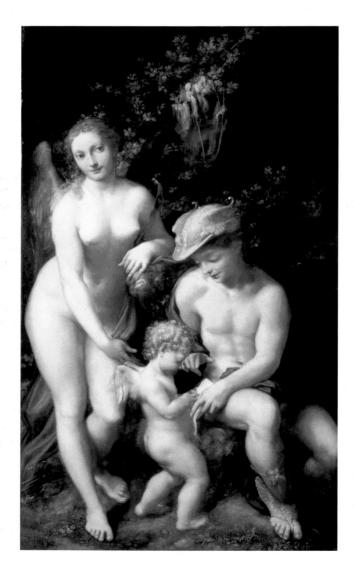

in an entirely individual way, partly through his method of composition, perceptively analysed by the eighteenth-century German artist Mengs: 'With regard to the contrast and the variety of the directions of the members [the arms and legs of the figures] one sees...that he gave to these members a little foreshortening, and seldom made his surfaces parallel...'

The animation thus imparted to individual figures and to the image as a whole is evident in 'The School of Love', which does not refer to any known myth but is perhaps based on long-established astrological lore. Its probable companion, now in the Louvre, Paris, shows a lustful satyr uncovering Venus sleeping in sensuous abandon on the ground. She represents the 'Terrestrial Venus' of carnal passion. In the National Gallery canvas (smaller because cut down on all four sides), a winged Venus and Mercury unite in instructing Cupid, as married lovers educate their offspring or the benevolent planets which these divinities personify influence children born under their zodiacal signs. This 'Celestial Venus', however, appears no less desirable than her earthly Parisian sister, and Correggio changed the position of her head so that instead of looking down with maternal solicitude, she now invites, and eludes, our admiring glance.

CORREGGIO (about 1494-1534)

The Madonna of the Basket about 1524

Oil on wood, 33 x 25 cm NG 23

If Correggio's mythologies seem to anticipate the boudoir decorations of the eighteenth century, this ravishing tiny picture – one of the most perfectly preserved paintings in the Gallery – prefigures developments in seventeenth-century religious sentiment and imagery. Indeed, it may have directly affected them through drawn and engraved copies, a rare distinction for such a small and intimate work.

Late medieval devotional literature described in minute detail the modest domestic life of the Holy Family, but it did so largely to stress the humility of Christ and the Virgin and their all too human sufferings. Correggio invests the theme with quite another emotional tone: he turns it into an idyll of innocence, of maternal and filial love. The scene is suffused with tenderness. Sitting outdoors under a tree, the Virgin, workbasket at her side, is trying a jacket she has just made on the Christ Child. He wriggles on her lap, reaching for the sun-dappled leaves. Mary is not dressed in regal robes of ultramarine blue, but in old rose, and the painting is dominated by the soft harmony of grey-pinks and grey-blues. In the background, pale as if in a haze of dust in the sunshine, Joseph is working with a carpenter's plane. Their ramshackle home has been built abutting grandiose ruins - an old symbol of the new faith rising out of the wreckage of pagan antiquity. There are other symbolic allusions: the Child's gesture recalls the act of blessing, the jacket may be that seamless coat which legend claims grew with him and for which the soldiers cast lots at the foot of the cross (John 19: 23-4). We are free to find these references, but they are not forced upon us, nor are the formal difficulties: the twisting, complex pose of the Virgin, the extreme foreshortening of the Child's leg and groin, are made to seem effortless. Correggio's famous 'softness', the gradual transitions from shadow to light which he learned from Leonardo's Milanese works but interpreted through a golden prism of Venetian colour, casts a seductive veil over the figures. Even though the scale of the picture invites close inspection, and the Virgin and Child are near to us, we cannot quite see them sharply in the blur and shimmer of the painter's brush.

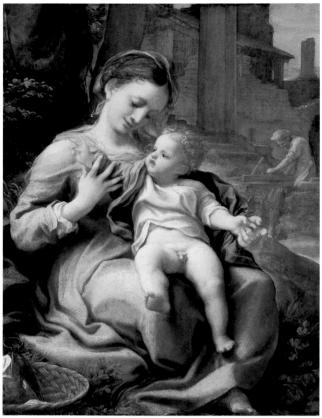

NG 23 The Madonna of the Basket

LUCAS CRANACH THE ELDER (1472–1553) Cupid complaining to Venus about 1525

Oil on wood, 81 x 55 cm NG 6344

Painter and printmaker, Cranach is the chief artist of the Reformation. In 1505 he was appointed court painter to Friedrich the Wise, Elector of Saxony and the protector of Luther, whom the artist grew to know well and painted several times and who stood godfather to one of Cranach's children. He remained in the employ of the Electors of Saxony until the end of his life, and although he executed some portraits of his humanist friends in a naturalistic style, he evolved a decorative calligraphic manner in his work for the court. In addition to pleasing his patrons, this formula enabled Cranach to produce, and reproduce, pictures of high quality with the participation of his large workshop, which included his two sons, Lucas the Younger and Hans. The need for streamlined methods can be gauged from the fact that 60 pairs of small portraits of the deceased Electors Friedrich the Wise and Johann the Steadfast were commissioned from the artist in 1533, the year Johann Friedrich (see page 114) came to the Electorship.

In addition to portraits and religious works for Lutheran and Catholic clients, Cranach developed new specialities for the court: paintings of the hunt and of the nude, such as this picture. Whether representing Old Testament heroines, pagan goddesses,

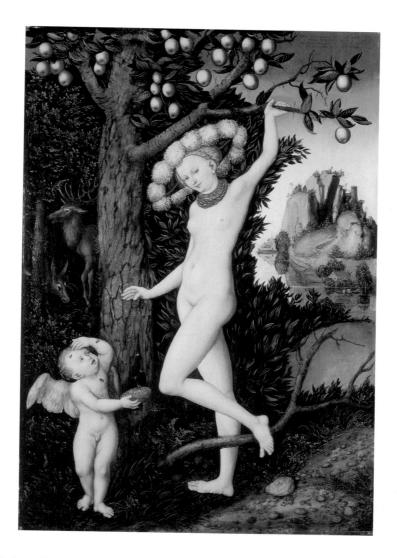

mythological narratives or allegorical abstractions, the appeal of works like this lay in their sophisticated sensuality and delightful fantasy. Cranach wittily adorns his slender aristocratic Venus with hat and jewels in the height of fashion, as if a court beauty had undressed to pose. Since hunting was the favourite pursuit of his aristocratic patrons – after religion, politics, women and a veneer of classical education – the artist included a vignette of stag and hind in the dark Germanic woods behind the figures. An inscription in the sky at the right glosses the image. It is a rough Latin version of a passage by the Ancient Greek pastoral poet Theocritus:

While Cupid was stealing honey from the hollow of a tree trunk, a bee stung the thief in the finger. Even so does a brief and transient pleasure which we seek harm us with sadness and pain.

The poet then tells how Venus mocked her son Cupid, saying that the wounds of love which he inflicted on others were much more painful. The moral is akin to that in Bronzino's Allegory with Venus and Cupid (page 106), also painted for a princely court.

Cranach's picture, however, seems less intense both in eroticism and morality, and the difference in scale between the two works makes this even more apparent when we see the originals. But it is no coincidence that Venus, looking at the viewer as she clutches the branch of an apple tree, resembles the temptress Eve.

LUCAS CRANACH THE ELDER (1472-1553)

Portraits of Johann the Steadfast and Johann Friedrich the Magnanimous 1509

Oil on wood, left 41 × 31 cm, right 42 × 31 cm NG 6538-9

Paired portraits of husband and wife were an established tradition (see page 30) when Cranach painted these likenesses of a father and his son in 1509. Six-year-old Johann Friedrich, heir to the Electorship of Saxony, was depicted jointly with Johann the Steadfast probably because his mother, Sophia of Mecklenburg, died giving birth to him in 1503. The commission gave Cranach the opportunity to paint one of the earliest and most sympathetic portraits of a child in European art. The boy, shown full-face, looks out with a shy sidelong glance from among the fantastical ostrich plumes of his hat and the exquisitely rendered jewels. Even the physical properties of the paint – bold three-dimensional swirls in the feathers, firm ridges where hat meets hair and skin and where the ornamental slashes of the outer garment reveal the red lining - seem to emphasise his frailty, as if his costume had more vigour and substance than he. His head placed higher than his father's suggests his small size: a little boy perched on a tall stool to face adult scrutiny. So spontaneous is the likeness that we feel it was taken by the artist specifically for this painting, perhaps the child's first formal engagement. The contrast between this portrait and later ones of him as an adult, in which Cranach depicts the almond-shaped eyes as aloof and inscrutable and the body bulky in its magnificent costume, could hardly be greater.

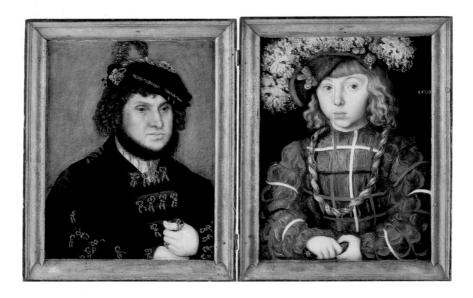

The portrait of Johann the Steadfast is less lively and resembles his likeness in a contemporaneous altarpiece by Cranach. Both these images of the Elector may have been based on a drawing from life which Cranach kept in his workshop ready for use in any number of commissions; many such drawings by him of German nobles have survived. Despite the discrepancies between the portraits of Johann and his son, Cranach has related them carefully to each other. The green background of the father's likeness is echoed in the green coat worn by the child, and the black background of the boy's portrait is similarly reflected in his father's coat. The paintings appear to be in their original frames, hinged to be closed like a book; Cranach must always have planned them as a diptych. On the back of the portrait of little Johann Friedrich are his parents' coats of arms, Saxony and Mecklenburg.

ADAM ELSHEIMER (1578–1610)

Saint Paul on Malta about 1600

Oil on copper, 17 x 21 cm NG 3535

The demand for landscape painting among educated Italian patrons of the Renaissance was stimulated by their reading of Pliny the Elder's first-century Latin text on ancient art. Collectors applied his descriptions of Greek and Roman specialists in different kinds of pictures to their own contemporaries. German and Netherlandish artists, with their magical ability to depict delightful vistas in the backgrounds of religious paintings (see, for example, Memling, page 78), were soon identified by Italian clients as potential purveyors of 'pastoral' or 'rustic' pictures to rival, like their ancient predecessors, the

effects of the lighter veins of poetry and music. Northerners under the spell of Italian art theory complied with this view (see Patinir, page 145), until Rubens (page 242) boldly staked out the claim of a Fleming to work on a large scale as an Italianate 'history painter' – which did not prevent him from admiring, and collecting, the rare pictures of Adam Elsheimer, a fellow Northerner who spent the last ten years of his short life in Rome.

Elsheimer's precious little pictures on copper helped to transform landscape from a decorative adjunct to a major artistic genre (see also Giorgione, page 116, and Annibale Carracci, page 188). Trained in Germany and Venice and adept at both figure and landscape painting, Elsheimer gave visual form to two equally exotic impulses: awe of Northern woods and waters, and nostalgia for the ancient Mediterranean past. This picture – one of three works by the artist in the National Gallery – belongs to the former category, although it treats two episodes from the Acts of the Apostles (27:41–4 and 28:1–6): the shipwreck of Saint Paul on the island of Malta and the miracle of the viper. Barely larger than a human hand, it recreates the effects of multiple illumination to reveal a drama of nature's might, human frailty and divine intervention. Lightning flashes on waves crashing against the shore, the spume rising to the tops of gnarled trees clinging to the rocks. A beacon burns on the clifftop. The survivors gathered in the foreground dry their clothes, aided by the natives. As sparks fly upwards, the firelight glows warm on Italianate nudes and a wrinkled Northern crone. A diminishing progression of reds from right to left leads us to Saint Paul:

[As] he laid [a bundle of sticks] on the fire, there came a viper out of the heat, and fastened on his hand. And when the barbarians saw the venomous beast hang on his hand, they said among themselves, No doubt this man is a murderer, whom, though he hath escaped the sea, yet vengeance suffereth not to live. And he shook off the beast into the fire, and felt no harm... [when they] saw no harm had come to him, they changed their minds, and said that he was a god.

GIORGIONE (active 1506-died 1510)

The Sunset (Il Tramonto) 1506-10

Oil on canvas, 73 x 91 cm NG 6307

Very little is known about Giorgione: only a handful of contemporary documents refer to him, and only some six or seven surviving paintings are now considered 'almost certainly' by him. Yet he is universally accepted as one of the most influential of Western artists. Probably trained by Giovanni Bellini (page 20), he originated a poetic painting of mood, based on colour, light and a new vision of landscape, which we still call 'Giorgionesque'. Although we attribute to him an altarpiece in his native town of Castelfranco, a ruined nude figure in fresco detached from a building in Venice which he and Titian decorated (page 164), and two portraits inscribed with his name in the sixteenth century, he seems to have specialised in small, enigmatic 'subject' pictures like this one for private collectors. Whether or not the picture, which was rediscovered, badly damaged, in 1933 in a sixteenth-century villa in Ponte Casale, south of Venice, is by Giorgione himself is not very important to us as viewers; it is certainly 'Giorgionesque'.

The Italian title, *Il Tramonto*, captures the painting's special temper better than the English translation, for in Italian the sun sets literally 'beyond the mountain'. Within a deep landscape meeting the horizon in a startling band of blue, two travellers halt beside a pool, from whose murky waters a little beaked monster emerges. A hermit inhabits the dark cave on the far side. The mounted Saint George in the middle distance

is a restorer's reconstruction, added in 1934 to cover an area of flaking paint, and to account for what appears, in a photograph from that period, to be the vestigial tail of a dragon. Other reconstructed areas include the larger monster in the water. The modern additions make unsafe any reading of the picture's intended meaning. If Saint George was originally present, the hermit may be Anthony Abbot – a saint distressed with sores, protector against epidemics – of whom it was told that demons in the shape of monsters came at nightfall to 'tear his body with teeth, with horns, and with claws'. The two men in the foreground may be Saint Roch, a medieval French pilgrim who caught the plague while nursing the sick, and his companion Gothardus tending the ulcer on the saint's leg. The body of Saint Roch, one of the main protectors against pestilence, is one of Venice's great relics.

If we compare *Il Tramonto* with, for example, a landscape from the workshop of Patinir painted a few years later (see page 145), it is possible to understand the great impact of Giorgione's work. For all its artificiality, this landscape invites us to enter it in imagination; the construction, in wedge-shaped planes alternately light and dark, stresses continuity from foreground through well-defined intervening space to the blue horizon. The wispy tree in the centre, like the cliff and foliage on either side, pushes back the far from the near. Soft gradations from shadow into light, contours and reflections blurred as if by haze, the isolated and mysterious figures, the barely visible, perhaps imaginary monsters, the alpine town in the distance, combine to create a sense of profound yet indefinable emotion, as 'Brightness falls from the air. . .' Thomas Nashe's haunting line may be more than visually apt: it comes from a poem entitled 'In Time of Pestilence'.

JAN GOSSAERT, ALSO CALLED MABUSE (active 1503-died 1532)

An Elderly Couple about 1510-28

Oil on vellum (?) mounted on wood, 46×67 cm NG 1689

Gossaert was probably trained in Bruges before becoming a master in Antwerp in 1503. He entered the service of Philip of Burgundy, later Bishop of Utrecht, an illegitimate son of Philip the Good, Duke of Burgundy. In 1508, when Philip went on a mission to the Vatican, Gossaert probably accompanied him to record ancient monuments, seemingly the first Flemish artist to do so. The trip had a momentous effect not only on his own work, but also on Netherlandish art in general. Under the impact of Gossaert and like-minded 'Romanists', the native pictorial tradition rooted in the work of van Eyck (page 46) and van der Weyden (page 94) was rejected in favour of an Italianate Renaissance idiom ultimately based on Ancient Greco-Roman sculpture, anatomical studies and mathematical perspective.

Gossaert's outstanding pre-Romanist painting, the Adoration of the Kings, is discussed on the next page. The picture illustrated here shows his mature style, in this instance equally compounded of Italianate elements and Flemish naturalism. It is the artist's only known double portrait. Unlike many of Gossaert's sitters, these elderly people seem to belong to the prosperous bourgeoisie rather than the nobility. Shown in bust-length against a dark green background, they are strongly lit from the upper left. The light unites them within the picture space, revealing underlying structure while at the same time accentuating the different tinges of their flesh and the sagging of their tired skin.

The badge on the man's hat shows two naked figures with a cornucopia, perhaps an ironic comment on the sitters' present state. Yet in an age when toothlessness and wrinkles were subjects of ridicule, Gossaert endows the couple with enormous stoical dignity. The man, more active, grasps his fur collar and the metal head of a cane and looks sternly ahead. But the woman, posed behind him with her hands concealed, her eyes downcast, is no less firm. Her white headdress is reflected on her cheek and chin and casts a translucent shadow on her forehead, thus lightening the tonal contrasts visible in her husband's face, and at the same time giving her an equal share of monumental authority.

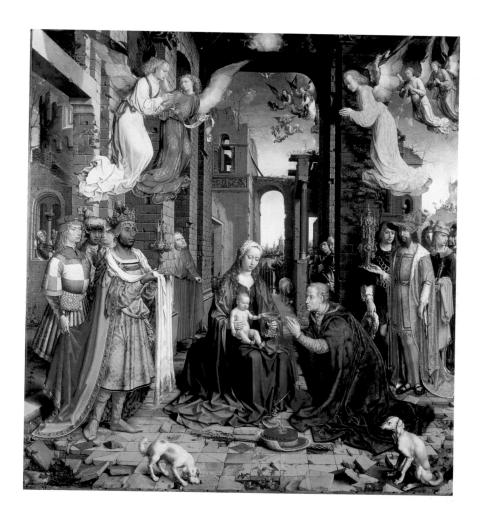

JAN GOSSAERT, ALSO CALLED MABUSE (active 1503—died 1532) The Adoration of the Kings 1510–15

Oil on wood, 177 x 161 cm NG 2790

This Adoration is one of the most sumptuous ever painted. It is thought to have been the altarpiece of the Lady Chapel of St Adrian's, Grammont, endowed by Joannes de Broeder, who became abbot in 1506; the picture is likely to have been begun soon after and may have been completed before Gossaert left for Italy. Every inch of the huge panel has been elaborated in dazzlingly crisp detail, without compromising the clarity and focus of the whole.

In the ruinous edifice of the Old Dispensation, the kings of the earth with their retinues, awestruck shepherds and the nine celestial orders of angels join to adore the newborn Child, seated on his mother's lap as upon a throne. Caspar has offered gold coins in a gold chalice; his name is incised on its lid lying next to his hat and golden sceptre at the hem of the Virgin's gown. Balthazar, advancing on the left, is identified by the inscription adorning his crown, and the artist has signed his name below. The

border of the cloth on which Balthazar, like a priest at the altar, holds his precious offering, is embroidered with the first words of the hymn to the Virgin, Salve Regina: 'Hail Queen, mother of mercy, life, sweetness...' The artist's second signature is incorporated in the neck ornament of Balthazar's black follower. The third king, Melchior, waits on the right; on the hillside behind his retinue the angel is announcing Christ's birth to the shepherds. Joseph, in red and with a cane, stands at some distance gazing up to heaven. Although generally following Netherlandish precedent, Gossaert shows his awareness of modern, and even foreign, art: the dog in the right foreground is copied directly from Dürer's famous engraving of the miraculous conversion of Saint Eustace, dated to 1500/1.

Two unusual features of the imagery are the dove of the Holy Spirit descending from the star, which becomes a symbol of God the Father – so that the three persons of the Trinity are represented in the Adoration – and the Virgin holding the chalice offered by Caspar. Jesus seems to proffer one of the gold coins. Of the three gifts which the Wise Men from the East presented to the Child (Matthew 2:11), the myrrh, later used to embalm Christ's body, traditionally symbolised his sacrifice; the frankincense was specified in the Old Testament as an incense reserved for the tabernacle of the Lord; the gold was tribute paid by kings to the King, after the example of Solomon. Yet perhaps an additional significance is suggested here in the Child's gesture. The royal tribute will be redeemed in blood – the eucharistic wine – through the Saviour's infinite charity.

Gossaert's painting provokes close reading, although its general message within the Christian story is clear. It is perhaps the last great exemplar of that painstaking art of the Netherlands which spared no labour to place at the feet of the Virgin and her son a minute description of the costliest products of human craft – the wares of goldsmiths, weavers, furriers, embroiderers, tailors, hatters and bootmakers – arrayed on panel through ingenious mastery of the painter's brush. As a testimonial to his own craft or to show his devotion, the artist may have included his own likeness, peeping out of a narrow doorway behind the ox at the Virgin's shoulder.

MARTIN VAN HEEMSKERCK (1498-1574)

The Virgin and Saint John the Evangelist, the Donor and Saint Mary Magdalene about 1540

Oil on oak, each panel 123 × 46 cm NG 6508.1-2

Born in the Dutch village of Heemskerck from which he takes his name, the painter worked in Haarlem until an extended stay in Rome from 1532 to 1536. The experience of studying ancient and Italian Renaissance art significantly altered his style. When commenting on his earlier period, he is recorded as saying, 'at that time I did not know what I was doing'.

The cleaning of these two wings of an altarpiece (from which the central panel has been lost) on their acquisition by the National Gallery in 1986 confirmed that they had been painted after the artist's return from Italy. This is suggested by the antique dress, jewellery, hairstyle and ointment jar of the Magdalen, the classical profiles of the two saints and the Michelangelesque way in which the bodies of the holy personages are revealed under clinging drapery. The donor, on the other hand, is portrayed in a much more realistic manner, closer to Netherlandish tradition, although even here Italian techniques have influenced the artist. Rather than laboriously painting in each

individual hair of the clergyman's fur stole, Heemskerck has worked over the still soft paint with a dry bristle brush or with some sort of comb-like implement, to create a convincingly furry texture.

In other areas the artist occasionally used Netherlandish oil painting techniques of modelling volume, in which dark shadows are built up with layers of translucent paint, but he mainly relied on the Italian method of working from dark to light, adding white to the base colour, and using pure lead white in the highlights. This is responsible for the transparency of the shadows in the dress of the Virgin, for example, for the great tonal variation between shadow and highlight, and the hard transition between the tones. Together with the artist's characteristic colour range of hot reds and pinks set against brilliant turquoise blues, they contribute to the painting's unnaturalistic appearance.

The frames, which are old but not original, show indentations where hinges attached them to a central panel. The anguished appearance of the Virgin supported by Saint John suggests that this might have depicted the Crucifixion, but the clouds behind the standing saints have led to the conclusion that the lost panel showed Christ as the Man of Sorrows, a devotional image which Heemskerck painted several times. The much-damaged reverses of the wings, which would have been visible when the altarpiece was closed, depict two unidentified bishop saints, painted in monochrome to resemble stone statues, above 'carved' coats of arms.

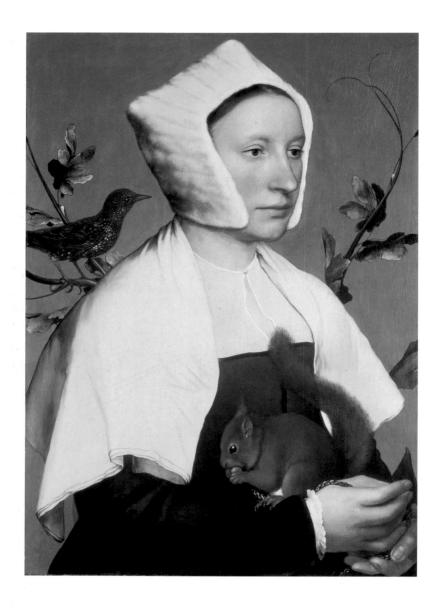

HANS HOLBEIN THE YOUNGER (1497/8-1543)

A Lady with a Squirrel and a Starling ${\scriptstyle about~1526-8}$

Oil on oak, 56 × 39 cm NG 6540

Holbein, the youngest of the great German sixteenth-century painters, draughtsmen and printmakers, is the best-known member of an Augsburg artists' dynasty which included his father Hans Holbein the Elder, his uncle Sigmund and his brother Ambrosius. Having had a solid grounding in Northern styles and technique from his father, Holbein made a brilliant solo debut in Basle in 1515–16. The influence of Leonardo's Milanese works (page 56) is noticeable in his paintings from the 1520s. In 1524 he went to France, where he learned his famous 'three-colour' technique of

drawing portraits in black ink and red and white chalks. Recommended by Erasmus to Sir Thomas More, he spent the years from 1526 to 1528 in England. The intense blue background with curling vines of this likeness of an unidentified woman holding her pet squirrel appears in other portraits he painted at this time. Leaving his wife and two children behind in Basle, he was to return to England again in 1532, and by 1536 was appointed court painter to Henry VIII.

While it may seem a pity that Protestant iconoclasm caused the versatile Holbein to become almost exclusively a 'face painter', anyone seeing his three great portraits in the Gallery can appreciate why eminent sitters flocked to him. Combining sober Netherlandish candour with Italianate subtlety, he discreetly conveyed the inner essence as much as the outward appearance – or so he leads us to think. That is why Holbein's Henry VIII remains posterity's image of the king.

The portrait of the lady with a squirrel, a speckle-breasted starling perched behind her – perhaps as a pun on her name or a coat of arms brought to life – is a wonderfully preserved example of Holbein's art at its most evocative. The picture may have been painted as one of a pair depicting husband and wife. In her warm fur cap the lady seems impassive, her eyes eluding the viewer's glance. Holbein's skill differentiates meticulously between the textures of white fur, white shawl and the translucent white cambric buttoned at her throat and gathered in a ruffle at her wrist. The squirrel was added later over the sitter's clothes. Her hands, rearranged to support him, are a discordant note: they look masculine, modelled perhaps on those of an assistant in the studio. Yet the bright-eyed animal is essential to our reading of the portrait. His bushy tail, suggestively poised between the lady's gently swelling breasts, hints at a sensuous nature beneath her reticently monochrome English costume.

HANS HOLBEIN THE YOUNGER (1497/8-1543)

Jean de Dinteville and Georges de Selve ('The Ambassadors') 1533

Oil on oak, 207 × 210 cm NG 1314

This huge panel is one of the earliest portraits combining two full-length figures on the scale of life, and it remains one of the most fascinating works in the National Gallery. A paean to two scholar-diplomats and to the artist's virtuosity, it is on closer examination a reminder also of the brevity of life and the vanity of human accomplishments. While life is short, Holbein seems to say, art is long-lasting – but eternity endures for ever.

On our left stands Jean de Dinteville, a French nobleman posted to London as ambassador. The globe on the bottom shelf shows Polisy, where he had his château; the ornate sheath of the dagger in his right hand gives his age as 29. To his left stands his friend and fellow countryman, Georges de Selve, whose visit to London in 1533 is commemorated here. A brilliant classical scholar, he had some years earlier been created Bishop of Lavaur. He leans his elbow on a book inscribed with his age: 25. In their attire, their poses and their bearing the two friends exemplify, respectively, the active and the contemplative life, which, together, complement each other.

On the what-not between them Holbein has depicted the wide range of their interests – a compendium of the culture of the age. On the top shelf, the minutely rendered 'Turkey' carpet bears a celestial globe and an array of astronomical and navigational instruments. The cylindrical dial gives the date as about 11 April or 15 August; the polyhedral dial on the right indicates two different times of day. In front of the terrestrial globe on the lower shelf lies a German textbook of *Arithmetic for Merchants*, propped

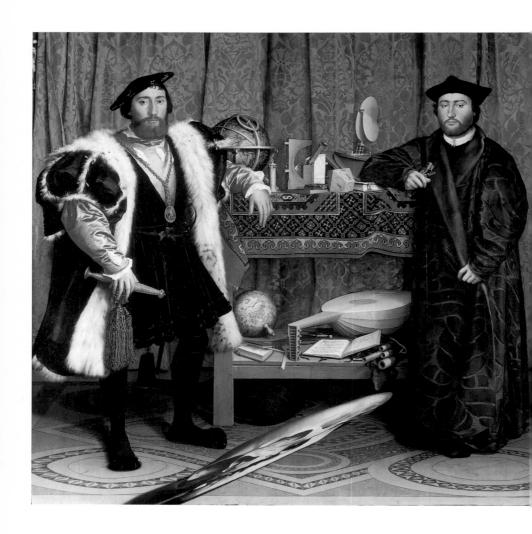

open with a T-square. A lute and a case of recorders or flutes demonstrate both Holbein's mastery of foreshortening and the sitters' musical interests. But a string of the lute has snapped, a traditional emblem of fragility. Just visible in the top left corner, at the edge of the magnificently patterned green hanging, is a crucifix. The hymnal in front of the lute is open at Martin Luther's hymn, 'Come Holy Ghost our souls inspire'. Christian faith offers hope of eternal life when dust returns to dust.

Across the mosaic floor – derived from the medieval pavement in Westminster Abbey – there spreads a curious shape between the two friends. It is a skull, skilfully distorted so that its true form can only be perceived from the correct viewpoint at the edges of the panel, or through a corrective device. Possibly referring to a personal device of Jean de Dinteville, whose cap medallion bears a skull, it is also the quint-essential *memento mori*, reminder of mortality. In Holbein's meticulously real-seeming picture, the distortion also functions as a signal that reality, as perceived by the senses, must be viewed 'correctly' to reveal its full meaning. A frontal nod of recognition at the worldly semblance of things is not enough.

HANS HOLBEIN THE YOUNGER (1497/8–1543)

Christina of Denmark, Duchess of Milan 1538

Oil on oak, 179 x 83 cm NG 2475

Holbein's painting of the sixteen-year-old Christina of Denmark, widowed Duchess of Milan, is his only surviving full-length portrait of a woman. Remarkably for a work of this period, we know precisely how and when it came to be made. The younger daughter of King Christian II of Denmark, an early Lutheran sympathiser who lost his throne in 1523, she had been brought up in the Netherlands at the courts of her greataunt, Margaret of Austria, Governess of the Netherlands until her death in 1530, and her aunt, Mary of Hungary, Margaret's successor and sister of the Emperor Charles V.

After her husband's death in 1535, Christina returned to Brussels. Henry VIII of England attempted, unsuccessfully in the event, to marry her as his fourth wife after the death of Jane Seymour. On 12 March 1538 she agreed to sit for Holbein for three hours, and the English envoy judged the resulting drawing or drawings to be 'very perfect'. Holbein must have worked up the painted portrait after his return to London, and the king was said to be 'in love' with Christina, whom of course he had never met except through Holbein's art. It has been suggested that the full-face pose, characteristic of Holbein's other portraits of Henry's prospective brides, was chosen on instructions from the king, who may have felt that any other view might allow blemishes to be concealed from him.

The figure stands out isolated against the plain but brightly coloured background relieved only by shadows, cast not merely by Christina herself but by an unseen window frame. Since the black mourning dress carried no ornament, Holbein stressed the three-dimensional modelling, creating enlivening patterns from the reflection of light on the folds of the silken robe. Not known as a great beauty, Christina was, however, much praised for the elegance of her hands, and in this area of the painting Holbein suggests the different textures of linen, velvet, fur, leather, gold and gemstone to set off the delicate beauty of the flesh. Christina's faint smile seems at once demure and intimate. Generations of viewers have shared Henry's infatuation with this engaging portrait.

WOLF HUBER (1480/5-1553)

Christ taking Leave of his Mother after 1520

Oil on wood, 95.5 x 68 cm NG 6550

This poignant fragment of a larger altarpiece illustrates the same subject and the same pictorial concerns as Albrecht Altdorfer's picture reproduced on page 102. It is the first painting by Wolf Huber to enter a British public collection, and – although, strictly speaking, Huber was born in present-day Austria – greatly strengthens the Gallery's holdings of German art (see also Cranach, page 112; Dürer, page 45; Holbein, page 122; Lochner, page 61; Master of Liesborn, page 72; Master of the Mornauer Portrait, page 74; Master of the Saint Bartholomew Altarpiece, page 75).

Like Altdorfer, Huber belonged to a small group of artists, working mainly in Bavaria, for whom the wooded vistas of the Danube River valley provided inspiration. The praise of Latin and Italian Renaissance authors for landscape painting, and the revival of the genre in Venice (see Giorgione, page 116) and, under Venetian influence, by Dürer, predisposed them to depict such scenes in drawings, prints and oil paintings. Huber, unlike Altdorfer, seems not to have painted 'pure' landscape pictures, although he executed many influential landscape drawings. Details from these, like the wooden bridge in the background of this panel, were used by him to provide evocative settings for his narrative compositions and portraits.

In this prelude to the Passion, when Christ bids farewell to his mother, the women's lament, all slowly falling loops and curves, gains in pathos through the descant of upright firs echoing the vertical figure of the Saviour glimpsed at the edge of the panel. His blessing hand, seen at the far right of this fragment, emphasises the right angles formed where tree trunks cross the bridge, whose horizontal line continues that of his outstretched arm. Female frailty is contrasted with masculine courage, mortal grief with divine will and the irrepressible, soaring life force of nature. The dark forest

vegetation sets off the strong reds and blue of the cloaks in the foreground and the wine-grey liquefaction of the Holy Women's draperies as they bend over to comfort the swooning Virgin.

The tragedy of loss and of a mother's grief is enacted in dress contemporary with the painting, in the original viewers' own countryside, all the more universal for being so precisely localised. Empathy with these figures is further heightened, however, by Huber's subtle mastery of perspective, best observed in the foreshortened planks of the bridge. The landscape, the sky – a portion of which must be lost – and the figures are all seen from a single unifying viewpoint, as it were the spectator's, at the eye level of the most upright women, the furthest of whom is gazing at Christ. The boards of this surviving fragment had at some point come apart and had then been misaligned when reassembled. During conservation treatment at the Gallery after the painting's purchase it proved possible to realign them, and also to replace a narrow section, 2.1 cm wide, missing between two boards at the right, making Christ's gesture of blessing easily legible once again.

LORENZO LOTTO (about 1480-1556/7)

The Physician Giovanni Agostino della Torre and his Son, Niccolò 1515

Oil on canvas, 84 x 68 cm NG 699

In life an eccentric and undervalued painter, Lotto remains an awkward customer for the historian of art. Venetian-born and influenced by Giovanni Bellini (page 20), but unable or unwilling to compete with the worldly Titian (page 163) in Venice, he worked in various cities on the Venetian mainland and in the Marches, spending the years 1513 to 1525 in Bergamo and his old age as a lay brother in the Holy House at Loreto. In 1508–9 he was in Rome, and is recorded as being paid for work in the same rooms in the Vatican which Raphael (page 148) was then decorating. The exchange of influence between him and Raphael has always been acknowledged.

Lotto's sympathies for Protestant Reform may have been exaggerated by recent writers, but it is obvious from the works, letters and account-book-cum-diary which have come down to us that he was a committed, if questioning, Christian, sympathetic to popular piety as well as to the more esoteric currents of mysticism agitating Northern Italy. An intellectual painter as well as a troubled character, he developed an individual style which set him apart from his Venetian contemporaries yet did not

place him within Lombard art. His portraits, which are among the most vivid of the Renaissance, are unusually intense in their depiction of character and influenced subsequent Bergamasque painters. Since they are off the beaten track, too few of his daring, beautiful and fervent altarpieces are widely known – although one influenced Rubens's (page 242) first monumental altar painting in Mantua. Devotional works and many portraits are dispersed in museums and galleries around the world.

Like many of Lotto's portraits, this likeness of the sixty-one-year-old physician, Della Torre, and his son identifies the sitters through inscriptions and surrounding objects. The scroll held by the father calls him 'Aesculapius of doctors': Aesculapius was the Greco-Roman god of medicine and healing. The tome in his hand is an edition of 'Galienus', the second-century Greek physician and anatomist Galen, whose authority continued through the Renaissance. Set forthrightly in front of – rather than behind – a table, the doctor presents himself frankly to our gaze, arms symmetrically bent at the elbows, only the slight inclination of his head deviating from strict verticality. Cleanshaven and ashen-faced, he wears a plain grey gown tightly reined in by a leather belt. The orange-brown binding of the book and the chunky gold ring on his finger – which like the belt catches our eye because of its illusionistic three-dimensionality – are the only colours about him. We feel a reticence coupled with professional authority; rarely has a portrait been painted with so little flattery, as if the artist shared the diagnostic eye of the doctor.

The portrait of his son must have been added later, for it spoils the picture's spatial and colouristic structure. He is identified by a letter on the table as a 'Bergamasque noble' and 'exceptional friend'. More lively in colour and personality, altogether more substantial and hirsute, he attracts a different intensity of light: his eyes gleam with reflections absent from his father's. As he crowds forward to the surface of the canvas we wonder whether the disharmony was entirely unintentional, or a comment on relations between fathers and sons and the irreversible passage of time.

LORENZO LOTTO (about 1480-1556/7)

Portrait of a Lady inspired by Lucretia about 1530-3

Oil on canvas, probably transferred from panel, 96 \times 110 cm $\,$ NG 4256 $\,$

Lotto had left Venice by 1532, and this portrait, showier than that of the Bergamasque doctor on the previous page, may not have been painted there. The lady's name was presumably Lucrezia: she points to a drawing of Lucretia, the virtuous Roman matron who was raped by Sextus Tarquinius, son of the king and her husband's kinsman. Unable to endure the dishonour, Lucretia stabbed herself. Her story became a favourite topic of poets – including Shakespeare – and artists in the Renaissance. It combined sex and violence with morality and politics, since Lucretia's suicide and its cause led directly to the foundation of the Roman republic. In case we fail to recognise the reference in the drawing (a nice illusion of ink and wash painted in oils), a paper inscribed in Roman script bears a quotation from Livy's History of Rome (I, 58): 'Nor shall ever unchaste woman live through the example of Lucretia.'

We need not make too much of the inscription. This is Lotto showing off, more than the lady protesting. The wallflower on the table alludes to mythological tales of rape, but the modern Lucrezia wears a wedding ring and the picture may have been commissioned as a marriage portrait. The unusual format – wider than it is high – seems to have been invented by Lotto and Savoldo (page 154) and allows portraiture

the same wealth of incident as other types of painting. Lotto sometimes introduces a landscape behind, or to the side of, the figure. Here, the shadow cast on the wall indicates that the window must be in our space, in front and to the right of the canvas. It is Lucrezia's forceful gesture that enables her to fill the space allotted her. Her head is high in the centre of the picture, but thanks to her action her body is asymmetrical, the asymmetry accentuated by the placing of the immense puffed sleeves. The gaudy green and orange dress – old-fashioned and provincial by 1530 – the turban of false curls on her head, the wonderful gold, ruby and pearl pendant whose many chains she wears tucked in – none of these can compete for our attention with the brilliantly lit and firm flesh of her *décolletage*, which a flimsy gauze scarf shrinks from veiling. Any prospective Tarquin had best beware when *this* Lucrezia proclaims fidelity to her husband.

MARINUS VAN REYMERSWAELE (active 1535-45)

Two Tax Gatherers about 1540

Oil on oak, 92 × 75 cm NG 944

Reymerswaele was a small town in Zeeland in the Netherlands. Marinus is known for a few half-length compositions which he repeated with variations, and which were widely imitated by others. Two or three of these, like the *Tax Gatherers*, of which this is the best variant, may have been satirical in intent and derived through Quinten Massys

(page 132) from the grotesque figures of Leonardo da Vinci (page 56). All may owe something of their intensity and waywardly sharp line to the engravings of Dürer (page 45).

From the legible entries in the ledger in which the man on the left is writing we can tell that he must be a borough or city treasurer composing an account of the municipal revenues from imposts on wine, beer, fish, etc. A 'visbrugge' (a fish market on a bridge) is mentioned and Reymerswaele was one of the few towns to have one. 'Cornelis Danielsz. Schepenen in Rey. . . le' is spelt out on the document above the head of the second man; since a person with this name was recorded in Reymerswaele in 1524, the entry confirms that a local reference was intended.

Some of the coins on the table have also been identified, among them French gold écus of King Francis I and two large silver 'Joachimsthalers of Schlick', struck for the first time in 1519 (indicating the earliest possible date of the picture). It is nevertheless unlikely that Marinus represented an actual scene. Curious illogicalities abound: for example, the pot for the sand needed to blot the ink stands on the shelf instead of on the table. Nor can the figures, dressed in fancifully archaic costumes and cruelly caricatured, be portraits of real tax officials. What is probably intended (for the profession was viewed then much as it is now) is an attack upon covetousness, or perhaps extortion.

ATTRIBUTED TO QUINTEN MASSYS (1465-1530)

A Grotesque Old Woman about 1525

Oil on wood, 64 × 46 cm NG 5769

For those who look to art for beauty, this picture comes as something of a shock. Why would anyone paint something so ugly, and why would people hang it on their wall? Is it a real portrait of a real person? We may never know exactly, but one part of the answer is as surprising as the picture itself: the painting reflects the work of the great Italian master, Leonardo da Vinci (page 56). It is, however, attributed to Ouinten Massys.

The leading painter in Antwerp by 1510, Massys was originally drawn to Early Netherlandish art, notably that of Jan van Eyck (page 46), Robert Campin (page 30) and Rogier van der Weyden (page 94). Perhaps as a result of a trip to Northern Italy, he came into contact with works by Leonardo, whose manner he brought back with him across the Alps. But although Leonardo drew many grotesque faces, he did not base entire paintings on such drawings. Why Massys did so can be explained by his friendship in Antwerp with Erasmus, the leading Northern European scholar of the Renaissance.

A Grotesque Old Woman seems to belong to the world of Erasmus's satire *The Praise of Folly*. It is at any rate one of a number of pictures by or after Massys which point a moral in a cruelly comical way, a kind of painting to be eagerly pursued by Massys's followers in the next generation, above all Marinus van Reymerswaele (page 130). The withered old woman is unsuitably dressed in a low-cut Italianate gown, her hair peeps out from her South German coif. Like the foolish old people mocked by Erasmus, she seems still to wish 'to play the goat'. The painting is related to a drawing after Leonardo now in the Royal Collection, Windsor, although details of the costume differ. Whether Leonardo's original recorded the appearance of a real person, or stemmed from his imagination, we do not know.

In an age when artists sought to ally themselves with writers and preachers, humorous images, like humorous writings, would have seemed a suitable way of persuading people to be wise. But the effects of pictures are more ambiguous than those of speech, and laughter is more culturally conditioned than grief or awe. The *Grotesque Old Woman* seems today more repellent than either funny or persuasive. One modern artist, however, found the perfect setting in which to revive something of its original spirit. The figure, which was later engraved, inspired John Tenniel for his illustrations of the Ugly Duchess in *Alice's Adventures in Wonderland*, first published in 1865.

THE MASTER OF DELFT (active early 16th century)

Scenes from the Passion about 1510

Oil on oak; central panel 98 \times 105 cm, wings 102 \times 50 cm NG 2922.1–3

The unknown painter of this shuttered altarpiece is thought to have worked in the Dutch city of Delft; the tower seen in the background at the left of the centre panel is recognisably that of the New Church at Delft as it was after its completion in 1496 and before alterations in 1536. The full story of the Passion of Christ is depicted. Incidents from all four Gospels and from devotional literature are shown almost as if they were happening before the eyes of a contemporary audience witnessing one of the perambulating miracle plays of the time. Just as they would have been in such a performance, most of the costumes are modern, while others, such as those of the two children in the foreground of the central panel, appear fancifully Greco-Roman. The weeping woman nearest us in the left panel wears a medieval Burgundian headdress. A contemporary portrait of a tonsured monk in a white habit is included in the central panel at the right-hand side of the swooning Virgin. He is the donor of the altarpiece who may have instigated the commission; kneeling in prayer, he is not watching the events depicted but meditating upon them.

The artist has cunningly deployed narrative, in which characters reappear in different episodes, within a spacious, seemingly unified landscape, and has combined storytelling with the static image of the crucified Christ, a reminder of the sacramental function of the altar table behind which the triptych originally stood. Christ is at the very centre of the central panel, silhouetted against the sky, and the only one of the three crucified figures to be represented frontally.

The main subject in the left wing is the Presentation of Christ to the People. Pilate is probably the figure with the reed sceptre to the extreme left. In the background, the two thieves are being led out of the city gate towards Calvary. The procession, this time with Christ carrying the cross, reappears in the background of the centre panel. Above the procession, Judas is hanging from a withered tree (the paint has become translucent

with age, and the cliff shows through); to his right, the Virgin reappears, supported by Saint John and three Holy Women. Further still in the background to the right, Christ kneels in the Agony in the Garden, and below him the soldiers march to capture him. In the foreground, at the foot of the cross, Longinus holds the lance with which he will pierce the side of Christ, while Mary Magdalene weeps. Pilate, now on horseback, witnesses the Crucifixion.

The right wing centres on the Deposition. Christ is being taken down from the cross for burial. Once again he appears in full-face view, and once more we are invited to grieve with the Virgin in the foreground. This repeated direct appeal underlines the emphasis, growing throughout the fifteenth century both north and south of the Alps, on seeking an emotional response from the believer.

MICHELANGELO (1475-1564)

The Entombment about 1500-1

Oil on poplar, 162 x 150 cm NG 790

Sculptor, architect, painter and poet, Michelangelo Buonarroti has always been viewed as the towering genius of Italian sixteenth-century art. Although his most influential works were made for the popes in Rome, he represents the culmination of the Florentine tradition centred on drawing (disegno) and focused on the human figure. Disegno as the fundamental principle of Tuscan art – and of academic practice since

Michelangelo's day – means much more than our words 'drawing' and 'design'. It implies the entire process of artistic creation, viewed as continuous from the first imaginative impulse, through endless studies involving both good judgement and dexterity, to the final composition. As Michelangelo perfected it, disegno is a sublime kind of problem-solving, and the work of art an ideal solution, reconciling the often conflicting demands of function, site, material and subject, verisimilitude, expressivity and formal beauty, unity and variety, freedom and restraint, invention and respect for tradition. Vasari writes of Michelangelo's Sistine Chapel ceiling: '...painters no longer need to seek new inventions, novel attitudes, clothed figures, fresh ways of expression, different arrangements, or sublime subjects, for this work contains every perfection possible under those headings. In the nudes, Michelangelo displayed complete mastery...'

Paintings on panel by Michelangelo are exceedingly rare. Only the *Doni Tondo* (now in the Uffizi, Florence), a meticulously finished circular picture representing the Holy Family, is documented. Most scholars, however, now believe that the poignant *Entombment* in the National Gallery is the altarpiece known to have been begun by Michelangelo in September 1500 for a funerary chapel in the church of Sant'Agostino in Rome and abandoned when he left for Florence in spring 1501. At this date the young artist had no experience of painting on this scale, and he approached the challenge with moving originality. The theme of Christ's body being lifted up, prior to being carried to the tomb, is combined with the motif of the dead Christ presented to the viewer for pious meditation. The composition was fully worked out before painting began, and the landscape background laid in around the blocked-in figures. The outline of the white silhouette of the tomb and the small figures around it, however,

was reinforced by scraping or pushing away the still wet brown paint of the rocks – the technique of a sculptor accustomed to chipping away material rather than adding it. The greenish tinge of Christ's body was traditional for depicting dead flesh, although no green pigment is used. This portion of the painting is most nearly complete. Even at this late stage, however, Michelangelo still omits the wounds in Christ's hands, feet and side.

Christ is supported on his right by Saint John the Evangelist in his canonical red gown (see also, for example, page 79). The second bearer may be one of the three Maries. Her robe was intended to be a deep green, but has turned brown with the effects of age and exposure on surface glazes of copper resinate. A drawing from the nude model (now in the Louvre, Paris) for the figure kneeling below Saint John, probably another Mary, shows her meditating on the crown of thorns and the nails of the Crucifixion. The missing figure on the right was to be the Virgin Mary mourning her son. This area may have been left completely untouched because it required ultramarine made from imported lapis lazuli for the Virgin's blue cloak. Michelangelo was perhaps waiting for delivery of this rare and costly pigment when he was called away to Florence.

MICHELANGELO (1475-1564)

The Virgin and Child with Saint John and Angels ('The Manchester Madonna') about 1497

Tempera, with some oil, on poplar, 105 x 76 cm NG 809

This picture, documented only from 1700, is almost certainly an unfinished devotional painting by the young Michelangelo. Its title the 'Manchester Madonna' derives from the picture having been included in the spectacular Art Treasures exhibition held in Manchester in 1857. Unlike the somewhat later Entombment, it is painted predominantly in egg tempera. Michelangelo used minute hatched brushstrokes of paint to create an alabaster-smooth surface, as in the bodies of the Christ Child and the infant John the Baptist. The final coat of blue was never applied to the black modelling of the Virgin's cloak, and the flesh of the unfinished angels on the Virgin's right is merely underpainted in traditional green earth colour, enabling us to appreciate Michelangelo's uncanny mastery of line – for it is through contour alone that we experience these figures as having volume and weight. They are contemplating the book held by the

Virgin, while the other adolescent angels study a scroll perhaps given them by Saint John. The Christ Child has stopped suckling and slipped off the Virgin's lap, perhaps the better to see her book. She may be reading the Old Testament prophecy of her own role in the story of Salvation, 'Behold, a virgin shall conceive, and bear a son...' (Isaiah 7:14); the Baptist's scroll normally predicts the coming sacrifice of Christ, 'Behold the Lamb of God, which taketh away the sin of the world' (John 1:29).

It is unusual at this late date to show Mary with her breast bared. Michelangelo's earliest known work, the marble relief of the Madonna of the Stairs (now in the Casa Buonarroti, Florence), also took up the medieval motif of the Virgin nursing the Child, but there is no exact precedent for the present scene. At a time when wealthy ladies employed wet-nurses, however, great importance was attached to the Virgin having herself breastfed Jesus, and her milk was understood symbolically as the sustenance of the Christian soul. Identified in the Christian East with Sofia, Holy Wisdom, the Virgin was pictured as suckling the apostles Peter and Paul. Her bared breasts had also come to represent her intercession on behalf of humankind, by analogy with the dramatic gesture of the Trojan Queen Hecuba in Homer's Iliad, when she implores her ill-fated son Hector not to fight Achilles. Thus Mary is sometimes depicted baring her breasts at the Last Judgement. Legends of the healing power of her milk were legion. Here, as with one breast still bared she gazes pensively at her son, all these associations seem apt. On her rocky pedestal Mary appears as Queen of the Angels and Mother of God, Throne of Wisdom, nurse, intercessor and healer.

The picture excludes all extraneous elements. In its grave rhythms – angel heads in profile enclosing the full-faced angels and Virgin, the infants like a single figure turning on its axis, legs alternating with drapery – it appears more relief than painting, a poignant forerunner of a long series of Michelangelo's unfinished works in stone.

MORETTO DA BRESCIA (about 1498-1554)

Portrait of a Gentleman 1526

Oil on canvas, 201 x 92 cm NG 1025

Brescia, an ancient town at the southernmost edge of the foothills of the Alps, was once part of the Duchy of Milan but had been ruled by the more liberal Republic of Venice since 1426. It was occupied by the French in 1509, rebelled in 1512 and was retaken and sacked, returning to Venice only in 1516. Alessandro Bonvicino, called Moretto, a native of Brescia, must – like the unknown gentleman in this portrait – have lived through these bloody events. With Savoldo (page 154), Romanino (also represented in the National Gallery but not included here) and, for a time, his own pupil Moroni (page 140), Moretto was one of the leading painters of the town, known especially for his religious pictures. Executed for patrons mainly associated with the Catholic Reformation, they are notable for their clear and explicit doctrinal content and the hypnotic power of their realism, often expressed through everyday settings and low-life models as well as through the minute depiction of surface detail. Some of his devotional images are harrowing in their description of the physical and emotional effects of Christ's torments – a Lombard version of that unflinching German realism intended to evoke the maximum of empathy from the viewer.

This work is of a very different kind: one of Moretto's comparatively rare aristocratic portraits. Although influenced by German pictures in its early adoption of the full-length life-size format popularised by Cranach (page 112) and adopted by Holbein

(page 122), it is more indebted to Venetian painting. Moretto was said to have studied with Titian (page 163), and must have known the poetic works of Giorgione (page 116). He was certainly also aware of Lotto (page 128), who worked for a while in nearby Bergamo. The painting owes something to all of them, notably in its sitter's melancholy expression as he gazes abstractedly beyond the marble loggia of a Renaissance villa. He may have been a member of the Avogadro family of Brescia, for the portrait comes from the palace of direct descendants. Genealogical research suggests that he was Gerolamo II Avogadro, the father of Moroni's 'Knight of the Wounded Foot' (page 142).

Although allied to Venice, the aristocracy of Brescia clung to the ideals of its political enemies, specifically the dream of a united Christendom under the rule of the Holy Roman Emperor (who was also the elective monarch of the German principalities). The sitter's appearance apes the military style of imperial Swiss mercenaries and German soldiers: short hair, a beard, the cap under the red beret of Brescian wool – the

wearing of which was compulsory to protect its local manufacture. Like other VIPs of Spanish-dominated Europe in the early sixteenth century, he wears bouffant slashed trunks and a slashed doublet. The short cape expands his silhouette to give it bulk, so that it extends beyond the edges of the picture, and his shoes are wide at the toes. (When Moroni painted the 'Knight of the Wounded Foot' some thirty years later, fashion favoured an elongated and slender outline.) He leans against a column which appears here, for the first time in a secular portrait, in its traditional role as a symbol of fortitude. The effect is beautiful, curious – and I occasionally think faintly risible: a gentleman undecided between acting the bravo or the poet.

GIOVANNI BATTISTA MORONI (1520/4–1578) Portrait of a Man ('The Tailor') about 1570

Oil on canvas, 98 × 75 cm NG 697

An artist particularly admired by English collectors and superbly represented in the National Gallery, Moroni was born in Albino, in the foothills of the Alps. The neighbouring towns of Brescia – home of his teacher Moretto (page 138) – and Bergamo, where Moroni worked from 1554, were situated in a frontier region between Milan and Venice, Central Italy and Southern Germany. We first encounter Moroni in 1546 in

Trent, painting altarpieces during the initial session of the Council convoked there to heal and reform the Church. When the Council of Trent closed in 1563, it had, however, formalised the rift between Catholics and Protestants. Moretto, deeply responsive to the injunctions of the Council, followed its prescriptions of doctrinal Catholic orthodoxy, clarity and realism in religious art. Throughout his life Moroni modelled his religious paintings on those of Moretto. But his real talent lay elsewhere, and it is as a portrait specialist that we prize him today.

Like Moretto's earlier likenesses of Brescian noblemen sympathetic to the Holy Roman Emperor and Titian's portraits of the Emperor and others, early aristocratic portraits by Moroni use the full-length, life-size format. By the 1570s, however, the fashion for portraiture had spread from nobles to the professional classes. Yet this sober and sympathetic depiction of a tailor at his work remains unique. It has been plausibly suggested that Moroni executed the painting in exchange for services rendered – perhaps a suit in that fashionable Spanish black cloth proffered by the tailor. The tailor wears a less stylish costume of red and buff, albeit with a Spanish ruff.

The realism of the painting, dispassionately even-handed in its description of objects, details of costume, physiognomy and expression, should not blind us to its artful geometric structure. The three-quarter-length format is justified by the table. Instead of creating the usual barrier between sitter and spectator, it forges a friendly link between them through the angle at which it is set, and because of the unaffected way it enables the tailor to pause before cutting his cloth in order to address the viewer. Were we to draw a vertical line dividing the picture in half, we would find that it coincides with the line – defined by his costume – bisecting the sitter's body. Our same imaginary line just touches the outer corner of the tailor's right eye, as he raises his head to look directly at us. With its prominent catchlight also helping to attract our attention, this eye becomes the expressive focal point of the painting. Pictorial geometry is subtly used by Moroni to reinforce our sense of shared humanity – with, in this case, a humble tailor. In the words of a seventeenth-century admirer, the artist succeeds in making him 'speak more eloquently than if he were a lawyer'.

GIOVANNI BATTISTA MORONI (1520/4-1578)

Portrait of a Gentleman ('Il Cavaliere dal Piede Ferito') probably about 1555

Oil on canvas, 202 x 106 cm NG 1022

The subject of this haunting portrait may have been the son of the Brescian gentleman painted by Moretto in 1526 (page 139). That he was a soldier is apparent from the shiny pieces of plate armour (of local manufacture) at his feet and from his costume of leather doublet, chain mail, under-doublet of black satin and the plain white linen collar of the shirt worn beneath. (The long sword is less a military appurtenance than a badge of nobility.) His legs are encased in black trunks and hose; he wears a brace to correct the weakening of the muscles of his left ankle, a condition known as 'drop-foot', caused either by disease or a wound. His Italian nickname, 'Knight of the Wounded Foot', refers to this. Standing firm with legs wide apart, he leans lightly on a magnificent jousting helmet crested with ostrich plumes and surmounted by a red disc, carved with the sun's face, from which rises a rare and costly osprey feather. Less extravagant ostrich plumes curl on his black velvet cap.

Like many of Moroni's sitters, the *cavaliere* is posed against a shallow light-coloured background of marble and part-ruined stone to which ivy, emblem of fidelity, clings

and from which seedlings sprout. The background serves many functions: it justifies the semblance of outdoor light while keeping our attention from wandering off through a distant landscape; it sets off the sitter's slender silhouette with its complex outline; its neutral tone combines and echoes the hard colours of costume and helmet, and the matt surface provides a foil for the whole range of textures in the sitter's dress, armour, flesh and hair; it provides a geometric grid within which the figure is firmly anchored; and it furnishes a ledge on which to place the helmet and give the sitter something to do with his left arm, motivating the hand's negligently elegant gesture. Finally, the eroded architecture suggests endurance, a metaphor for the knight himself.

The unsparing way in which Moroni depicts the crippled foot has been related to the precepts of the Council of Trent, which had urged realism in religious art. It is probably more accurate, however, to perceive conciliar ideals behind the portrait's nostalgic neo-feudal imagery. The cult of chivalry to which it alludes was widespread among the

international-minded supporters – in Brescia and Bergamo as elsewhere – of the Holy Roman Emperor Charles V, whose vision of a united Christendom first prompted the convocation of a general church council. The haughty melancholy of the Knight of the Wounded Foot also echoes the austere manners which became fashionable throughout Europe under Spanish influence, like the black cloth being cut by Moroni's more plebeian tailor (page 140).

PARMIGIANINO (1503-1540)

The Madonna and Child with Saints John the Baptist and Jerome 1526-7

Oil on poplar, 343 × 149 cm NG 33

Like Correggio (page 109), who was the greatest early influence on him, Parmigianino is called after his place of birth, the Northern Italian city of Parma (to the French he is *Le Parmesan*, like the famous cheese from the same locality). His real name was Girolamo Francesco Maria Mazzola.

Brilliantly precocious, the young Parmigianino, brought up after his father's early death by two painter uncles, determined to go to Rome. Among the samples of his skill which he presented to Pope Clement VIII in 1524 was an astonishing self portrait, now in the Kunsthistorisches Museum in Vienna, recording his appearance in a convex barber's mirror. He studied, Vasari tells us, 'the ancient and modern works [in Rome]... but he held in supreme veneration especially those of Michelangelo Buonarroti and Raphael of Urbino' (pages 134 and 148). 'Indeed,' continues Vasari, 'it was said later that the spirit of Raphael [who had died in 1520] had entered into the body of Francesco...'

Parmigianino's triple artistic inheritance is clearly discernible in this altarpiece, the greatest work he executed in Rome. Although commissioned by Maria Bufolina for a burial chapel in a Roman church, San Salvatore in Lauro, it was later moved to the parish church of Città di Castello. The pope's plans to employ the young prodigy foundered in the wake of that most terrible event, the Sack of Rome by imperial troops. According to Vasari, Parmigianino was 'intent on the frenzy of working' on this picture, when noisy German soldiers irrupted into his chamber: '...seeing him [and] stupefied at this work...they let him pursue it.' Parmigianino's 'frenzy' was, however, the fruit of innumerable drawings both for the whole composition and for individual figures. The effect would have been even more powerful in the originally intended location, for which he must have been given precise instructions. These would have specified not only the unusually elongated format but also the source of natural light from a high window to the right of the altar. Following Italian tradition, Parmigianino reproduces its effects in painted light, so that in a darkened church the Baptist's right arm would seem not only to curve upwards towards the Christ Child but also outwards from the painting, 'catching the light', and his left foot to protrude from the panel. Even more daringly, the Child, from his mother's lap above and behind Saint John, bobs up to the picture's surface and kicks his left foot mischievously into our space.

A second, miraculous illumination 'clothes' the Madonna 'with the sun' like the Woman in Revelation (12:1), under whose feet the moon also appeared, and shines on the Baptist's reed cross, his left shoulder and foot, and on Saint Jerome, exhausted from his vigils, lying in steep foreshortening in the wilderness. The name given to the painting in the nineteenth century, *The Vision of Saint Jerome*, originates in his pose. But the altarpiece illustrates no such narrative. When facing the compositional problem of fitting in two saints on either side of the Virgin and Child within a tall but very

narrow panel, Parmigianino – after much trial and error – looked to Correggio for a dynamic solution based on figures set obliquely in deep space. Raphael's *Madonna of Foligno*, then on the high altar of Santa Maria in Aracoeli in Rome (now in the Vatican), would have suggested the horizontal division of the picture in two, Saint John's gesture and the open heavens. The types and poses of the Virgin and Child originate with Michelangelo, tempered with Raphaelesque grace. But the tempestuous drama of the whole is Parmigianino's own.

ATTRIBUTED TO THE WORKSHOP OF JOACHIM PATINIR

(active 1515 to about 1524)

Saint Jerome in a Rocky Landscape 1515-24

Oil on oak, 36 x 34 cm NG 4826

Patinir came to Antwerp, where he is recorded as a master in the painters' guild in 1515, from a town in the Meuse River valley. His landscapes were praised by the great German artist Dürer (page 45), who attended Patinir's second wedding in the course of a trip to the Netherlands.

During his brief and ill-documented career, Patinir became the first landscape specialist of the modern era. Since the Dark Ages no painter had worked exclusively to represent landscape, and even in antiquity no one had done quite what Patinir was to do: paint panoramas seen from on high as if by a bird or by the eye of God. The human scale – which ensures that these small pictures seem to encompass huge vistas – is established by little figures of hermit saints, or the Holy Family fleeing to Egypt, or Christ being baptised.

We have very few pictures securely by Patinir's hand – even this one can only be attributed to his workshop – but his imitators and followers have been legion. At a

time when seamanship, and its related science of map-making, were opening up the globe to exploration, Patinir opened the way to new modes of imagining.

Saint Jerome sits under a lean-to near a natural rock arch, taking a thorn out of his lion's paw. Our eye travels to a hill town (more accurately, a monastery complex), valleys, woods, mountains, fortresses, farmhouses, fields, the sea, the high horizon, sky; light and dark areas are layered in quick succession, occasionally interpenetrating. As in many of Patinir's pictures, the solid volumes of crags are flanked by avenues into distant space (the picture was cut down on the right, restricting the open view). The sense of recession is aided by a colour scheme which we can still identify in the panoramic landscapes of Rubens (page 242): a predominant brown in the foreground yields to green in the middle ground, which turns to blue in the background. But even the artists in Patinir's workshop are too practised to divide up the panel into discrete strips; so, for example, Jerome's tunic brings the blue of the sea down to the bottom and front of the picture.

On the plateau behind the saint unfolds the story of his lion as related in the thirteenth-century compendium of miraculous tales, *The Golden Legend*. Charged with looking after the monastery ass, the lion fell asleep. The ass was stolen by some merchants passing with a caravan, and the lion accused of having eaten him. When the merchants returned again, the lion recognised the ass and carried him off with camels and baggage to the monastery, where the thieves knelt to beg the pardon of the abbot. It adds to the pleasure of our voyage of discovery to realise that the epic grandeur of the rocks that frame this story must have been studied from stones brought into the workshop – as if the Creator of the world was revealed to be but a child playing with its toy garden.

JACOPO PONTORMO (1494–1557)

Joseph with Jacob in Egypt 1518?

Oil on wood, 96 x 109 cm NG 1131

The 'strange and shy' Jacopo Carrucci from Pontormo near Florence was not as rebellious an artist as he may appear from this picture. His style is a logical summation of the Florentine tradition, and assimilates the latest developments of Michelangelo (page 134) as well as Andrea del Sarto's (page 153) interest in Northern European prints. (The gabled gateway in the background is borrowed from just such an exotic import: an engraving by Lucas van Leyden dated 1510.) The picture is not 'anti-naturalistic', but 'non-naturalistic': it belongs in the tradition of furniture painting, not the window on the world of large-scale 'history painting', but a brilliant surface embellishment combined with continuous narrative like a comic strip. It originally formed part of a famous scheme of bedroom decoration – painted panels set into the wall, seats, storage chests and a bed – illustrating the story of Joseph from Genesis, the first Book of the Old Testament.

Four Florentine artists, Andrea del Sarto, Granacci, Pontormo and Bacchiacca, collaborated on the project. The National Gallery owns two of Bacchiacca's panels and all four of Pontormo's; other parts of the scheme are in galleries in Florence, Rome and Berlin. The decoration was said by Vasari to have been commissioned by Salvi Borgherini on the occasion of the wedding in 1515 of his son Pierfrancesco (probably the donor of Sebastiano del Piombo's *Madonna and Child*, page 158) and Margherita Acciaiuoli.

The story of Joseph was in fashion at the time for the decoration of furniture, and seems particularly suitable for Pierfrancesco Borgherini, a banker commuting between Florence and Rome. Joseph's commercial success in a foreign land, and his generosity,

forgiveness and family feeling, were clearly apt examples. The dreams which Joseph interprets make his story appropriate to a bedchamber, as do the more serious subjects of adultery, chastity and the fruitful outcome of marriage. Even the theme of the coat of many colours lends itself to the decoration of a room in which clothes were stored in painted chests. Finally, Joseph was seen as an Old Testament forerunner of Christ, the Saviour of the World, who presided over the room in a circular painting of the Trinity by Granacci.

All of Pontormo's panels are hauntingly beautiful in colour and design, but this one, larger than the others, the last executed and perhaps commissioned as an afterthought, has always been singled out for praise. Joseph - dressed in a golden-brown tunic, lavender cloak and scarlet cap - appears four times. In the right foreground, as governor of Egypt, he is seated on Pharaoh's 'second chariot' and listens to a petition from the leader of the victims of famine seen in the background. On the left he presents his old father Jacob to Pharaoh; Pontormo poignantly includes Joseph's mother Rachel, whom the Bible does not mention as having been present. He reappears on the winding staircase with one of his sons, while the other is welcomed by a woman on the landing. In the round bedchamber, Joseph presents his children for the dying Jacob's blessing - a scene diagonally counterpoised with the presentation of his parents to Pharaoh (underdrawings reveal that Pontormo had originally planned to include it in the painting's top left-hand corner). Vasari tells us that the boy in modern clothes, seated in the foreground holding a shopping bag, is Pontormo's pupil, Bronzino (page 106), 'a figure so alive and beautiful it is a marvel'. And troubled though Vasari is by the picture's small scale, he writes that it is not possible to see another painting made 'with such grace, perfection and excellence' as this panel.

RAPHAEL (1483-1520)

Saint Catherine of Alexandria about 1507-8

Oil on wood, 72 x 56 cm NG 168

Younger than either Leonardo (page 56) or Michelangelo (page 134), Raphael is associated with them in creating what we now call the High Renaissance style, based on drawing from life tempered by the study of Ancient Greco-Roman art and the search for ideal beauty. More prolific than Leonardo, more suave and less exclusively obsessed with the human form than Michelangelo, personable, a rapid learner and an excellent organiser, Raphael was to suffer none of the professional setbacks which marked the careers of the two great Florentines.

Born in Urbino, where his father, Giovanni Santi, was a poet and artist associated with the ducal court, he became an assistant to the Umbrian painter Perugino (page 80), who so influenced him that Raphael's early works can hardly be distinguished from the older artist's. He is documented as an independent master in 1500. After some years

during which, based in Florence, he worked throughout Tuscany and Umbria, he was summoned to the Vatican in 1508 to assist with the redecoration of the papal apartments for Julius II; they were to be completed for Leo X. He rapidly became the supreme artist of Rome, rivalled only by Michelangelo. Many great Italian artists trained in his workshop, and his frescoes, easel paintings and architectural projects inspired the ideals of many generations.

One of the greatest draughtsmen in Western art, Raphael built up a composition step by step from rough 'idea' sketches, through studies from life, to finished 'cartoon' for transferral to panel, canvas or wall. For this unusually well-preserved painting there exists a cartoon (not slavishly followed), sketches for the pose of Saint Catherine and a detailed study for her neck.

Halfway between a work of private devotion and a collector's piece, this picture was probably painted just before Raphael's move to Rome. Rather more evident than the influence of Perugino is that of Leonardo, who perfected the 'serpentine' pose in which the body twists about its axis, lending movement, grace and three-dimensional presence even to static figures. Characteristically, Raphael justifies this unnatural position through a narrative device: Catherine turns her head upwards and to her right. in ecstatic communion with the divine light descending in thin gold rays from the sky. She is supported by one of the wheels between which she was condemned to be torn to pieces; instead of the cruel spikes of legend. Raphael has set its rim with studs. The perspective and modelling of the wheel help to define the space within which Catherine voluptuously turns, wound about by the yellow lining of her red cloak, which is twisted into a golden spiral below the grey-blue of her dress and folded over her left shoulder, where it is met by a transparent gauze scarf. These firmly defined areas of colour, unaffected by reflections, clarify her anatomy without jeopardising the semblance of a pliant whole unfurling to absorb the radiance falling from heaven. But these same tones of grey-blue, olive-green, gold and red are softly stroked throughout the landscape behind her, uniting figure and background – as if, standing among the flowers (the dandelion is a symbol of Christ's Passion), the saint were a distillation of all the colours of nature.

RAPHAEL (1483-1520)

The Madonna and Child with Saint John the Baptist and Saint Nicholas of Bari ('The Ansidei Madonna') 1505

Oil on poplar, 210 x 149 cm NG 1171

This altarpiece, of a type known as *sacra conversazione* (Italian for 'holy conversation'), in which the enthroned Virgin and Child and their attendant saints seem to commune together, was commissioned by Bernardino Ansidei for his family chapel in a Perugian church. The chapel was dedicated to Saint Nicholas of Bari, and the bishop saint is shown with his attribute of three golden balls (the origin of pawnbrokers' signs) representing the bags of gold he donated as dowries to three poor girls. John the Baptist, who foretold the coming of Christ and baptised him, wears the camel tunic of his desert sojourn and a crimson prophet's cloak. Instead of his usual reed cross, he holds a wonderfully transparent cross of crystal. Pointing to the Child on the Virgin's lap, he looks up gravely to the Latin inscription above her, 'Hail, Mother of Christ'. Beads of scarlet coral, a common charm against evil, the colour of Christ's blood, hang from the canopy. The vaulted niche open onto the luminous Umbrian countryside was designed to seem continuous with the actual architecture of the chapel.

Other than to note Raphael's continued debt to Perugino (page 80), I had not looked particularly closely at this painting until one day I accidentally projected a slide of it back to front. Suddenly the figures lurched sideways almost out of the frame (the effect can be replicated by holding the illustration up to a mirror). Only then did I become aware of how subtly Raphael (unlike Perugino) varied the symmetrical arrangement, echoing the arched top of the panel and leading us to 'read' the picture circularly from left to right. Saint John's outstretched right leg and the shadow of the throne suggest the segment of an arc inscribed within the rectangular lower edge,

simultaneously leading us into three-dimensional space. John's head, tilted back and sideways in difficult foreshortening, the angle of his crystal cross, the inclined heads of Virgin, Child and Saint Nicholas (all of these poses, as was second nature to Raphael, psychologically and almost narratively justified) set up a series of parallel diagonals. But this rightward movement is counteracted in the painting through the line of Nicholas's crozier, the weighty curve of his dark green cope and the vertical drop of its red lining. His downcast glance as he reads his book redirects our own gaze to complete the implied downward circle and look upwards again with Saint John, reinforcing our sense of the holy personages sharing the same endless meditation as well as the same bright space. The scene is lit from two directions. Daylight from the opening in the background illuminates the cool grey stone of the niche. From above the painting and to its right, as from an actual chapel window above our heads, brighter light shines on the figures and the throne, drawing us even closer into Raphael's limpid universe.

One of the three predella panels for this altarpiece survives and is also in the National Gallery, *Saint John the Baptist Preaching*, which must have been placed to the left, beneath the figure of the saint. Below the Virgin and Child there was once a scene of the *Marriage of the Virgin*, and *Saint Nicholas saving the Lives of Seafarers* originally supported Nicholas's image on the right.

RAPHAEL (1483-1520) **Pope Julius II** 1511-12

Oil on wood, 108 x 81 cm NG 27

Thirty years after Raphael's death, Vasari wrote of this portrait of Julius II: 'it was so lifelike and true it frightened everyone who saw it, as if it were the living man himself." Indeed, a viewer coming into its presence would have been immediately aware of standing before someone of higher rank, seated in an armchair adorned with his own personal emblem, the acorn (Julius's family name was della Rovere, the Italian word for 'oak'). The painting has been so influential, its composition so widely copied, that today its novelty may escape us. Frontal views of enthroned rulers had long served as emblems of sovereignty, in every medium from seals and coins to paintings of the Virgin or Christ in Majesty. But Raphael does not confront us with a rigid icon of a seated pope wearing the triple crown; he allows us a close view, at an angle, of a thoughtful old prelate in a fur-trimmed cap - a view such as might be granted to an intimate coming not before the pope but standing at his side. Yet something of the formal scheme remains, for the pope's head is in the centre of the painting's width, if not centred between the arms of the chair, and that line is emphasised down to the handkerchief in his hand. It was the conflation of ceremonial significance and intimacy which was so startling, combined with Raphael's ability to define the inner structure of things along with their outer texture. A Netherlandish artist might have captured the reflections from the window and from the pope's crimson cap in the golden acorn, or differentiated between the white of hair, fur and cloth - but few, if any, could have defined the planes of the forehead as it turns from light to shadow at the temple, or foreshortened the pope's left hand gripping the arm of the chair.

Raphael's technique is also less graphic than a Northerner's, more reminiscent of Venetian painterliness, as is the colour harmony of red and green, white and gold. The pattern of papal keys and tiaras just visible in the green curtain was originally painted gold to simulate embroidery, and the artist's change of mind, disclosed when the

painting was scientifically assessed in 1969 prior to cleaning, is one of the main reasons for its acceptance as the original of several versions of the portrait.

The picture can be dated by Julius's beard, which he grew as a token of mortification at having lost the city of Bologna in 1511 and had shaved off by March 1512. He was to die at 70 the following year. A choleric and active man, much criticised during his turbulent pontificate for personally leading his troops in strenuous military campaigns, he is represented as at once forceful (as in the left hand), aristocratic (the right hand) and meditative. The portrait is in every way worthy of a patron unique in the history of art, a pope discerning and fortunate enough to have been served by three of the greatest artists of the High Renaissance – the architect Bramante, Michelangelo and Raphael.

ANDREA DEL SARTO (1486-1530)

Portrait of a Young Man about 1517

Oil on canvas, 72 x 57 cm NG 690

Andrea the Tailor's son ('del Sarto') became the leading painter in Florence from about 1510, after the departure of Leonardo, Michelangelo and Raphael (pages 56, 134, 148). Trained first as a goldsmith then as a painter, under Raffaelino del Garbo and Piero di Cosimo (page 81), like all Florentines he sought to learn from his most celebrated predecessors. In particular, he 'reworked' the art of Leonardo, emulating the spiral fluidity of the older artist's figure poses and adopting his famous *sfumato* – blurred and veiled transitions – while rejecting his monochrome modelling to replace it with melting colour, luminous even in the shadows.

Andrea del Sarto is among the most influential and copied of Tuscan artists, and all the important Florentine painters of the next generation served in his workshop. Although he was renowned in the eighteenth and nineteenth centuries (Robert Browning made him the subject of a dramatic monologue, subtitled *The Faultless Painter* after a phrase of Vasari's), his fame has been eclipsed in our own day by the growth of interest in Mannerist painters like his pupil Pontormo (page 146). The recent restoration of Andrea's majestic frescoes in Florence, however, and an exhibition there of

cleaned canvases and panels on the quincentenary of his birth in 1986, demonstrated once again the inventiveness and strength of his draughtsmanship, the elevated yet humane sentiment and the colouristic splendour of his painting. Because Andrea's colour is so subtle, relying on harmonies of pale smoky greys, browns, apricot and rose, shot draperies of gold and pink or blue and mauve, contrasted in the grander or more decorative pictures with flourishes of vermilion and green-blue azurite, it is especially vulnerable to distortion through dirt or yellowed varnish.

The subject of this famous portrait, an unknown young man looking up from his book, unlike the celestial apparitions of Andrea's altarpieces admits only the subdued hues of reality. Yet even here subtlety is played off against boldness. Daylight enters as if through a high and narrow window on our left. Brilliant on the gathered shirt, reflections from which define the curve of the jaw and the twist of the neck, it casts deep shadows on the eye sockets, smoulders in the dark eyes, shapes the skull under the triangular hat, lends mobility and colour to the distinctive features, bulk to the freely painted taffeta sleeve; it sheds light on the ill-defined page before dissipating itself in the stern gloom of a Florentine studio. The twisting pose is at once momentary and stable. Impetuous, the young man will soon turn back to his reading. Yet we remain, as generations have done before us, rapt in front of this most eloquent stranger, waiting to hear him speak.

GIAN GIROLAMO SAVOLDO (active 1506 to 1548)

Saint Mary Magdalene approaching the Sepulchre about 1530

Oil on canvas, 86 x 79 cm NG 1031

Savoldo came from Brescia (see page 138), but is first recorded in 1508 in Florence. From around 1520 he was mainly resident in Venice except for a period in Milan in 1532–4. We know little about his training but he must have looked closely at Netherlandish pictures, and also at Leonardo (page 56) and Giorgione (page 116). The few paintings by him are mainly of single figures in half or three-quarter length against a distant background. There are four variants of this composition.

The magic of this work – half devotional image, half collector's piece – resides in the contrast between the disproportionately massive figure, boldly outlined, and the minutely recorded subtleties of light. The subject refers to the episode in the Gospel of Saint John (20:1) when Mary Magdalene came to the sepulchre where the body of Christ had been laid and found that the stone had been taken away from the entrance. Her identifying jar of 'very precious ointment' is set on the ledge of the tomb behind her. But the sepulchre of Christ has moved from the Holy Land to Venice, seen across the lagoon; perhaps we are on the melancholy cemetery island of San Michele. In 1620 this version of the picture was described as 'a beautiful Magdalen covered in a white drapery': the shimmering silver of her cloak is the colour of night reflected on white satin, as the invisible sun flares up in the clouds behind. The directness of her mysterious glance, the rustling of her cloak so near us, evoke echoes beyond John's text. In legend if not in the Gospels she is identified with the prostitute who with her long hair anointed Jesus' feet, whose 'sins, which are many, are forgiven; for she loved much' (Luke 7:47), and with the 'woman taken in adultery' whom Jesus saved from stoning (John 8:3–11). She wept at the foot of the cross, and anointed Christ's body to prepare it for burial. It is she to whom he will first miraculously appear in the guise of a gardener (see page 165) and it is she who will end her days in the desert clothed only in

her flowing long hair, perpetually fasting, refreshed by angels with celestial food. Now, hair covered, jewels given away, the great penitent, emblem of human love and divine forgiveness, seems to beckon us to follow, poised between the darkness of the tomb and the dawning of the light.

SEBASTIANO DEL PIOMBO (about 1485-1547)

The Raising of Lazarus about 1517-19

Oil on wood, transferred to canvas, remounted on synthetic panel, 381×289 cm $\,$ NG 1

In 1510, with his master Giorgione (page 116) dead and Titian (page 163) working in Padua, young Sebastiano Luciani was the leading painter in Venice. His career changed abruptly when in 1511 the pope's banker, Agostino Chigi, persuaded him to join in the decoration of his suburban villa (now Villa Farnesina) in Rome. Soon the youthful Venetian, 'il Veneziano', was being befriended by the Florentine Michelangelo (page 134) and supplied by him with compositional drawings. In this way Sebastiano became the cat's paw in Michelangelo's bitter rivalry with Raphael (page 148).

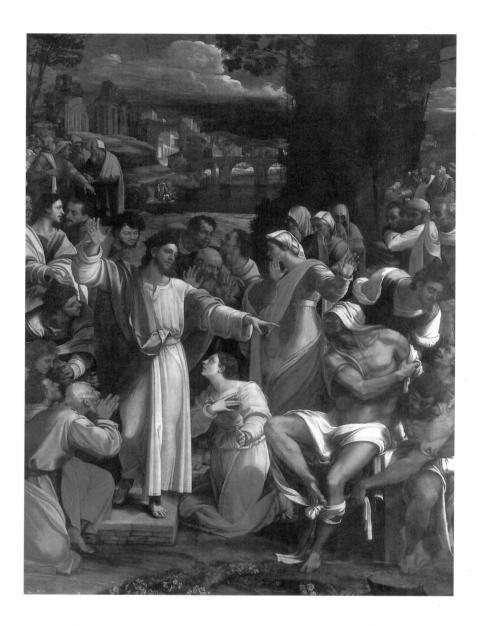

In 1515 Pope Leo X appointed his cousin Cardinal Giulio de' Medici to the see of Narbonne in south-west France. The new archbishop, unlikely ever to visit his cathedral, decided to endow it with a great altarpiece. He commissioned the *Transfiguration* from Raphael in 1516. Later that year, perhaps at Michelangelo's urging, he ordered a companion piece from Sebastiano. In the pictorial cycles of Christ's life which correspond to the feast days of the Church, the *Raising of Lazarus* comes after the *Transfiguration*. It is an even clearer statement of Christ's mission: 'I am the resurrection, and the life: he that believeth in me, though he were dead, yet shall he live' (John 11:25). The subject was well suited to its intended location because relics of Lazarus were venerated at Narbonne. It was also attractive to a Medici, whose name means 'doctors', for it shows Christ as healer, the Divine Physician.

Three drawings by Michelangelo survive relating to the group of Lazarus and the men who help release him from his winding cloths. Michelangelo probably also assisted with the figure of Christ commanding 'Lazarus, come forth'. The general composition, however, was most likely Sebastiano's own, as are the wonderful figures of Lazarus's sisters – Mary, who, seeing Christ, 'fell down at his feet...', and Martha, recoiling like the women behind her because '[Lazarus] stinketh: for he hath been dead four days'.

While striving for Roman grandeur, Sebastiano imbued the huge panel with Venetian atmosphere, setting the figures in a vast landscape extending to the high horizon. The Pharisees plot Jesus' death at the outskirts of the throng of witnesses. The women's headdresses, the ruined buildings and the bridge are Roman, but the changeable weather evokes the city of the lagoons. So too does the daring palette of rare pigments, such as those found in Titian's *Bacchus and Ariadne* (page 164). (Sadly for us, the colours have suffered through age and from the transferral of the painting from panel to canvas in 1771. Christ's red gown has turned pink and some of the greens dark brown, leaving stable pigments, such as lead whites and lead-tin yellows, looking brighter than they would have originally.)

Sebastiano's altarpiece was on public view by May 1519; everyone who saw it, wrote a mutual friend to Michelangelo, 'remained stupefied'. The true test, however, was yet to come. Raphael died in April 1520, the *Transfiguration* perhaps not quite complete. The two panels were exhibited together a week later. Giulio de' Medici elected to keep Raphael's last masterpiece, while the *Raising of Lazarus* was dispatched to Narbonne. But with Raphael dead, and Michelangelo away in Florence, history repeated itself: Sebastiano Veneziano became the leading painter in Rome. In 1531 he was appointed Keeper of the Papal Seal (*piombo*, lead – as used for sealing) and he has been known as Sebastiano del Piombo ever since.

SEBASTIANO DEL PIOMBO (about 1485-1547)

The Madonna and Child with Saints Joseph and John the Baptist and a Donor ${\tt about\ 1519-20}$

Oil on wood, 98 × 107 cm NG 1450

The donor – the kneeling man addressing his prayers to the Christ Child from under the Virgin's sheltering arm – may be Pierfrancesco Borgherini, Michelangelo's Florentine banker and friend, whose nuptial bedchamber had been decorated by Pontormo and others with stories of the life of Joseph (see pages 146–7). Sebastiano painted his chapel in the church of San Pietro in Montorio in Rome from small figure drawings supplied by Michelangelo.

Unlike the chapel, this painting is undocumented; it would most probably have remained in a domestic setting as a private devotional image. Although Sebastiano may have experienced difficulties in drawing together Roman and Venetian elements in the huge *Raising of Lazarus*, no such hesitation appears in this less dramatic, but in its way equally intense, picture. Within the horizontal format of Venetian paintings of the Holy Family or the Madonna with saints, Sebastiano arranges figures inspired by Michelangelo: the Christ Child resembles the putto holding the prophet Daniel's book on the Sistine Chapel ceiling, and the Virgin's arm echoes (in reverse) Daniel's expansive gesture. Yet the picture's smaller scale and the intimate three-quarter 'close-up' view transpose Michelangelo's public rhetoric into a different key.

I wonder whether Sebastiano ever saw Raphael's famous circular painting of the *Madonna della Seggiola* (fig. 4) in the Medici collection, for his panel is also curiously reminiscent of it, as if the coiled springs of Raphael's composition had unwound in the broader format, and Raphael's unseen viewer, imagined kneeling in front of the picture, had been welcomed inside Sebastiano's. Raphael's Madonna wears a Roman woman's scarf around her head, and Sebastiano's regal figure the headdress of a peasant from the Roman countryside. Raphael's Madonna and Child are accompanied by the infant John the Baptist. Here it is the adult Baptist with his reed cross who points to Christ. But if the temper of Sebastiano's painting is less flamboyant than that of the Sistine ceiling, it is also less cosy than that of the *Madonna della Seggiola*. Joseph's sleep is traditionally

Fig. 4 Raphael, Madonna della Seggiola, about 1514. Oil on wood, diameter 71 cm. Florence, Palazzo Pitti, Galleria Palatina. associated, not merely with his prophetic dreams, but also with his grief at Christ's Passion to come. Certainly the sombre background from which these secondary figures barely emerge seems to speak of tragedy, as do their anguished profiles and Joseph's lax hand. The play of hands across this picture is itself extraordinary: John's and Joseph's sunburnt hands at the edges of the panel, Mary's tender hand on Christ's shoulder, his plump hand reaching for her breast, her firm hand clasping the shoulder of the kneeling man, his hands crossed in fervent prayer – a garland of hands linked in varying expressions of emotion.

Vasari wrote that Sebastiano's greatest talent lay in portraiture, and we can well believe that the donor here was drawn from life. His sober black clothes balance the black background, a foil to the Venetian harmonies of orange and red, blue, fawn and emerald green which are among this remarkable picture's many splendours.

BARTHOLOMAEUS SPRANGER (1546-1611)

The Adoration of the Kings about 1595

Oil on canvas, 200 x 144 cm NG 6392

Born in Antwerp, Spranger became one of the leading representatives of a cosmopolitan sixteenth-century style which has come to be called Mannerism. The term was first coined in 1792 and is derived from the Italian word *maniera* – meaning 'manner' or 'style' and embracing all its modern connotations: personal or period style, stylishness, more style than substance. As used by art historians, Mannerism implies above all a sophisticated art, fully aware of all the techniques of naturalistic representation but concerned more with artifice than with fidelity to nature. Like Bronzino (page 106), Spranger worked at court, an environment which puts a premium on artificiality. After ten years, 1565 to 1575, in Italy, where he particularly admired the works of Correggio (page 109) and Parmigianino (page 143) in Parma, Spranger was appointed court painter to the Emperor Rudolph II in Vienna, and in 1581 moved with the imperial capital to Prague. As Rudolph's art impresario, he designed the displays of the imperial collection – decorative objects, sculpture, prints – which were to influence artists throughout Northern Europe and the Iberian peninsula. Above all, he furnished erotic imagery to Rudolph's taste, silken titillation couched in mythological or allegorical guise.

A less familiar aspect of Spranger's work is this altarpiece possibly commissioned by Rudolph and given by him to a prince-bishop of Bamberg for his private chapel. The subject allows Spranger to show off the fully international range of his talent. In the darkened stable we can just make out rustic Flemish shepherds; the dog in the foreground has found a tasty morsel; the kings proffer goldsmiths' wares almost as elaborate, and just as detailed, as Pieter Bruegel's or Jan Gossaert's (pages 108, 118). These touches of Northern realism, however, are peripheral to the almost oppressive magniloquence of the main scene, more grandly Italianate than any Italian's. As their elder bends down to kiss the infant's foot, the two standing kings pose like ballet dancers in virtual mirror image of each other. All three are gorgeous in shot satins, acid harmonies of yellow highlights on red silk, blue shadows on pink. The red-haired king at the right is said to be an idealised self portrait of the artist. His regal bearing is echoed in the elaborate signature by the feet of the black king, which describes Spranger as born in Antwerp and painter to His Holy Majesty the Emperor.

A humorous subplot is provided by the little pageboys carrying the trains of the kings' cloaks. Two mimic the grandeur of their grown-up masters, but the child on the

extreme right has succumbed to natural mischief: unnoticed by those within the painting, he has wrapped himself in the great green swathe of cloth, from which his red-hot little face peers out at the viewer. The Holy Family are less flamboyant, but only in the brooding figure of Joseph, his pose as complex but less obviously contorted than that of the others, do we sense something of the spiritual significance of the theme.

JACOPO TINTORETTO (1518-1594)

Saint George and the Dragon 1560-80?

Oil on canvas, 158 x 100 cm NG 16

Jacopo Robusti took his nickname, Tintoretto, from his father's profession of dyer (*tintore*). Notably devout, he was much in demand as a painter of altarpieces and religious narratives for the churches and confraternities of his native Venice, and also

executed many portraits. As can be seen in the two paintings illustrated here, he modified his style and technique according to the commission. He sometimes deliberately imitated the style of other painters, but his ideal was said to be 'the drawing of Michelangelo [some of whose sculpture he knew in casts or models] and the colouring of Titian' (pages 134, 163). What is uniquely his own is his sense of drama, often verging on melodrama, expressed through violent movement and vertiginous shifts in scale, as figures plunge towards us or recede abruptly into the distance, and by lurid tonal or colour contrasts.

Saint George and the Dragon is a small, even miniature, painting in the context of Tintoretto's work, detailed and highly finished. It was probably commissioned as a private altarpiece, and the conventional arched vertical format had never before, and has rarely since, been used to such dynamic and disturbing effect. The imagery also is unusual. The story of Saint George of Cappadocia, Roman officer and Christian martyr, was made popular in Western Europe through The Golden Legend, a calendar-book of tales of the lives of the saints compiled in the late thirteenth century. It is there that we find the story of a dragon terrorising the countryside demanding human sacrifice. When the fatal lot fell to Cleodolinda, the daughter of the king, Saint George, riding by on his charger, turned to help her and vanquished the dragon 'in the name of Christ'. In a departure from tradition, Tintoretto has shown the livid cadaver of a previous victim in the pose of the crucified Christ and included God the Father in the heavens blessing the victory of good over evil. The terrified princess, fleeing uphill from the dragon climbing out of the sea, nearly stumbles out of the foreground. Saint George has galloped into the painting from our right, the direction of a hidden source of light which picks out the trunks of the trees, the rump of the horse, the armour of the knight and the flesh and garments of Cleodolinda.

Although Tintoretto was a pioneer of dark-coloured grounds, he painted this picture over smooth white gypsum, and laid a translucent glaze of ultramarine directly over the white to achieve the glowing blue of the princess's gown, and red lake glazes for parts of her cloak. Further highlights in white lead paint flash like lightning over these draperies. Fevered contrasts of light and dark zigzag from foreground to background, where a mighty Venetian fortress looms out of the turbulent clouds. The acid green tones of the landscape are largely achieved through the use of natural malachite, a semi-precious stone rarely used as a pigment in European art but a staple of Tintoretto's palette.

JACOPO TINTORETTO (1518-1594)

Christ washing his Disciples' Feet about 1556

Oil on canvas, 201 x 408 cm NG 1130

This picture was painted for the right side wall of the chapel of the Holy Sacrament in the church of San Trovaso (Saints Gervasius and Protasius) in Venice, where by 1720 it had been replaced by a copy. It was paired with a *Last Supper* on the left-hand wall. The Gospels of Saints Matthew, Mark and Luke describe the Institution of the Eucharist in the course of the Passover meal which Jesus ate with his disciples shortly before the Crucifixion, but the Gospel of Saint John does not. John is, however, the only one to include the scene depicted here (chapter 13). The dramatic text interweaves and contrasts two heart-rending themes, expounded mainly through a dialogue between Jesus and Saint Peter: Christ's exemplary humility and self-sacrificial love, expressed in the new commandment 'That ye love one another, as I have loved you', and betrayal. Jesus acquiesces in his betrayal by Judas, 'That thou doest, do quickly', and predicts his betrayal by Peter, 'The cock shall not crow, till thou hast denied me thrice'.

As Peter confronts Jesus in the Gospel story, first protesting at the Lord washing his feet, then proclaiming his readiness to follow him unto death, so the two protagonists confront each other in the centre foreground of Tintoretto's composition. Jesus is shown kneeling, 'girded' with the towel which he took up to wipe the apostles' feet, and with the basin into which he poured the water. His youthful profile haloed in light, he raises his eyes to the horrified old man who leans forward to gaze into them;

the disciple's bared right leg extends parallel to the Saviour's left arm with its sleeve rolled up, a gestural echo of verbal response. Christ's divine light pierces the darkness between two physical lights: the cooking fire in the background and the torch held by the gigantic figure stepping out of the picture on our left – perhaps Judas Iscariot, who, 'having received the sop went immediately out: and it was night'.

The picture is exceptionally dark even for an evening scene. Although the effect has been intensified as surface glazes have grown transparent with age and wear, it was always intended. Over the white gypsum ground laid on the canvas, Tintoretto painted a second ground in thick charcoal black, sometimes drawing on it with lead white, sometimes using a translucent glaze directly over it. Neither the figure of 'Judas' on the left nor his counterpart drying his feet on the right was ever much more than sketched in. Ridolfi, Tintoretto's biographer, writes that the painter was so burdened with commissions that pictures by him were sometimes shown unfinished, since he was always working in haste. Possibly the artist thought these two figures, in the corners of the wall of a rather gloomy chapel, would in any case be only partly visible. Equally, he may have been emulating in paint Michelangelo's famous 'non finito' - where rough areas of unhewn marble contrast with the suave polish of the main figures. Combined with the vertiginous changes of scale, the fitful contrasts of white, crimson, malachite green, yellow and orange-yellow against black, the precipitous (and faulty) perspective of the tiled floor, the agitated poses, these variations of finish give the painting an extraordinary urgency - as the story of the Passion, begun here, draws ineluctably towards the climax of the Crucifixion, represented by the cross on the altar of the chapel for which the picture was made.

TITIAN (active about 1506–1576)

Bacchus and Ariadne 1520-3

Oil on canvas, 177 x 191 cm NG 35

Tiziano Vecellio's known self portraits show a thin-faced old man with a white beard, in opulent black, wearing a gold chain. In a career of some sixty-five years, Titian, perhaps

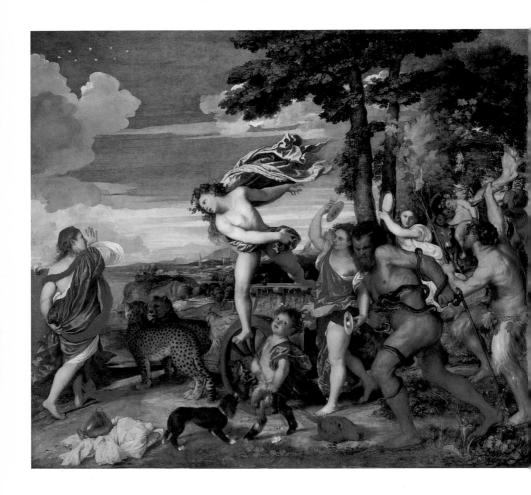

the most successful painter in history, included among his patrons a cross-section of the Italian nobility, the state of Venice, a pope, three Holy Roman Emperors and the Kings of France and of Spain. But apart from short visits he chose to live in Venice – 'whose praises he is always singing to me', as the Spanish ambassador reported to his master. Oils on canvas made his works transportable, regardless of scale; not having to produce them 'on location' abroad, he retained his precious freedom to live as he wished at home. 'A pair of pheasants and I don't know what else await you at supper...' wrote the publicist Aretino to his painter friend, in one of many reports of Titian's festive Venetian evenings in the company of pretty women. But it was Titian's mastery of oils which prompted Aretino, describing the view from his window, to exclaim, 'Oh, with what beautiful strokes did Nature's brush push back the air, making it recede from the palaces just as Titian does when he paints a landscape!' Although Titian did not invent Venetian colourism (see pages 100–1), his fluent brush, complemented in old age with fingers and thumb, earned him the title of its 'father', almost eclipsing the fame of his teachers, the Bellini (page 20) and Giorgione (page 116).

Bacchus and Ariadne is not a product of Titian's fabled old age but was painted when he was in his thirties as one of a series of canvases for the studiolo (see page 92) of Alfonso d'Este in the castle of Ferrara. Alfonso wished to recreate an ancient picture gallery, as described in a late-antique Greek text. His original plan was to acquire paintings by

the best artists in Italy to accompany Giovanni Bellini's Feast of the Gods of 1514. The Florentine Fra Bartolommeo and Raphael (page 148) both died having completed only drawings, and their commissions reverted to Titian. These canvases are now in the Prado Museum in Madrid.

The story of Bacchus and Ariadne, rarely represented until then, is told by the Latin poets Ovid and Catullus. Translated extracts would have been sent to Titian along with canvas and stretchers. Never have texts or pagan myth been brought to life so clamorously, nor in such a rare variety of costly pigments, available only in Venice. Ariadne, having helped Theseus vanquish the Minotaur, was abandoned by him on the 'wave-sound shore' of the island of Naxos. His ship sails away on the left. 'Then over all the shore cymbals resound and drums beaten by frenzied hands': they herald the god Bacchus in his chariot drawn by cheetahs, with his rowdy retinue of maenads, goat-footed satyrs – one 'girded with writhing serpents' – and drunken Silenus clinging to his long-eared ass. 'Voice, colour – and Theseus, all were gone' from terror-stricken Ariadne, as the god leaps down to carry her off as his bride. She will become the constellation we see above her in the sky. Silhouetted against an expanse of precious ultramarine, god and girl pause on a single heartbeat, echoed in the clash of cymbals by Ariadne's maenad mirror image, glowing in a tunic of orange realgar within the picture's earthy half. Titian's little dog barks excitedly at the strutting faun with jasmine in his hair, trailing a mangled calf's head alongside a caper flower, symbol of love.

TITIAN (active about 1506–1576)

'Noli me Tangere' about 1514

Oil on canvas, 111 × 92 cm NG 270

The Latin title, meaning 'Touch me not', refers to Christ's first miraculous apparition after his death, when he reveals himself to Mary Magdalene. Finding the tomb empty, she mistakes him for a gardener and implores him to tell her where he has moved Jesus' body. As he calls out her name she recognises him and, leaning on her jar of ointment, reaches out, saying, 'Master'. But he replies, 'Touch me not; for I am not yet ascended to my Father' (John 20:17). The theme was very rare in Venetian art at this time. This picture should be understood, however, as a devotional image of a popular penitent saint (see page 154) elaborated into a narrative. The unusual coherence of the figure group, joined in a continuous eloquent movement, reflects Florentine influence, and, like a Florentine artist, Titian must have evolved the complex figure poses through preliminary studies on paper. The buildings in the background must also have been first recorded in drawings, for they appear in other works painted by him at this time. An X-radiograph reveals, however, that Titian modified the design of the landscape directly on the canvas (fig. 5). Having first painted a hill crowned with buildings on the left, he obliterated it with a layer of lead white paint, then added the farm complex we now see on the right. And to achieve a perfect balance between figures and landscape, he also modified the outline of the tree in the middle, originally smaller and with an extra branch to the right. It has been suggested that its leaves, and other areas of foliage in the picture, have been affected by the tendency for copper green glazes to turn brown, but the main pigment present in those areas has been shown to be a red-brown earth. The contrast between the brown leaves, the weeds and grasses that Christ treads with nail-pierced feet and the green pastures behind him where the sheep safely graze was intentional.

Fig. 5 $\,$ X-radiograph of Titian's 'Noli me Tangere', showing changes in the painting.

The tree in its final position defines a middle plane between foreground and background, serving, in Aretino's wonderful phrase (see page 164), to 'push back the air' of the sky. But it also functions on the picture surface to prolong the expressive outline of the Magdalen, and to buttress the exaggerated curve of Christ's back. That curve itself now continues through the hill and buildings on the right.

No Florentine painter at this date would have been able to integrate so thoroughly two such large figures with a landscape, which as a consequence becomes much more than background setting. The blue shadow of Christ's shroud brings the sky down to earth. The same sunlight gleams on the Magdalen's hair as warms the distant flocks and bleaches the rustic thatch roofs; the same breeze plays through the cambric of her sleeve as through the clouds. Our eye is led back in space not by perspective lines, but, as in Giorgione's landscape (page 117), by bands, wedges and lozenges of colour, alternately pale or dark, patterned across the whole canvas from top to bottom, suggesting recession. Only the unique crimson of Mary's Venetian gown isolates her in the foreground. Titian's technique of simultaneously adjusting and readjusting line, form and colour results in a haunting fusion of Christian miracle and pastoral poetry.

TITIAN (active about 1506-1576)

A Man with a Quilted Sleeve about 1510

Oil on canvas, 81 x 66 cm NG 1944

Although the 'Noli me Tangere', discussed above, emulates the technique, colours, land-scape formula and poetic mood of Giorgione (page 116), Titian was a very different kind of painter, as became evident soon after Giorgione's death in 1510. Where Giorgione is elusive and nostalgic, Titian is vigorously direct. I have referred to his known self portraits, all of them showing the celebrated painter in old age (page 163); it has been plausibly suggested that the assertive unknown man in this portrait, once wrongly identified as the poet Ariosto, is Titian himself when young, proclaiming his artistic credentials and his aspirations.

Titian's international reputation was founded largely on his portrait practice. No previous artist had flattered so subtly: his sitters look noble by nature, instinctively refined and intelligent without obvious contrivance. This early work, however, wears its art on its sleeve. Subverting the Venetian convention by which a parapet defines the picture plane, locating the sitter behind it, Titian's elbow in the blue sleeve projects beyond the stone ledge, off the canvas into our space. It would have appeared even bulkier originally, before the fine red lines painted in the fabric faded and the quilting lost some of its puffiness through blanching. From a passive object of our gaze, like Bellini's Doge Loredan (page 21), the sitter has become an active subject. While we, as viewers, seem to have interrupted Andrea del Sarto's young man's reading (page 153), this brisk personage turns his attention from more absorbing matters to glance down his nose at us. The painting of the quilted satin is as illusionistic as any Netherlander's, albeit by different means; a monogram – T V – is 'carved' into the parapet. As we look upward, however, Venetian softness engulfs the beard and flesh, although the silhouette, a simple pyramid, remains firm against the vibrant grey.

The pose, despite the implications I have read into it, is fully compatible with a self portrait: the artist turning from his easel on the right to look into a mirror. The distortion of a convex glass, the only kind available at the time, would help account for the supercilious angle of the face. It is entirely fitting, therefore, that even when the

picture was identified as Ariosto more than one artist should have adopted its formula for his own likeness: most notably Rembrandt (page 235), who had seen the painting or a copy of it in Amsterdam, and perhaps Van Dyck (page 200), who may have bought the picture seen by Rembrandt.

TITIAN (active about 1506–1576)

The Vendramin Family venerating a Relic of the True Cross about 1540-5, reworked perhaps about 1555

Oil on canvas, 206 x 289 cm NG 4452

This tremendous group portrait of male members of the Vendramin family (there were also six daughters, but they are not included) is more than a dynastic celebration. Titian's most notable work for Venetian patrons in the 1540s, it symbolises the ancient

devotion of the *casa* Vendramin to a holy relic, and their invocation of its continued protection. In 1369 a fragment of the True Cross was presented to Andrea Vendramin on behalf of his confraternity, the Scuola of Saint John the Evangelist in Venice. Encased in a cross-shaped reliquary of rock crystal and gold – still preserved in the Scuola and shown here on an imaginary open-air altar – the relic fell into the canal during the presentation. It remained, however, suspended above the water until Andrea was privileged to jump in and save it. This miracle, along with others performed by the relic, is commemorated in a series of paintings by Gentile Bellini, made for the Scuola and now in the Galleria dell'Accademia in Venice.

Andrea Vendramin's sixteenth-century namesake, a great-nephew of his grandson, stands on the altar steps in the crimson robe of a Venetian senator, venerating the cross and indicating his own seven sons. The bearded young man immediately behind him is the eldest, Lunardo. The youngest, Federigo, is the little boy in scarlet stockings seated on the right; cradling his bright-eyed puppy, the child turns, uncomprehending, to his nearest brothers. The white-bearded man kneeling at the altar may be Andrea's brother, Gabriele. We know from his will that Gabriele, a great collector and a friend of Titian's, felt that the family's future depended on their continued veneration of the relic. He adopted his young nephews as his heirs, and perhaps commissioned the picture from Titian so that they might grow up with it as a vivid admonition.

The brush drawing of Andrea's right leg, bent under straight-falling drapery, is now visible beneath his velvet gown. But the picture was subjected to more major revision. It must have been meant to be longer, for Titian originally placed Lunardo's profile further to the left, where it can be seen through the blue of the sky. As a consequence of the changed format, the three younger boys had to be squeezed in front of Lunardo; they were clearly not painted by Titian himself.

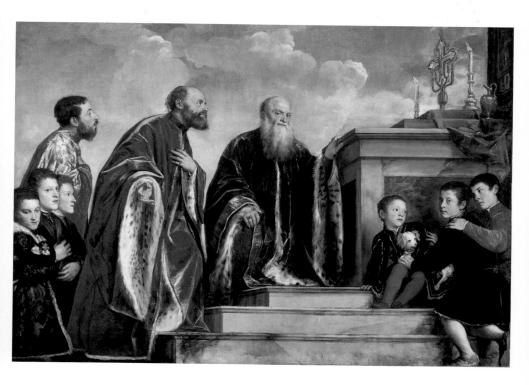

Perhaps following the example of Andrea Schiavone and of Tintoretto (page 160), Titian had by the 1540s adopted a freer and more varied technique. On the reliquary, and on the candles flickering in the wind, the paint is applied freely with single strokes of a loaded brush. White highlights zigzag across the draperies. These effects are, however, always tied to description; lynx-fur linings, hair, beards and silky canine ears are carefully differentiated.

The painting remained in the Vendramin family until at least 1636. It was subsequently bought by Titian's great admirer Van Dyck (page 200), who applied most of its many lessons to his portrait of *The Earl of Pembroke and his Family* at Wilton House. But Van Dyck, painting a great family in seventeenth-century England, did not omit the women so conspicuously absent from Titian's tribute to the Venetian ruling class.

PAOLO VERONESE (1528?-1588)

The Family of Darius before Alexander 1565-70

Oil on canvas, 236 × 475 cm NG 294

After the death of Titian, Tintoretto (page 160) and Paolo Caliari succeeded him as the leading painters of Venice, where Paolo was known as 'Veronese' (from the city of

Verona). In some ways both these artists are more 'Venetian' than Titian, since more of their work adorned the churches, palaces, villas, convents and confraternity meeting rooms of the city and its mainland possessions. It was Veronese above all, however, whose vast decorations, secular and religious, in fresco and on canvas, on ceilings and on walls, imprinted on the European imagination a vision of Venice personified – a magnificent blonde, shimmering with pearls and precious stuffs – and of Venetian life as a succession of stately pageants unfolding against white marble and blue sky. Veronese is the inspiration behind Tiepolo's exhilarating art (page 338). More unexpectedly, he influenced nineteenth-century painters, Delacroix (page 284) among them, seeking the secret of luminous daylight colour.

As we see in this splendid 'history painting', Veronese juxtaposes richly saturated hues – warm reds, greens, orange, gold, brown, grey-blue and violet – in the shadows, diluting them in the highlights. Reversing convention, he even uses bright red in the shadows 'behind' a darker figure, in the hot little pageboy kneeling near the centre of the composition. The woman's white ermine collar serves to 'push back' his red costume, as to a lesser extent do the highlights on her sleeve. By such means, Veronese's paintings seem to reflect sunlight even in the shade without a loss of modelling or spatial recession.

The protagonists in this ancient story, painted for a palace of the Pisani family, wear a mixture of contemporary dress and fancy costume: the ermine collar and cape of the wives of Venetian doges, modern jousting armour and operatic Roman battle

dress – anachronisms which have become identified with Veronese's Venice as much as 'vandyke' collars with the court of Charles I (see page 200). The episode principally illustrates the magnanimity of Alexander the Great. Having defeated the Persian King Darius at Issus, Alexander spared his foe's mother, wife and children, sending word that Darius lived and that their royal persons would be respected. The following morning he went to visit them with Hephaestion, his dearest friend and general. When they entered the royal pavilion the Queen Mother, Sisygambis, prostrated herself in front of Hephaestion mistaking him for Alexander as he seemed the taller of the two. Hephaestion recoiled, an attendant corrected her, but Alexander himself courteously alleviated her embarrassment by saying, 'It is no mistake, for he too is an Alexander'. The gestures of Sisygambis and the courtier towards Darius' beautiful wife may refer to the secondary theme of the epoch-making 'continence' of Alexander, who abstained from claiming the Persian Queen as a concubine.

The huge canvas must have been designed to hang above head height, for Veronese has deployed the figures – some of them surely family portraits – in three groups at the very edge of the picture, on a terrace in front of a thinly painted open colonnade (the architectural background was altered in the course of painting). The painting's very eloquence implicates us in the Queen Mother's confusion. Are we seeing Alexander in imperial red pointing to Hephaestion and reassuring the Queen? Or has Veronese substituted magnificence for height, and is Alexander the battle-weary general in the gold cloak confirming his own identity?

PAOLO VERONESE (1528?-1588)

Allegory of Love, II ('Scorn') mid-1570s

Oil on canvas, 187 x 188 cm NG 1324

This canvas is one of a series of four evidently representing various attributes of love, or perhaps different stages of love culminating in happy union. They were clearly designed as compartments of a decorated ceiling (see also pages 338–9) and might conceivably relate to a nuptial bedchamber. Veronese used this type of 'oblique perspective' for ceiling decorations in Venice: the angle of foreshortening corresponds to a viewpoint obliquely beneath the painting, avoiding the extreme distortion of figures imagined as directly above the viewer's head. By 1637 the four allegories, now all in the National Gallery, were recorded in the collection at Prague of the Emperor Rudolph II, the great art patron of his age, who probably commissioned them.

The appearance of all four paintings has been badly affected by the irreversible discoloration of the smalt – a comparatively cheap blue pigment made from pulverised glass coloured with cobalt oxide – used to paint the sky, which now gives it a pale grey tinge instead of its original warm blue. With age, some of the green copper resinates of the foliage have oxidised to brown. In most respects this is the best preserved of the four pictures, and the one where Veronese's own hand, as opposed to his workshop assistants', is most visible.

As befits an allegory, the meaning of the picture must be teased out. A nearly naked man is lying writhing on a ruinous ledge – perhaps an altar – in front of a statue in a niche holding a set of Pan pipes against its hairy thigh. The marble torso to the left of the statue has the goatish features of a satyr. This is a crumbling temple to the pagan divinities of unbridled sexuality (see also pages 164 and 231). Cupid uses his bow mercilessly to beat the man, watched by two women: a shimmering bare-breasted beauty in

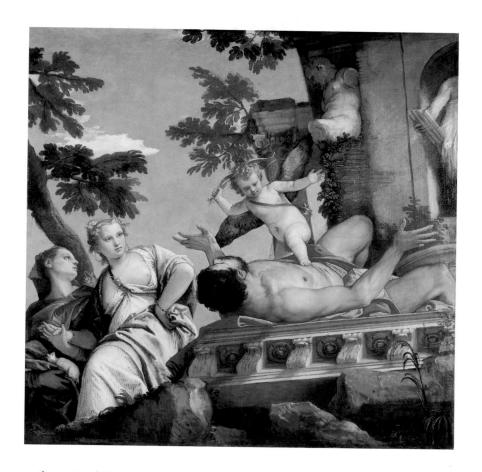

a silver-striped dress with rose and yellow kirtle, accompanied by a dark duenna. Enfolded within her green mantle the chaperone holds a small white beast: an ermine, symbol of chastity, thought to prefer death to impurity. The general significance, then, is clear. The man has been felled by lust for a sensuous yet chaste woman and is being punished. But the trite verbal translation does not begin to do justice to Veronese's robustly and wittily imagined scene: the ferocious plump Cupid astride his hapless victim, the scornful femme fatale drawing aside her skirts.

A visitor going from the Wohl Room (Room 9) into the North Wing expecting to see seventeenth-century pictures may be startled to find, in the small octagonal Room 15, a coastal scene and a dramatic harbour view by the nineteenth-century English painter Turner. The anomaly is explained by a clause in Turner's will in which he donated his Sun rising through Vapour and Dido building Carthage to the National Gallery on condition that they be shown between Claude's luminous Seaport with the Embarkation of the Queen of Sheba and Landscape with the Marriage of Isaac and Rebekah. Turner's Dido has been called one of his most ambitious imitations of Claude, but by stipulating that their works be seen together, Turner did more than acknowledge his debt to his great predecessor or seek direct comparison with him. He asserted that landscape painting as a major art form was a creation of the seventeenth century.

Much loved by English collectors, landscape paintings constitute a significant proportion of the pictures in the North Wing, giving an accurate impression of the wide range of the genre as well as of its proliferation north and south of the Alps. Outdoor views in this period might be topographical records of actual locations or imaginary, of local interest or exotic, stormy or serene, wintry or summery, independent vistas or settings for narrative. All landscapes, however, have in common certain pictorial problems: how to suggest distance and how to depict outdoor light. Any viewer interested in painting or in photographing scenery is well advised to study the devices of seventeenth-century landscape artists: the use of human figures to indicate scale; of trees or tall buildings rising from the foreground to help 'push back' background and sky, and the ways in which the height of the horizon and the location of the vanishing point affect the relationship of the spectator to the view.

Just as the size and format of painted landscapes related to their content, function or intended location, so narrative pictures varied in scale, and the issue of scale assumed a particular significance in the seventeenth century. (We are only really aware of size when looking at originals, but readers away from the Gallery can try to visualise the size of paintings from the dimensions given under each reproduction.) In the Middle Ages and the Renaissance, Italian and Italianate art theory had favoured large pictures (even when individual components, such as predella panels, were small). Murals, altarpieces, portraits on the scale of life were associated with public buildings and princely palaces and were available, at least notionally, for viewing by the whole community. They were thus useful in forming and propagating communal values or transmitting the values of a ruling class. The painter of large pictures could aspire to influence his fellow-citizens no less than a lawgiver, orator or preacher. The painter of privately owned small pictures, on the other hand, even when providing devotional images, might seem mainly to cater to an individual's love of luxury, in the same way as a goldsmith or furniture-maker. It was this distinction of ultimate purpose which differentiated what today we might call 'high art' from 'mere craft'. While most Italian Renaissance painters worked in both the public and the private spheres, their claim

Previous page: Peter Paul Rubens, An Autumn Landscape with a View of Het Steen in the Early Morning (detail), about 1636

to artistic and social status tended to depend on their ability to design or execute monumental commissions. Although these ideas developed more slowly in Northern Europe, they influenced artists and patrons who came into contact with Italian art and art theory.

The growing stratification of urban society, the rise of private collecting, the importation of small Northern pictures and the arrival of Northern artists in Italy all played their part in modifying Italian attitudes, as did a growing emphasis among Catholics on conspicuous personal piety during this period of Reform and Counter-Reformation. By the late seventeenth century, artists such as the Florentine Carlo Dolci were particularly esteemed in aristocratic circles for their precious small works for private devotion. Yet the Italo-Flemish Rubens, resisting classification as a 'Northern specialist', insisted on his ability to paint on a grand scale. Luca Giordano, who also worked in fresco directly on ceilings and walls, executed gigantic mythological and biblical easel pictures as mural decoration for private palaces. Other Italian and Italianate artists throughout the century maintained the scale associated with public art even in moderately sized pictures for private collections. Caravaggio, Reni, Guercino, Rembrandt, ter Brugghen and others painted monumental narratives in 'close-up' with life-size figures in half length. When 'history painting' was finally redefined to include domestic easel pictures with smaller than life-size full-length figures, it was largely through the efforts of a Frenchman, Nicolas Poussin, virtually self-taught and unsuccessful, by Italian standards, in murals and altarpieces. Most of his mature paintings were sent to patrons in France, where they influenced the formation of French academic art, although they also left their mark on some Italian painters - such as Cavallino, one of whose rare pictures is also shown in this wing.

Official likenesses of rulers, ecclesiastics and nobles – the imposing international 'state portraits' which became increasingly important throughout the century – were, as they nearly always still are, life-size or larger. Outstanding examples from all over Europe, by Van Dyck, Velázquez, Rembrandt and others are on view in the North Wing. Fascinating in themselves, and in their shared ideals and formal devices, they lead us paradoxically to yet another seventeenth-century phenomenon observable here: the development of new national schools of painting. Without minimising the continuing vitality of Italian art, or the achievements of the great Flemings or of French-speaking painters in France and Italy, it may fairly be said that the most innovative and distinctive schools of the seventeenth century are the Spanish and Dutch.

Painting in Spain before 1600 is represented in the National Gallery almost solely through a few works by El Greco, and while they do not give an accurate impression of the artistic riches of the Iberian peninsula in this period, they rightly imply that painting by native-born Spanish artists flowered mainly in the Golden Age after 1600. Influenced by Netherlandish prints as well as by Italian painting, notably works by Titian in the Spanish royal collections, and patronised by an art-loving monarch, Velázquez evolved into perhaps the most original and moving painter of the age. Superb examples from the whole range of his work, including his unique surviving female nude, the 'Rokeby Venus', are shown here. Almost as arresting are pictures by

Murillo and Zurbarán, mainly painted for the many religious orders active in Spain and in the Spanish possessions in the New World.

Religious divisions precipitated the break-up of the Spanish empire in the Netherlands. The Southern Netherlands remained under Spanish domination and Catholic. The formation of a Dutch state, a pluralist nation under the banner of Calvinism, in the Northern Netherlands resulted in the virtual end of Church patronage throughout the area and in a radical redistribution of artistic production. New pictorial forms were created, and traditional ones evolved in specialised ways: domestic paintings of the indigenous landscape and marine views to celebrate national identity and the new nation's hard-won achievements; townscapes and architectural views of whitewashed Protestant churches; moralising pictures of 'everyday life'; still lifes similarly combining self-congratulation and admonishment; barrack-room scenes of Dutch soldiery. In a society in which literacy was encouraged so that all could read the Word of God, and which identified itself with God's Chosen People, even obscure narratives from the Old Testament became popular, as they could not be in Catholic states where lay people were discouraged from reading the Bible. Portraits were as important here as elsewhere, although they also assumed different functions, mainly familial and corporate.

Virtually all these genres – with the exception of militia and other institutional group portraits – are represented in the North Wing, as well as works by Italianate Dutch painters from the Catholic stronghold of Utrecht. Above all, the wing houses a score of paintings by Rembrandt, Dutchman and yet heir to all that is most universal in the European tradition: small deeply felt scenes of the life of Christ, the tenderly erotic Woman bathing in a Stream, the grandiose Belshazzar's Feast, commissioned portraits, and self portraits of boastful youth and disillusioned old age.

HENDRICK AVERCAMP (1585-1634)

A Scene on the Ice near a Town about 1615

Oil on oak, 58 x 90 cm NG 1479

Avercamp, also known because of his disability as 'The Deaf-Mute of Kampen', spent most of his life in that quiet provincial backwater on the Zuider Zee where his father settled as an apothecary. Here he made numerous coloured drawings of people engaged in winter sports, fishermen and peasants, on which he based the human incidents in his paintings. The winter scenes in which he came to specialise are so vivid that we could almost believe that they, too, were executed out of doors, but like all highly finished paintings in this period they were in fact made in the studio.

Winter landscape painting began with the work of Burgundian miniaturists in the fifteenth century, in calendar scenes of the 'labours of the months' designed to show the harmony between human activity and the cycle of nature. The theme was taken up in easel paintings and prints by the sixteenth-century Flemish artist Pieter Bruegel (page 108) and his followers, and Avercamp's earlier works, such as the circular *Winter Scene with Skaters near a Castle* also in the National Gallery, are closely based on such Flemish models. In this later picture he has lowered the horizon and simplified the composition. Despite its apparent realism, it probably does not depict an actual place.

Like most other small-scale Dutch landscape paintings, Avercamp's pictures were not executed on commission but for sale on the art market. They must have had a special significance for their original owners, presumably townspeople of moderate means who enjoyed outings to the country. Landscapes provided a memento of these, but this painting is also a reminder that the native countryside now belonged to Dutch men and women in a new sense. Under the orange, white and blue flag of the Republic of the United Netherlands – the confederation of seven provinces of the Northern Netherlands which had in effect won their independence from Spanish rule with the truce of 1609 – a whole cross-section of Dutch society is shown, united and at play. (The

flag is visible in the distance, just below the horizon and to the left of the church spire.) The isolated old man seated on the right resembles a personification of winter in allegorical pictures of the seasons, and the horse's or cow's skull in the foreground may suggest the end of earthly pleasures – but these are only incidental details. Peacefully enjoying the fruits of freedom and of their industry on land and sea (the fishing boats are immobilised by the ice), old and young, men, women and children, peasants, nobles and fisherfolk, all carefully distinguished by dress and deportment, skate or sledge on the ice. Several groups of men in the distance play *kolf*, the Dutch ancestor of our game of golf. Intentionally or not, Avercamp seems to have based his palette on the colours of the Dutch flag – adding only black – for orange-red, white and blue are deployed in various intensities throughout the picture, fading away into the distant and delicately tinted winter sky.

NICOLAES BERCHEM (1620-1683)

Peasants with Four Oxen and a Goat at a Ford by a Ruined Aqueduct 1655-60

Oil on oak, 47 × 39 cm NG 820

Son of a still-life painter, Berchem belongs to the second generation of the so-called Italianate Dutch landscape artists. He probably visited Italy, but the greatest influence on him is the work of older artists painting in this mode, especially Jan Both (also represented in the National Gallery). Indirectly he owes much to Claude Lorrain (page 191).

The poetic and imaginative paintings of Italianate Dutch artists were highly prized in their day, and by eighteenth- and early nineteenth-century collectors, then fell out of favour until the 1950s and are still overlooked by many gallery visitors. Whether depicting Dutch landscape under Italian skies or, as is the case here, an Italianate landscape through Dutch eyes, their theme is the Northerner's longing for the South.

This small picture by Berchem is a fine example of the type. The vertical format, unusual in landscape, was obviously chosen to emphasise the height of the Ancient Roman ruins in which the creepers and saplings of Nature have taken root. The horizon – and correspondingly our point of view – is comparatively low, so that we look up into the aqueduct's single arch, and the wonderfully luminous sky takes up most of the picture space. The painting is backlit, like the landscapes of Claude, and there is no second source of light in the viewer's space illuminating the foreground to disturb the unity of the scene. To make sure, however, that those objects nearest to us seem to stand out, Berchem has provided a white cow.

The peasants driving their cattle home are dressed more like contemporary Italians than Dutch, although dairy cattle, the source of much of Holland's wealth and pride, were of particular interest to Dutch viewers.

The mood has been called pastoral, but these are not the fanciful shepherds and shepherdesses of pastoral poetry; it is their modern presence by the ancient ruins, under the southern sky, which gives the painting its poetic resonance.

GERARD TER BORCH (1617-1681)

A Woman playing a Theorbo to Two Men $_{\rm about~1667-8}$

Oil on canvas, 68 × 58 cm NG 864

Many artists represented in the National Gallery have painted beautiful satins and silks (see, for example, page 155), but no one has ever depicted satin more exquisitely than the much-travelled Dutchman Gerard ter Borch. First trained by his father Gerard ter Borch the Elder, who had lived in Italy in his youth, the precocious young painter worked in Amsterdam and Haarlem before venturing to Germany, Italy, England, France and Spain. In 1646 he went to Münster, where he witnessed the ratification of the treaty of 1648 signalling the triumphant end of the Dutch wars of independence from Spain – an event which he recorded in a tiny painting on copper now in the Gallery, as well as in individual miniatures of the delegates. In 1654, he married and settled down, permanently, in Deventer.

Whether miniature full-length portraits, or scenes of – supposedly – everyday life, ter Borch's pictures are distinguished by technical and psychological refinement. It seems curious, therefore, that he first specialised in guardroom subjects – although he brings even to the rowdy theme of garrisoned soldiers an element of stillness and reflection, as in the Officer dictating a Letter while a Trumpeter waits, also in the collection. His best-known paintings, however, represent elegant interiors with only a few figures, one of them usually a young woman in ravishing pale satin. Here, in an old-ivory bodice trimmed with fur and a white skirt setting off her fair hair, her shoe propped against a foot-warmer, she plays the theorbo, an early form of lute, accompanying the man holding a song book. A man in a cloak looks on, and a spaniel seems to listen. Behind them is a curtained bed. Under the red Turkey carpet covering the table lies a single playing card, the ill-omened ace of spades.

The woman and the singing man each appear in other paintings by the artist, as do the silver box and candlestick – this is 'selective' naturalism, a scene composed from

the imagination with ingredients assembled from drawings and studio props. In Dutch paintings of this type music-making is usually suggestive of love, while playing cards may be emblems of improvidence, and dogs and foot-warmers can signify base desires. Yet it would be foolhardy to read this subtle painting, with its subdued tonality, as a scene of the demi-monde. We can never know what the relationships of these three figures are, and their thoughts and feelings, so delicately implied, are infinitely ambiguous. That, surely, was the artist's intention: to evoke imperfectly understood events, tantalising in their suggestion of mutability and transience.

ADRIAEN BROUWER (1605/6-1638)

Tavern Scene about 1635

Oil on wood, 48 × 76 cm NG 6591

Brouwer's early biographers identified him with the figures in his paintings – Flemish wastrels drinking, smoking, gaming and quarrelling in pothouses – even while admitting that he was a cultured man and a supremely talented artist. The scant factual record

of his life apparently confirms the tradition: although his pictures fetched high prices Brouwer was insolvent, and he died at an early age. But a dissolute young man could not have painted with such firm control of a delicate yet lively technique, and with such psychological acumen. Great artists understood him better: Rubens (page 242) owned seventeen of his paintings, Rembrandt (page 235) owned six, and an album of drawings; Van Dyck (page 200) included Brouwer's likeness in his album of portraits of eminent people.

Born in Oudenaarde in Flanders, the son of a pattern-maker for tapestries, Brouwer had already left home when his father died in 1621/2. Between 1625 and 1627 he was in Holland, in Amsterdam and Haarlem, where he belonged to a learned literary society and may have studied with Frans Hals (page 210). In 1631/2 he was enrolled as a master in the painters' guild in Antwerp.

We can discern both Flemish and Dutch influences in Brouwer's work, especially the sixteenth-century peasant scenes of Pieter Bruegel (page 108) – another cultivated artist misidentified with the boors in his pictures - and the 'Merry Companies' pioneered by the Dutch painter and etcher 'Witty Willem' Buytewech. The imagery of these paintings was, however, rooted in allegorical representations of the Occupations of the Months, the Five Senses or the Seven Deadly Sins, and in moralising illustrations of unruly human behaviour as described in the Bible or satirised by the Dutch humanist Erasmus (see pages 132-3; see also the Narrative Pocket Guide). Brouwer, on the other hand, seems to avoid allegory or overt satire, although engravings after his works were inscribed with prim captions. His aim appears to be to represent the full range of human expression observable in a comic context. According to Greco-Roman literary theory, comedy deals with people 'like ourselves or lower than ourselves', in contrast to the superior personages of tragedy and epic. The first-century Latin writer Pliny the Elder (see page 105) celebrated the success of painters of grylli (small comic scenes), and Brouwer evidently sought to emulate these ancient artists in modern guise; Van Dyck captioned his portrait 'Gryllorum pictor Antverpiae', 'Antwerp painter of grylli'.

The National Gallery panel, which may have belonged to Rubens, is an exceptionally large example of Brouwer's mature style. It is fluidly painted with minute touches

and subtle gradations of light and shade, in a warm ochre-grey overall tonality that suggests the cosy fug of the tavern. (Allowing for differences of handling, colour and subject matter, this tonality recalls the 'omnipresent air' enveloping the figures in pictures of interiors by Van Eyck, the 'father' of Netherlandish oil painting; page 46.) White and black, with subdued variants of the primary colours blue, yellow and red, enliven the prevailing monochrome, mould volume, render texture and lustre, lead the eye from figure group to figure group and arrest it at beautifully painted details of costume and still life. But above all it is the exploration of characters and their interaction that draws us into the scene: the drunken client groping the waitress, and her spirited defence; the voyeuristic glee of the old person watching them from the window; the jeers of the two ruffians egging them on, unrestrained by a more sober spectator; the friendly absorption of two boon companions conversing by the fire.

HENDRICK TER BRUGGHEN (1588-1629)

The Concert about 1626

Oil on canvas, 99 × 117 cm NG 6483

A number of painters from the old Catholic city of Utrecht visited Rome in the early years of the seventeenth century. There they encountered the splendours of antiquity and of the High Renaissance, but were moved even more by the recent work of Caravaggio (page 187) and his followers. Among these Dutch artist-pilgrims were ter Brugghen and Honthorst (page 214) – two pupils of Abraham Bloemaert, a Utrecht

painter of heroic narrative. Ter Brugghen was the first to go south and the first to return home in 1614. In his short career – the earliest-known dated work is from 1616 – he painted mainly religious subjects and half-length figures, singly or in groups, of musicians and drinkers on the scale of life. Many of these images, like the *Concert*, explored the effects of candlelight. Indebted both to Caravaggio and to native Netherlandish tradition, this theme became characteristic of the so-called Utrecht Caravaggisti painters, and through them influenced many other Dutch artists, above all the young Rembrandt (page 235), though few handled it with the fluency and delicacy of ter Brugghen.

Musical parties were a major feature of Dutch domestic life, and also, less reputably, of taverns and brothels. This scene, however, does not look like a realistic depiction of an actual concert. A young boy sings, his eyes on the song book lit by the oil lamp on the wall, his hand beating time. But the lute-player and flautist have turned away from him towards the viewer. As we look at them, and listen, we are drawn into the warm light cast by the low-burning candle. They are exotically dressed - she wears the costume of Caravaggio's gypsy fortune-tellers; her companion is dressed like one of Caravaggio's swaggering young gallants, retainers of the great, who gambled, drank, wenched and fought in the streets and squares of Rome. His crenellated beret, however, derives from prints of soldiers and dandies of the previous century – evoking the old Burgundian court and a Netherlandish Golden Age. Both are playing instruments associated in poetry, theatre and the visual arts with the make-believe world of romantic shepherds and shepherdesses. And something of the ambiguity between tavern merry-making and pastoral idyll informs the scene, in the creamy light and the heavy curves of cloth and flesh, as the two instrumentalists in perfect symmetry and accord turn their faces in profile as they play.

The painting celebrates the power of music and the night. Ter Brugghen has used his study of the effects of artificial light – so subtly distributed between background and foreground, so realistically depicted in the shadow of the flute on the man's cheek – to conjure up an enchanted night-time world reminiscent of Shakespeare's lyrical comedies, which he could not have known, although they are nearly contemporary. As Sir Toby Belch and Sir Andrew Aguecheek drink late in *Twelfth Night*, Feste the Clown sings a love song which, with its last line, 'Youth's a stuff will not endure', could be a caption to the picture.

JAN VAN DE CAPPELLE (1626-1679)

A Dutch Yacht firing a Salute as a Barge pulls away, and Many Small Vessels at Anchor 1650

Oil on oak, 86 × 114 cm NG 965

In 1567 an Italian traveller to the Netherlands observed that 'the sea may well be termed not only a neighbour but also a member of these Low Countries'. By 1594 the Haarlem painter Hendrick Vroom was exempted from military duty 'because of his unique skill in painting marine subjects', and his biographer van Mander reported, 'since there is a lot of shipping in Holland, people began to like these ship paintings more and more'.

Where Vroom led, others followed. They learned to depict ships within a single composition sailing under the same wind; to observe wind and weather conditions; and for the first time to represent accurately clouds reflected in the water and filling

the whole 'vault of the sky', which seems to extend from the painted horizon over the viewer's head, no mere backdrop but sharing foreground and middle ground with the ships and water.

The greatest Dutch marine painter was Jan van de Cappelle, rich heir to his father's dyeworks in Amsterdam, amateur collector of paintings, drawings and etchings (he owned some five hundred drawings by Rembrandt). He painted only about two hundred pictures in his lifetime, of which some hundred and fifty were views of estuaries and rivers, invariably with calm waters, stirred at most by a light breeze. The National Gallery owns nine. He was said to have been self-taught, but is known to have copied seascapes by painters of the generation before him.

Like all Dutch marine painters, van de Cappelle is meticulous in the depiction of ships. Here an official yacht with the Dutch colours and a coat of arms on her stern is firing a salute, and a trumpeter on board is sounding. It has been suggested that the grey-haired man standing near the stern of the row-barge in the right foreground is Frederik Hendrik, Prince of Orange (died 1647), and the youth in front of him his son, Prince Willem II. But the figures are not recognisable, and it is unlikely that van de Cappelle would have put Prince Frederik Hendrik in a picture of this kind, which does not seem to depict a specific historical event, three years after his death. In the left foreground is a ferry with a yellow and white ensign, crowded with people; a white horse is leaning into the water as if to drink.

The subject may be nothing more specific than patriotic pride in the variety of Dutch shipping safely plying Dutch coastal waters. But if we compare this painting with the fresh-coloured river view by Salomon van Ruysdael (page 249) we realise that the real theme is tonal variation within chromatic unity: the orange, white and blue of the Dutch flag, muffled to tawny, grey-white and blue as if by a veil of moisture in the air, is expanded throughout the scene over ships, sails and figures, clouds, sky and water, glassy and hatched reflections. Through the luminous haze ships and clouds sail in stately harmony across the canvas.

CARAVAGGIO (1571-1610)

The Supper at Emmaus 1601

Oil on canvas, 141 x 196 cm NG 172

Perhaps no great artist is as well documented in police records as Michelangelo Merisi, the painter from Caravaggio in Lombardy who stalked the streets of Rome with a sword at his side, threw a plate of artichokes at a waiter, fought a duel and killed a man. He subsequently fled Rome, joined the Knights of Malta, insulted a superior, escaped from prison, was disfigured by hired thugs, and died of a malignant fever at Porto Ercole while the ship taking him to Rome and a papal pardon sailed on with his belongings on board. There were those who saw in Caravaggio's dark paintings a reflection of his life. Some thought he had come to destroy art with his depictions of saints as coarse contemporary proletarians. Yet the truth must have been more complicated.

When Caravaggio first arrived in Rome seeking employment, his style was not as dark and rugged as it became later. He specialised in still life, like the one toppling off the table at Emmaus into the viewer's lap, and in pictures of cardsharps and pretty boys pretending to be Eros or Bacchus, Music or the Sense of Touch (like the *Boy bitten by a Lizard* also in the Gallery). His colours were clear and his religious paintings poetic. In time he found patrons among sophisticated princes of the Church and the nobility, and was given the chance to paint altarpieces and religious narratives. Perhaps he experienced a conversion, although the documents do not tell us so. Perhaps he remembered the art of Milan, where he had trained, where Leonardo's 'black' manner (see page 57) had recently been revived and a new climate of reform and piety dictated everyday attitudes and humble dress in religious imagery. From about 1600, with the exception of some portraits, he was never again to paint a secular subject, and soon after his flight from Rome even still lifes ceased to appear in his work.

This painting is at a crossroads between Caravaggio's early and late works (such as Salome receives the Head of Saint John the Baptist nearby). The subject is the first miraculous appearance of Christ to the disciples after the Resurrection, from the Gospel of Saint Luke (24:13–31). An unknown pilgrim has joined Cleophas and his companion on their way to Emmaus. When he blesses and breaks the bread – as he did at the Last Supper – they recognise Christ. Caravaggio follows Titian (page 163) and other Venetian painters in showing the gesture of blessing. His Christ is beardless like the Christ in Leonardo's lost Christ among the Doctors (see the version by Luini in the Gallery) or Michelangelo's Christ in the Last Judgement. The disciple on the right wears the scallop shell, symbol of pilgrims. Cleophas's sleeve is torn. As in Leonardo's Last Supper, to which the composition is indebted, light passes through the carafe onto the tablecloth, which is in turn reflected in the ceramic dish. Cleophas's elbow and the other disciple's arm puncture the canvas surface; we are drawn and prodded into the scene. So compelling is the illusion of reality that we forget its artifice. For in life the harsh light would cast the innkeeper's shadow on the face of Christ, and not leave it radiant as it is here.

ANNIBALE CARRACCI (1560-1609)

Christ appearing to Saint Peter on the Appian Way ('Domine, Quo Vadis?') 1601-2

Oil on wood, 77 × 56 cm NG 9

When the art of painting was dying... it pleased God that in the city of Bologna... there arose a most elevated genius; and with him... art rose again. This genius was Annibale Carracci..., wrote a biographer in 1672. Annibale, the youngest member of a Bolognese family firm which included his cousin Ludovico and brother Agostino, was one of the greatest Italian painters. But his 'reform' of art, fallen into mannered repetition of Michelangelesque formulas (page 134), was made possible by a new climate of opinion and Bologna's situation on the artistic map of Italy. After the Council of Trent church leaders called for a return to earlier ideals of decorum, clarity and empathy in religious art. The northern city of Bologna looked simultaneously to Lombardy, with its double inheritance of realism and Leonardo (page 56), to Venice where Veronese (page 170) was still at work, north across the Alps to Germany and Flanders, and to Central Italy. The churches of neighbouring Parma contained frescoes and altarpieces by Correggio (page 109). The Carracci, so 'mad for drawing' that they ate their meals pencil in hand, sought out influences from all these sources, and founded an academy in which theoretical questions and the merits of individual artists and schools were debated.

Annibale, summoned to Rome by a powerful patron, remained there as head of an active studio and champion of an anti-Caravaggio faction. The antagonism has been exaggerated by posterity, but it is true that, unlike Caravaggio, he tempered realism with Raphael (page 148). To these ingredients he added, as can be seen so poignantly here, Venetian sensibility to the expressive potential of landscape and light (see also Elsheimer, page 115).

This small picture was commissioned in Rome either by the pope, Clement VIII, or by his nephew Cardinal Pietro Aldobrandini to honour his name saint, Peter. According to legend, Peter fled Rome during Nero's persecutions of the Christians. On the Appian Way, he encountered Christ bearing his cross. To Peter's 'Domine, quo vadis?' ('Lord, where are you going?') the Saviour replied that as Peter had abandoned his flock he was returning to be crucified again. Peter turned back and suffered martyrdom.

The viewer is on the Appian Way with Peter, or rather, is Peter meeting Christ. The foot of the cross protrudes from the panel, Christ's hand points outwards, and the shadows he casts attest to his corporeality as he strides toward us. While Peter's left foot remained in place, the rest of the figure was altered during painting, drawn back to the right edge of the panel in an attitude halfway between terror and obeisance, more deeply felt than his earlier pose but also making room for our implied presence. Firm contours delimit Christ's athletic body, yet its internal modelling is subtly lifelike, rippling with the movement of muscles and the angle at which surfaces catch the light. It is obvious that this figure was based on a live model, for his hands and lower legs are more sunburnt than his torso and thighs, although the face he turns to Peter is an idealised mask of pathos under the crown of thorns. Despite the dual sources of light from the background and in the foreground, the same sun seems to warm sky, trees, fields and Roman temples, and the crimson, white, gold and blue draperies, the metal keys, the youthful and the aged flesh and the chestnut and grizzled hair of the two wayfarers at the crossroads between time and eternity.

PHILIPPE DE CHAMPAIGNE (1602-1674)

Cardinal de Richelieu 1633-40

Oil on canvas, 260 x 179 cm NG 1449

Born in Brussels, Philippe de Champaigne settled in Paris in 1621 and became one of the city's leading artists, painting portraits and religious compositions for the Queen Mother, Marie de' Medici, the court of Louis XIII, the city administration, fashionable congregations and private individuals. Trained in Flanders and influenced by his compatriots Rubens and Van Dyck (pages 242, 200), he gradually rejected the flamboyance of their style for a more severe and naturalistic idiom. The change is particularly noticeable after 1645, when he became sympathetic to the rigorous doctrines of the Dutch Catholic theologian Cornelis Jansen practised at the Paris convent of Port Royal, where Champaigne sent both his daughters.

The sitter for this grandiose portrait, however, is obviously not one of the artist's Jansenist patrons. Where they wear sober black, he – as a cardinal – wears crimson; where they appear against a plain grey background, he stands in a palatial gallery against a great Baroque swathe of curtain, a glimpse of his château gardens behind him. He is Armand-Jean du Plessis, Duc de Richelieu (1585–1642), cardinal, Chief Minister to the King and virtual ruler of France from 1624 until his death. Richelieu consolidated the central powers of the crown and suppressed the rebellious Huguenots. He created the French merchant navy and effective fighting fleets in both the Atlantic and the Mediterranean. On land, he challenged the might of the Habsburg Empire. To readers of Alexandre Dumas he will always be the haughty antagonist and sometime patron of the (four) *Three Musketeers* – but then, Dumas had Champaigne's portraits of Richelieu on which to base his unforgettable character.

Unable to have himself portrayed as ruler, Richelieu stands in the pose traditionally associated with French monarchs. (Neil MacGregor has pointed out to me how rare it is for a cardinal to be shown standing - 'Like women, they sat'; although for an exceptional standing woman, see page 130.) Richelieu wears the chivalric Order of the Saint-Esprit, its blue moiré ribbon contrasting with the starched white linen and the crimson satin of his collar and cloak. Instead of a baton or cane, he holds a scarlet biretta in his stiffly extended right hand. This extraordinary object seems to float up to the surface of the canvas in defiance of spatial logic; as it hypnotically draws our glance we become aware of its tacit message. Champaigne has carefully shown its inner lining catching the light, thus drawing attention to our viewpoint from below - an optical fact underscored by the low horizon line beyond. We are gazing upwards at Richelieu, his face the distant apex of an elongated pyramid down which lustrous drapery flows like lava. Although diminished in scale by the distance between us, the face is undistorted by foreshortening (see also page 202), like the majestic images of Christ the Ruler in the apses of Byzantine churches. But where these spiritual icons look deep into our eyes, the King's Minister stares haughtily out, allowing us to look at him... as a cat may look at a king.

CLAUDE LORRAIN (1604/5?-1682)

Seaport with the Embarkation of the Queen of Sheba 1648

Oil on canvas, 149 x 197 cm NG 14

When Claude Gellée arrived as a boy in Rome from his native Lorraine, perhaps to serve as a pastry cook, landscape painting was already a recognised speciality (see Patinir, page 146; Annibale Carracci, page 188; Domenichino, page 197; Elsheimer, page 115). Claude, however, was to surpass all previous practitioners. His poetic reinventions of a Golden Age, appealing to a cultivated aristocratic clientele, were assembled in the studio from drawings made out of doors in Rome and the surrounding countryside and in the Bay of Naples. The German painter Sandrart, who accompanied him on sketching trips, described his procedures:

[Claude] . . . only painted, on a small scale, the view from the middle to the greatest distance, fading away towards the horizon and the sky. . . [he is an example to all] of how one can order a landscape with clarity, observe the horizon and make everything diminish towards it, hold the colouring in proportion with the depth, each time represent recognisably the time of day or the hour, bring everything together in correct harmony by accentuating strongly the front and shading off the back in proportion. . .

Claude's influence indeed became all-pervasive, most of all in eighteenth-century England, where it affected not only painting and collecting but the very ways in which real landscape was viewed and artifical parkland constructed.

Like many of Claude's pictures, the Seaport with the Embarkation of the Queen of Sheba was conceived as one of a pair; its companion, the Landscape with the Marriage of Isaac and Rebekah ('The Mill'), is also at the National Gallery. Although the Gallery's 'Mill' is a virtual replica of a composition begun earlier for the nephew of Pope Innocent X, which is now in the Galleria Doria Pamphilj, Rome, the two paintings at Trafalgar Square were commissioned together in May 1647 by the Duc de Bouillon, French general of the papal armies, and completed the following year. Both relate (through inscriptions, our only clues to their subjects) to stories from the Old Testament on the theme of love, or esteem, between men and women, and recounting fateful journeys.

Claude follows his usual method of simultaneously harmonising and contrasting two 'pendant' pictures: the *Marriage of Isaac and Rebekah* is a landscape in late summer afternoon, the *Embarkation* a coastal view, depicted in early morning light like all of Claude's *Embarkations*. The Queen of Sheba's land journey 'with camels... and very much gold' to visit King Solomon (1 Kings 10: 1–2) is transformed into the viewer's own imaginary voyage, leaving harbour to sail on the open sea towards the light. (The queen, a small figure in red, descends the stairs to be rowed out to her vessel moored on the horizon.)

Including the sun within a painting was Claude's greatest early innovation. Exactly halfway up the canvas in this stateliest of his seaport compositions, it is the basis of its pictorial unity, all the colours and tones adjusted in relation to it; Claude's palm and finger prints can be seen in many places in the sky where he smoothed transitions from one passage to the next. The boy sprawling on the quayside shields his eyes from the sun's dazzle, and its rays gild the rounded edges of the fluted column and Corinthian capital beside him.

CLAUDE LORRAIN (1604/5?-1682)

Landscape with Aeneas at Delos 1672

Oil on canvas, 100 x 134 cm NG 1018

In the last ten years of his life Claude painted six stories of Aeneas, hero of Virgil's *Aeneid* – the Latin epic describing the legendary origins of Rome. The theme seems to have been suggested by Claude himself. He chose scenes which had never been illustrated before; they do not form a series, nor were they painted in the order in which they appear in the *Aeneid*. As if echoing Virgil's 'I am that man who in times past tuned my song on the slender reed [of pastoral poetry]', the painter turned, at the age of 68, to sing the voyages of the survivor 'fated to be an exile... the first to sail from the land of Troy and reach Italy'. These six Aeneas pictures, of which *Aeneas at Delos* is the first, represent Claude's most personal achievement, attaining a nobility of style visually equivalent to the grandeur of Virgil's poem.

Throughout the 1640s and 1650s Claude had often illustrated Ovid's *Metamorphoses*, and it may be through the *Metamorphoses* that his interest in Aeneas' adventures was first aroused. In Book XIII Ovid relates the hero's flight from burning Troy; Claude's painting is based as closely on this passage as on Virgil's description in Book III of the *Aeneid*. Ovid tells how – taking with him sacred images of the gods, his father Anchises (the bearded man in blue) and his son Ascanius (the child on the right) – Aeneas (in short red cloak):

set sail...and...reached with his friends the city of Apollo [Delos]. Anius [in white on the left], who ruled over men as king and served the sun god as his priest, received him in the temple and his home. He showed his city, the new-erected shrines and the two sacred trees [olive and palm] to which Latona had once clung when she gave birth to her children [Diana and Apollo].

The stone relief atop the portico in the foreground represents Diana and Apollo slaying the giant Tityus, who tried to ravish their mother.

Smaller, more rarefied in its silver-blue tonality than the *Embarkation* reproduced on the previous page, this is one of the most evocative pictures ever painted. The figures, elongated perhaps in the belief that the ancients were taller than we, are dwarfed by the sacred trees and the majestic buildings. Apollo's round temple, an imaginative recreation of the original appearance of the Pantheon in Rome, may have been intended to remind us of the Delian oracle's prophecy of Rome's future splendour. Meditation on time is at the very heart of the painting. A dual longing, for both the Trojan past and Aeneas' future as founder of Rome, is embedded in the perspectival construction. The projecting lines of the architecture meet at the level of the horizon to the left of the canvas, while the lines of the road converge to the right. As the painter Paula Rego said recently, '...there is a kind of mood to do with time that can only be put down if you use perspective'.

AELBERT CUYP (1620-1691)

River Landscape with Horseman and Peasants late 1650s

Oil on canvas, 123 × 241 cm NG 6522

The son and pupil of a portrait painter in the Dutch city of Dordrecht, Cuyp came to specialise in landscape in the manner first evolved by Jan van Goyen; in the early 1640s he changed his style under the influence of the Dutch Italianate landscape painters (see page 180). From that time onwards his landscapes, whether real or imaginary, acquired a certain grandeur and were bathed in the honeyed light of the Italian Campagna. In 1658 Cuyp married a wealthy widow from one of Dordrecht's leading families with a strong Calvinist tradition. After his marriage he became a deacon of the Reformed Church and took on numerous public offices, devoting progressively less time to painting. His later work was commissioned by members of the Dordrecht patrician class for specific locations in their spacious town houses – in contrast with the

majority of Dutch seventeenth-century landscapes, which were not commissioned but executed for sale on the art market.

A location high above the wainscot in just such a house was the probable original destination of this large canvas, arguably the finest of all Cuyp's landscapes. An imaginary view, with mountains on a scale not be found anywhere in the Netherlands, and below them the visible remains of a feudal past, it is designed to flatter the sensibilities of patrician owners. An aristocratic horseman surveys his happy flocks, the source of Dutch prosperity, and the happy peasants tending them. On the far left a huntsman is about to shatter for a moment the golden peace of the afternoon. Hunting was largely a privilege of nobility in the United Provinces of the time, and still lifes of dead game a popular subject in households aspiring to aristocratic status, but regardless of social allegiance we are drawn to Cuyp's idyllic countryside.

The painting, purchased by the National Gallery in 1989, has an additional importance for a British national collection: it seems to have been the first work by the artist to enter this country. Bought for the third Earl of Bute in about 1760, it initiated the enthusiasm for Cuyp in Britain, where the majority of his best pictures can still be found and where they had a powerful formative effect on the evolution of landscape painting. A print made after the painting by the English printmaker William Elliot in 1764 shows a higher sky and gives the dimensions as some twenty-five centimetres taller than at present, but no evidence has been found that the painting was ever cut down.

CARLO DOLCI (1616-1686)

The Adoration of the Kings 1649

Oil on canvas, 117 \times 92 cm NG 6523

The personality and work of Carlo Dolci, one of the most prized painters of his day, could hardly be less in tune with the values of our own time. As a child in his native Florence, he was so pure and pious, writes a contemporary, that he inspired other children with the love of God. On the morning of his wedding day, his friends had to scour the churches of Florence, finding him lost in prayer in SS Annunziata. He frequented the Confraternity of Saint Benedict, whose motto was 'To work is to pray', and, although also a gifted portraitist, he decided to devote himself wholly to sacred images, which could 'bring forth the fruits of Christian piety in whoever looks at them'.

Dolci was not inventive, often basing himself on the compositions of others – as he does in this picture – and making several variations of each image, so lovingly painted that they are best thought of as 'multiple originals'. A painstakingly slow worker, he sometimes spent as long as a week painting a single foot. He refused high prices and, despite being in enormous demand among 'the foremost monarchs of the world' and private collectors, had some difficulty in making ends meet. He is said to have fallen into terminal depression after the flashy Luca Giordano (page 206) told him he would need to speed up his work if he were not to die of hunger. The majority of his paintings were small, depicting either half-figures on the scale of life, like his *Virgin and Child with Flowers* also in the National Gallery, or 'little stories' with small full-length figures, like this picture.

Why, then, was the Gallery so eager to acquire this, one of his finest works, in 1990, and why does it merit close study by visitors? Contemporaries praised Dolci's drawing, his diligence, his faultless technique, the gracefulness of his figures, the boldness of his colouring, as much as his religiosity. All these traits are exemplified here. The painting

is in superb condition; unusually for a work from this period, it has not had to be relined with new canvas, and remains on its original stretcher and in its original frame. The artist signed and dated it on the back and, as he often did, added a devout inscription on the stretcher bars. The Magi's gifts of gold are executed in paint, but the 'real', spiritual, gold of the haloes of the Holy Family and radiating from the Christ Child is painted in ground gold leaf applied with a fine brush. The best and costliest ultramarine is used for the blue of the Virgin's robe; gold leaf underlays the translucent paint of the jewels on the oldest king's cloak.

All this might be of interest only to specialists, were it not for the poetic intensity of the picture. Its charm does not depend on the sumptuousness of the Magi's garments, the subtlety of the glazing, the play of light and colour in the dark stable. If we take the time to look, we are drawn into another world, at once miniature and monumental, sophisticated yet candid, free of envy, devoid of doubt, where grace abounds and the mighty pay homage to a Child.

DOMENICHINO (1581-1641)

Apollo killing the Cyclops 1616-18

Fresco, transferred to canvas, 316 × 190 cm NG 6290

Domenico Zampieri, called Domenichino – 'Little Dominic' – because of his short stature, was a Bolognese pupil of the Carracci (page 188). After Annibale's death in 1609 he became one of the leading painters in Rome, and one of the chief proponents of an idealised style based on the study of Raphael (page 148) and Greco-Roman antiquity, in rivalry with the partisans of Caravaggio (page 187). Poussin (page 230) worked in his studio soon after his own arrival in Rome, and was much influenced by him.

Domenichino was equally adept in oils – on canvas, wood and copper – and in the demanding medium of fresco, in which pigments bound in lime water are applied directly to freshly plastered areas of wall, chemically bonding with the plaster as it dries. Understandably, not many frescoes find their way into museums and galleries, and Domenichino's famous paintings in the churches of Rome and Naples remain in place. In the eighteenth century, however, a method of detaching frescoes from walls was evolved in order to preserve them from destruction (it involves gluing gauze onto the fresco, peeling it off with a film of painted plaster adhering to it, fixing the back of this

film with a stronger adhesive to a new support, then removing the gauze from the surface). Domenichino's frescoes in the National Gallery were treated in this way sometime around 1840. They once decorated the Stanza di Apollo, a garden pavilion built in 1615 at the Villa Aldobrandini in Frascati, the rural retreat of Cardinal Pietro Aldobrandini. Two other scenes remain in situ on the wall. It was not uncommon at this time, in imitation of the Ancient Romans, to paint vistas of the surrounding countryside, or an idealised version of it, in such buildings.

The mythological stories in the landscape frescoes of the Stanza di Apollo depicted the sun god as death-dealer; his beneficent aspect as patron of the arts was revealed in a fountain on the end wall showing Apollo and the Muses on Mount Parnassus, a hidden water organ beneath lending sound to the sculpted musical instruments. The recherché programme and obscure sources of some of the painted scenes suggest the collaboration of a learned adviser. This episode derives from *The Library*, a book on Greek mythology by the second-century BC Greek scholar Apollodorus. Apollo, freely copied from the ancient statue of Apollo Belvedere in the Vatican, slays the Cyclops, a one-eyed race of giants, because they had provided Zeus with the thunderbolts which killed Apollo's son, Aesculapius.

An additional layer of complexity is provided through the framing, which suggests that the frescoes are not actual scenes witnessed through picture windows, but costly woven hangings. A similar illusionistic device was used by Raphael for a room in the papal apartments in the Vatican. The corner of the 'tapestry' reproduced here is lifted to reveal a barred window, once symmetrical to a real one in the wall opposite. Chained to the bars is the cardinal's dwarf, with a cat tearing apart a roasted quail and 'vile leftovers' at his feet. His ungainly frame contrasts with the beauty of Apollo and his small stature with that of the giants. He is supposedly being punished for his insolence. The cruel joke is reported to have so embittered the poor man that when the fresco was unveiled he retreated to his room 'staying there all day with an empty stomach'. Yet Domenichino's pathetic and lifelike portrait remains among the most moving in the collection.

GERRIT DOU (1613-1675) A Poulterer's Shop about 1670

Oil on oak, 58 × 46 cm NG 825

The son and pupil of a Leiden glass engraver, Dou also studied with a copper engraver and a glass painter before becoming Rembrandt's (page 235) first pupil in 1628. He was then 15, Rembrandt only 22, and so great was his teacher's influence on Dou that the attribution of certain paintings from this period has swung between the two. After Rembrandt moved to Amsterdam in 1631/2 his style shifted from the high finish of his early pictures to a broader, freer manner. Dou, however, continued to work in the same miniaturist vein, often returning to the brilliant colours of the glass painter. The enamel-like technique which enabled him faithfully to reproduce any texture, his mastery of light and shade, and the intriguing details of his paintings earned him an international reputation. He refused the invitation of Charles II to come to England, preferring to stay in his native city where he founded the local school of fijnschilders ('fine painters'), which continued into the nineteenth century.

Dou popularised 'niche' paintings such as this one, with interiors seen through a window or other aperture. Like other Dutch masters of 'everyday life', he was a selective

realist, his pictures composed in the studio, his motifs chosen to show off his special skills. The 'antique' bas-relief of children playing with a goat, for example, derives from a sculpture executed in Rome sometime before 1643 by the Fleming, François Duquesnoy; it is known to have been copied in stone and ivory, and is seen frequently in Dou's pictures from 1651 onwards. Here it is used to emphasise the flatness of the oak panel on which Dou has created, with his brush, both the projecting relief of the sculpture and the shadowy depths of the poulterer's shop behind. At the same time it contrasts a sculptor's stony imitation of reality with the painter's convincingly lifelike version.

At one level it is easy to see what is happening in this picture: an eager young woman points to a dead hare shown her by the elderly woman poulterer; in the foreground, a caged fowl leans out to drink, unmindful of the dead game birds sprawling over the sill. Inside the shop a birdcatcher is in conversation with another woman. Other cages hang at the window and from the ceiling. Plumage, shining metal, stone,

cloth, smooth and wrinkled skin – the varied surfaces are, as always in Dou's paintings, brilliantly described and differentiated. Yet the girl's exaggerated pose and expression may suggest an additional significance.

Many of Dou's pictures have been interpreted as contrasting innocence and experience, and that may also be the comic theme of this painting. Seventeenth-century texts indicate that in Dutch and German <code>vogel</code> (bird) was often synonymous with the phallus, <code>vogelen</code> (to bird) was a euphemism for sexual intercourse, and <code>vogelaar</code> (bird-catcher) could refer to a procurer or lover. Empty birdcages could symbolise the loss of chastity, and in some images indicate a brothel. It is always risky to interpret paintings from a list of symbols, like translating a foreign language with the aid of a dictionary. But it does not seem to me too far fetched to suggest that here the girl's enthusiasm is being compared with the caged fowl's thirst. Surrounded by emblems of sexuality, she is reaching out for a hare, in a secular context associated (like the fecund rabbit) with lust. But as the poulterer's fowl will leave its cage only for the pot, so the girl should beware before drinking too eagerly of experience, and losing her childhood innocence.

ANTHONY VAN DYCK (1599-1641)

The Emperor Theodosius is forbidden by Saint Ambrose to enter Milan Cathedral about 1619–20

Oil on canvas, 149 × 113 cm NG 50

Something of the brittle melancholy with which Van Dyck endowed the Stuart court clings to the artist himself. Precocious and highly strung, he passed through life like a shooting star, incandescent, soon burnt out. The paintings he left behind, however, continue to bewitch us. His ideal of languid elegance informs ours. There is hardly a society portrait of the last three hundred years that has not deferred to the tapering-fingered glamour conferred by him on Flemish compatriots, Genoese grandees, Roman prelates and English nobles. Because of Van Dyck we know the cut of a vandyke beard or collar, the colour of vandyke brown; we mourn the Cavaliers and their martyr-king.

The poignancy of Van Dyck's religious imagery and the lyricism of his mythological narratives affect us less – mainly because his career in England permitted him to paint fewer pictures in these genres, but perhaps also because the artist's most profound feelings are filtered through a repertoire of gestures and expressions which have come, in a later and less emotionally demonstrative age, to seem febrile or insincere.

Following a curtailed apprenticeship with an Italianate painter in Antwerp, Van Dyck, an independent master at a youthful age, moved further and further into the orbit of Rubens (page 242) who had returned from Italy to Antwerp in 1608. Around 1618 he entered Rubens's studio as an assistant, quickly assimilating the older artist's style and methods of working, but with a dashing freedom and surface brilliance particular to himself.

The differences in the two painters' approach are observable in this picture, a free copy of a large painting now in Vienna executed in Rubens's studio, possibly by Van Dyck himself. The finely drawn profile to the right of Saint Ambrose has been identified as a portrait of Nicolaas Rockocx, the friend for whom Rubens painted Samson and Delilah (page 247). Saint Ambrose, the fearsome fourth-century Archbishop of Milan, is said to have refused Theodosius entry into the cathedral because of the emperor's vengeful massacre of the inhabitants of Thessalonica. In the Vienna picture the figures

have weight and substance; a sturdy, almost bewildered emperor is physically halted by the massive presence of the saint. In the Gallery's variant the physicality of the encounter is diminished, to be replaced by something at once psychologically more thrilling and more decorative. Theodosius impetuously thrusts his face – now beardless, less Flemish and closely resembling an emperor's profile on a Roman coin or medal – upwards towards the saint. Ambrose's sturdy vigour has been transferred to the crozier – in the original less stout, more ornamental and symbolic – as if the priest who holds it for the saint were ready to bring it crashing down on the emperor. Ambrose's cope in the Vienna painting looks as heavy as lead, its elaborate pattern barely disturbed by the saint's gesture. Here, its cloth-of-gold shimmers and appears to float on the very surface of the canvas, agitated by the saint's indignation and by the current of spiritual energy which flows from God through the holy archbishop's insubstantial frame.

ANTHONY VAN DYCK (1599-1641)

Equestrian Portrait of Charles I about 1637-8

Oil on canvas, 367 x 292 cm NG 1172

King Charles I (1600–49) succeeded his father James I in 1625. The union of the Kingdoms of England and Scotland, a matter of political, juridical and ecclesiastic controversy throughout his life, is celebrated in the Latin inscription on the tablet tied to the tree in this portrait: CAROLUS REX MAGNAE BRITANAE – Charles King of Great Britain. Van Dyck's international reputation, his knowledge of contemporary painting and his devotion to Titian (page 163), whose work he had avidly studied during his stay in Italy between 1621 and 1627, particularly recommended him to the art-loving king.

The painter had already spent a brief period in 1620–1 in the service of James I. Back in Antwerp after his Italian travels, and in demand as a painter of religious and mythological pictures as well as of portraits, he resumed his contacts with the English court. Charles was given, and commissioned, works by him. By April 1632 he had succeeded in attracting Van Dyck to London. In July of that year the artist, now Principal Painter in Ordinary to their Majesties, was knighted at St James's. From that time he was to have a virtual monopoly of portraits of the king and queen on the scale of life, having rendered the work of his predecessors at court old-fashioned. In a series of huge canvases strategically placed at the end of great galleries in the king's various residences, he displayed the power and splendour of the British monarchy and of the early Stuart dynasty, modernising traditional themes of royal panegyric.

This likeness of the king on horseback takes as its point of departure the archetypal image on the obverse of all the Great Seals of England: the sovereign as warrior. King Charles is wearing Greenwich-made armour and holding a commander's baton. A page carries his helmet. In keeping with the imperial claim of the inscription, the pose and woodland setting echo Titian's equestrian portrait of the Emperor Charles V at Mühlberg (now in Madrid), when the Catholic monarch defeated a league of Lutheran princes in the cause of Christian unity. (Titian's painting itself recalled the famous Roman bronze of the Emperor Marcus Aurelius on horseback.) Over his armour Charles wears a gold locket bearing the image of Saint George and the Dragon, the socalled Lesser George. He wore it constantly; it contained a portrait of his wife, and was with him the day he died. Here, however, it identifies him with the Order of the Garter of which Saint George was patron. As Garter Sovereign he is riding, like Charles V, at the head of his chivalrous knights in defence of the faith. In a profound sense the portrait is a visual assertion of Charles's claim to Divine Kingship. Albeit high above our heads - the horizon line ensures that our viewpoint is roughly at the level of his stirrup - his face is undistorted by foreshortening (see also page 190). Van Dyck's three-quarter view refines his features, and he bestrides his horse with a remote air of noble contemplation.

ANTHONY VAN DYCK (1599-1641)

Lord John and Lord Bernard Stuart about 1638

Oil on canvas, 238 x 146 cm NG 6518

Early in 1639 the two Stuart brothers, cousins of King Charles I and younger sons of the third Duke of Lennox, set off on a three-year tour of the Continent. They must have posed for Van Dyck just before their departure. Since his arrival at the court, the artist had developed a new portrait type: the double portrait recording friendship, often, but not necessarily, between relatives. (Another magnificent example at the National Gallery is the three-quarter length of the daughters of Earl Rivers, the Viscountess Andover and Lady Thimbelby.) The two brothers are shown as if poised on the point of departure, waiting perhaps for servants to bring up their carriage. Both were to die a few years later in the Civil War, and hindsight gives the image an added valedictory poignancy.

The younger brother, Lord Bernard, later Earl of Lichfield (1622–1645), is shown in the more active stance, one foot on the stair, gloved hand on hip, glancing over his shoulder at the viewer. (A drawing for this complex pose, excluding the face, has been preserved and is now in the British Museum.) The elder, Lord John (1621–1644),

represents the more contemplative nature, leaning in elegant abstraction against a pillar. The device is an artful means of constructing a composition at once diversified and coherent, in motion yet stable. The figures twist apart above the cluster of booted, belaced, befringed legs on the step. Their faces, with the long Stuart noses and prominent chins, are drawn in mirror-image three-quarter views; the diagonal alignment of the heads is echoed in the line implicitly linking Lord John's right hand with Lord Bernard's left. But the composition also preserves familial hierarchy: it is the elder son who stands higher.

Convincing though the characterisations now seem, they may be misleading. The contemplative-seeming Lord John was described after his death as 'of a more choleric and rough nature than the other branches of that illustrious and princely family, [he] was not delighted with the softness of the Court, but had dedicated himself to the profession of arms'. The haughty-looking Lord Bernard was said to be 'of a most gentle, courteous and affable nature'.

Van Dyck's compositional skill is surpassed only by his matchless ability to depict satin, lace and meltingly soft kid leather. But these carefully described effects are somehow not local: the whole surface of the canvas is brought alive with a flickering touch. The costumes, so fashionably similar, are beautifully contrasted – receding warm gold and brown on Lord John, cooler and advancing silver and blue on Lord Bernard – so that the two brothers, complementing each other in apparel as in character, seem to form one shimmering, indivisible whole.

CAREL FABRITIUS (1622-1654)

A Young Man in a Fur Cap and a Cuirass (probably a Self Portrait) 1654

Oil on canvas, 70×62 cm NG 4042

This resolute likeness most probably represents Carel Fabritius only months before he was fatally wounded in his studio in Delft by the explosion of a gunpowder magazine on 12 October 1654. (The aftermath of the disaster is recorded in a painting by Egbert van der Poel, also in the Gallery.) The son of a schoolmaster and Sunday painter who may have taught him the rudiments of the art, Fabritius studied with Rembrandt (page 235) between around 1641 and 1643. Only eight certainly authentic works by him survive. The National Gallery is fortunate in owning two: this portrait, and a curious small *View of Delft* which may have formed part of a perspective box or peepshow. Fabritius is also recorded as having made illusionistic perspective wall paintings, but none is known.

Fabritius proved to be Rembrandt's most gifted and original pupil. At the time of his death at 32 he had already evolved a style and technique at variance with his teacher's. While Rembrandt normally – although not invariably – set his sitters in light against a dark background (see page 237), Fabritius's silhouette looms starkly against a cloudy

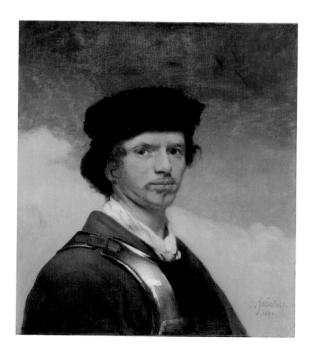

sky – colder and less agitated than the one Rubens painted behind Susanna Lunden (page 246) – impastoed white highlights on the metal thrusting the cuirass forward in space. His preparation of the canvas was also quite different. Rembrandt preferred a double ground, a cool grey superimposed over orange-red; analysis has shown that the single ground of this picture is a light cream colour.

Rembrandt had painted himself wearing a military breastplate or gorget (a collar-like piece of armour) in the late 1620s and 1630s, and this became a popular type of self portrait among his pupils. Its significance has been much debated, some scholars arguing that it suggests Dutch patriotism, a readiness to champion the homeland's hard-won independence, others denying that any such topical meaning could have been intended. Military armour, like pastoral costume, Italian Renaissance or Burgundian dress (see page 184), was thought to be less susceptible to the vagaries of fashion than civilian outdoor wear, and thus more 'timeless'. Fabritius's fur cap also seems anachronistic, its shape closer to the outline of sixteenth-century headgear than to contemporary hats. But perhaps Rembrandt's invention of a timeless or heroic type of portrait had a more personal significance for Fabritius.

His surname, sometimes used by his father and adopted by the artist by 1641, is derived from the Latin word *faber*, meaning manual workman, and was applied to smiths, building workers and carpenters. Fabritius worked as a carpenter before entering Rembrandt's studio, and a probable self portrait of about 1648–9 showing him in coarse working dress (now in Rotterdam) has been interpreted as alluding both to his former occupation and to his name. 'Fabritius' has, however, another, altogether grander significance. C(aius) Fabritius or Fabricius was a soldier and consul of the Roman republic, celebrated for frugality, courage and integrity. His story was familiar from Plutarch's account, and a fellow student in Rembrandt's studio was later to paint an episode from his life in Amsterdam Town Hall. The last records of C(arel) Fabritius in Delft speak of mounting debts but growing professional recognition. If the Rotterdam picture depicts Fabritius/*faber* the craftsman-painter, might not the National Gallery portrait recall the man of whom Virgil wrote 'Fabricius, poor, yet a prince'?

LUCA GIORDANO (1634-1705)

Perseus turning Phineas and his Followers to Stone about 1680

Oil on canvas, 275 × 366 cm NG 6487

Rarely has an artist been as prolific and energetic as Luca Giordano, nicknamed *Luca fa presto* ('speedy Luke'). Trained in his native Naples, he left about 1652 to study in Rome, Florence and Venice. This painting is a superb example of the exuberant style which he forged from these varied sources. Especially indebted to the brio and colourism of the great Venetians Titian and Veronese (pages 163, 170), it owes its disciplined organisation of an exceptionally large surface to the example of the Romano/Florentine painter and architect Pietro da Cortona. The device of silhouetting figures against a light and insubstantial background was characteristic of Giordano's compatriot Mattia Preti. Eclectic though it is, however, the picture is recognisably Giordano's.

Tempestuous action and firm composition, light against dark, good versus evil and beauty juxtaposed with horror – these opposites govern many works by the artist. His easel paintings and his wall and ceiling decorations throughout Italy earned him international fame. From 1692 until 1702 he worked at the court of Spain with tireless energy, which he was able to maintain after his return home, and he was still vigorously at work when he died.

Over three and a half metres wide *Perseus turning Phineas and his Followers to Stone* from Ovid's *Metamorphoses* (v, 1–235) is the largest mythological painting in the National Gallery. It was one of three vast canvases by Giordano decorating a reception room in a Genoese palace. The second painting, the *Death of Jezebel*, illustrates an incident in the Old Testament (2 Kings 9:30–7) and the third was the *Rape of the Sabine Women* from the history of Ancient Rome. (Why themes of violence and lust were so popular as room decoration in the seventeenth century is one of the mysteries of art history.)

Andromeda had long been betrothed to Phineas when she was offered in sacrifice to a marine monster. After the hero Perseus rescued her, she married him instead and the wedding was followed by a great banquet, bloodily interrupted by Phineas coming to claim the bride. Outnumbered, Perseus was forced to bring out his secret weapon – the snake-haired head of the gorgon Medusa, which turned to stone those who looked on it. Giordano daringly depicts the moment of Phineas' and his men's transformation – they are turning grey from head and hands downwards, before our very eyes.

Even if we did not know the story, it would be clear which figure is the hero. Dividing the composition diagonally in half from upper left to lower right, the artist isolates Perseus on the right. Dressed in the purest blue in the painting, he is the only figure to face the viewer (with the exception of Medusa, whose horrid gaping-mouthed visage is carefully contrasted with his own beautiful resolute head). The pose is justified narratively: Perseus must avert his gaze from Medusa in order to remain alive. Phineas in an elaborate fancy helmet is at the extreme left; by letting his men fight in front of him, he is shown up for a villain. The composition is held firmly in check and the narrative clarified not only by tone, line and pose but also through colour, in the bold patches of pure yellow and blue of two mirror-imaged antagonists, and in the red of the great curtain at the right, which stand out against the broken and mixed hues of the mêlée of dead bodies, overturned tables and fleeing revellers.

EL GRECO (1541-1614)

Christ driving the Traders from the Temple about 1600

Oil on canvas, 106 x 130 cm NG 1457

When Domenikos Theotokopoulos left Crete for Venice around 1558, he abandoned his name as well as his native land, and was identified forever after as an alien. 'El Greco' conflates the Italian for 'the Greek', *il Greco*, with the Spanish equivalent *el Griego*, his nickname in Toledo where the artist had settled by 1577. Trained as a painter of icons in the Byzantine style, he became a pupil of Titian (page 163) in Venice and was also influenced by Tintoretto and Bassano (pages 160, 103). After a trip to Parma to study the work of Correggio and Parmigianino (pages 109, 143) he spent some years in Rome, where, despite his admiration for Michelangelo (page 134), he offered to repaint the *Last Judgement*, to eliminate the 'indecent' nudes.

In Spain El Greco's pictures failed to please King Philip II and he worked mainly for churches and convents. He painted several versions of most of his compositions, including this one, and still further versions were often produced by his studio assistants. The subject of this picture, also called 'The Purification of the Temple', comes from the Gospel of Saint Matthew (21:12–14). Jesus enters the temple at Jerusalem and casts out the moneychangers and merchants of sacrificial doves, saying, 'My house shall be called the house of prayer, but ye have made it a den of thieves'. In the stone relief between the columns to Christ's right, El Greco has depicted the Old Testament episode of the Expulsion of Adam and Eve from Paradise, and in the relief to his left the Sacrifice of Isaac, at the moment when the angel stays Abraham's hand from killing his beloved son. The Expulsion seems to echo the violence of Christ's gesture as he swings the whip in his right hand, causing havoc among the traders on that side of the picture.

His peaceably extended left hand may signal forgiveness to the figures beside it; their poses suggest meditation, acceptance and contrition. Since the Sacrifice of Isaac was understood as an Old Testament prototype of the Crucifixion, these figures may symbolise the repentant sinners saved through Christ's Passion.

El Greco has adapted details from engravings after Italian Renaissance masters, and the scene as a whole is indebted to drawings by Michelangelo. Nonetheless, it is powerfully individual. The elongated Christ is set in the centre and isolated from the others through the crimson red of his robe, the only area in which the colour is used, and by the darkest shadows and strongest highlights. As the other figures rotate around him, activated by the swing of his arm and of the blue strip of his cloak, he appears like the hub of a wheel seen in ellipse from above. Bold jagged blues and yellows combine and recombine in different patterns and mixtures against an all-pervasive grey which draws together, as the painter Bridget Riley has pointed out, the flesh colours and the stone of the architecture.

El Greco's solemn treatment of this theme, devoid of the traditional trappings of doves and scattered coins, may indicate that he and his patrons regarded it as symbolic of the contemporary Counter-Reformation movement to purify the church and purge it of Protestantism and heresy.

GUERCINO (1591-1666)

The Dead Christ mourned by Two Angels about 1617-18

Oil on copper, 37 × 44 cm NG 22

'Guercino' means 'squint-eyed' and is the unpromising nickname under which the artist Giovanni Francesco Barbieri won international fame. Coming from Cento, a small town equidistant between Ferrara and Bologna, he was virtually self-taught and like many seventeenth-century artists was able to choose his own influences. He looked to Bologna, to the work of the Carracci (page 188) and to paintings by Caravaggio (page 187) in private collections, forging from these a lyrical idiom of his own.

A local nobleman having lent him rooms in his house, Guercino founded there an Academy of the Nude, where he and his followers were able to draw from the model. The figure of Christ in this beautiful small painting on copper palpably relies on just such a study from life, in the words of a contemporary, 'in a manner at once relaxed and grandiose, obtaining with decisive strokes of white chalk and charcoal on tinted paper marked contrasts of light and shade which provoked wonder'. Guercino subtly translates the tonal code of white and black into colour. In this picture, pure red and blue in the angel's sleeve and the sky, and pure white and black paint, are intermixed and blended with an earth colour to produce a wonderful range of ashen violets and misty ochres, against which the body of Christ on his luminous shroud glows like a golden-tinged pearl. The subject is a free version of the traditional Venetian theme of two angels holding up the dead Christ beside his tomb for the viewer's pious meditation: it does not illustrate any biblical text. The wounds of Christ are discreetly suggested. Pathos arises from the juxtaposition of beauty with grief, of close observation in the studio with poetic invention, and the borderline between them is as blurred as the melting contours between flesh and stone, feather and cloud.

Guercino may have taken the picture with him to Rome when he was summoned there by a Bolognese patron elected pope in 1621. After a heady start, he was evidently intimidated by the example of High Renaissance painting and by the work of his competitors, the Bolognese Reni and Domenichino among them (pages 239, 197), and

adopted a classicising style which relied less on shadow, bold foreshortenings and study from life. With the death of the pope in 1623 Guercino returned to Cento, where he pursued a successful career providing easel paintings to clients throughout Europe. He resisted offers from the French and English kings to work at their courts. After the death of Reni he moved to Bologna, where he became the leading painter. In the best works from this late period of his life, like the *Cumaean Sibyl with a Putto* of 1651 (also on display in the Gallery), he contrived to emulate Reni's cool elegance without compromising his own gifts as both colourist and draughtsman.

FRANS HALS (about 1580?-1666)

Young Man holding a Skull (Vanitas) 1626-8

Oil on canvas, 92 x 81 cm NG 6458

The leading painter in the Dutch town of Haarlem, where he spent most of his life, Hals specialised in portraiture and received many commissions from wealthy Haarlem burghers for individual, marriage, family and institutional group portraits. But he also produced some religious paintings and a number of scenes of everyday life, all probably with some moralising or allegorical significance. This picture certainly belongs in the latter category.

Hals was famous in his lifetime, as he is again today, for the audacious spontaneity and freedom of his brushwork. Scientific examination has confirmed that the *Young Man holding a Skull* was painted quickly and boldly. There is no trace of the usual underpainting. The drapery was laid down in one layer only over the reddish ground, which

shows through in places to provide mid-tones between highlight and shadow. In some areas, such as the skull modelled with coarse hatching, and the red feather, paint is applied into wet paint; the contour of the nose is scratched through wet paint, perhaps with the handle of the brush. The vigour of the execution is matched by that of the composition, especially in the foreshortened hand that stabs out of the canvas into the viewer's space. Hals's nineteenth-century admirer Van Gogh (page 298) wrote movingly about:

hands that lived, but were not finished in the sense they demand nowadays. And heads too – eyes, nose, mouth done with a single stroke of the brush without any retouching whatever... To paint in one rush, as much as possible in one rush... I think a great lesson taught by the old Dutch masters is the following: to consider drawing and colour one.

The identification of the young man in the portrait with Hamlet at the grave of Yorick is virtually irresistible, but there is no evidence of Shakespeare's play having been performed in Holland or even translated into Dutch in Hals's lifetime. Rather, both the painting and Shakespeare's scene are rooted in the same tradition: a youth holding

a skull is an emblem of mortality, a reminder of the transience of human life, of the 'vanity of vanities' (see page 255). The symbolic character of Hals's painting is underlined by the costume, a fanciful recreation of Italian dress brought to Holland by the Dutch followers of Caravaggio (page 187), such as Hendrick ter Brugghen, whose Concert (page 184) similarly calls up associations, albeit of a different kind, with the world of Shakespeare.

'They say he was a drunkard, a coarse fellow, don't you believe it...,' said the dying painter Whistler in the summer of 1902 when he went to Haarlem for a last encounter with Hals. 'Just imagine a drunkard doing these beautiful things!'

JAN VAN DER HEYDEN (1637-1712)

View of the Westerkerk, Amsterdam about 1660

Oil on oak, 91 x 114 cm NG 6526

A prolific Dutch specialist of the newly developed theme of townscape, van der Heyden was in his day better known as an inventor: he organised municipal street lighting in Amsterdam and patented the first fire engine equipped with pump-driven hoses. With seemingly endless patience and a talent for technical drawing, he painted architectural vistas, real and imaginary, in the greatest and most minute detail. In this picture, for example, one can read some of the tattered posters on the wooden hoardings protecting the young trees in the foreground; one of them advertises a sale of paintings. At the same time, however, he was able to subordinate detail to the whole, and what makes this painting so especially magical is the luminous sky, the light of which reflects from the rosy brick and yellow cobblestone as much as from the sluggish water and, glinting through the leaves, permeates the entire scene.

The picture is exceptional in van der Heyden's work by virtue of its large size, about three times the scale of similar compositions by him. It was commissioned by the governing body of the Westerkerk to hang in their meeting room in the church, and the patrons must have specified the dimensions.

Unlike older Netherlandish churches, the Westerkerk was purposely built to accommodate Protestant worship. It was designed by Thomas de Keyser, father of the painter of the same name (page 219), and completed only in 1638. By choosing a viewpoint from across the canal, van der Heyden simultaneously locates it companionably along the city street and isolates it, screening neighbouring buildings and closing off the edges of the painting with foliage (the mature tree on our side of the canal on the left was an afterthought). Lively incidents are added for human interest, although the scale of the figures is less secure than the architectural composition, and they, like the reflectionless swans, may have been painted in by another artist. Such collaboration between a view painter and a figure specialist was quite frequent at the time. An additional point of interest for the modern viewer is that Rembrandt (page 235) was buried in the Westerkerk in 1669.

MEINDERT HOBBEMA (1638–1709)
The Avenue, Middelharnis 1689

Oil on canvas, 104 × 141 cm NG 830

It used to be thought that Hobbema gave up painting after his marriage in 1668, when he became one of the wine-gaugers of Amsterdam, yet the date 1689 on this picture has been shown to be original. Perhaps it was because he was painting only intermittently that he was able to abandon the tired conventions of his earlier work and

strike out afresh, creating this most memorable of Dutch landscapes at a time when Dutch art was already in decline. Other painters had used the motif of a straight road at right angles to the surface of the painting, but Hobbema's picture does so in a way which transcends any possible prototypes in earlier art.

The painting looks at once obvious and subtle, the sharp man-made perspective lines of the road and canals, reinforced by the softer and more irregular diminishing outlines of the trees, meeting at a vanishing point just fractionally left of centre. We now know that Hobbema did not achieve this effect immediately, for X-rays reveal that he had originally placed other trees in the foreground, one on either side of the avenue, and subsequently painted them both out. (There is extensive damage in the sky, perhaps because an early nineteenth-century restorer attempted to remove the paint, translucent with age, in order fully to reveal these trees.) The artist must have decided that an even taller pair of trees in the foreground screened off the background from the foreground at the sides of the painting while exaggerating the 'rush' to the vanishing point in the centre. (You can check out this hypothesis by positioning two pencils or strips of paper vertically over the reproduction.) In the definitive composition which we see today, the dark patches of ground and vegetation to the left and right of the road echo and reinforce the horizon line and counteract the inward pull of the perspective. As well as being impelled to look towards the vanishing point, we are encouraged to scan the landscape from side to side, where it appears to continue unbroken beyond the lateral edges of the canvas.

The village of Middelharnis lies on the north coast of an island in South Holland in the mouth of the Maas. It is seen here from the south-east. The figures were added by the painter to suggest the human scale and human activity and not necessarily from direct observation at the site. A man is tending trees in a nursery garden at the right and a couple pause in the lane to talk. The hunter strolling with his dog down the road towards us, however, plays a more active role in the composition. Because his head is exactly level with the vanishing point and almost coincides with it, we have the distinct impression that as he continues to walk forward on the road we shall meet face to face halfway. Hobbema exploited optical laws, which objectively place a vanishing point directly opposite our viewing eye, to draw us companionably into his picture, onto the avenue leading to Middelharnis.

GERRIT VAN HONTHORST (1592–1656)

Christ before the High Priest about 1617

Oil on canvas, 272 x 183 cm NG 3679

Honthorst, like ter Brugghen (page 184), was a pupil of the 'history painter' Abraham Bloemaert in Utrecht and also went to Rome. Unlike ter Brugghen, however, he there achieved an international reputation, working for nobles and princes of the Church. The Italians called Honthorst *Gherardo delle Notti* (Gerard of the Nocturnes) and this painting, made for the Marchese Vincenzo Giustiniani, in whose palace he stayed, explains why. On his return north of the Alps Honthorst was so famous that he was invited to England by Charles I, for whom he painted mythological subjects and many portraits. He continued to receive commissions from royalty in Holland, executing portraits and allegorical decorations for Prince Frederik Hendrik of Orange, and in 1635 he sent the first of a long series of historical and mythological narratives to Christian IV of Denmark. The exiled Queen of Bohemia, Elisabeth Stuart, and her daughters were

among his many pupils in The Hague; the National Gallery has a portrait by the artist of this romantic and unhappy lady.

Where ter Brugghen in the *Concert* uses candlelight to create a scene of dreamlike enchantment, Honthorst employs it to lend veracity and dramatic tension to a biblical story (Matthew 26:57–64). After his capture on the night of the Agony in the Garden, Jesus is taken for interrogation and trial before the High Priest Caiaphas, where two false witnesses – the shifty-looking men behind Caiaphas – speak against him. 'But

Jesus held his peace.' Within the vast composition – in scale and format like an altarpiece but never intended for one – the visibility of the life-size figures depends entirely on that single candle flame. Its gleam unifies the whole, by giving the impression of illuminating the entire room with evenly decreasing intensity until its force is spent in the dark, and by justifying the reddish cast of all the colours. It allows the two principal characters to stand out more solidly in relief and in greater detail than the others. It focuses attention on their poses, gestures and expressions. It picks out the few significant accessories, notably the books of the Law and the rope by which Christ is tied, and it creates the solemn and threatening atmosphere of a night-time interrogation.

Through his mastery of the physical effects of illumination from a single source, Honthorst is also able to make symbolic points. Christ's white robe, torn from his shoulder when he was made prisoner, reflects more light than the priest's furred cloak – so that light seems to radiate from him. Though submissive, Christ is without question the main subject of the painting, the Light of the World and the Son of God.

PIETER DE HOOCH (1629-1684)

The Courtyard of a House in Delft 1658

Oil on canvas, 74 × 60 cm NG 835

Pieter de Hooch's best-loved pictures, like this one, were painted in Delft where he worked between 1652 and 1660 and, perhaps under the influence of Carel Fabritius (page 205), developed a particular interest in the depiction of natural light. In his earliest known paintings the Rotterdam-born de Hooch had specialised in guardroom and tavern scenes, peopled with soldiers and serving girls; after he moved to Amsterdam he depicted elegant town life, hectic colours contrasting sumptuous marble pavements with russet Oriental carpets and silk gowns. In Delft, however, a milder tone evokes the modest virtues of domesticity, the homely sphere of burgher women, their children and maidservants. They pass their lives in surroundings as neatly kept as they are meticulously defined by the artist, usually extended through glimpses of other rooms, views through windows or, as here, through a doorway onto the street.

A pale fawn ground, similar to that used by Fabritius, lends a warm glow to the whole, modulated in the rosy bricks of walls and paving. The colour balance has, with time, altered through the fading of yellow and blue pigments: originally, the foliage would have been much greener, the sky bluer and brighter, the blue skirt of the maid more intense and less translucent. These discolorations have not, fortunately, greatly affected our perception of serene daylight shining down on the little courtyard, casting shadows under the arch and, bright again on the house opposite, silhouetting the housewife looking towards her neighbours' window.

The yard and house are old and the rudimentary trellis ramshackle. The broom, no doubt recently used, has fallen into the border. But the maid has turned her attention to the little girl, affectionately teaching her by word and example. The stone tablet above the arch was originally placed over the entrance to the Hieronymusdale Cloister in Delft. De Hooch also included it in a racier variant of this picture (now in a private collection), in which a serving maid leaves a little girl unattended to bring wine to two men wasting their time in smoking and drinking. Although he somewhat modified the phrasing in both pictures, the painter may well have meant viewers to recall the original inscription: 'This is in St Jerome's vale if you wish to retire to patience and meekness. For we must first descend if we wish to be raised.' In this scene the inscription

suggests that the meek patient life of domestic service leads to heaven as surely as more overt religious observance. The tablet has survived and until recently was set in the wall of a garden in Delft.

WILLEM KALF (1619-1693)

Still Life with the Drinking-Horn of the Saint Sebastian Archers' Guild, Lobster and Glasses about 1653

Oil on canvas, 86 x 102 cm NG 6444

Exceptionally for a still-life specialist, the Rotterdam-born Kalf was praised by an Amsterdam poet as one of the city's leading painters. Perhaps the praise would not have been forthcoming had he persevered in his first interest: shabby peasant barn

interiors and still lifes of humble kitchen implements, painted during his stay in Paris from about 1640 to 1646. After his arrival in Amsterdam, however, following his marriage to a cultivated young woman of good family, Kalf began to paint the type of still life for which he is best known. Called in Dutch *pronkstilleven* ('still lifes of display or ostentation'), these compositions, influenced by Flemish antecedents, feature luxury manufactured goods – silverware, Chinese porcelain, Oriental carpets, fragile glass – and exotic foodstuffs. They do not seem to have specific symbolic meaning (see pages 255–6) but must have spoken to contemporary viewers of the wealth of the Dutch Republic, the might of its sea power and the efficiency of its distribution systems – for all this is implied in the Eastern table carpet and in the fresh Italian lemon unwinding its peel in the foreground.

The buffalo horn in a silver mount belonged to the Saint Sebastian Archers' Guild, part of the city's civic guard. Dated 1565, this beautiful example of the silversmith's art, now in the Historisch Museum in Amsterdam, also testifies to the old Netherlandish tradition of municipal freedom, and the will of Dutch burghers to defend it. Kalf was to paint it more than once; it also appears in pictures by other artists.

Ultimately, however, none of these associations is responsible for the grave monumental beauty of Kalf's painting. As in all his mature works, only a few objects are displayed and soberly arranged, in contrast with the luxuriant profusion of Flemish still lifes. Against a dark background, succulent paint, broadly applied, models large forms and captures the very feel of surface textures. Strong accents of the richest and brightest colours surge to the surface – the huge scarlet lobster, the clear yellow and white lemon, touched with pink where it reflects the lobster. And it is the play of reflections and tinted shadows of these powerful hues which, like a musical motif, draws the composition together.

THOMAS DE KEYSER (1596/7-1667)

Portrait of Constantijn Huygens and his Clerk (?) 1627

Oil on oak, 92 × 69 cm NG 212

De Keyser was one of Amsterdam's most favoured portraitists until his eclipse by Rembrandt (page 235) after the latter's arrival in the city in 1631/2. In addition to important life-size commissions for guild and militia groups, he popularised small full-length likenesses such as this one. It is always a surprise, when viewing the original after seeing the reproduction, to discover its almost miniature scale. De Keyser cunningly endowed the picture with the grandeur of the large 'state portrait' evolved for rulers and grandees, although its size and technique are more usually associated with intimate domestic scenes.

The sitter, Constantijn Huygens (1596–1687), was a nobleman of intellectual and artistic interests. Lord of Zuylichem, he served in the Dutch embassies in Venice and London, where he was knighted by King James I in 1622. During his period of office as secretary to the Stadholder Prince Frederik Hendrik of Orange, he wrote in praise of the promising young artist Rembrandt, and secured him a commission from the prince. He continued until his death to advise successive rulers of the House of Orange and to interest himself in the arts and sciences. These interests are neatly encapsulated here by the architectural drawings (perhaps the ones for his house in The Hague on

which he collaborated with the architect Pieter Post) which he has been measuring with dividers, by the *chitarrone* (a long-necked lute), by the books and by the globes, one of the heavens and the other of the earth. Huygens's noble lineage is not forgotten either, for his coat of arms is woven into the border of the tapestry in the background. His spurs refer to the knighthood conferred on him by King James.

The young clerk or page entering with a letter serves a number of functions within the painting. By doffing his hat while Huygens retains his, and by standing deferentially while Huygens sits, he demonstrates the other man's superior social position. Setting the page in profile lends the seated figure the animated air of having just turned to him, and justifies the portrayal of Huygens in full face while avoiding overformal confrontation with the viewer. Finally, the direction of the youth's glance, the perspective lines of the mantelpiece and of the floorboards, and the fold of the tapestry all tend to draw our eyes to the face of Huygens, spotlit and supported as on a pedestal by his snowy unstarched ruff.

LAURENT DE LA HYRE (1606-1656)

Allegory of Grammar 1650

Oil on canvas, 102 x 112 cm NG 6329

Although the Parisian painter La Hyre seems never to have travelled to Italy, he was well aware – through study at Fontainebleau and through the work of contemporary artists like Vouet, Poussin (page 230) and Claude (page 191) – of the achievements of the Italian Renaissance. He became a major exponent of a restrained and refined classical manner fashionable in the French capital. The sculptural clarity and weight of the figure in this allegorical painting, the measured regularity of the composition with its emphasis on horizontal and vertical lines, the even lighting and discrete local colour can all be contrasted with the sweeping movement, dramatic play of light, shade, textures and reflections in Baroque works by contemporaries such as Rembrandt (page 235).

This unlikely gardener represents Grammar and is one of a series of personifications of the Seven Liberal Arts painted to decorate a room in the Paris town house of Gédéon Tallemant, one of the counsellors of King Louis XIII. The Liberal Arts were the literary trio, Grammar, Rhetoric and Dialectic, and the mathematical quartet of Arithmetic, Music, Geometry and Astronomy. It had long been traditional to decorate private studios and libraries with their images (see also pages 91–2). They were always shown as women, in keeping with the feminine gender of the Latin nouns *grammatica*, *rhetorica*, etc., which retain their femininity in all the Romance languages. The other paintings of these high-minded ladies by La Hyre survive, dispersed in various collections. We do not know precisely how they were arranged in the room, but the pictures, of different sizes, were probably set into carved panelling and hung above head height.

The Latin legend on Grammar's winding ribbon can be translated as 'A meaningful utterance which can be written down, pronounced in the proper way'. The function of Grammar among the Liberal Arts was not to parse sentences or teach conjugations but to ensure that ideas could be communicated clearly and effectively. In Cesare Ripa's illustrated dictionary of personifications of concepts, the *Iconologia*, first published in 1593, a book much used by painters, the author comments, 'Like young plants, young brains need watering and it is the duty of Grammar to undertake this'. La Hyre shows Grammar, with a homely jug, watering primulas and anemones in terracotta pots as

lovingly studied from the object as any kitchenware by Chardin (page 274). The overflow runs off through the drainage hole onto a fragment of antique Roman wall or pillar ornamented with an egg-and-dart frieze. Behind her, grand fluted Roman columns and a Roman urn close off our view into the garden beyond the wall, but the mood is as friendly and serene as if she were nursing her plants on a balcony in a quiet Paris backwater away from the traffic, airing the ravishing harmonies of her shot-silk gown and mild blue cloak.

PIETER LASTMAN (1583-1633)

Juno discovering Jupiter with Io 1618

Oil on oak, 54 × 78 cm NG 6272

Lastman was the most important and influential Amsterdam painter of his generation, and his influence persists throughout the work of Rembrandt (page 235), the very much greater artist who was his pupil for only six months. After an extended stay in Italy, Lastman returned home to practise 'history painting' – heroic narratives with a moral bias, based mainly on the Bible but occasionally also on classical history and literature, as in this picture. Because he did not rely on commissions he could choose his own subjects and he favoured ones involving conversations and sudden confrontations. Characteristically he has here taken an unusual moment from a famous mythological tale in Ovid's *Metamorphoses*. As in most of his work, whether on a large or small scale,

Lastman has invested the scene with a mixture of Italianate grandeur and a sly humorous realism of Netherlandish extraction.

Ovid relates that Jupiter, king of the gods, has fallen in love again, this time with the beautiful nymph Io. His wife Juno, looking down from the heavens, sees the dark cloud he has spread to entrap Io and descends to earth to check on him. Hoping to deceive her, Jupiter turns Io into a beautiful heifer, but Juno makes him give her the beast and despatches hundred-eyed Argus to guard it. On Jupiter's orders Mercury lulls Argus to sleep and kills him. Juno then takes his eyes to decorate her peacocks' tails.

Lastman illustrates the confrontation between deceitful Jupiter and suspicious Juno (Metamorphoses 1, 612–16). The peacocks who draw Juno's celestial chariot, their tails still dull in colour since Argus has not yet come into the story, are furiously braking their flight. Jupiter, with the aid of winged Love and red-masked Deceit with his attribute of a fox's pelt, two characters not mentioned by Ovid, is trying to conceal the enormous heifer from the goddess. The juxtaposition of heroic nudity with his guilty and rueful expression makes him look foolish. Henpecked husband and domineering wife are old themes of humorous Northern prints and Lastman may have wittily seized this opportunity to graft the native genre onto a Latin tale of adulterous passion among the pagan gods.

THE LE NAIN BROTHERS (17th century)

Four Figures at a Table about 1643

Oil on canvas, 45 × 55 cm NG 3879

The early years of the three Le Nain brothers, Antoine, Louis and Mathieu, are ill-documented and their individual artistic identities are submerged under the surname with which they signed their works. Their small unfinished *Three Men and a Boy* in the

collection, dated about 1647–8, may be a likeness of the Le Nain firm. They were born in Laon, probably between 1600 and 1610, and were working in Paris by 1629; Antoine and Louis died within a day or two of each other in May 1648 but Mathieu survived until 1677. All three became members of the French Royal Academy at its formation in 1648. In circumstances which have not yet been clarified, Mathieu seems to have enjoyed the personal protection of Louis XIV for 'his services in the armies of the King', and from 1658 aspired to the nobility.

Although the Le Nain first made their reputation with portraits and large-scale mythological and allegorical compositions and altarpieces (many of which were lost during the French Revolution) and continued to receive commissions of this type, they are now chiefly known for their small and striking paintings of 'low life', especially those depicting peasants. Recent scholarship has associated their new kind of realistic rustic genre, neither romanticising nor satirising country dwellers, with an emergent class of bourgeois landowners whose ideals of the dignity of agricultural labour and of the partnership between owners of land and tenant farmers they seem to reflect.

Four Figures at a Table is one of many 'peasant meals' painted by the Le Nain. The strong light falling from the upper left emphasises the darkness and stillness of the humble but respectable interior – brightened only by the well-washed linen – at the same time as it delineates form, texture and expression. It has been suggested that the picture depicts the Three Ages, the old woman's lined face, marked by resignation, contrasting with the interrogatory glance of the young woman, the wide-eyed eagerness or apprehension of the little girl and the contented indifference of the boy cutting the bread. But an allegorical interpretation seems neither necessary nor probable; the painting speaks to us directly of shared human destiny, borne with dignity.

What looks like a *pentimento* (a painter's change of mind) in the face of the little boy has been revealed by X-radiography to be a crimson ornament in the costume of a

Fig. 6 X-radiograph of Four Figures at a Table by the Le Nain brothers, revealing the portrait of a bearded man painted under the present surface.

bust-length portrait of a bearded man painted underneath (fig. 6). This figure is not a sketch, but a finished, or nearly finished, work. He wears a ruff and a grey doublet with cream braiding. Whether the sitter refused the portrait, or was painted in preparation for a larger picture or an engraving, we do not know, but it seems that not long afterwards, and in the same studio, this prosperous citizen was effaced by four country people at their frugal meal.

NICOLAES MAES (1634-1693)

Christ blessing the Children 1652-3

Oil on canvas, 218 × 154 cm NG 757

Born in Dordrecht, Maes went to Amsterdam in about 1650 to study with Rembrandt (page 235). He was back in his native city by 1653 and stayed until 1673, when he returned to settle in Amsterdam. By 1654 he had abandoned Rembrandt's way of painting in favour of small domestic interiors depicting the life of women and children (there are three works of this kind by him in the National Gallery). They differ from similar subjects painted by de Hooch (page 216) in their extensive use of glossy black and warm reds, and the strong contrasts between light and dark, but some share de Hooch's interest in views into another room or space – although we don't know of any direct connection between the two painters. From 1660 Maes confined himself to portraiture, in time adopting the elegant French style favoured in Holland in the latter part of the century.

The attribution of this huge picture has been the subject of much debate, but it is now generally accepted as an early work by Maes painted either during his time in Rembrandt's studio or just after. One of his two surviving preparatory compositional sketches is loosely based on Rembrandt's famous *Hundred Guilder Print*. Both works

illustrate a passage from the Gospel of Saint Matthew (19:13-14): 'Then were there brought unto him little children, that he should put his hands on them, and pray: and the disciples rebuked them. But Jesus said, Suffer little children, and forbid them not, to come unto me: for of such is the kingdom of heaven.'

In Maes's picture dark browns and blacks are enlivened with touches of cream and red - most striking in the cheeks of the little girl on whom Jesus has 'put his hands', and who turns around shyly and uncomprehendingly, finger in mouth. Her school slate hangs at her side – for these are seventeenth-century Dutch mothers and children who crowd around Jesus, although he, like Saint Peter standing rebuked behind the tree and the man lifting up the child (a disciple removing an infant, or a father jumping the queue?), is wearing 'timeless' dress. The young man awkwardly squeezed in at the left is likely to be a self portrait, a reminder that this picture is dated to Maes's late teens. He has followed all the precepts for monumental narrative painting - the fulllength figures on the scale of life, a significant and elevated biblical story, the poses and emotions of all the figures carefully delineated, the lights and darks disposed so as to highlight Jesus and the children - yet something genre-like and sentimental keeps breaking through. Whether because most patrons with space on their walls for a canvas of this size wanted something loftier than the homely figures depicted here, or whether Maes himself realised that 'history painting' was not what he wished to do, he was never again to attempt a picture on this ambitious scale.

225

PIERRE MIGNARD (1612-1695)

The Marquise de Seignelay and Two of her Sons 1691

Oil on canvas, 195 × 154 cm NG 2967

Pierre Mignard, known in his native France as *Le Romain*, lived in Rome from 1636 (visiting Venice and other Northern Italian cities in 1654–5) until summoned home by King Louis XIV in 1657. His style was largely based on Annibale Carracci, Domenichino and Poussin (pages 188, 197, 230). However, he pretended allegiance to Titian and Venetian colourism (see page 164) on his return to France, mainly to oppose his rival Lebrun, whom he succeeded in 1690 as First Painter to the King and Director of the Royal Academy. Despite all his years abroad, his work looks to us unmistakably French, at least as relating to the France of the Sun King's court: calculated and grand. Hogarth's xenophobic English judgement, half a century later, might apply to this superb portrait: 'insolence with an affectation of politeness.' But Mignard was doing no more than following the wishes of his sitter, the widow of Jean-Baptiste-Antoine Colbert de Seignelay, Minister for the Navy.

Catherine-Thérèse de Matignon-Thorigny, Marquise de Lonray, *veuve* de Seignelay, instructed Mignard to portray her as the sea-nymph Thetis, to whom was said (according

to Ovid's Metamorphoses XI, 221–3): 'O goddess of the waves, conceive: thou shalt be the mother of a youth who, when to manhood grown, shall outdo his father's deeds and shall be called greater than he.' Past writers have attributed Mme de Seignelay's transformation into a sea goddess to her husband's office, but Neil MacGregor has suggested that this passage from Ovid is the key to the portrait. Like Thetis, Mlle de Matignon, of old Norman nobility, had been married off against her will to a social inferior: Colbert, her husband's father and the great Minister of the King, was the son of a draper. The goddess's husband, Peleus, had to rape Thetis to 'beget on her the great Achilles', the most celebrated Greek hero of the Trojan War. 'The hero's mother, goddess of the sea, was ambitious for her son' and by descending into the fiery crater of Etna, the volcano seen here smoking in the background, obtained for him armour made by Vulcan, the blacksmith god. This is the armour, 'work of heavenly art', worn in the guise of Achilles by Marie-Jean-Baptiste de Seignelay, the eldest son for whom Mme de Seignelay had just bought a military commission.

The painting's brilliant effect depends in large measure on the vast expanse of Thetis' best ultramarine-blue cloak, contrasting wonderfully with the coral and pearls in her hair, and the mauves and greens of Achilles' garments. Ultramarine was the costliest of pigments, more expensive than gold itself and for that reason seldom used by this date, and never in such quantities. Thus did Mme de Seignelay confound the rumours put about by *mauvaises langues* that she was bankrupt. And there is more: other rumours circulated that the noble widow either was, or wished to be, mistress to the king. The Cupid proffering a precious nautilus shell brimming over with a king's ransom in jewels publicises the liaison as a *fait accompli*. Thus might a classical education, and the talents of a Roman-trained and responsive artist, be put to insolent use 'with an affectation of politeness'.

BARTOLOMÉ ESTEBAN MURILLO (1617-1682)

The Two Trinities about 1675-82

Oil on canvas, 293 × 207 cm NG 13

Murillo was one of the leading artists in seventeenth-century Spain, surpassed in his lifetime only by Velázquez (page 256). Both artists were from Seville, but their temperament, careers and critical success could hardly have been more different. Velázquez spent the greater part of his life at court in Madrid. Murillo remained in Seville, painting mainly religious subjects for pious foundations; his death was the result of a fall from a scaffold in the Capuchin church in Cadiz. His secular paintings included a few masterly portraits, but otherwise consisted almost entirely of scenes of childhood, an unprecedented genre in Spain.

Murillo's fame eclipsed Velázquez's through the eighteenth century, when he was ranked second only to Raphael (page 148) and influenced, among others, Gainsborough and Reynolds (pages 291, 328). Only around 1900 did his manner, so well attuned to the religious sensibilities of his time, begin to cloy. For Murillo is the great interpreter of a range of feelings we have come to mistrust: avoiding scenes of martyrdom, he specialised in tender Holy Families, lovable infant saints, graceful Madonnas and Immaculate Conceptions. In later life he was charmingly reassuring even in his portrayal of vagrant children. But the emotional springs of his work were not what they might seem to a twenty-first-century viewer. The youngest of fourteen siblings, he lost his parents when he was nine, and outlived his wife and all but three of their nine children. From

1635 Spain was interminably at war throughout Europe. In 1649 half the population of Seville died in the plague; there was a popular uprising in 1652. As the world about him sank further into grim despair, it was not sentimentality but heroism which impelled Murillo to cloak his painted world in clouds of incense and of roses. The visitor who flinches from uplifted eyes and pink-cheeked cherubs should perhaps first focus on the firm drawing of the hands, here masterfully foreshortened and individually characterised in eloquent communion. The artist's impeccable draughtsmanship, at first sight concealed under the 'vaporous' brushwork of his late style, influenced by Rubens and Van Dyck (pages 242, 200), is the visible sign of his underlying stoicism.

Murillo had treated the subject of the Two Trinities before, early in his career, when he depicted the Holy Family returning from the Temple (Luke 2:51). The compositions of both pictures derive from sixteenth-century engravings made for Jesuit devotional books by the Flemish Wierix brothers. These images, designed to appeal to a broad lay audience, stressed the humble labours of the Holy Family, and glorified Saint Joseph, carpenter, protector of the Virgin and earthly father of Christ. As God the Father, the dove of the Holy Spirit and Christ form the Celestial Trinity, so Mary, Joseph and Jesus mirror them on earth in a Terrestrial Trinity. In this painting, probably commissioned as an altarpiece, Joseph – the only character directly to address us – holds the flowering rod, sign of God's will that he become Mary's husband. The Christ Child is raised on a dressed stone, both a compositional device to set him at the apex of a triangle in the centre of the painting and symbolic: 'thus saith the Lord God, Behold, I lay in Zion... a precious corner stone, a sure foundation' (Isaiah 28:16). As the clouds part to reveal the divine light, their shadows temper the bold red and ultramarine blue, the apricots, pinks, gold and white of the highlights to a wonderful overall harmony, a haze of grey, sky-blue and saffron.

BARTOLOMÉ ESTEBAN MURILLO (1617–1682)

Self Portrait 1670-3?

Oil on canvas, 122 x 107 cm NG 6153

The tablet beneath the fictive frame of this self portrait is inscribed in Latin: 'Bart[olo]mé Murillo portraying himself to fulfil the wishes and prayers of his children.' By 1670, when this portrait was probably painted, only four of Murillo's nine children were still

living. His only daughter had entered a Dominican convent, and his youngest son was deciding on a career in the church; he was later to become a canon of Seville Cathedral.

After the artist's death, the painting was engraved in Antwerp at the request of Murillo's friend Nicolas de Omazur, a Flemish poet and silk merchant established in Seville. The portrait itself borrows a device from Netherlandish engravings, much used in the frontispieces of books. A gilded oval frame, set against a wall on a shelf or console table, encloses Murillo's half-length likeness. But in a feat of legerdemain only possible in art, it is the painter himself, not his image, who paradoxically extends his hand beyond the frame. Dressed in sober black, with a soft lace collar at his throat, he looks at the viewer with a dignified and slightly melancholy air. Nothing within this portrait betrays that he is anything other than a gentleman. Around the frame, however, are disposed the tools of his profession: a palette laid out with paint, brushes, a drawing in red chalk, the chalk itself, a pair of dividers and a ruler. The white on the palette is a real, three-dimensional swirl of white lead paint, not the image of one. The dividers and ruler tell us that he is a learned artist, creating pictures according to the rules and proportions of mathematical laws and not merely imitating appearances. A drawing - the academic basis of all the visual arts - recalls that in 1660 Murillo co-founded the Academy of Seville of which he was the first president.

As in all his portraits, in contrast to his other pictures, Murillo emphasises truth-fulness above charm. Strong light, casting dark shadows, is used to model the forms, and his famous 'soft' brushwork is apparent only in the hair and lace. The sombre colour scheme of black, white and ochre is relieved only by red – as indicated on the palette, where its undiluted presence helps to clarify the spatial construction of the painting and enlivens its solemn play on the art of reality and the reality of art.

NICOLAS POUSSIN (1594-1665)

The Adoration of the Golden Calf 1633-4?

Oil on canvas, laid down on board, 153 × 212 cm NG 5597

How Nicolas Poussin the son of a Norman farmer became Nicolas Poussin 'painterphilosopher' in Rome, with 'a mind... as it were naturalised in antiquity', is one of the great triumphs of pertinacity over circumstance. Few artists of his importance have had such inadequate training, or found their true vocation so late. His interest in art was aroused by a minor itinerant painter working in a local church in Les Andelys. In the same year, 1611/12, Poussin left home for Paris. After years of hardship, and two unsuccessful attempts to reach Rome, he attracted favourable attention in 1622 with six paintings for the Jesuits. In 1624 he finally settled in Rome, firmly intent on emulating Raphael (page 148) and ancient sculpture.

Poussin's early period in Italy was barely easier than his years in Paris. As well as Raphael, engravings, statuary and a famous ancient wall painting then in a princely collection, he studied Domenichino (page 197) and Guido Reni (page 239) and discovered Titian (page 163), whose *Bacchus and Ariadne*, among other mythological scenes, had just been brought to Rome from Ferrara. Not until he was in his thirties did Poussin find his own voice, and patrons to heed it. From about 1630, with the exception of an unhappy interlude in Paris working for the king in 1640–2, he mainly painted smallish canvases for private collectors. Out of his very limitations, he created a new kind of art: the domestic 'history painting' with full-length but small-scale figures, for the edification and delight of the few (but see Annibale Carracci's earlier picture in the

same genre, page 189). Seldom has a painter been more intense, more serious and, in the event, more influential.

The Adoration of the Golden Calf was originally paired with the Crossing of the Red Sea now in Melbourne. Both works illustrate episodes from Exodus in the Old Testament; this painting relates to chapter 32. In the wilderness of Sinai the children of Israel, disheartened by Moses' long absence, asked Aaron to make them gods to lead them. Having collected all their gold earrings, Aaron melted them down into the shape of a calf, which they worshipped. In the background on the left Moses and Joshua come down from Mount Sinai with the tablets of the Ten Commandments. Hearing singing and seeing 'the calf and the dancing... Moses' anger waxed hot, and he cast the tablets out of his hands, and brake them beneath the mount'. The tall bearded figure in white is Aaron still 'making proclamation' of a feast to the false god.

Poussin is said to have made little figures of clay to use as models, and the story is confirmed by the dancers in the foreground. They are a mirror image of a pagan group of nymphs and satyrs carousing in Poussin's earlier *Bacchanalian Revel* also in the Gallery. Within a majestic landscape painted in the bold colours Poussin learned from Titian, before a huge golden idol more bull than calf (and many earrings' worth), these Israelite revellers give homage to the potency of Poussin's vision of antiquity. As on a sculpted relief or painted Greek vase, figures are shown in suspended animation, heightened gestures or movements isolated from those of their neighbours, so that the effect of the whole is at one and the same time violent and static.

NICOLAS POUSSIN (1594-1665)

The Triumph of Pan 1636

Oil on canvas, 136 × 146 cm NG 6477

The *Triumph of Pan* was one of several paintings commissioned from Poussin, in 1636 the leading French artist in Rome, by Cardinal Richelieu (see page 190). They were intended for a room in his château in Poitou which would also house mythological pictures by Mantegna, Perugino and Costa (pages 64, 80, 35). Poussin must have been advised about the scale not only of the canvases but also of the figures, for although he never saw the Renaissance paintings his personages are much the same size as theirs. He must also have been told that the pictures were to be set above a high dado, divided by gilt caryatids, gold fleur-de-lys against a blue ground, and marine battles, all under a gilt ceiling; the Cabinet de la Chambre du Roy celebrated the French crown's presumed mastery of the seas. The room, with its 'Combat of Wealth and Art', as a contemporary panegyric puts it, and furnished in addition to paintings and panelling with porphyry vases and ancient busts, must have presented a formidable challenge to Poussin. Not

only would he be competing with some of the foremost Italian Renaissance artists, his pictures also had to contend with the glittering décor – hence the colours here are among the most brilliant he ever lavished on a painting. Sadly, the room was dismantled long ago and the pictures dispersed, so we can judge the full effect only in our mind's eye.

Poussin carefully allowed for the spectator's point of view. Nimble visitors to the Gallery can sit on the floor to look at this picture, the better to appreciate its spatial construction and thus its full significance. The revellers occupy a raised stage extending back to where rocks and vine-hung trees screen off the backdrop of sky and distant mountains. Propped up vertically against this earthen stage are a timbrel and two masks – an ancient satyr mask and a modern Italian Columbine. Behind them a Punchinello mask joins a still life drawn from the imagery of ancient bacchanals: thyrsi – staffs wreathed with ivy and surmounted by pine cones – the crooked stick and pipes of Pan, wine in a metal bowl or crater, and a Greek wine jar showing the god Dionysus, the Roman Bacchus.

The composition is indebted to an engraving after Giulio Romano, a pupil of Raphael, but Poussin also demonstrates his first-hand access to antiquarian lore. The mixture of modern and ancient masks, and the stage-like construction, allude to the origins of theatre in bacchic rites. The main scene represents the 'triumph' or worship of the armless bust of a horned deity mounted on a pillar, his face smeared red with the juice of boiled ivy stems. This is the 'term' of Pan, Arcadian god of shepherds and herdsmen, and Priapus, a phallic god of fertility, protector of gardens, whose cult was imported into Greece from the Near East. Confused with each other, both were associated with Dionysus/Bacchus: Dionysus, god of the grapevine, who died, descended into Hades then rose again was himself identified with seasonal decay and rebirth. All the participants are members of his entourage (as we find them in Titian's *Bacchus and Ariadne*, page 164): nymphs and their lewd playmates the satyrs; maenads who rend deer limb from limb or strew flowers from the winnowing basket sacred to Dionysus. A world of pagan imaginings is brought to life in all its cruel and seductive charm, without a hint of anachronistic moralising.

NICOLAS POUSSIN (1594-1665)

The Finding of Moses 1651

Oil on canvas, 116 × 175 cm NG 6519

This painting, the latest and grandest of Poussin's three versions of the theme, was acquired by the National Gallery jointly with the National Museum of Wales in 1988 and is shown alternately in London and Cardiff. Even though it is not always on view, I wanted to include it in this guide because it is a magnificent picture which I could not bear to leave out.

Poussin illustrated events from the life of Moses at least nineteen times (see also page 231). It has been pointed out that when he could, he avoided painting scenes of saintly visions or martyrdoms, the stock-in-trade of seventeenth-century religious art. He concentrated instead on the central themes of Christianity, relating them both to their historical context in the ancient Near East and to the basic tenets of other religions, following an intellectual fashion of the day. Of the Old Testament subjects which he painted, the majority belong to the category of types, or prefigurations, of Salvation.

From Early Christian times the Old Testament was read by Christians for its analogies with the New. Thus the waters of the Nile to which the infant Moses is consigned by his mother in 'an ark of bulrushes', following Pharaoh's cruel order to drown all the male Israelite babies (Exodus 1:22), were likened to the waters of baptism. But Poussin's interest in Moses may have been prompted also by contemporaries' identification of the Old Testament patriarch with pagan deities; as one of them wrote of this picture: 'He is Moses, the Mosche of the Hebrews, the Pan of the Arcadians, the Priapus of the Hellespont, the Anubis of the Egyptians.'

All these ideas reverberate throughout the painting. The baby on whom Pharaoh's daughter has taken pity resembles the Christ Child blessing the Magi or the shepherds in a scene of the Adoration. In the background on the left an Egyptian priest worships the dog-shaped god Anubis (barely visible now that the surface paint has grown thin and transparent). We know we are in Egypt because on the rock above the main scene a river god, symbolising the Nile, embraces a sphinx, palm trees stand on the shore and an obelisk rises up behind a stately temple. (Curiously, the many-windowed buildings with which Poussin - who had never been there - endows Pharaoh's country now resemble modern resort hotels.) The main interest and beauty of the painting, however, do not reside in its possible symbolism, but in the wonderful grouping of the figures, all women to contrast with an analogous group of men in Christ healing the Blind Man (now in the Louvre, Paris), painted for the same patron the year before. Each plays her role in the dramatic tale, the princess generous and commanding, the maids curious and delighted. The humbler figure in a white shift at Moses' head may be his sister who watched from nearby to see what would happen to him, and recommended their mother to Pharaoh's daughter as a wet nurse. It is tempting to see their brilliant draperies as a compliment to Poussin's patron, the Lyon silk merchant Reynon. Bodies and colours, each distinct and separate, combine in ample rhythms across the picture surface, echoed by the rocks beyond. It is at once solemn and joyful, as befits a scene in which a child is rescued from death, and through him an entire people is saved.

REMBRANDT (1606-1669)

A Woman bathing in a Stream 1654

Oil on oak, 62 × 47 cm NG 54

Rembrandt van Rijn is agreed to have been the greatest Dutch painter of the seventeenth century and the National Gallery is fortunate in owning a score of works by him. The most versatile of artists, he excelled in all the genres while aspiring to be recognised as a 'history painter'. Although the opportunity to paint altarpieces was denied him in the officially Calvinist United Provinces where the interiors of the churches had been whitewashed, he was able to supply private collectors with biblical scenes. More mythological and biblical paintings were produced in Holland than we

sometimes think, and Rembrandt received a number of such commissions. But the bulk of his practice was in portraits, and his ambition may explain why he began to invest them – especially the group portraits of corporate bodies – with the vivid semblance of narrative. His superb pictorial imagination and unparalleled technique enabled him to introduce drama and mystery by bold contrasts of light and shadow and of texture, from the delicately translucent to the thickly three-dimensional. His surfaces, unlike those of most of his contemporaries (but see also Hals, page 210), are as alive as the characters he portrays. Not only was he able to evoke specific emotions to suit the action depicted, he convinces us that every figure he paints has the capacity to feel.

The small *Woman bathing in a Stream* has always been one of the best loved of Rembrandt's works. It is so tenderly intimate, so informal in pose and spontaneous in technique that it appears at first sight like the record of an actual experience: Rembrandt's mistress Hendrickje Stoffels wading in a stream. But the gold and crimson robe lying on the bank suggests that the bathing woman should be read as a biblical or mythological figure, Susanna, Bathsheba or Diana. The year of the painting, 1654, was also the year when Hendrickje, whom we recognise from other pictures, suffered public humiliation because of her liaison with the artist and bore him their only child. Recasting a personal and sensuous image of a loved sitter in traditional guise was a seventeenth-century convention, and the ambiguous narrative could add resonance to the real-life relationship. The apocryphal heroine Susanna innocently aroused sexual desire in the old men who falsely accused her; Bathsheba's beauty (2 Samuel 11) tempted King David into mortal sin; seeing Diana bathing in the woods cost the hunter Actaeon his life.

Rembrandt's procedures here are no less 'revolutionary' than those of Monet, the nineteenth-century Impressionist (page 315), and demonstrate the Dutch master's economy and variety of means in achieving complex optical effects. The warm buff ground colour is left uncovered in places, near the lower edge of the woman's shift, for example, to suggest shadow. The painting of the shift itself is so direct that we can see every movement of the brush stroking wet paint into wet, at times dipped into several shades of white, unmixed on the palette, with the different colours showing side by side. Cool half-tones are created by mixing white and black or by letting the ground colour show through, casting a mauve tinge. At other times the mauve is achieved by an admixture of red. The deepest shadows are marked by strokes of pure black dashed into the still wet brushstrokes of white and grey. Similar virtuosity is deployed in the cast-off robe, where the illusion of brocade is produced by a whole variety of irregular strokes finished off with toothpaste-thick highlights of pure orange and yellow ochres.

REMBRANDT (1606-1669)

Self Portrait at the Age of 34 1640

Oil on canvas, 102 x 80 cm NG 672

Rembrandt was a prosperous miller's son and received more than the rudiments of a classical education at the Latin School in Leiden. In this self portrait he claims for himself the status not only of a wealthy man and successful painter, but also of a liberal artist whose powers of eloquence rival those of a poet.

The composition was inspired by two great Italian Renaissance portraits, Raphael's likeness of the courtier, diplomat and writer Baldassare Castiglione, now in the Louvre, Paris, and Titian's *Man with a Quilted Sleeve* (page 168) also in the National Gallery. The

former was sketched by Rembrandt when it appeared on the Amsterdam art market in 1639. It was bought by Rembrandt's acquaintance Alfonso Lopez, the Portuguese dealer and collector, who at some time between 1637 and November 1641 also owned Titian's picture or a copy of it. While the dark hat silhouetting the sitter's face derives from Raphael's picture, the pose, the direct address to the viewer and the emphasis on the rich material of the sleeve are all indebted to Titian's. At the time, Titian's painting was thought to represent the illustrious Italian poet Ludovico Ariosto. By dressing up in luxurious 'Renaissance' costume (we know that he kept such props in his studio) and posing as Ariosto, Rembrandt was not only adapting a famous composition: he was drawing comparisons between his own art of painting and the art of poetry. The historic debate about their relative status concealed timely practical considerations. As craftsmen, painters were considered morally, intellectually and imaginatively inferior to poets; they were also subject to legal restrictions and taxes from which 'liberal artists' such as poets were exempt.

Unlike the later *Woman bathing in a Stream* (page 235), the self portrait is meticulously painted, covering the ground completely with smooth blended colours. Rembrandt may have intended to emulate the technique of Raphael and Titian. In the earlier but much more turbulent *Belshazzar's Feast* (opposite) he relies on contrasts of thick and thin paint, whereas here the only texture trick he allows himself is to suggest the hairs at the back of the neck by scratching in the wet paint with the end of his brush. X-rays show that he twice changed his mind while painting. He had originally included his left hand, the fingers distractingly resting on the parapet next to his right hand; he then painted it out. He also changed the shape of the coloured collar and shortened the shirt front, altering the proportions of the light and dark areas around and under the face.

The shape of the painting was later altered from a rectangle to the arch we see now, with a narrow strip added at the bottom. But the most drastic alteration – now visible to the naked eye only as a slightly sunken, wrinkly texture on the paint surface – was the transferral of most of the paint layers from the original canvas to a new one in the nineteenth century, some time before the painting entered the Collection.

REMBRANDT (1606-1669)

Belshazzar's Feast about 1636-8

Oil on canvas, 168 x 209 cm NG 6350

This dramatic scene illustrates chapter 5 of the Old Testament Book of Daniel. Belshazzar, King of Babylon, gave a great feast at which wine was drunk in the golden and silver vessels looted by his father, Nebuchadnezzar, from the temple in Jerusalem, and 'gods of gold, and of silver, of brass, of iron, of wood, and of stone...which see not, nor hear, nor know' were praised while God himself was not glorified. And there 'came forth fingers of a man's hand and wrote...upon the plaster of the wall'. Only the Jewish seer Daniel was able to read the supernatural inscription MENE MENE TEKEL UPHARSIN which foretold the defeat – in fact, death – of Belshazzar that same night and the partition of his kingdom among the Medes and Persians.

Hebrew commentators on the Bible had long speculated as to why the wise men of Babylon summoned by the king had been unable to read the writing on the wall. Menasseh ben Israel, a Jewish scholar, friend and neighbour of Rembrandt (who had etched his portrait in about 1636 and provided illustrations for one of his books), published his conclusion. According to him, the Hebrew letters had been written vertically from top to bottom as well as from right to left (contrary to normal usage in which Hebrew is read horizontally from right to left). Rembrandt's inscription follows Menasseh's formula.

The upheaval at the king's feast is accentuated by narrow wedge-shaped pieces having been cut from all four sides of the canvas at some time in the past. When remounted on its stretcher, the canvas was twisted very slightly anticlockwise, and as a consequence Rembrandt's turbulent effects are exaggerated by the table running uphill and the wine spilt by the woman at the right falling sideways instead of vertically. But even before these small misalignments the artist had pulled out all the stops. Belshazzar's necklace – that 'chain of gold' which he promises to put about the neck of whoever deciphers the writing – sways convulsively, casting a dark shadow. Its jangle, the gasps and cries of the guests, the clang of royal fist on metal and of gold goblets striking gold, the splashing of wine – while in the background the unseeing musician

still plays his pipe – are almost audible. The miraculous spotlight dazzles as paint swirls from dark translucencies and pale scratched-out lines to the heavy encrustations of Belshazzar's brocaded cloak.

The huge scale of the figures is made possible within this large but essentially domestic-sized canvas by the cinematic 'close-up', half-length format which virtually presses our faces to the scene.

We do not know who commissioned this barbaric feast, but it was probably intended to hang in the dining room of some rich patrician, where, at once delighted and alarmed, the assembled company might dine ever mindful that the 'gods of gold...see not, nor hear, nor know', and of the need to glorify 'the God in whose hand thy breath is, and whose are all thy ways'.

GUIDO RENI (1575-1642)

Lot and his Daughters leaving Sodom about 1615-16

Oil on canvas, 111 x 149 cm NG 193

The Bolognese Reni, like the Florentine Dolci (page 195), is one of the great Italian artists of the seventeenth century whom present-day viewers find difficult to like. He seems to us alien and contradictory. Active mainly in Bologna and Rome, he was admired for his natural talent *and* his ceaseless study, his physical beauty *and* his lifelong celibacy;

he was pious and a compulsive gambler. His paintings often couch violent subjects in icy beauty. He emulated Raphael (page 148) and the antique, but imitated the draperies in the engravings of Dürer (page 45). He himself said that 'the only paintings that were beautiful and perfect were those that continued to grow on one as one viewed them day after day'. Lot and his Daughters is just such a work. Painted for a private collector shortly following Reni's return to Bologna from a stay in Rome, its effect relies on the viewer's sophistication and willingness to spend time with the picture.

The first hurdle for the modern spectator is the subject. For in this curiously intense painting *nothing happens*, nor can we tell what the characters are thinking or feeling, nor how we are meant to react. We ourselves need to know what has occurred before and what is about to take place. Only in a private work intended to allure and interest, not to propagandise, can such a theme succeed. The subject is from Genesis, chapter 19. The righteous man, Lot, is warned by an angel that the Lord is about to destroy his city Sodom, and is told to flee to the mountains with his wife and two daughters. His wife looks back at the burning city and is turned into a pillar of salt. In a cave in the mountains, Lot's two daughters believe the three of them to be the only people left alive on earth. In order to 'preserve seed of our father' they make him drunk and seduce him. The incestuous unions give birth to Moab and Ammon, ancestors of the Moabites and Ammonites, enemies of Israel.

Most artists depicted the sensuous episode of the seduction, easily recognisable since, in addition to the drunken old man and the two young temptresses, it generally included a burning city in the background. Reni proceeded differently. Basing himself on two sources: a sixteenth-century relief on the high portal of San Petronio – the main church of Bologna and therefore known to his patron – and a fresco in the Old Testament cycle in the Vatican designed by Raphael, he painted 'in close-up' the flight of Lot and his daughters from Sodom. It is up to us to recognise that behind these three figures Lot's wife is turning into salt and that they are proceeding towards incest, the elder daughter carrying the fateful wine. Through his close focus, Reni

has been able to retain the life-size scale of heroic narrative painting while shunning its normal explicitness. Everything is crystal clear yet intriguingly ambiguous: from the expressions – the old man almost leering, the daughters, like ancient masks of Medea or the Bacchantes, beautiful yet dangerous – to the 'speaking gestures' which we cannot read, the colours, rich yet indeterminate, and the draperies. Ample and gorgeous, the cloak of the woman on our right does not reveal a body underneath, in the traditional manner, but *excavates* it.

SALVATOR ROSA (1615–1673)

Self Portrait about 1645

Oil on canvas, 116 × 94 cm NG 4680

'Keep silent unless your speech be better than silence' proclaims the tablet under Salvator Rosa's hand in this intransigent self portrait. Poet, actor, musician, satirist, letter-writer, etcher as well as painter, Rosa presents himself here as a Stoic philosopher, in the cap and gown of a scholar, scornful of the 'sound and fury, signifying nothing' of

worldly life. The dark cloak may have been inspired by the 'brown mantle' of Silence in a poem by Ariosto. An equally fantastical companion portrait of his beloved mistress Lucrezia (now in Connecticut) depicts her as Poetry. Together the two paintings may have signified Silence and Eloquence.

Rosa was trained in Naples as a painter of decorative small-scale battle scenes, land-scapes and coastal views. Aspiring to the higher genre of figure painting, he left Naples for Rome, where he made enemies among artists and potential patrons alike. Between 1640 and 1649 he worked in Florence, nominally attached to the Medici court, which he professed to despise, but finding patrons and admirers among the noble families and literati of the city. This portrait and its companion were painted for the town

house of just such a family, the Niccolini.

Despite its theatricality and self-advertisement, the self portrait is eloquent also of Rosa's rejection of the pursuit of ideal beauty characteristic of the age. The National Gallery owns two examples of his many landscapes, some of which depicted wild woodlands and mountain scenery and were much collected by eighteenth-century lovers of the picturesque. Describing a journey over the Alps in 1739 Horace Walpole was to write: 'Precipices, mountains, torrents, wolves, rumblings – Salvator Rosa.' Even more influential on Gothick taste were Rosa's scenes of witchcraft inspired by Northern prints, and the Gallery also houses a particularly fine – if characteristically revolting – example. His disregard for beauty, his 'savage' or macabre subjects, his claims for the dignity and freedom of the artist, the legend of his youth among Neapolitan bandits and of his 'fighting by day [in a popular revolt against Spanish rule in Naples] and painting by night' – all these made Rosa a hero to the Romantics, and a villain to Ruskin, who thought his art infected by the 'dragon breath' of evil.

PETER PAUL RUBENS (1577–1640)

Minerva protects Pax from Mars ('Peace and War') 1629–30

Oil on canvas, 204 × 298 cm NG 46

Rubens and Rembrandt (page 235) were the outstanding protagonists of seventeenth-century Northern painting. Rembrandt was a spendthrift and unprincipled, yet we venerate him as a humane artist, as well as a great one. His older contemporary Rubens was a clear-sighted idealist, cultured and reticent, upright and loyal. He laboured in the cause of peace and toleration among the great European powers, and despised the arrogant affectations of nobles and courtiers. He was a more influential artist than Rembrandt, and he painted in what was thought to be a universal idiom.

To our great loss, we no longer find Rubens sympathetic. We ridicule his delight in fleshy women, and think him a grandiloquent and possibly insincere painter. We find it difficult to appreciate his blend of erudition and exuberance, of wit and deep seriousness, even in paintings as eloquent as this allegory of Peace and War. The picture was presented to Charles I in 1630 during Rubens's stay in London, in the course of his diplomatic mission on behalf of the Archduchess Isabella, Regent of the Spanish Netherlands, to secure peace between Spain and England.

Like all allegories, 'Peace and War' requires decoding – but we need not begin reading it in such a disembodied and fusty way. Surely Rubens meant our eye to be caught first by the lustrous glance of the little girl peering shyly yet intently out of the canvas. She is dressed in contemporary clothes. Indeed she, her older sister and the torch-holding

boy are portraits of the children of Rubens's host in London, the painter and royal agent Balthasar Gerbier. But above them looms a dark warrior in black armour and blood-red cloak; the sky smoulders, a ghostly figure screams. If we could see or understand nothing else, we could grasp the message of the picture from these details. Who can resist the child's direct appeal? Who would not wish to preserve that fragile happiness from sword and fire?

From further away, we see that Rubens has divided the large canvas diagonally in two from the upper left corner to the lower right. Light shines on the left-hand triangle. This is the realm of Peace, where living children mingle happily with robust personifications of abstract notions, drawn from the once common coin of Greco-Roman myth and poetry. It has recently been suggested that Rubens intended to illustrate the Greek poet Hesiod's invocation of Peace as 'Protector of Children'. Peace is the radiant mother squirting milk from her breast to feed the infant Plutus, god of wealth. Around her the followers of Bacchus, god of wine and of fertility, celebrate her blessings: one bacchante brings a basin full of goldsmiths' rich wares, another dances to her tambourine. A winged child holds a crown of olive and Mercury's snake-wreathed staff, both emblems of peace, above Peace's head. At her feet, the sun-bronzed satyr proffers a horn of plenty filled with the earth's bounty, and a winged Cupid beckons the girls to receive and eat the sweet fruit. Bacchus' leopard plays like a kitten with tendrils of vine. An adolescent boy tenderly urges both girls forward, while torch-carrying Hymen, Roman god of marriage, and the boy's seeming double, poses a wreath on the older girl's head. But only the vigorous action of helmeted Minerva, armed goddess of wisdom, wards off the dark threat of Mars, god of war, and his attendant Fury.

PETER PAUL RUBENS (1577-1640)

An Autumn Landscape with a View of Het Steen in the Early Morning about 1636

Oil on oak, 131 x 229 cm NG 66

After the death in 1626 of his much-loved wife Isabella Brant, Rubens travelled abroad in the service of the Archduchess Isabella. He returned to Antwerp in 1630, wearied and in 'declining strength'. In the same year, however, 'not yet inclined to live the abstinent life of the celibate', he married again. Helen Fourment was a beauty of sixteen, whom Rubens had known since her childhood. He now had two aims, domestic happiness and painting on his own behalf. Cutting the 'golden knot of ambition', he obtained release from official duties. In 1635 he bought the seignory of Steen, near Malines, a purchase officially approved by the Council of Brabant, as he had already been ennobled by the Kings of England and Spain. The sixteenth-century manorial castle, with park, pastures and farmlands, provided a healthy country retreat for the summer months, and, as his nephew was to write, the estate gave the artist the opportunity 'to paint vividly and from nature the surrounding mountains, plains, valleys, and meadows, at sunrise and sunset with their horizons'.

This picture was almost certainly painted as one of a pair with the Landscape with a Rainbow (now in the Wallace Collection, London), which shows a view in the late afternoon. Both remained in Rubens's possession during his lifetime. In the National Gallery picture the sun has just risen, dispersing the clouds, gilding the foliage of trees and shrubs, sparkling in the windows of Het Steen and on the flintlock of the fowler stalking partridges in the foreground. Shadows mark the undulations of the terrain and gather about the trees. A peasant and his wife ride out to market. Behind them, the lord and lady of the manor set out for a stroll while a wet nurse suckles the baby. The painting's huge size means that we are compelled to view it in two quite different ways. To make out these and other details, we must pore over the surface, moving our bodies as well as our eyes. As we do so, we share the point of view of the crouching

hunter, yet the partridges seem nearer to us than they might to him. The picture dissolves and recomposes itself into myriads of incidents of landscape, rural and leisured life, some larger, others smaller, virtually all with their own viewing point. But to see the whole painting, we must move away.

From a distance, the high horizon implies a promontory from which we survey a vast panorama, and the sunrise on the right indicates the east as on a map. We can now also note Rubens's use of an old Flemish convention: dividing the panel in three horizontal bands to suggest aerial perspective, the lowest one brown with red accents for the foreground, the second green and the third blue. While the Lord of Steen was master merely of his estate, the painter is lord of all that his brush brings before our eyes. Constable (page 275), who knew and admired *Het Steen*, was as much influenced by its vision of nature and man in harmony as by its pictorial devices.

PETER PAUL RUBENS (1577-1640)

Portrait of Susanna Lunden (?) ('Le Chapeau de Paille') about 1622-5

Oil on oak, 79 × 54 cm NG 852

The sitter of this famous portrait is almost certainly Susanna, older sister of Helen Fourment who was to become Rubens's second wife in 1630. When the picture was painted, however, Rubens was already related to the Fourments through his first wife, Isabella Brant: her sister had married Daniel Fourment, brother of Susanna and Helen. The familial relationship is evident in the informality of the picture, which may be a betrothal or marriage portrait, as suggested by the prominent ring on the sitter's right index finger (just such a ring on the same finger had been shown by Rubens on Isabella's hand in their marriage double portrait, now in Munich).

Susanna was widowed not long after her first marriage in 1617. In 1622, at the age of 23, she married Arnold Lunden, and these events may be reflected in the grey clouds dispersing to reveal the blue of the sky. The portrait was executed in the studio, but its setting out of doors enabled Rubens to depict natural lighting, so that even the shadow of Susanna's plumed felt hat does not diminish the brightness of her skin and eyes. This effect was much admired, and imitated by the French painter Mme Vigée Le Brun in a self portrait of 1782 (page 342). Like many works by Rubens, the painting was enlarged at a late stage, and the added strips of wood on the right and along the bottom edge, less carefully prepared than the rest, are now clearly distinguishable from the main panel.

Rubens was exceptional in his ability to depict beautiful and desirable women as lively and intelligent. He habitually enlarged the eyes and exaggerated the dark colour of the iris; here the catchlights make Susanna's eyes seem lustrous and expressive, but their glance avoids direct contact with ours, although her lips are partly open in a warm confiding smile. Her face thus becomes wonderfully lifelike, momentarily poised between reserve and spontaneity.

Rubens's accomplished technique of painting flesh gives Susanna's fair skin its pearly translucency. He first covered the reflective white chalk ground of the panel with an irregular hatching of raw umber paint applied with a coarse brush, creating a shimmering middle tone between light and dark. The face and upper torso, with the breasts pushed unnaturally high and close together by a corset, were then modelled in the same way. Flesh colour was applied over the silvery brown hatching; where it is thinnest, the brown undermodelling is perceived as a luminous shadow. As the paint has grown more transparent with age, the brushed hatching is now visible in Susanna's forehead

shaded by the hat brim, as are the coarser hatching in the background and the taller outline of the hat originally sketched in by Rubens. White highlights and red and dark shadows were then added over the flesh colour on nose, cheeks, chin, neck and breasts.

Equally rapid and effective is the treatment of Susanna's hair, stray wisps painted with the tip of the brush or scratched with the point of the handle. The fluent handling extends to her costume, especially in the dashing ostrich feathers and the splendid removable red sleeves, attached to the bodice with ribboned gold-tipped laces, whose bold colour echoes and concentrates the warm blush of lips, nostrils and eyelids.

PETER PAUL RUBENS (1577–1640)

Samson and Delilah about 1609–10

Oil on wood, 185 x 205 cm NG 6461

In 1608 Rubens hastily returned home to Antwerp after an absence of eight years in Italy, in a vain attempt to reach the bedside of his dying mother. His arrival in the city virtually coincided with the truce between Spanish Flanders and the Dutch United

Provinces, and he was quickly appointed official painter to the Regents of the Southern Netherlands, the Archduke Albert and the Archduchess Isabella, with leave to remain domiciled in Antwerp. He was never to return to Italy, although he was irrevocably marked by his study of Ancient Greco-Roman and Italian Renaissance art. In Antwerp he proceeded to work towards the reconstruction of his war-torn country and to establish himself as a leading figure in its artistic and intellectual life.

One of his closest friends and patrons at this time was the wealthy and influential alderman Nicolaas Rockocx, for whom Rubens painted Samson and Delilah to hang in a prominent position over the mantelpiece of his 'great saloon' in Antwerp. When the picture was hung at its original height of just over two metres some years ago in an exhibition at the National Gallery, it became clear how nicely Rubens had calculated the angle of vision. The surface of Delilah's bed receded to a properly horizontal plane, with the space of the room leading convincingly back to the wall and the door through which the Philistine soldiers enter to capture the hapless Jewish hero. To the multiple light sources in this room, for which Rubens was indebted to his friend Elsheimer (page 115) – the flaming brazier, the candle held by the old procuress and the torch of the Philistines – we must add in our mind's eye a fire blazing in the fireplace below, highlighting the saffron satin throw behind Delilah and the patterned Oriental rug, and casting warm reflections in the shadows of the skin tones and the

white drapery, where the coarse brown hatching of the underpaint is left uncovered

or barely veiled.

The story of Samson's fatal passion for Delilah is told in the Old Testament (Judges 16: 4–6, 16–21). Bribed by his Philistine enemies, she cozens Samson into revealing the source of his supernatural strength: his uncut hair. As he lies asleep in her lap during a night of love, she calls in a barber to cut off 'the seven locks of his head'. The tale of a man brought low by lust for a woman was often treated in sixteenth-century Netherlandish art, and Rubens follows this Northern tradition by introducing a procuress, who does not appear in the Bible. Her profile juxtaposed with that of the youthful harlot both reveals her own past and suggests Delilah's future. At the same time the painting is rich in Italian memories, not least in the ample scale of its life-size foreground figures, accommodated on the panel only by being shown reclining. A statue of Venus and Cupid presides over the erotic scene. Brawny Samson derives from antique sculpture and from Michelangelo (page 134); Delilah's pose is that of Michelangelo's *Leda* and *Night* in reverse. In Delilah's breast band Rubens draws on Roman marbles, but following his own maxim translates marble into soft and yielding flesh – some of the fleshiest ever painted.

Ultimately, however, this sumptuous picture is entirely original, and nowhere is this more apparent than in the incongruously dainty professional gesture of the barber and in Delilah's ambiguous expression, compounded of sensuality, triumph and pity.

JACOB VAN RUISDAEL (1628/9?-1682)

An Extensive Landscape with a Ruined Castle and a Village Church about 1665-70

Oil on canvas, 109 x 146 cm NG 990

Panoramic views of the flat plains of Holland are often said to be the most distinctive contribution of Dutch landscape painting. They differ from the 'world panorama' of earlier Flemish art – of which Rubens's View of Het Steen (page 244) is a very late example – by seemingly recording the momentary view of a single scene, rather than being composed of a collection of separate visual memories. Formally, they are characterised by a low horizon line, implying a low viewpoint. Although Ruisdael, perhaps the greatest and the most versatile Dutch landscape specialist, did not invent this type of picture, he became one of its most distinguished practitioners (visitors to the North Wing might like, however, to compare this picture with the great 'extensive landscape' by Philips Koninck).

Born in Haarlem, Ruisdael is assumed to have been taught by his father Isaack and by his uncle, Salomon van Ruysdael (see next entry), whose influence is apparent in his early pictures. By 1657 he had settled in Amsterdam. This painting may represent a view in Gooiland, a district to the east of that city; there are, however, at least four other, smaller landscapes by Ruisdael that show the same view or part of it with considerable variations (see, for example, his Extensive Landscape with Ruins in the Gallery), and it is clear that he was not attempting strict topographical accuracy. Despite the pretence of spontaneity, this work, like all landscape paintings of the time, is a synthetic product

of the artist's studio.

Its dominant feature is the sky, to which two-thirds of the picture surface is devoted and which is also reflected in the water of the foreground. This is the real, moisture-laden sky of Holland billowing with clouds, the sun breaking sporadically through

scattering shafts of light across the countryside – effects which Constable (page 275) was later to emulate. Almost more remarkable than the truthful record of the shape, density and illumination of the clouds is the illusion that they are moving through space and over our heads (we tend to think that perspective does not govern cloud-scapes, but these seem to taper towards the horizon and broaden at the upper edge of the painting). The long horizon too seems to extend beyond the frame, broken only by church spires and the tiny white sails of a windmill. But our sense of inhabiting the landscape is compromised by our viewpoint in relation to the foreground. By letting us look down into the bastion standing below the horizon line, the painter suggests that we are viewing it from some improbably high place, higher also than the shore on which peasants graze their flock (both figures and animals were painted by Adriaen van de Velde, a division of labour quite common in Dutch landscapes). This implied detachment, however, strengthens the elegiac mood aroused by the sight of overgrown ruins, melancholy reminders of a distant and more heroic past.

SALOMON VAN RUYSDAEL (1600/3?-1670)

A View of Deventer seen from the North-West 1657

Oil on oak, 52 x 76 cm NG 6338

Salomon van Ruysdael, the uncle of Jacob Ruisdael (above), was, with Jan van Goyen, the greatest painter of Dutch inland waterways. He lived in Haarlem, painting small pictures for sale rather than on commission, mostly variations on the native landscape; late in life he also executed some still lifes with dead game. Water soon became the major element in his work, beginning with atmospheric descriptions of cottages silhouetted against rain-laden clouds, and progressing to views of lakes, ponds, rivers,

canals and ditches with trees reflected in their calm or slowly running waters. After 1640 his work grew bolder, the intimate backwaters giving way to more open vistas, almost marine riverscapes from which trees disappear, to be replaced, as here, by boats sailing close to the wind and the distant silhouettes of cities.

Like many of van Ruysdael's later pictures, this view of Deventer, not topographically exact and probably derived from an engraving, seems almost to illustrate a passage in the influential treatise by Karel van Mander published in Haarlem in 1604. In prescribing attractive motifs for landscape painting, van Mander recommends: 'The rivers with their sweeping bends, winding through the marshy fields... Moreover, let the water always search for the lowest level and, to heighten the artistic effect, build sea-towns stretching up to higher grounds...' Rather than invent the castles on cliff-tops, which van Mander then describes, van Ruysdael has placed the belfry of the Grote Kerk nearly in the centre of the horizon line to provide a dominant vertical against the streaky sky, lightest where, in van Mander's words, it meets 'the heavy element of earth'.

Set on the River Ijssel in the eastern province of Overijssel, Deventer is far from the sea, and the vessels flying the Dutch flag and tacking into the wind are proceeding upriver, inland. Yet van Ruysdael lends this commonplace view of commercial shipping the epic quality of a voyage on the open seas. Their sails silhouetted against the sky, the ships move in a diagonal line, outlined by a patch of marshy land and brightly lit as cloud shadows fall across the foreground. This diagonal, which leads our eyes to a vanishing point on the horizon, is reinforced by the receding shoreline on the right. It is an astonishingly bold and dynamic effect within the modest scope of the picture. Although three-quarters of its surface is taken up with sky, the focus of attention is on human achievement: stone-built church towers, mills harnessing the power of the wind, heroic sailing ships, fishermen hauling on their net – not least, the making of art from these everyday ingredients, with no picturesque motifs to frame the composition or stand between us and the flat waters and sandy ground.

PIETER SAENREDAM (1597-1665)

The Interior of the Buurkerk at Utrecht 1644

Oil on oak, 60 × 50 cm NG 1896

Trained in Haarlem in the studio of a 'history painter' and portraitist, Saenredam turned to the more rigorously intellectual speciality of architectural painting, prized by contemporaries for demonstrating the universal laws of mathematics and optics. The metaphysical nature of these sciences was underlined through the light-flooded church interiors which were his preferred subject.

Working closely with the architect Jacob van Campen, Saenredam is the first major artist to have used the methods of architectural surveyors. His paintings of churches throughout the Northern Netherlands are based on meticulous perspectival drawings, or cartoons, of the same size as the picture, derived from sketches and measurements taken *in situ*. Absolute fidelity was often later sacrificed for greater effect, however, as

the paintings were executed in the studio, sometimes years afterwards. The original drawing, of which this picture shows only the right half, is dated 16 August 1636; another painting (now in the Kimbell Art Museum in Fort Worth, Texas) corresponding to the left half dates from 1645.

Like all of Saenredam's church interiors, this view of the Buurkerk, originally the only parish church in Utrecht, shows a medieval building stripped of all vestige of Catholic decoration and whitewashed to the requirements of Protestant worship. Positioned with the artist at the north door, we look into the nave. Most of the surviving structure is fourteenth or fifteenth century, but Saenredam has deliberately chosen to focus on the Gothic remnants of the thirteenth-century edifice, exaggerating the height of the columns. Hanging on one of these in the centre is a guild board; in the recess of the pier on the right are the Tables of the Ten Commandments, and above them the bust of Moses. Higher on the same pier are heraldic mementoes. Below, drawn in red chalk evidently by the standing child, is a crude illustration of a medieval tale of chivalry popular throughout most of Europe and recently published in Dutch. It shows the sons of Amyon of Dordogne on the magic horse Bayard. Beneath the drawing is an inscription with the name of the church, the date and the artist's signature.

The figures in Saenredam's paintings are not always by him. They do not appear in the drawings and are included to give a sense of the buildings' scale, to provide colour accents and human interest, but they may also underline the pictures' deeper significance. We may never know precisely what is intended by the group in the foreground here. The second boy is training a dog to stand on its hind legs, a Dutch emblem of obedience and the capacity to learn. Perhaps the painting could be viewed as a pictorial metaphor for the famous verses of Saint Paul contrasting worldly blindness with the full clarity of vision in heaven (I Corinthians 13:11–12): 'When I was a child... I understood as a child... but when I became a man, I put away childish things. For now we see through a glass, darkly; but then face to face: now I know in part; but then shall I know even as also I am known.' Profane frivolity, exemplified in the childish drawing, may be 'put away' through obedience to the teachings of religion, so that the solemn architecture of God's House can be clearly seen, as it is in Saenredam's re-creation, painted with the pure white light of true understanding.

SASSOFERRATO (1609-1685)

The Virgin in Prayer 1640-50

Oil on canvas, 73 × 58 cm NG 200

Like Carlo Dolci (page 195), Giovanni Battista Salvi, called Sassoferrato from his birthplace in the Marches, had close ties with the Benedictines. Their motto, *laborare est orare* ('to work is to pray'), seems as fitting to him as it does to his devout Florentine contemporary. Like Dolci, he relied on the compositional inventions of others: fifteenthand sixteenth-century artists such as Perugino (page 80), Dürer (page 45), Tintoretto (page 160), Lo Spagna; contemporaries, above all Reni (page 239); and the fashionable Madonnas painted in Rome by the Frenchman Mignard (page 226). His work has often been mistaken for that of a follower of Raphael (page 148), so closely did he model himself on the 'pure' style of an earlier age. After he had copied some pictures for the Benedictine monastery in Perugia at the age of 21, he was introduced to a reformed Franciscan friary in Rome, the city in which he lived for some forty years and where he died. A pious princess commissioned his one famous altarpiece, for the Dominican

church of Santa Sabina in Rome, to replace a precious Raphael which the Dominicans unwisely sold to a collector.

With the exception of some portraits of devout ecclesiastics, and a self portrait commissioned by a cardinal in 1683 for Duke Cosimo III de' Medici's gallery of artists' likenesses, Sassoferrato made his living from devotional pictures such as this one. Most were made in 'multiple originals', on commission and for sale to pilgrims. This popular composition, based on an engraving purported to be after Reni, is known in more than fifteen variants.

Sassoferrato suffers in our estimation partly for being the kind of self-abnegating artist we least admire, and partly because his pictures directly influenced the pious art of the nineteenth century in all its sentimental excess. Yet his own work is too robust to be sentimental, and too well painted. The enamel-like finish, the jewel brightness of white, red, costly ultramarine blue on black, preclude neither vigorous modelling of

form nor acute observation – as of the pale reflections of the Virgin's veil in the shadows on her face and cheek.

Sassoferrato is catering to the Counter-Reformation reaffirmation of the cult of the Virgin and of the efficacy of her images, in the same spirit in which histories and atlases of these miracle-working icons were being compiled and published throughout Europe. The Virgin in Prayer, her veil leaning out of the painting into our space, is praying over us, for us, as an example to us, in submission to the will of the Father, to the Son. She has been abstracted from narratives of the Annunciation, the Adoration, the Nativity, so that we may pray through her, lose our fretful egoism in her infinite mercy and humility, as the artist has submerged his handwriting in the icon. Her eyes are lowered, but if we look up at her from a hassock or a prie-dieu, a sickbed or a deathbed, her tender glance will fall on us. She is alone, without the Child, our mother, our nurse, intercessor on our behalf, and Sassoferrato's message is that to submit to her is to reclaim our strength, our freedom and our dignity.

JAN STEEN (1626-1679)

The Effects of Intemperance about 1663-5

Oil on wood, 76 × 106 cm NG 6442

Even today a 'Jan Steen household' is what the Dutch call a boisterous and ramshackle family. Jan Steen painted many such families, often including his own portrait as a pipe-smoking, beer-drinking, cheerful rake. His prolific output, during a career when he was constantly on the move from town to town, and the very high quality of much of his work, should make us beware of a literal interpretation of this raffish portrayal of the artist. One of the many Dutch seventeenth-century painters who remained Catholics, Steen is a moralist, but he relies on popular proverbs, the popular theatre and festive customs to preach through laughter at the human comedy: people like ourselves behaving as they shouldn't.

Not all his paintings are of this kind. The National Gallery also owns a landscape-like *Skittle Players outside an Inn,* which despite its subject seems to make no disparaging comment on the people taking their ease in the summer sunshine, and a late *Two Men and a Young Woman making Music on a Terrace,* which anticipates the eighteenth-century painter Watteau's lyrical and melancholy compositions. Steen also painted biblical and mythological subjects and portraits. While many of his pictures are small, the *Effects of Intemperance* is on a larger scale and demonstrates the broader touch he may have learned from Hals (page 210) during his nine-year stay in Haarlem.

The woman on the left is that most reprehensible creature, a Dutch housewife and mother who is *not* teaching her children virtue. She has slumped in drunken slumber, her clay pipe slipping from her hand (see page 256). The little coal brazier by her side threatens to set fire to her gown, and her child is picking her pocket. Above her head hangs a basket in which the fate of those who grow up without parental guidance is foretold: it contains the crutch and clapper of the beggar and the birch of judicial punishment. Another child illustrates a Dutch proverb by throwing roses (we would say 'pearls') before swine, while the trio to the right waste a good meat pie by feeding it to a cat. The parrot, that mimic of human behaviour, is drinking wine given to him by the maid, as luxuriously dressed as her mistress and almost as tipsy, while in the arbour beyond a man, perhaps the father, is dallying with a buxom girl – 'wine is a mocker' indeed, as the saying goes.

Just as the ancient painter Zeuxis painted grapes so realistically that birds came to peck at them, so may we, attracted by Steen's ravishing still life in the foreground, the glow of pewter and the shimmer of silks, be drawn to taste his wares. Through looking deep into his picture, we may yet reform our ways and so avoid the effects of intemperance.

JAN JANSZ. TRECK (1605/6-1652)

Vanitas Still Life 1648

Oil on oak, 90 x 78 cm NG 6533

Jan Treck was an Amsterdam still-life painter. This work is one of two pictures by him in the National Gallery; the other, a *Still Life with a Pewter Flagon* of 1649, uses a muted range of greys, blacks and whites, in contrast to the vigorous reds and golds deployed here. Such exuberance of colour may seem a strange setting for the prominently displayed and gaping skull, but the painting belongs to a distinct category of still life popular in the Northern Netherlands in the seventeenth century, the *vanitas* (see the *Still Life Pocket Guide*). While admiring the artist's representational skills, the viewer is meant to reflect on the inevitability of death and the futility of worldly ambitions, especially the accumulation of riches and the striving for power. This type of painting takes its name from the Latin of Ecclesiastes 1:2 – 'Vanity of vanities, saith the Preacher... all is vanity.' The skull, of course, is the key to the picture's character and enables us to 'read correctly' all the objects depicted, just as it does in the only other *vanitas* still life in the collection, the *Allegory of the Vanities of Human Life* by Harmen Steenwyck also in the North Wing.

By wreathing the skull with straw, Treck parodies the practice of putting evergreen laurel leaves around the brows of victors, and the message is reinforced by the helmet – as if both had belonged to the same long-dead hero, whom the best armour could not save from the Grim Reaper's scythe. The hourglass recalls the implacable passage of

time, and the Dutch clay pipe and tapers allude to sinful waste, as well as the brevity of human life: 'For my days are consumed like smoke', in the words of Psalm 102 – reminding us also of the importance of the Bible in Dutch homes. The seemingly incongruous shell and straw were used by children for blowing soap bubbles, also a foolish pastime but more specifically a reference to the notion of *homo bulla*, man as a fragile and ephemeral bubble.

Neither the collecting of luxury goods such as Rhenish stoneware jugs, precious silks and lacquer boxes, nor the practice of music and the visual arts, nor the pomposity of the law exemplified by the document with its lead seals, nor scholarship, is spared – 'all is vanity'. The inclusion of the title-page to a published play, Evil pays its master, a comedy by the author and diplomat Theodore Rodenburgh, was presumably motivated by the aptness of its moralising message.

DIEGO VELÁZQUEZ (1599-1660)

Philip IV of Spain in Brown and Silver about 1631-2

Oil on canvas, 195 x 110 cm NG 1129

Velázquez entered the service of Philip IV of Spain when he was 24 and the king, who had succeeded to the throne only two years previously, 18. After an apprenticeship in his native Seville with the painter and writer Pacheco, who was so impressed by him that he gave him his daughter in marriage, Velázquez was appointed Court Painter in

Madrid, a post he would never leave and to which other official duties were gradually added. As Philip and he matured together, the close contact between the king and his painter was interrupted only by two visits to Italy which Velázquez was granted in 1629–31 and 1649–51. The first was prompted by Rubens (page 242) during his diplomatic mission of 1628. Studying the great Venetian Renaissance pictures in the royal collection with Velázquez, the only contemporary Spanish artist he admired, Rubens was able to deepen the younger man's understanding of Titian's painterly language (page 163).

Philip IV in Brown and Silver was the first likeness of the king taken after Velázquez's return from Italy in 1631; Philip had allowed no one else to portray him during his painter's absence. The pose is conventional in Spanish royal portraits and may have been based on the protocol of royal audiences, when ambassadors or petitioners were led rapidly through the rooms of the palace to where the king courteously stood bare-headed with his hat beside him on a table. The suggestion is strengthened by Velázquez's signature in the form of a petition held by the sovereign. Philip wears the Order of the Golden Fleece on a gold chain and a stiff white collar, the golilla, introduced by law at the beginning of his reign in an effort to curb extravagance in dress, replacing the elaborate pleated ruff of earlier fashions.

Exceptionally in an indoor portrait, the king is not dressed in plain black but in a sumptuous costume which is the glory of Velázquez's painting. While the face, with its malformed Habsburg lower jaw and surprisingly timid glance, is modelled with a close-knit patchwork of paint, the costume is executed in freely brushed smears and blobs inspired by Titian and Tintoretto (pages 163, 160). From a distance, these marks – sometimes thin and fluid, at other times so thick as to be three-dimensional – create the illusion of sparkling silver embroidery over lustrous cloth. They are likely to have been painted, somewhat later than the face, with the extremely long brushes which

Velázguez is known to have used.

The thin red and dun washes of the background, grown more translucent with age, now reveal changes to the pose of the legs and the outline of the cloak, and even traces of the artist wiping his brushes on the underpaint above the hat. The pale grey undercoat would have always shimmered softly through the surface colours, suggesting ambient air. Contemporaries praised the free virtuoso technique, associating it not only with Velázquez's illustrious Venetian predecessors but also with an art fit for princely palaces of great rooms and long vistas, in which large paintings could be viewed from afar.

The portrait, suitably regal from a distance, can be read as an icon of the so-called Planet King, heir to all the magnificence of the Spanish throne. On closer observation, however, it is also a sympathetic but unflinching record of a vacillating young man, ensnared in the trappings and etiquette of office.

DIEGO VELÁZQUEZ (1599-1660)

Kitchen Scene with Christ in the House of Martha and Mary 1618?

Oil on canvas, 60 x 104 cm NG 1375

This picture is one of a group of *bodegones* – naturalistic kitchen or tavern scenes with prominent still lifes, from *bodega*, cellar or tavern – painted by Velázquez in Seville early in his career, in a total departure from the academic style of his master, Pacheco. They seem to have been inspired by Caravaggio (page 187), who had worked in Spanish dominions in Italy and whose paintings came to be prized in Spain, although we do not know which, if any, could have been seen by the young Velázquez. Spanish taste for low-life subjects had been formed by the picaresque novels with their cast of beggars and rogues, the first of which was published in 1554, and Velázquez's essays in the genre found favour both in Seville and Madrid.

While the earliest known of his *bodegones* were exuberant scenes in the picaresque mode, the more accomplished adopt the dignity of this picture. Several show women at work. In this, as in the inclusion of a biblical scene in the background, they were

inspired by Netherlandish sixteenth-century paintings, or more likely engravings after such paintings (see Beuckelaer, page 104). Yet they have an entirely original, and very Spanish, character.

Just as Velázquez rejects the showier aspects of Caravaggio's style, so the improbable profusion of foodstuffs in the Northern prototypes is pared down to the ingredients of a real meal, and displayed in commonplace Spanish vessels. The young woman in the foreground is pounding garlic in a mortar, perhaps to make a spicy mayonnaise for grilled fish, with egg yolks, olive oil (in the jug on the right) and chilli pepper. The modesty of these ingredients sparsely laid out in a series of diminishing ovals is elevated to sublimity through Velázquez's incomparable treatment of form and texture. The silvery slipperiness of fish, the weighty gleam of brass, the dense glowing glaze, chipped, over terracotta, the papery-thin skin of the garlic, the thicker crinkly dryness of the pepper, the reflections in the convex bowl of the pewter spoon – all these defy reproduction or description. And never have two eggs been painted so attentively, their volume and the subdued reflectance of eggshell suggested so precisely. In this still life the nineteen-year-old Velázquez already demonstrates that unique and mysterious mixture of virtuosity and reticence, amounting to self-abnegation, which was to characterise all his work.

The hatch in the kitchen wall reveals the scene of Christ in the house of Martha and Mary (Luke 10:38–42). Mary sits at Jesus' feet, but Martha is troubled that she is left to serve alone, and he rebukes her, 'Martha, Martha, thou art careful and troubled about many things: But one thing is needful: and Mary has chosen that good part...' The exact relationship of the foreground to the more sketchily and conventionally painted background is not clear. Is the sullen young woman with the reddened hands, working the mortar and pestle, Martha? Or is she a modern cook being exhorted to do her duty, in a mistaken interpretation of the tale as sanctifying domestic drudgery? And are we being addressed in this sense through her? A comparison of the foreground with the background suggests that Velázquez, in this painting at least, lavished more care on the everyday things of Martha's realm.

DIEGO VELÁZQUEZ (1599-1660)

The Toilet of Venus ('The Rokeby Venus') about 1647-51?

Oil on canvas, 122 x 177 cm NG 2057

For reasons of religious scruple, the female nude was rarely represented in Spanish art, although the royal collection was rich in mythological nudes by Titian and other Venetian Renaissance masters. The *Toilet of Venus*, called the 'Rokeby Venus' after Rokeby Hall in Yorkshire where it hung in the nineteenth century, is the only surviving picture of this kind by Velázquez (one other, now lost, is recorded) and remained unique in Spain until Goya (page 302) depicted the *Naked Maja*, which was probably inspired by it. Painted either just before or during Velázquez's second visit to Italy in 1649–51, the *Venus* was recorded in 1651 in the collection of the young son of Philip IV's prime minister, famous both for his womanising and his patronage of art. He was later to become Marqués of Carpio and later still Viceroy of Naples, and it must have been his standing at court which enabled him to commission such a painting without fear of the Inquisition.

If the subject of this picture is a conflation of the Venetian Renaissance inventions of 'Venus at her mirror with Cupid' and 'Reclining Venus', its all-pervasive theme is reflection. Venus reflects on her beauty, reflected in the mirror; since we can dimly see her face, we know that ours can be seen by her, and she may be thought to reflect on the effect her beauty has on us. Velázquez has reflected long before his canvas and the living model – for this girl, with her small waist and jutting hip, does not resemble the fuller, more rounded Italian nudes inspired by ancient sculpture, and she wears her hair in a modern style. Only the presence of the plumply and innocently deferential Cupid transforms her into a goddess. The painter has moulded her body with infinitely

scrupulous and tender gradations of colour, white, pink, grey and muted black and red, and the grey-black satin which reflects on her luminous skin itself shimmers with pearly reflections of flesh tones. Streaks of pink, white and grey loop in ribbons around the ebony frame of the mirror. Even more astonishing is the single brushstroke, laden with black paint, tracing the line that runs beneath her body from the middle of the back to below her calf. Both the exact notation of appearance and such free and spontaneous touches are the fruit of lengthy meditation and practice.

The very genesis of the painting may have been an act of reflection. The suggestion has been made that it was designed as a harmonious contrast to a nude Danaë (later transformed into a Venus) attributed to Tintoretto. By 1677 both were incorporated, probably as a pair, in the decoration of a ceiling in one of Carpio's palaces. The Danaë-Venus, recently rediscovered in a private collection in Europe, is of nearly identical dimensions and a virtual mirror image of Velázquez's *Venus*: the figure reclining in a landscape in the same pose, but facing the viewer, and on red drapery. The witty reversal echoes Titian's procedure in the mythological *poesie* ('poems') painted for Philip IV's grandfather Philip II and still in the royal collection, in which he promised to show the different aspects of the naked female form. But, typically of Velázquez, in this haunting successor to the more sensuous and exuberant Renaissance works, the narrative and the poetry consist in the act of looking and being looked at.

JOHANNES VERMEER (1632-1675)

A Young Woman standing at a Virginal about 1670

Oil on canvas, 52×45 cm NG 1383

The Delft painter Vermeer is famous for his small domestic scenes, mainly of the easeful life of women, serene interiors of subtle geometry inhabited by one or two figures. Yet his earliest works, large dramatic narratives influenced by the Italianate Catholic painters of Utrecht (see ter Brugghen, page 184, and Honthorst, page 214) show him to have originally aspired to 'history painting'. At some point around 1656, the date of a low-life *Procuress* now in Dresden, he changed into the artist we see here, although we know from a few works in other collections that he never altogether gave up his allegiance to the 'higher' genre.

It may have been mainly the difficulty of obtaining commissions in this traditional category that caused Vermeer, himself a Catholic, to turn to marketable subjects from 'everyday life' in Protestant Holland. In the event, only some thirty pictures by him in any genre (including two ravishing townscapes) were recorded and are known today, for he worked slowly, ran an inn inherited from his father, held town office, and practised as an art dealer and valuer. He was virtually bankrupted during the French invasion in 1672. After his death at the early age of 43, his widow, encumbered with debts and with eight under-age children, had to sell his paintings to pay off her creditors.

As we might suspect in an artist with his aspirations, Vermeer injected narrative or allegorical significance even into his domestic interiors. The young woman strokes the keys of the virginal – a smaller version of the harpsichord – but looks expectantly out of the picture. Music, we recall, is 'the food of love', and the empty chair calls to mind an absent sitter, perhaps travelling abroad among the mountains depicted in the picture on the wall and on the lid of the virginal. Cupid holding up a playing card or tablet has been related to an emblem of fidelity to one lover, as illustrated in one of the popular contemporary Dutch emblem books, where the image is explained in the

accompanying motto and text. It has been suggested, not altogether convincingly, that the painting forms a contrasting pair with its neighbour, Vermeer's Young Woman seated at a Virginal, where the viola da gamba in the foreground awaits the partner of a duet but the picture of the Procuress (by the Utrecht artist Baburen) behind the woman points to mercenary love.

Whether or not the paintings are thus related, both surely portray young women dreaming of love. But the theme seems commonplace beside Vermeer's treatment of it. Cool daylight streams in through the window on the left, as it always does in his pictures. The textures of grey-veined marble and white-and-blue Delft tiles, of gilt frame and whitewashed wall, of blue velvet and taffeta and white satin, of scarlet bows, are differentiated through the action of this light in their most minute particularities and specific lustre. Volume is revealed, shadows cast and space created. Yet the real magic of the painting is that all this does not, as it were, exhaust the light. Enough of it remains as a palpable presence diffused throughout the room to reach out to us beyond the picture's frame.

FRANCISCO DE ZURBARÁN (1598–1664) Saint Margaret of Antioch about 1630–4

Oil on canvas, 163×105 cm NG 1930

Zurbarán was apprenticed as a painter in Seville, where he began his youthful friendship with Velázquez (page 256), through whose good offices he was later employed on the decoration of the king's new pleasure palace in Madrid. Early in his career he was the main purveyor of paintings to the many monastic foundations of Seville; after about 1650 he had to depend on overseas contracts, dispatching series of canvases on religious themes to the Spanish colonies in the New World. He died in straitened

circumstances in Madrid, having tried, late in life, to soften his hard-edged style to the more graceful, 'vaporous' manner of his successful rival in Seville, Murillo (page 227).

Saint Margaret is an excellent example of his earlier style, indebted, probably indirectly, to Caravaggio (page 187). The picture may have been destined for a compartment of an altarpiece, or for a series of virgin saints, a number of which were supplied by Zurbarán and his workshop to convents in Spain and Latin America. Margaret stands solid, intensely and almost evenly lit from above, like one of the brightly painted wooden statues populating Spanish churches. Her attribute, the dragon, is less distinctly visible against the dark background. Legend has it that the devil appeared to her as a dragon when she was being held in a dungeon for refusing to marry, having dedicated herself to Christ. When he threatened her, she made the sign of the cross on her breast. When he swallowed her, the cross grew larger and larger, finally splitting the dragon in two and allowing her to escape unharmed. She was later executed, but in memory of this miraculous interim delivery, Margaret is invoked for help by women in childbirth.

Here she is dressed as a shepherdess (albeit a learned, severe and extremely well-groomed one) because she is also said to have guarded her nurse's sheep. Over her left arm are woven-wool alforjas – Spanish saddle bags – and in her right hand a shepherd's crook with a metal head. All the details of her costume, especially the straw hat whose plaited bands curve with the brim, are obviously studied from life, whether worn by a patient model or draped on a mannequin, and are depicted with a realism so emphatic that it serves paradoxically to underline her martyr's victory over nature.

FRANCISCO DE ZURBARÁN (1598-1664)

Cup of Water and a Rose on a Silver Plate about 1630

Oil on canvas, 21.2 × 30.1 cm NG 6566

If the sixteenth-century Netherlandish pioneers of still life emphasised the contrast between the material world and Christian values (see Beuckelaer, page 104), Spanish seventeenth-century painters sometimes relied on an older tradition, in which still-life motifs symbolised spiritual truths. We have seen how in 1311 Duccio represented a vase of lilies in a scene of the Annunciation to signify the Virgin Mary's purity (page 43; see also pages 40 and 60). In the same way, Zurbarán featured many vivid still-life accessories in his religious paintings. Variants of this composition appeared in the artist's Miraculous Cure of the Blessed Reginald of Orléans, painted for a church in Seville, and in his Family of the Virgin, now in Madrid. An even closer version stands on the right of his Still Life with a Basket of Oranges in Pasadena. That work, one of Zurbarán's very few independent still lifes, has been interpreted as a kind of rebus in homage to the Virgin Mary (since orange blossoms and oranges appear together on the tree, they may symbolise simultaneous virginity and fecundity). The serene little picture reproduced here, the first seventeenth-century Spanish still life to enter the National Gallery, may be a study recorded from life, intended for copying in different contexts but possibly always endowed with religious significance.

The painting shows a delicate white ceramic cup, probably Sevillian-made, filled almost to the brim with water. It sits in a silver plate of the kind manufactured near the silver mines of Peru. A pink rose, its red lake glazes probably faded, rests upon the plate's broad rim and is reflected in it. These objects are shown life-size, isolated on a wooden shelf or table against a dark background which is neither wall nor void, and brought up close to the picture surface and the viewer. Light falls on them from

the upper left, casting shadows and creating highlights and reflections on the various surface textures; most remarkable is the soft shimmer of the water in the cup. The canvas has been cut down on three sides – top, bottom and right – but the composition is probably complete.

It is perhaps immaterial whether we read this image literally in the light of the Old Testament Song of Solomon, claimed by Christians to prefigure the Virgin Mary, or of the prayers intoned to her. We shall never know if Zurbarán's rose was meant to evoke the 'mystic Rose' that blooms in the Garden of Paradise, and the pure water in the cup 'a well of living waters' or 'a fountain sealed'. Possibly they represent a royal offering of a cooling drink, such as is made to the Spanish princess in Velázquez's great Maids of Honour (Las Meninas) painted in 1656 (for Zurbarán's Sevillian compatriot Velázquez, see page 256). Yet however we view it, the picture seems more than a mere depiction of worldly goods. If it does not arouse religious contemplation, it still moves us to meditate on the fragility of flowers and of life itself – on water, transparent yet reflective, formless, colourless, tasteless, yet the most precious of substances; on human craft that creates objects of utility and beauty from clay and shapeless metal ore – and fixes a fleeting moment between dawn and dusk with a few strokes of paint on canvas.

Many visitors, entering the National Gallery from the imposing portico on Trafalgar Square, seek out the colourful canvases of the Impressionists, located in the East Wing with the other later paintings in the collection. Such works as Monet's *Beach at Trouville* or Renoir's *Boating on the Seine*, created over a hundred years ago, still seem to speak to us very directly, recalling our own experience of the simple pleasures of summer holidays by the sea or in the country. It is difficult, at first sight, to relate them to the more obviously 'artful' earlier works in the collection, with their sometimes obscure religious or classical references. And yet I think an overall theme unites them all.

In academic shorthand I think of this theme as 'The Perseverance and Transformation of the Genres', traditional types of painting codified in the seventeenth century. If we close our eyes for a moment to the technical innovations of mid-nineteenth-century French painting – the brash new palette or range of colours, the apparent spontaneity of brushwork, the obtrusive new paint textures – and look instead at *what* is being painted, in what format and for what original purpose, we realise that tradition has been as powerful a force at work here as the urge for novelty.

The very strength of established tradition provides an incentive for, and a measure of, innovation. The Impressionists are but the latest in a long line of Western European artists to wrestle with the problems of *landscape painting*. From the sixteenth-century Fleming Patinir, through Elsheimer, Rubens, Claude, Poussin, Ruisdael, the Venetian masters of *vedute* and *capricci*, to Constable and Turner, painters had been devising various ways of depicting distance and natural outdoor light. The modes of producing, marketing and displaying landscape paintings in the Dutch United Provinces of the seventeenth century anticipated the way landscapes were made and sold in the nineteenth century, and it was largely the example of Dutch realism which first encouraged eighteenth- and nineteenth-century painters to set up their easels out of doors.

If landscape became a dominant preoccupation of 'modern' painting, the other categories forged throughout the history of European art were not forgotten. The East Wing also houses paintings in the 'higher' genres: altarpieces, allegories and mythological or religious history paintings (see the Narrative Pocket Guide). This may be hard to see at first, since mural decorations for the Spanish court, and altarpieces by Tiepolo, the greatest Italian painter of the eighteenth century, are represented only by small oil sketches, models for the full-size works. Tiepolo's vast allegorical wall and ceiling decorations are exemplified through small fragments, including a shaped canvas, Allegory with Venus and Time, removed from its original emplacement in a Venetian palazzo. Most of the great altarpieces and 'history paintings' produced in France from about 1700 have remained in their native land, but the Gallery owns two outstanding monumental narratives by Delaroche and Puvis de Chavannes. The vitality of 'history painting' in the nineteenth century is, however, most convincingly demonstrated in Manet's now fragmentary Execution of Maximilian, while Fragonard's school piece on the subject of Psyche and her sisters testifies to the continuing importance of mythology.

Although attenuated, even this tradition survived into our own times, as is shown by Cézanne's *Bathers*, with its challenge to the monumental nymphs of sixteenth-century Venice.

Portraiture on the scale of life is well represented in the East Wing, with works ranging from the eighteenth to the twentieth century. In Protestant England this was the most often commissioned type of easel painting in the 1700s, much to the despair of many artists. Reynolds's attempt to 'elevate' portraiture to the more inventive and overtly didactic 'history painting' can be seen in most of his works here. But all painters embarking on portraits of status sought – and still seek – to give sitter and picture additional significance, often through reference to the Old Masters. This is as true of Matisse, who looked to Veronese in his 1908 likeness of Greta Moll, as it is of Goya, Ingres, Degas, and even Gainsborough, Reynolds's 'naturalistic' rival.

The humbler but lively sister of 'history painting', *genre* or the *painting of everyday life*, continued to flourish – whether overtly moralising, as in Hogarth's *Marriage A-la-Mode*, or non-judgemental, even hedonistic, as in the Impressionist scenes of modern life.

Still life, the Cinderella of academic art theory beloved by princes and commoners alike, has never been forsaken. From Meléndez to Picasso it continues to be the vehicle of artistic experiment in the representation of form and texture. Van Gogh's Chair personalises a symbolic motif of Dutch seventeenth-century still life.

Is there nothing new under the roof of the National Gallery's East Wing, besides technique and the tools and materials of the craft? Painting is a craft, so it would be foolish to dismiss technical change as trivial. Changes in economic and social organisation also profoundly affected the look of painting between 1700 and the present: the rise of professional 'colourmen' and canvas merchants, for example, distancing the artist from his raw materials and making artists' workshops and training through apprenticeship redundant; the growth of public exhibitions and private dealers; the shift from princely collection to state museum; most obviously, the decline of private devotion and public religiosity and the rise and fall of monarchies, republics and empires.

Yet even within that persevering tradition of the pictorial genres which I have been tracing, consciously or unconsciously absorbed by artists and viewers alike, significant change has in fact come about. Precisely because we know the rules, we can all play the game. New meanings are created from crossing 'higher' with 'lower' genres. As we have seen, Reynolds combined portraiture and 'history painting'. Inversely, portraits were domesticated through assimilation with scenes of 'everyday life', producing the small-scale 'Conversation Piece' of which Stubbs's *Milbanke and Melbourne Families* is a beautiful, if exceptionally silent, example.

More startling is Seurat's hybrid *Bathers at Asnières*. Anonymous industrial workers in the pursuit of leisure – a typical subject of small domestic genre – are elevated to heroic dignity by being depicted on a monumental scale and with the geometric rigour of a Piero della Francesca fresco. Seurat is not alone in thus 'elevating' the 'lower classes'; Millet's *Winnower* is another instance of the same impulse. In Friedrich's modestly sized landscapes, religious faith is expressed as poignantly as in any altarpiece. Redon conceals Shakespeare's Ophelia in a bouquet of flowers. Surprised and delighted at the

infinite capacity of art for transformation and renewal, we move among the pictures in our National Gallery to find and redefine ourselves.

In 1997 the National and Tate Galleries agreed that pictures by foreign artists painted before 1900 would form part of the collection at Trafalgar Square, while most twentieth-century works would be displayed at the Tate. Gauguin's beautiful late Tahitian canvas Faa Iheihe, painted in 1898, is one of the works accordingly transferred from the Tate collection to the National Gallery. Conversely, the Portrait of Greta Moll by Matisse, Picasso's Bowl of Fruit, Bottle and Violin and Redon's Ophelia among the Flowers, all painted after 1900, are no longer on show in the East Wing. These entries have been retained in the Companion Guide, however, because they tell a vital part of the story of Western European painting between 1700 and the early twentieth century and may help the reader to view pictures not only in the National Gallery but also in other collections.

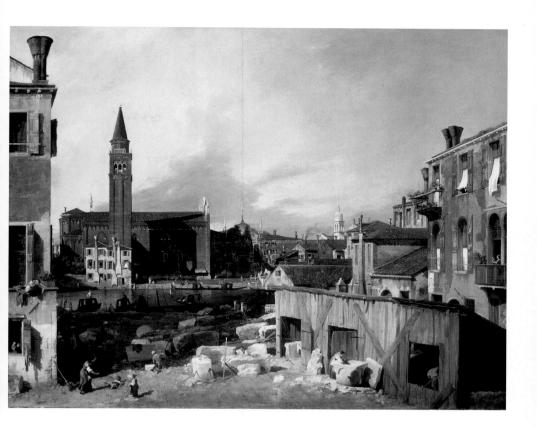

CANALETTO (1697-1768)

'The Stonemason's Yard' about 1726-30

Oil on canvas, 124 x 163 cm NG 127

Giovanni Antonio Canal's popularity with English Grand Tourists – mainly young noblemen completing their education with an extended trip to the Continent – has meant that many more of his pictures can be found in Britain than in his native Venice or even throughout Italy. Trained as a scene painter, by 1725 he was specialising in *vedute* – more or less topographically exact records of the city, its canals and churches, festivals and ceremonies. He visited England several times, but his English paintings did not please, and he returned home for good in about 1756.

Although we associate Canaletto for the most part with mass-produced, crystal-clear scenes of celebrated sights, the 'Stonemason's Yard', his masterpiece, is not of this kind. A comparatively early picture, and almost certainly made to order for a Venetian client, it presents an intimate view of the city, as if from a rear window. The site is not in fact a mason's yard, but the Campo San Vidal during rebuilding operations on the adjoining church of San Vidal or Vitale. Santa Maria della Carità, now the Galleria dell'Accademia, the main art gallery in Venice, is the church seen across the Grand Canal.

Canaletto's later works are painted rather tightly on a reflective white ground, but this picture was freely brushed over reddish brown, the technical reason for the warm tonality of the whole. Thundery clouds are gradually clearing, and the sun casts powerful shadows, whose steep diagonals help define the space and articulate the architecture.

Not doges and dignitaries but the working people and children of Venice animate the scene and set the scale. In the left foreground a mother has propped up her broom to rush to the aid of her fallen and incontinent toddler, watched by a woman airing the bedding out of the window above and a serious little girl. Stonemasons kneel to their work. A woman sits spinning at her window. The city, weatherbeaten, dilapidated, lives on, and below the high bell-tower of Santa Maria della Carità it is the little shabby house, with a brave red cloth hanging from the window, which catches the brightest of the sunlight.

PAUL CÉZANNE (1839-1906)

Bathers about 1900-6

Oil on canvas, 127 x 196 cm NG 6359

The Cézanne we know best was a painter of still lifes and of the landscape of his native Provence, built up slowly and methodically, with orderly patches of colour simultaneously representing form and the effects of light. Because his work influenced the Cubist paintings of Braque and Picasso (page 320), and because of a famous quotation—cited out of context—about treating nature 'according to the sphere, the cone and the cylinder', we tend to think of Cézanne as a disciplined, cerebral artist. Nothing could be further from the truth. His forceful, agitated early paintings treated subjects as violent and sensual as those of Delacroix (page 284), and in a letter written in 1858 to his boyhood companion Emile Zola he is described as 'that poetic, fantastic, bacchic, erotic, antique, physical, geometrical friend of ours'.

The son of a wealthy banker who fiercely opposed his artistic leanings, Cézanne trained initially as a lawyer at the university of Aix-en-Provence. He then took drawing lessons at the local academy; in 1861 he followed Zola to Paris, where he visited museums and met Pissarro (page 321), who encouraged him to paint out of doors. Success as a painter came late, and he never shook off a certain awkwardness in drawing the human figure. But in his three great canvases of *Bathers*, executed between about 1895 and 1905, he was at last able to synthesise his mature experience with the passions, now sublimated, the ambitions, and perhaps even the memories, of his youth.

Like the other two *Bathers* (now in the Barnes Foundation, Merion, Pennsylvania, and the Museum of Art in Philadephia), the National Gallery picture recalls the sensuous, monumental bathing nymphs and pagan goddesses of Venetian Renaissance mythological painting. As a young man, Cézanne had studied such works, notably those by Titian (page 163), in the Louvre, Paris – although he invokes no specific narrative here. At the same time, these imaginary nudes are as firmly integrated with nature as the rocks, vegetation and stone houses of the landscapes he recorded under 'the good sun of Provence'.

The painter Bridget Riley has observed of this picture: 'The back leg [of the girl on the left] plants the line of the tree trunk firmly on the ground, her head merges into the bark' and 'the ochres, blues, pinks, greens and white' of the composition are 'derivatives of earth, skin, sky, sunlight, leaves and opalescent clouds'. The same brushstrokes and flat areas of paint are used throughout, and the sensation evoked by the whole is of luminous daylight. While the equally anonymous and ungainly female nudes of Cézanne's early paintings traced the tormented fantasies of the artist – the lure and fear of the *éternel féminin*, woman as both victim and emasculator, love inseparable from rape, murder and self-immolation – these figures transcend subjective emotion, and achieve an enigmatic serenity.

PAUL CÉZANNE (1839–1906)

The Stove in the Studio late 1860s

Oil on canvas, 41 × 30 cm NG 6509

In the late 1860s Cézanne divided his time between his bourgeois family home in Aix-en-Provence and a Bohemian existence in Paris, where this tiny yet powerful picture was probably painted. He spent much of his time in the city sketching in the Louvre, where, paradoxically, he also found inspiration for a new kind of art based on direct observation from nature. In particular, he may have studied a famous painting by Chardin, the *Copper Cistern*, which entered the Louvre in 1869. Like the other Old Masters being rediscovered or reassessed in these years – the Dutch painters of domestic interiors Vermeer and de Hooch, the Le Nain brothers, Hals, the young Velázquez (pages 261, 216, 222, 210, 256) – Chardin (page 274) had depicted what he had truly observed, and Cézanne would remain interested in him all his life.

In this picture the artist has boldly rearranged everyday objects in his studio, and we see them from his high point of view as he stands at his easel, with the strong light from the windows behind his left shoulder. The emblems of his profession, a palette and a small painting, glitter against the dark wall, and a flat, light-coloured canvas on its stretcher frames the bulging cauldron reminiscent of Chardin's kitchenwares. Within the larger studio interior this motif constitutes a quasi-independent still life. Tone and colour, paintstuff and form, seem, as in Velázquez or Hals, inseparable.

Darkness is not an absence of colour, but luscious, lustrous streaks of different blacks; whites range from the purest and most brilliant through cream and grey, and the fire is the hot red heart of the whole composition. Years later, when the elderly Cézanne was asked by a young artist for advice on the most necessary study for a beginner, he replied, 'paint your stovepipe'.

JEAN SIMÉON CHARDIN (1699-1779)

The House of Cards about 1736-7

Oil on canvas, 60 × 72 cm NG 4078

At a time when large-scale heroic narrative painting was thought to be the most meritorious, Chardin, thwarted by his lack of academic training in drawing, became one of the greatest practitioners of the 'lowly' art of still life. Born in Paris, where he spent most of his life, he first trained at the guild school of Saint-Luc, before gaining admittance to the French Royal Academy in the category of a still-life and animal painter. By the end of his life his works were to be found in most of the great private collections of the time. Although totally dependent on observation and on working closely from nature, Chardin evolved methods of painting at a distance from the model, so that he was able to reconcile particular detail with a more generalised effect. While some critics deplored his inability to paint more 'elevated' subjects, others, like the influential philosopher Diderot, praised the 'magic' of his brush: 'This magic defies understanding... it is a vapour that has been breathed onto the canvas... Approach the painting, and everything comes together in a jumble, flattens out, and vanishes; move away, and everything creates itself and reappears.'

In the early 1730s, perhaps in response to the amicable taunt of Joseph Aved, a portrait-painter friend, Chardin also turned to small-scale figure painting, influenced

by the Dutch and Flemish seventeenth-century masters of everyday scenes. Encouraged by the success of these homespun compositions of kitchen maids and serving men at work, he moved from the sculleries of the bourgeoisie to their living quarters. By narrowing the focus to the half-length figure, he was also able to enlarge it in scale, as he does here. In this wonderfully intimate and contemplative picture, he portrays the son of his friend Monsieur Lenoir, a furniture dealer and cabinetmaker.

The *House of Cards* owes its subject to the moralising *vanitas* paintings of the seventeenth century (see page 255). The verses under the engraving of the picture, published in 1743, stress the insubstantiality of human endeavours, as frail as a house of cards. But the painting tends to undermine the moral. Its rigorously geometric and stable composition gives an air of permanence which contradicts the fugitive nature of the boy's pastime, and of childhood itself. Chardin's 'magic accord' of tones envelops the scene securely in its warm and subtle light, at once direct and diffused. His technique remained secret, although it was suspected that he used his thumb as much as his brush. We can well believe, however, his response to the enquiry of a mediocre painter: 'We *use* colours, but we *paint* with feeling.'

JOHN CONSTABLE (1776-1837)

The Hay Wain 1821

Oil on canvas, 130 x 185 cm NG 1207

John Constable's father was a wealthy Suffolk miller. 'When I look at a mill painted by John,' said the painter's brother, 'I see that it will go *round*, which is not always the case with those by other artists.' Constable's truthfulness to nature and devotion to his native

scene have passed into legend. Less widely known, however, is his biographer's report that it was seeing Claude's *Hagar and the Angel* – now in the collection – and water-colours by Girtin which first provided him with 'pictures that he could rely on as guides to the study of nature'. Ruisdael, Rubens, Richard Wilson and Annibale Carracci were among other 'reliable guides' whose work he copied as a young man, writing, on a visit to Ipswich, 'I fancy I see Gainsborough in every hedge and hollow tree' (pages 248, 242, 188, 291). He also learned from contemporary painters, never forgetting the advice given him by Benjamin West, the President of the Royal Academy: 'Always remember, sir, that light and shadow *never stand still*...in your skies...always aim at *brightness*...even in the darkest effects...your darks should look like the darks of silver, not of lead or of slate.'

Constable's youthful exclamation, 'There is room enough for a natural painture', must be understood not as the outpouring of a 'natural painter' but as the proclamation of an aspiring student struggling for proficiency in the language of art, which shaped his deepest feelings before he could give expression to them.

The Hay Wain, exhibited at the Royal Academy in 1821 and at the British Institution in 1822 under the title Landscape: Noon, was one of the big 'six-footers' on which Constable worked in the winters in London from sketches and studies made in the country in summer. The harvest wagon of the modern title was copied from a drawing made by John Dunthorne, Constable's childhood friend and assistant, and sent at Constable's request from Suffolk. The view is of farmer Willy Lott's cottage on a mill stream of the River Stour near Flatford Mill, of which Constable's father had the tenancy. A full-scale sketch for the picture is in the Victoria and Albert Museum, London. In this final version Constable omitted a figure on horseback at the edge of the stream, substituting a barrel which he later painted out (but which is beginning to show through).

In thus 'selecting and combining' from 'some of the forms and evanescent effects of nature' Constable sought an 'unaffected truth of expression' without the loss of poetry.

He laboured 'almost fainting by the way' to preserve the sparkle of sketches in these large paintings worked over for many months in the studio. The Hay Wain, that best-loved icon of the English countryside, was admired by Constable's closest friends but did not meet with success at the London exhibitions. He sold it in 1823 with two other pictures to an Anglo-French dealer who exhibited them in the 1824 Salon in Paris. There at last Constable's achievement was understood, especially by the painters (see Delacroix, page 284) who raised 'the alarum in my favour; [they] acknowledge the richness of texture, and attention to the surface of things. They are struck with their vivacity and freshness. . .' An English traveller reported overhearing a visitor say to another, 'Look at these landscapes by an Englishman – the ground appears to be covered with dew'. A cast of the gold medal awarded to Constable by King Charles X of France is incorporated in the picture's frame.

JOHN CONSTABLE (1776-1837)

Weymouth Bay: Bowleaze Cove and Jordon Hill 1816-17

Oil on canvas, 53 × 75 cm NG 2652

Constable met Maria Bicknell in 1800, when she was thirteen. She was the grand-daughter of the rich Dr Rhudde, Rector of East Bergholt, Constable's native village. In 1811 they became engaged, but Maria's father, Solicitor to the Admiralty, and especially her grandfather the rector, opposed her union to 'a man below her in point of fortune, and... without a profession'. Constable's friend and biographer C.R. Leslie reports that for five years Maria was treated 'as if she were a boarding-school girl in danger of falling a prey to a fortune-hunter'. At 29, however, 'she felt entitled to determine for herself a matter which so entirely affected her own happiness'. They were married on 2 October 1816 at St Martin's Church by Constable's friend the Reverend John Fisher. Fisher invited them to stay with his wife of three months and himself in Osmington, near Weymouth: 'The country here is wonderfully wild and sublime, and well worth a painter's visit.'

There is some disagreement over whether this painting of Weymouth Bay is a sketch painted out of doors during Constable's honeymoon, or a later work prepared for sale on the basis of sketches made at this time and left unfinished. It seems so fresh and spontaneous that most viewers have wished it to be a direct record of Constable's visit, his easel set a little west of Redcliff Point, facing Jordon Hill and Furzy Cliff on a gusty October day. The reddish brown of the priming shows through the blue sky and water, lending a warm glow to the landscape, which is framed and 'pushed back' by a promontory on the right and rocks and pebbles at the lower edge, painted freely but in greater detail than the rest. The glory of Weymouth Bay, however, is the cloudscape: clouds rising from the horizon to form the 'vault of the sky', that pictorial discovery of Dutch seventeenth-century marine painting (see page 185). 'By a windmiller', wrote Leslie, 'every change of sky is watched with peculiar interest,' going on to quote Constable's description of an engraving made after one of his oil sketches:

those [clouds] floating much nearer the earth may perhaps fall in with a stronger current of wind, which... causes them to move with greater rapidity; hence they are called by wind-millers and sailors, messengers, and always portend bad weather. They float midway in what may be termed the lanes of the clouds.

Constable's early employment in his father's mill must indeed have alerted him to the appearance and behaviour of clouds. It is all the more moving, therefore, to find that

in his youthful exertions to train himself in art he had sat down and carefully copied and labelled a series of cloud patterns published in 1785 for the use of his pupils by Alexander Cozens, a landscape painter and drawing master. There are no more truthful studies of clouds than those by Constable, but even the observant windmiller had to acquire a vocabulary of representation before setting them down in paint. The Royal Academician Fuseli 'wished for an umbrella when standing before one of Constable's showers'. We are tempted to reach for scarves and anoraks in front of <code>Weymouth Bay</code>.

JEAN-BAPTISTE-CAMILLE COROT (1796–1875) Peasants under the Trees at Dawn about 1840–5

Oil on canvas, 28 × 40 cm NG 6439

Until after 1900, Corot's fame and popularity rested mainly on his artificially composed late landscapes: romantically suggestive silvery confections of hazy willows dissolving against luminous sky and water. Even in the late 1930s, as a gallery-going child, I can remember grown-ups sighing with pleasurable melancholy in front of these monotonous if lyrical canvases. It wasn't until many years later that I discovered the other Corot, the mentor of the naturalistic Barbizon School, of Pissarro (page 321) and the Impressionists: the unpretentious painter from nature whose delicate and precise vision resists verbal analysis and doesn't lend itself to facile nostalgia.

Corot's 'studies' painted outdoors directly from the motif were private works and were not exhibited by him at the Paris Salons. They were nonetheless formative on generations of artists, having been bought up after Corot's death by fellow painters, including Degas (page 281). A late developer, inspired by Constable's landscapes exhibited at the Salon of 1824 (see page 277), fortunate to be supported and encouraged by his parents, Corot became one of the most unassuming revolutionaries in the history of art. He is the agent of change from the severely stylised French 'ideal landscape'

tradition derived from Poussin and Claude (pages 230, 191) to modern landscape painting, finding classical peace and harmony in the face of nature itself.

Corot's records of the classical south – ancient aqueducts, tawny ramparts, scrubby hills, umbrella pines and olive trees under the spacious blue skies of Italy and Provence – are among the most beautiful of his oil sketches, and the visitor to the Gallery will enjoy the exquisite little view of *Avignon from the West*. But I have chosen to illustrate an even more unassuming picture, painted in the Morvan, a district west of Dijon in Burgundy, which Corot visited frequently on painting expeditions in the early 1840s. His father's family had originated there, and he must have felt a particular affinity with the region. A peasant saws timber; his wife helps him. Trees and distant village buildings are silhouetted against the sky, irradiated with the fresh cool light of early morning, and long shadows fall on the grass, where we can just make out a glint of white plumage on the back of a goose with dun-feathered wings waddling out to graze. There is nothing heroic here, nor overtly poetic, no temperamental flourishes, only perfectly judged notes of white, grey, brownish grey, green, a very little blue, warmed with one single touch of red in the woman's bonnet.

JACQUES-LOUIS DAVID (1748–1825)

Jacobus Blauw 1795

Oil on canvas, 92×73 cm NG 6495

Purchased by the National Gallery in 1984, this beautifully preserved work is the first painting by David to enter a British public collection. The artist distinguished himself in France both as a painter and as a political figure, actively participating in the Revolution and later becoming Napoleon's court artist. After Napoleon's fall David went into exile in Brussels where he died; his *Portrait of the Vicomtesse Vilain XIIII and her Daughter*, painted there in 1816, was acquired by the Gallery in 1994.

Although David made his name with large heroic narrative pictures on themes from antiquity, some of his finest works are portraits of contemporaries, in which he combines lifelike realism with the severe compositions, controlled colour range and unostentatious brushwork of the Neo-classical style. *Jacobus Blauw* is an especially fine example, and interestingly combines the painter's political and artistic concerns. The sitter was a leading Dutch patriot who, in 1795 – or, as David dates the painting, year 4 of the French Revolutionary Calendar – helped to establish the Batavian Republic. When the French army invaded the Netherlands later that year, Blauw, along with his countryman Caspar Meyer, was sent to Paris to negotiate a peace settlement. It was then that they commissioned David to paint their portraits (the one of Meyer is in the Louvre, Paris). It is clear, however, that of the two it was Blauw whom David found more sympathetic.

Blauw is shown seated writing an official document, a device which enables the artist to organise the composition with strict geometry, predominantly horizontal and vertical lines meeting at a right angle and echoing the shape of the canvas. (Or one can think of the sitter as forming a pyramid above the desk.) The fiction that Blauw has just turned from his work to pause for thought provides the motive for presenting him in full-face view. David softens the discomfort felt in such direct confrontation, however, by placing the head off-centre and by leaving the eyes unfocused. The pose combines great stability with a sense of momentary action, and seems to give us an insight into Blauw's character. He is shown in simple dress befitting a republican: a plain coat, a soft cravat, his own hair powdered, instead of an aristocrat's wig. A wonderful touch enlivens his brass buttons: gleams of red, implying unexplained reflections from the artist's studio, the viewer's space.

HILAIRE-GERMAIN-EDGAR DEGAS (1834–1917)

After the Bath, Woman drying herself 1880s

Pastel on several pieces of paper mounted on cardboard, 104×98 cm NG 6295

'An uneasy participant in the tragicomedy of modern art, mad about drawing' – such was the poet Valéry's description of Degas. A progressive artist deeply devoted to academic tradition, as taught to him by pupils of Ingres (page 308) and absorbed during a study tour of Italy from 1856 to 1859, Degas first essayed 'history painting'. From the late 1860s he became a penetrating if selective observer of modern urban subjects – café concerts, the ballet, racecourses, proletarian women at work or bathing. From 1874 he exhibited with the Impressionists without, however, subscribing to their theories or technique.

Impressionism involved virtually abandoning line for colour, and Degas, a great draughtsman, was unwilling to break this link with the past. For him, as for Ingres and the Central Italian artists of the Renaissance, drawing was the cornerstone of representation; painting necessitated extensive preparatory studies and a disciplined approach to pictorial organisation. When, in 1900, he went with the English artist Sickert to see Monet's water garden pictures (see pages 317–8) he commented: 'I do not feel the need

to lose *connaissance* [consciousness, discernment] in front of a pond.' In addition, from at least 1870 Degas suffered from visual disorders which made it painful for him to paint out of doors; his choice of subject matter was constrained by the need to work in a studio with controlled lighting (in a note of 1882 he describes daylight as 'more Monet than my eyes can stand'). His eye afflictions, which necessitated constant effort, treatment and periods of rest, made him especially conscious of the willed nature of perception: 'One sees as one wishes to see'; 'Drawing isn't a matter of what you see, it's a question of what you can make other people see.'

Degas turned to pastels for a number of reasons. Their matt texture resembled that of Italian frescoes which, like Puvis de Chavannes (page 323), he admired; pastels were available in a bright, 'modern' range of hues; above all, they enabled him to draw with colour: 'I am a colourist with line.' In the mid-1880s he produced a series of 'everyday' washing and bathing nudes executed in pastel on paper, a contemporary attack on a traditional motif: 'hitherto the nude has always been represented in poses which presuppose an audience, but these women of mine are honest and simple folk. . . It is as if you looked through a keyhole.'

Standing, probably on a platform, close to the model posed in his studio, Degas began with a charcoal sketch which remains visible under the lattice-work of coloured pastels. In addition to the outlines of shoulders and arms, we can see charcoal modelling on her back under a superimposed hatching of pink. Colours as vivid and pure as those of the Impressionists are used descriptively in some areas, but arbitrarily elsewhere – blue strokes on the yellow chair, orange in the woman's armpit – energising each other and the composition. Degas blended some layers, spraying fixative on others to allow new tints to act upon the ones already laid down. The final effect is at once beautiful and dissonant. A claustrophobic corner is treated with spatial complexity; the model, denied even a face, is depersonalised in the (simulated) performance of an intimate act; the viewer is made accomplice to the voyeur, who asserts his presence with bold gestures on the paper.

HILAIRE-GERMAIN-EDGAR DEGAS (1834-1917)

Hélène Rouart in her Father's Study about 1886

Oil on canvas, 161 x 120 cm NG 6469

Hélène Rouart, whom Degas had painted as a young girl on her father's knee in about 1877, was the only daughter of Degas's lifelong friend Henri Rouart, who made his fortune as an engineer and manufacturer and spent it as a collector and painter. He exhibited at seven of the eight shows of the Impressionist group. According to Hélène's brother Louis, this portrait, painted when she was about eighteen, was the outcome of a project to depict the whole Rouart family. Two pastels and a drawing survive of Hélène standing, wrapped in a shawl, admiring a Tanagra figurine with her mother. Perhaps due to Madame Rouart's ill health, Degas later decided to paint Hélène alone in her father's study. A number of preparatory drawings show her seated on the arm of the chair that appears here.

Since the 1860s Degas had been preoccupied with a type of likeness in which personality is expressed through surrounding attributes. All the more curious, then, that Hélène is defined exclusively through her father's possessions: Egyptian wood statues in a glass case; on the wall, a Chinese silk hanging, an oil study of the Bay of Naples by Corot and a drawing by Millet. Her father's presence is evoked through the

enormous chair on which Hélène rests her hands and the desk on which his books and papers await his return, as she herself seems passively to be doing.

Immobilised between chair and wall, Hélène looks inward, taking notice neither of the painter/viewer nor of the objects around her. It has been said of this portrait that it shows her 'as someone nurtured in a cultivated environment'. To me it seems a likeness stifled by its surroundings. The bright red outlines which Degas brushed freely around the figure to detach her from the background – and which he may have intended to work over at a later stage – serve to connect her all the more with the dominant colour note of Chinese red, chosen perhaps also as a comment on her own red hair. As an unmarried daughter – Degas shows us ringless fingers, although Hélène was apparently engaged, and married shortly after – she may have served as an amanuensis to her father. Degas includes her as the most esteemed object in an inventory of Henri Rouart's eclectic collection. This portrait of her, one of the more enigmatic great works of its century, remained in Degas's studio until his death.

A critic, reviewing in 1881 Degas's statue of a prematurely aged young ballerina, wrote of the artist, 'If he maintains this style, he will make a place for himself in the history of the cruel arts'.

FERDINAND-VICTOR-EUGÈNE DELACROIX (1798–1863)

Louis-Auguste Schwiter 1826–7

Oil on canvas, 218 x 144 cm NG 3286

Delacroix's grandest pictures have never left their country of origin. His interpretations of 'antique myth and medieval history, Golgotha and the Barricade, Faust and Hamlet, Scott and Byron, tiger and odalisque' – in the words of the art historian Lorenz Eitner – are best seen in great easel paintings and ceiling decorations in Paris. Only there can we fully appreciate the bold reconciliation of beauty with cruelty, sensuality with control, fantasy with observation, modernity with tradition that characterises the art of this influential painter. 'When Delacroix paints', said a contemporary, 'it is like a lion devouring a gobbet [of flesh].'

As Byron signifies Romantic poetry, so Romantic French art means above all Delacroix. Like Byron he achieved his flamboyant artistic effects through intense intellectual application and a firm grasp of technique. Pupil of an academic artist, he was essentially self-taught through the study of the great Renaissance and seventeenth-century

colourists in the Louvre. He was fascinated by the vibrant brushwork of the Venetians and their Flemish heir Rubens (see pages 160, 163, 170, 242), imitating their capacity to simulate brilliant daylight even in the shadows, their use of colour instead of line as the primary structural element. It was precisely these effects which, as employed by Constable in the Hay Wain (page 276) exhibited at the Paris Salon in 1824, caused a sensation and further exacerbated Delacroix's fashionable Anglomania. In 1825, having sold his picture of the Massacre of Chios to the French State, he set out for London with two English friends, the watercolourists Richard Bonington and Thales Fielding. They visited galleries and the theatre and read English poets. Delacroix met other English artists, including Thomas Lawrence (page 310). Appropriately for a painting in an English collection, the National Gallery life-size likeness of Louis-Auguste Schwiter, painted after Delacroix's return to Paris, is an essay in the portrait style of Lawrence.

Schwiter, a lifelong friend of Delacroix, was himself a painter. He is presented here, however, as a gentleman, dressed in elegant black and hat in hand, standing on what appears to be the terrace of a great country house, as if waiting to be admitted. The blue Chinese vase with its heavily paint-textured flowers contrasts with the red lining of his hat. Like the trumpet vine clippings on the paving, these touches of colour serve to relate the foreground to the brooding sunset landscape (said to have been painted in part by Paul Huet, another artist friend), thus counteracting the isolation of Schwiter's monochrome silhouette.

The portrait is lit from the right, a reversal of the more usual illumination from the left, highlighting the left side of the sitter's face and perhaps helping to account for the curiously tentative impression he gives, despite his firm stance in the centre of the picture and his direct gaze. The unemphatic 'modern' pose, with its hint of English-style reserve, and the free 'unfinished' brushwork made this full-length portrait, at once so formal and so unconventional, unacceptable to the judges of the 1827 Paris Salon exhibition, and it was rejected. Delacroix later reworked the painting, finally completing it in 1830.

PAUL DELAROCHE (1795-1856)

The Execution of Lady Jane Grey 1833

Oil on canvas, 246 x 297 cm NG 1909

Anglomania was in fashion in France in the 1820s and 1830s (see previous entry). Interest in British history, fuelled by the novels of Sir Walter Scott, was further stimulated by parallels drawn between recent events in France and the turbulent accounts of Tudors, Stuarts and the Civil War. The pictorial representation of British history may have been pioneered in Britain, but it was the Frenchman Paul Delaroche who gained a European reputation with the grand scenes drawn from it which he exhibited at the annual Paris Salon between 1825 and 1835. Popularised through mass-produced engravings, these set pieces, combining ostentatious antiquarianism with the pseudorealism of bourgeois melodrama, in turn influenced the painters of national history in mid-Victorian Britain. The fame of Delaroche is all but eclipsed today, yet his Execution of Lady Jane Grey is one of the most popular pictures in the National Gallery.

It depicts the last moments on 12 February 1554 in the life of the seventeen-year-old Jane Grey, a great-granddaughter of Henry VII who was proclaimed Queen of England upon the death of young King Edward VI, a Protestant like herself. She reigned for nine days in 1553, but, through the machinations of the partisans of Henry VIII's Catholic daughter, Mary Tudor, she was convicted of high treason and sentenced to death in the Tower of London.

I myself don't like this picture very much: I find the surface slick, the detail over-finicky for the large scale. Mainly, I dislike its sentiment: the apotheosis of female fragility pitied by a genteel executioner in russet tights. Delaroche, who based the painting on a sixteenth-century Protestant martyrology, has falsified the historical account the better to appeal to his contemporaries. Lady Jane Grey, a humanist-educated young married woman, was in fact executed out of doors. Attended by two gentlewomen, probably no less stoical than she, she resolutely made her own way to the block. She could not have worn a white satin dress of nineteenth-century cut with a whalebone corset, and her hair would have been tucked up, not streaming down over her shoulders. But a painting cannot be judged by the criteria of historical accuracy. Much more applicable to this particular picture are the standards of popular melodrama and tableau vivant.

As on a stage, the heroine gropes her way towards the audience, gently guided by the elderly Constable of the Tower whose massive, dark, male presence acts as a foil to her own. A spotlight trained on her from above complements the dim stage lighting, reflecting from her immaculate dress and the straw which spills over into the front row of the stalls. The emotions of each actor are carefully delineated and distinguished, and we are left in no doubt as to the character of each – even of the lady in the background who turns her back on the terrible sight. Despite my own misgivings, *The Execution of Lady Jane Grey* remains a most potent image, the very embodiment of John Foxe's words in the 1563 *Book of Martyrs:* 'let this worthy lady pass for a saint: and let all great ladies which bear her name imitate her virtues.'

FRANÇOIS-HUBERT DROUAIS (1727–1775)

Madame de Pompadour at her Tambour Frame 1763–4

Oil on canvas, 217 × 157 cm NG 6440

The son of a painter, Hubert Drouais, François-Hubert became a successful portraitist at the French court. He was especially fashionable for his likenesses of aristocratic children dressed as gardeners or Savoyard beggars to emphasise their 'natural' or 'filial' characters (little Savoyard hurdy-gurdy players brought their earnings back every year to their mothers in the Haute Savoie). This sumptuous portrait of Madame de Pompadour, Louis XV's mistress, similarly employs the imagery of bourgeois virtue and industry to flatter a great lady.

In this case, however, the fiction is less pronounced: the Marquise de Pompadour had been born plain Mademoiselle Poisson. Pretty, charming, good-natured and well educated, at the age of nine she had been told by a fortune-teller that she would reign over the heart of a king – after which her family called her Reinette, 'little Queen' (20 years later she was to reward the woman with the gift of an enormous sum, 600 livres). Married to the nephew of her mother's rich lover, she began to entertain

Parisian intellectuals at her *salon*; Voltaire is the best known of the *philosophes* whom she captivated and supported. She soon attracted the eye of the king, Louis XV, and by 1745, separated from her husband, she was installed at Versailles and ennobled. To her enemies she remained always a Parisian bourgeoise, member of a class which was enriching itself, as they saw it, at their expense. She kept the friendship and interest of the king, however, even after their sexual relationship had ended in 1751–2, by her affection, her charm, and above all through her interest in music and the arts.

Drouais's painting faithfully records her pursuits, surrounding her with books, a mandolin, an artist's folio, her beloved pet dog, and dressing her in a lavishly embroidered silk dress edged with yards of superb lace. Her embroidery - more accurately, tambouring - wools are kept in an elaborate worktable in the latest fashion, with Sèvres plaques (Madame de Pompadour had earlier taken the porcelain factory of Vincennes under her protection and transferred it to Sèvres, near one of her houses). She looks up at the viewer as she might have done at the king when he came into her apartment by their private staircase - a woman no longer young, yet still with that 'wonderful complexion' and 'those eyes not so very big, but the brightest, wittiest and most sparkling', as praised by a contemporary. Yet there is more here than we can see at first sight. As his signature tells us, Drouais painted the Marquise's face from the life in April 1763 on a separate rectangle, which was then joined to the rest of the canvas. She must have approved of the likeness for other, half-length portraits were commissioned from Drouais. But this picture was finished in May 1764, some weeks after her death on 5 April at the age of 43. All her life she had suffered from ill health, and even in her last illness she stoically wore rouge and smiled at everybody. Drouais's suave and grand yet somehow intimate portrait installs her in our memory as she would have wished to be remembered.

JEAN-HONORÉ FRAGONARD (1732-1806)

Psyche showing her Sisters her Gifts from Cupid 1753

Oil on canvas, 168 x 192 cm NG 6445

A prize-winning pupil of François Boucher, Fragonard, in this youthful picture painted at the Ecole des Elèves Protégés in Paris, seems a perfect exponent of the taste of Boucher's patrons King Louis XV and his mistress the Marquise de Pompadour. However, after an unsuccessful final bid for institutional recognition at the Paris Salon exhibition of 1767, Fragonard virtually disappeared from official artistic life under the monarchy, working almost entirely for private patrons, many of them his friends. He was thus able to give free rein to a more individualistic celebration of nature, instinct and impulse. Whether in oils, gouache, pastels, in engravings and etchings, or in his many drawings in chalk, pen or wash, he came to efface the distinctions between sketch and finished work, and even between the boundaries of the genres. We cannot always tell, for example, whether one of his many pictures of single figures is a portrait in fancy dress, or imaginary.

On his two visits to Italy, the first to the French Academy in Rome (1756–61), and the second over a decade later as the guest of a patron, Fragonard was drawn to the land-scape and to contemporary and near-contemporary Italian artists, notably Tiepolo and Giordano (pages 338, 206). He was unmoved either by ancient ruins or by Renaissance art. With the collapse of the art market during the French Revolution he retired to his native Grasse in southern France, but was drawn into politics by his son's teacher, the

painter David (page 279). His late paintings show him trying to conform, not always successfully, to the Neo-classical austerity of David's 'republican' style.

The subject here is drawn from the allegorical tale of Cupid and Psyche by the Latin poet Apuleius, probably in a French version by La Fontaine. Psyche is showing off her 'storehouses of treasure' to her sisters in the magical castle in which she has been installed by Cupid, god of love. The sisters 'conceived great envy' – personified here by the serpent-haired figure of Eris, goddess of discord, hovering above – and try to wreck her happiness by destroying her faith in her invisible lover. In its handling of paint, and in such details as the chubby flying babies – the *putti* of ancient art, who here represent the castle's invisible servants – the picture, painted when the artist was barely 21, betrays the influence of Rubens's works at the Luxembourg Palace and also of Watteau and Boucher.

The composition is derived from a tapestry design for the same subject by Boucher. But the colours, with harmonies of gold and orange beginning to replace Boucher's accords of rose and blue, are already recognisably Fragonard's own. They appear in their purest and most concentrated form in the flowers at the foot of Psyche's throne, the area of the painting most clearly 'in focus'. Definition diminishes towards the edges of the picture, as it might in a convex mirror, and with it the colours tend to lose their identity, to mix and mingle, framing the main figures in shades of grey or darkened tones, presaging the disasters to come.

CASPAR DAVID FRIEDRICH (1774-1840)

Winter Landscape 1811

Oil on canvas, 32 x 45 cm NG 6517

One of the leading artists of the German Romantic movement, born in the small Baltic seaport of Griefswald and trained at the Academy in Copenhagen, Friedrich specialised in landscape painting. His aim was not, as he wrote, 'the faithful representation of air, water, rocks and trees...but the reflection of [the artist's] soul and emotion in these objects'. Later, using landscape to convey subjective feelings, he also invested it with symbolism. Natural elements such as mountains, sea, trees, the seasons of the year and the times of day, often acquired religious significance.

Winter Landscape was originally exhibited by Friedrich in 1811 in Weimar with another winter scene, now in the museum in Schwerin. In the bleak Schwerin picture a tiny figure on crutches stares out across a snow-covered plain. He is surrounded by the gnarled trunks of dead or dying oaks, and stumps of felled trees stretch away into the distance. But the uncompromising desolation of this image is countered by its companion now in London. Here the same cripple has abandoned his crutches. He leans against a sturdy rock, raising his hands in prayer before a crucifix gleaming against the vigorous evergreen branches of young fir trees. On the horizon the façade and spires of a Gothic church, whose silhouette echoes that of the firs, rise like a vision out of a bank of mist. Shoots of grass push through the snow, and the sky is streaked with the glow of dawn. The mortal despair in the first painting is here transformed into the hope of resurrection, the salvation vouchsafed through Christ's sacrifice on the cross.

Friedrich was not the only one of his countrymen in this period to draw an analogy between 'native German' Gothic church architecture and the natural growth of forest trees, and the imagery here almost certainly reflects his sympathies with the patriotic and democratic movements of the day as well as his religious faith.

Winter Landscape was painted with surprisingly few pigments, suggesting that Friedrich was less interested in colour than in smoothly graduated tones. He achieved the striking effect of shimmering, transparent haze by careful stippling with the point of the brush, using a blue pigment – smalt – which is transparent in an oil medium.

Technical examination, however, has yielded other discoveries. The *Winter Landscape* known to have been exhibited in 1811 had long been lost when a plausible candidate came to light in Dresden in 1940 and was bought for the museum in Dortmund. In 1982 a second picture showing the same composition was found in Paris among the effects of an exiled Russian prince. This was bought by the National Gallery in 1987, the first of the artist's works to enter a British public collection. It has now become apparent that only the London *Winter Landscape* bears the hallmarks of Friedrich's meticulous procedures, and is therefore likely to be the picture painted by him in 1811. Whether the Dortmund work is a replica by the artist or, as seems more probable, a copy by a pupil or imitator, remains to be established.

THOMAS GAINSBOROUGH (1727-1788)

Mr and Mrs William Hallett ('The Morning Walk') 1785

Oil on canvas, 236 x 179 cm NG 6209

Instinctive, unpompous, drawn to music and the theatre more than to literature or history, and to nature more than to anything, Gainsborough continues to enchant us, as the serious Reynolds (page 328) seldom can. Suffolk-born, like Constable (page 275), he also became, within his means and times, a 'natural painter' – albeit of a very different kind. Although he said he wished nothing more than 'to take my Viol de Gamba and walk off to some sweet Village where I can paint Landskips', his feeling for nature encompassed much more than landscape. Children and animals, women and men, everything that dances, shimmers, breathes, whispers or sings, look natural in Gainsborough's enchanted world, so that 'nature' comes to encompass silks and gauzes, ostrich feathers and powdered hair as much as woods and ponds and butterflies. But this rapturous manner of painting, in which all parts of a canvas were worked on together with a flickering brush, only appears in mature works, such as this famous and splendid picture.

In his early years in Sudbury, after his training in London restoring Dutch land-scapes and working with a French engraver, Gainsborough's finish was less free. After moving to the resort town of Bath in about 1759 he found a metropolitan clientele, and discovered Van Dyck (page 200) in country-house collections. Both were to be decisive, and the effects are best judged in his portraits of women sitters, on the scale of life, in which elegance and ease of manner combine with a new, more tender colour range and a loosening of paint texture. In 1774 he moved permanently to London, where he built up a great portrait practice, but also began to paint imaginative 'fancy pictures' inspired by Murillo (page 227). He never aspired to 'history painting' in the Grand Manner. His poetry resides mainly in his brush, not in compositional inventiveness.

It was surely Gainsborough's own inclination, however, to interpret a formal marriage portrait, for which the sitters probably sat separately, as a parkland promenade. William Hallett was 21 and his wife Elizabeth, née Stephen, 20 when they solemnly linked arms to walk in step together through life. A Pomeranian dog paces at their side,

right foot forward like theirs, as pale and fluffy as Mrs Hallet is pale and gauzy. Being only a dog with no sense of occasion he pants joyfully hoping for attention. The parkland is a painted backdrop, like those of Victorian photographers, yet it provides a pretext for depicting urban sitters in urban finery as if in the dappled light of a world fresh with dew.

THOMAS GAINSBOROUGH (1727-1788)

Mr and Mrs Andrews about 1750

Oil on canvas, 70 x 119 cm NG 6301

Robert Andrews and his wife Frances Mary, née Carter, were married in 1748, not long before Gainsborough painted their portraits – and that of Auberies, their farm near Sudbury. The church in the background is All Saints', Sudbury, where the couple were married, and the tower to the left is that of Holy Trinity Church, Long Melford. The small full-length portrait in an open-air rustic setting is typical of Gainsborough's early works painted in his native Suffolk after his return from London; the identifiable view is unusual and may have been specified by the patrons. We must not imagine that they sat together under a tree while Gainsborough set up his easel among the sheaves of corn; their costumes were most likely painted from dressed-up artist's mannequins, which may account for their doll-like appearance, and the landscape would have been studied separately.

This kind of picture, commissioned by people 'who lived in rooms which were neat but not spacious', in Ellis Waterhouse's happy phrase about Gainsborough's contemporary Arthur Devis, was a speciality of painters who were not 'out of the top drawer'. The sitters, or their mannequin stand-ins, are posed in 'genteel attitudes' derived from manuals of manners. The nonchalant Mr Andrews, fortunate possessor of a game licence, has his gun under his arm; Mrs Andrews, ramrod straight and neatly composed, may have been meant to hold a book, or, it has been suggested, a bird which her husband has shot. In the event, a reserved space left in her lap has not been filled in with any identifiable object.

Out of these conventional ingredients Gainsborough has composed the most tartly lyrical picture in the history of art. Mr Andrews's satisfaction in his well-kept farmlands is as nothing to the intensity of the painter's feeling for the gold and green of fields and copses, the supple curves of fertile land meeting the stately clouds. The figures stand out brittle against that glorious yet ordered bounty. But how marvellously the acid blue hooped skirt is deployed, almost, but not quite, rhyming with the curved bench back, the pointy silk shoes in sly communion with the bench feet, while Mr Andrews's substantial shoes converse with tree roots. (The faithful gun dog had better watch out for his unshod paws.) More rhymes and assonances link the lines of gun, thighs, dog, calf, coat; a coat tail answers the hanging ribbon of a sun hat; something jaunty in the husband's tricorn catches the corner of his wife's eye. Deep affection and naive artifice combine to create the earliest successful depiction of a truly English idyll.

AKSELI GALLEN-KALLELA (1865-1931)

Lake Keitele 1905

Oil on canvas, 53 × 66 cm NG 6574

The first Finnish painter to be represented in the National Gallery, Gallen-Kallela was also one of the first artists to proclaim his identity as a Finn. The area we now call Finland (Suomi

in Finnish) was dominated by Sweden from 1323 until 1809, when it became an autonomous Grand Duchy within the Russian Empire; it gained full independence only with the Bolshevik Revolution of 1917. Throughout most of this time Swedish persisted as Finland's official language. Finnish – although written down in the sixteenth century, when Lutheran reformers translated the Bible into the vernacular – was mainly used in the speech of peasants. It was with the explicit aim of creating a native literary language that, in 1835, the scholar Elias Lönnrot published a heavily edited compilation of old Finnish folk songs collected in the remote countryside of Karelia. As an epic account of Finland's mythical past, Lönnrot's Kalevala (homeland of the hero Kaleva) became a symbol of indigenous Finnish culture and nationalist aspirations. It inspired many artists working in the 1890s, among them the composer Jean Sibelius and the architect Eliel Saarinen. Akseli Gallen-Kallela became its most influential interpreter in painting. This nationalist theme, paradoxically, brought him international renown when he illustrated it in murals for Saarinen's Finnish Pavilion at the Paris Exposition of 1900.

Technically, however, Gallen-Kallela was always an internationalist. He completed his training in Paris, was in contact with the avant-garde in Paris and Berlin, and regularly exhibited abroad – jointly, in 1895, with the Norwegian painter Edvard Munch. Like his peers throughout Europe, Gallen-Kallela became disillusioned with pictorial realism. To express realities more profound and enduring than those of contemporary urban civilisation, he adopted the simplified forms, decorative patterns and heightened colours of Gauguin's 'primitivist' paintings. Unlike Gauguin (page 295, opposite), however, Gallen-Kallela sought out primeval truths above all in the Finnish wilderness.

This picture is the third and most elaborate of the landscapes he painted at Lake Keitele in Karelia, one of about 50,000 lakes in Finland. Still signed with the original Swedish version of the artist's name, Axel Gallén, it shows water, clouds, distant mountains, a wooded island. With its silvery tonality, heightened through touches of blue and green, few paintings appear at first sight more coolly elegant, or reconcile with greater pictorial sophistication a

sense of distance with flat pattern, convincing description with decorative Modernist design. Letting the small and reticent painting work on us, however, and with the help of local legend, we gradually uncover its deeper, and deeply felt, significance.

A central figure of the *Kalevala* was Väinämöinen, miraculously born builder of boats, fisherman, singer and enchanter (for 'to enchant' means to bewitch with song). He retrieved fire from the belly of a fish, and made the Finnish folk instrument, the *kantele*, from the jawbone of a giant pike, holding all living things spellbound with its music. At the end of Lönnrot's epic, Väinämöinen departs in a copper boat, predicting that he will return again when he is needed, to bring new light and new songs.

The grey bands that interrupt the sparkling reflections playing across the waters of Lake Keitele record a phenomenon caused by the wind. In Finnish, however, it is known as 'Väinämöinen's Wake', left by the passage of the hero as he rows across the lake. Just as his once-and-future presence transfigures the wilderness, so the artist's own presence in this vast solitude is signalled by the track of his thickly loaded brush dragged across the canvas.

PAUL GAUGUIN (1848-1903)

A Vase of Flowers 1896

Oil on canvas, 64×74 cm NG 3289

Gauguin was born in Paris but lived in Peru until the age of seven. At seventeen he became a sailor. These early experiences left him with a mistrust of urban civilisation and rationality, and nostalgia for the mystery of 'primitive' cultures, ways of life which he imagined to be founded on direct relationship with the soil and on religious faith. When he lost his job as a stockbroker due to a financial slump in 1883, he decided to devote his life to painting, which he had taken up around 1873. Having met the Impressionists and exhibited with the group from 1879, he came to reject their ideals of painting directly from nature and their everyday subject matter.

Between 1886 and 1889 Gauguin became the focus of a group of artists working at Pont-Aven in Brittany. In that harsh and remote province he found the qualities of 'rustic superstitious piety' which he admired, and evolved a method of painting from the imagination in flat colour-planes and heavy outlines. In 1887 he visited Panama and Martinique, and in 1888 stayed with Van Gogh at Arles (see page 299). In 1891 he settled in Tahiti where he remained until 1901, except for a visit to France in 1893–5. He died in the Marquesas Islands. Under the sun of the tropics he finally found what he had sought: a way of life which was primitive but, unlike that of Brittany, sensuous. There he treated universal themes in a direct and powerful way, using the bold rhythms and colours of Oceania within a network of symbolic and formal allusions to Western and Oriental traditions.

This flower piece was painted in Tahiti in 1896 and bought by Degas (page 281) in 1898 from Gauguin's friend Daniel de Monfreid. Degas himself had arranged an exhibition of Gauguin's Tahitian paintings in Paris in 1893. Flower painting had seen a revival in France in the latter part of the nineteenth century, but Gauguin's flowers are very different from Fantin-Latour's cultivated blooms also on view in the East Wing. Gauguin's motif is traditional – blossoms and leaves in a round vase on a table or shelf – but the bold contrasts of orange-red, green and blue are as unfamiliar as the exotic flowers themselves. The vase sits four-square in the centre, near the front, and the table extends on either side. In contrast to these inert and flattened forms the flowers twist and turn, quivering with energy, showing their countenances from every aspect. Despite their rudimentary modelling and generalised textures, they are not merely decorative patterns of colour. We see them as still living creatures, in a last hectic glow before their petals fade and fall.

PAUL GAUGUIN (1848-1903)

Faa Iheihe 1898

Oil on canvas, 54×169.5 cm L708 On loan from the Tate Gallery, London

This picture – which entered the National Gallery in 1997 as part of an exchange with the Tate – was painted in Tahiti, like Gauguin's flower piece in the previous entry. It is, however, a very much more innovative and important work. Not only does it reflect more clearly Gauguin's preoccupation with the 'primitive' art and ethos of Oceania, it also marks the beginning of a new phase in his life. Shortly before it was painted he had tried to kill himself with poison; the attempt was unsuccessful and was never repeated. Faa lheihe resembles in format and style the last picture completed before his failed suicide, Where do we come from? What are we? Where are we going? (now in Boston), but its very title, inscribed by the artist in the panel at the bottom right, signals a new serenity. There is no such expression in the Tahitian language as Faa lheihe; Gauguin either mistook two glottal stops for h-sounds in the word fa'ai'ei'e ('to beautify, adorn, embellish [oneself]'), or mistranscribed faa ineine ('preparations for a festival'). Either meaning seems apt for a work which is at once decorative and solemn, and whose significance derives from its exotic motifs and colours, and their formal arrangement, rather than from any specific narrative.

The shape of the canvas and the poses of certain figures – notably the woman with her hand raised in a ritual gesture of prayer or greeting – derive from the sculptural decoration of Javanese temples, photographs of which were found in Gauguin's hut

after his death. We are not invited to read the painting from one side to the other, like a Western storytelling or processional frieze, but outwards from the centre, following the red-haired woman's glance to our left, and that of her naked mirror image to our right; the dark profiles of the horse and the dog impel our gaze to return inwards. (The dog is no more studied from life than other details, but derives from one in a painting by Courbet which had belonged to Gauguin's guardian.) Colours also help divide the painting in two, cooler on the left, warmer to the right. This binary division is counteracted, however, by the way figures and setting are interwoven on the surface: an arabesque of branches and vines runs across the top of the canvas, and upright tree trunks and figures, ornamental shrubs and flowers rhythmically punctuate its entire length.

Gauguin defended this type of pictorial organisation in a letter to his friend Charles Morice, written between 1896 and 1898 but excoriating the Parisian critics of his 1893 Tahiti exhibition:

...the crowd and the critics howled before my canvases saying they were too dense, too nondimensional. None of their beloved perspective, no familiar vanishing point... Did they expect me to show them fabulous Tahiti looking just like the outskirts of Paris, everything lined up and neatly raked? ... Any receding perspective would be an absurdity. As I wanted to suggest a luxuriant and untamed type of nature, a tropical sun that sets aglow everything around it, I was obliged to give my figures a suitable setting... these women whispering in an immense palace decorated by nature itself... This is the reason behind all these fabulous colours, this subdued and silent glow.

But none of this exists!

Oh yes it does, as an equivalent of the grandeur, the depth, the mystery of Tahiti, when you have to express it on a canvas measuring only one square metre...

VINCENT VAN GOGH (1853–1890)

Van Gogh's Chair 1888

Oil on canvas, 92 × 73 cm NG 3862

Vincent van Gogh's moving letters to his brother Theo, an art dealer who supported him emotionally and financially throughout his life, shed light not only on his own practice but also on his response to earlier art. It was partly his admiration for the spontaneous brushwork of the great Dutch seventeenth-century painter Frans Hals (page 210) which enabled Van Gogh to assimilate the apparent lack of finish and the brilliant colours of Impressionism, encountered for the first time when he joined Theo in Paris in 1886.

The son of a Dutch Protestant minister, Van Gogh tried various careers, some of which he pursued in England – art dealing, teaching, the ministry and missionary work – before deciding to become a painter. After brief periods of study in The Hague, Antwerp and Paris, he left in February 1888 for Arles in Provence. He had begun to collect Japanese prints in Antwerp and, like Monet with his water garden (see page 318), thought of Japan as an idyllic country of which he hoped to find the equivalent: '[In Arles] my life will become more and more like a Japanese painter's, living close to

nature *en petit bourgeois...*' He looked out of the train window travelling south 'to see if it was Japan yet' and wrote of his early impressions: 'This country seems to me as beautiful as Japan as far as the limpidity of the atmosphere and the gay colour effects are concerned.' He dreamed of setting up an artist's colony, but in the end his hopes were disappointed. After a period in a mental hospital at St-Rémy in Provence and under medical supervision in the north of France, Vincent van Gogh shot himself.

His violent quarrels with Gauguin (page 295), who came to stay with him in Arles in October 1888, precipitated his breakdown in December. Van Gogh's Chair is one of two paintings he began in that month, to symbolise Gauguin and himself and their different approaches to art. He described his own painting as a picture of 'a wooden rush-bottomed chair all yellow on red tiles against a wall (daytime)' and 'a chair of white wood with a pipe and tobacco pouch'. The companion picture of Gauguin (now

in Amsterdam) is an 'armchair, red and green night effect...on the seat two novels and a candle'. The motif of chairs may have been suggested to him by Luke Fildes's engraving *The Empty Chair – Gad's Hill*, Charles Dickens's chair drawn on the day of the writer's death.

Gauguin advocated painting from the imagination, starting with an idea – nourished by literature – then seeking pictorial form for it. Van Gogh's *Chair* exemplifies his own inspiration: a simple rustic seat of natural materials, seen by daylight in 'Japanese perspective' with sprouting bulbs behind it suggesting natural growth. But a darker association may also brood over this picture 'in light colour'. In seventeenth-century Dutch art, as Van Gogh would have known, pipe smoking was a symbol of transience, illustrating a verse from that Good Book with which he was also very familiar: 'Hear my prayer, O Lord... For my days are consumed like smoke...' (Psalm 102:1–3).

VINCENT VAN GOGH (1853–1890)

Sunflowers 1888

Oil on canvas, 92 x 73 cm NG 3863

In the summer before Gauguin's arrival in Arles, Van Gogh began to paint a series of pictures of sunflowers as a decoration for his house, which he hoped to share with 'the new poet [who will be] living here'. Gauguin, in Van Gogh's words, was 'mad about my sunflowers', and portrayed him at his easel painting them; of all the artist's works, they are the most popular and the most widely reproduced. He painted four canvases in all before the flowers faded, but considered only two good enough to sign and to hang in Gauguin's bedroom. The Gallery's picture is one of these two signed paintings; the other is now in Munich. They were among the few works which Van Gogh felt confident enough to select for exhibition, and were shown, and admired, in Brussels in November 1889. 'To get up enough heat to melt those golds... it's not everyone that can do it, it takes the energy and concentration of a person's whole being...' Vincent had written to his brother Theo.

The London *Sunflowers* is the first successful example of Van Gogh's 'light on light' technique, perhaps indebted to the experiments in one-colour painting pursued in 1887 in Paris by his fellow student, Louis Anquetin. Its predominant yellow hue – for Van Gogh an emblem of happiness – is also a tribute to Provence, and to the contemporary Provençal painter Monticelli, who 'depicted the south [of France] all in yellow, all in orange, all in sulphur'.

In January 1889, however, Van Gogh painted three 'absolutely equal and identical copies', with the intention of showing copies and originals as side panels to versions of his portrait of Mme Roulin, wife of his friend the Arles postman. The red-haired Mme Roulin is painted in violent shades of green and red holding the strings of a baby's cradle. 'I imagine these canvases [the portraits] between those of the Sunflowers, which would thus form lampholders or candelabras of the same size... And then the yellow and orange tones of the head will gain in brilliance by the proximity of the yellow wings.'

Thus Van Gogh's interest in colour, while grounded in nature, differed from that of the Impressionists by extending also to decorative combinations, in which the hues of one painting intensified those of others, at the same time modifying their original significance.

The Sunflowers illustrates the cycle of life, from the bud, through maturity and death. The spiky or gnarled forms of nature also symbolised human passions to Van Gogh, although it would be wrong to see evidence here, as many people have, of artistic 'frenzy'. The luminous sunflowers look extremely lifelike, their raised dabbed-on texture – made possible by the stiff consistency of the new machine-ground paints available to nineteenth-century artists – carefully controlled to mimic bristling seed-heads and hairy green sepals, vigorous longer brushstrokes flowing to match the direction of the petals, leaves and stems. As if in contrast to these natural forms, the table top and vase are simplified, flattened and outlined, recalling crude popular prints, and Van Gogh's signature, 'Vincent', becomes a naive blue decoration in the glaze of the Provençal terracotta jar.

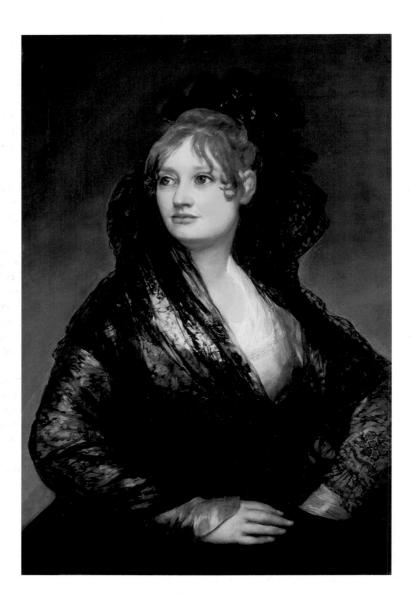

FRANCISCO DE GOYA (1746–1828) Doña Isabel de Porcel before 1805

Oil on canvas, 82 x 55 cm NG 1473

Goya's fame is as ambiguous as his career. A fashionable court painter and society portraitist, once renowned for his designs of light-hearted decorations, he is now celebrated as a passionate denouncer of injustice and the horrors of war. Supreme recorder of his countrymen's diversions, superstitions and travails, he is also the greatest master of private nightmare, expressed above all in the horrific 'Black Paintings' made for his own house. Perhaps the last great artist working in a style associated with *anciens régimes* throughout Europe, he has been called 'the first of the moderns'.

A painter rivalling Velázquez (page 256) in the freedom of his brush and his understanding of light and shade, Goya came to be known outside Spain for his lithographs, etchings and aquatints, some of the finest ever produced. In a career spanning over sixty years he left some five hundred paintings, most of them still in Spain (where he also executed frescoes), and many more prints and drawings. It is not possible to 'get to know' Goya in the National Gallery, but even the few works in the collection demonstrate some of his abrupt changes of style and temper, from the artificial pleasures of A Picnic, a sketch for a tapestry cartoon, through his comic scene of witchcraft, to the silvery-thin Don Andrés del Peral and this full-blooded portrait of a woman, Doña Isabel de Porcel.

Doña Isabel and her husband Don Antonio were close friends of Goya; according to tradition he painted both their portraits during a visit to their home in gratitude for their hospitality. Don Antonio's likeness, formerly in the Jockey Club, Buenos Aires, was subsequently destroyed in a fire.

Doña Isabel wears the dress of a maja – a style originally associated with the demimonde of Madrid, but in the late eighteenth and early nineteenth centuries adopted by ladies of fashion as a token of Spanish patriotism, and also, no doubt, because its black lace mantilla and high waist were madly flattering, as we can see here. The dress justifies the pose, which we know from Flamenco dance: left arm akimbo, torso and head sharply turned in different directions. Perfectly adapted to the half-length format, the protruding right arm and hand providing a stable base for the torso, this pose without the maja connotation would have been unacceptably vulgar in the portrait of a lady. We experience it as wonderfully emancipated.

Goya emphasises Doña Isabel's best features, her eyes and her fresh colouring, without hiding the fleshy nose and slightly underslung jaw; the incipient double chin adds to her youthful charm. Freely painted, the mantilla serves as a dark aureole to her bright face, and tones down the shimmering pink and white bodice in order not to distract from the flesh tones. It is just such effects that attracted Manet (page 311) to Goya.

The lady hides a secret: X-ray photographs reveal that she was painted over a portrait of a man in uniform (see fig. 7).

Fig. 7 X-radiograph of Goya's Doña Isabel de Porcel. Detail showing the portrait of a man painted under the present surface.

FRANCISCO DE GOYA (1746–1828)

The Duke of Wellington 1812–14

Oil on mahogany, 64 x 52 cm NG 6322

'He painted only in one session, sometimes of ten hours, but never in the [late] afternoon. The last touches for the better effect of a picture he gave at night, by artificial light', wrote Goya's son, Francisco Javier, in his biography of the artist. The liveliness of this portrait, one of three in oils of Wellington by Goya, suggests it is the only one painted from life (although it is doubtful that 'Señor Willington', as Goya called him, sat for the full ten hours). The glitter of the decorations, so much bolder than the highlights on the flesh or the catchlights in the eyes, equally suggests that they may have been touched up at night. We know that both uniform and decorations were altered by Goya after the first sitting.

Wellington is the only Englishman, and one of very few foreigners, to have had a portrait painted by Goya. As victor of the Battle of Salamanca, the Earl of Wellington and Lieutenant-General, as he then was, had liberated Madrid from the French, entering the city in August 1812, when he sat for Goya. He is shown with the decorations of three Orders: the Bath (topmost star), the Tower and Sword of Portugal (lower left) and San Fernando of Spain (lower right). The insignia of the Golden Fleece was probably added

to the costume later in the month, and the uniform altered to an approximation of Wellington's dress uniform as General. Originally he had been painted wearing the oval Peninsular Medallion; Goya retouched the portrait two years later, when Wellington returned as ambassador to the restored King Ferdinand VII and the medallion had been replaced by the Military Gold Cross.

Arthur Wellesley, first Duke of Wellington, 43 when the portrait was made and greying at the temples, looks out from above his medals with an alert and good-humoured air. Goya often gave his sitters an animated expression by showing them with their mouths slightly open; even the Queen of Spain, Maria Luisa, shows her teeth in a famous group portrait of 1800 – an unthinkable breach of etiquette in any earlier age. Here, the duke's short upper lip is drawn up over two large English front teeth, a 'speaking likeness'. He is unlikely to have been speaking to Goya, who was totally deaf as a result of an illness in 1792 and could communicate only in sign language and by writing.

Sadly, the restoration of the Bourbon monarchy after the heady days of liberation inaugurated a new era of fanaticism and repression. Goya retained his position as First Court Painter for another decade. In 1824, the persecution of liberals having been renewed, he went into hiding. After a declaration of amnesty in the same year he settled in Bordeaux and remained there until his death four years later.

FRANCESCO GUARDI (1712–1793) **An Architectural Caprice** 1770–8

Oil on canvas, 54 × 36 cm NG 2523

Francesco Guardi, although remembered almost exclusively for his real and imaginary Venetian scenes, worked with his older brother Giovanni Antonio on paintings in many genres: altarpieces, mythological narratives, battle pictures, and even murals. A newly discovered altarpiece, dating from after his brother's death around 1777, proves that Francesco continued to paint some large-scale pictures after the dissolution of the family firm. But from around 1760 his main work consisted of views indebted to Canaletto (page 271), whose designs he often copied. Soon, however, Guardi freed himself from both literal topography and Canaletto's more prosaic manner, to concentrate on poetic capricci - airy compilations of Venetian architectural motifs such as this picture, as well as ruins, and evocations of the sparkling waters of the lagoon which he was the first painter to depict. (Examples of all these subjects can be seen nearby.) His pastel colours and glancing touch may have been influenced by his sister's husband, Giovanni Battista Tiepolo (page 338). Guardi's pictures, however, became smaller and smaller, some barely larger than matchboxes (three such tiny views are shown at the Gallery framed together). These were presumably intended as tourist trinkets, souvenirs for the boudoir rather than mementoes of the Grand Tour for great English country houses.

Unlike most views, many of Guardi's imaginary architectural vistas are vertical in format. After his final return to Venice in about 1756, Canaletto had produced some small vertical pictures of the Piazza San Marco seen from under, or through, its colonnade, and Guardi may have been inspired by these. (There are two such works by Canaletto in the collection.) Canaletto's viewer stands still like a camera on a tripod, but in Guardi's picture we are impelled to follow the little figure in lemon yellow carrying its load of what looks like white laundry: we stroll from sunlight into shadow, to emerge once again into a sunlight all the brighter for being framed in light-reflecting

darkness, just as the scale of the echoing arches gains from the small stature of the figures beneath. Charity is being dispensed. It may be spring, perhaps early in the morning. Sunshine falls in patches of pale pink, slightly darker on faraway brick walls and on a cloak in the foreground, and, darker still, in the line of a sunlit flagpole. The yellow of our distant guide's robe is drawn forward onto a brass lantern – sky blue fades to white, lemon yellow and pink colours emerge from a silver haze and merge again to enliven the silver and pewter-grey stone. There is no pure red anywhere and just a few nervous touches and lines of black. The perfect harmony of this unpretentious picture can only be experienced in front of the original – when it is as consoling as music, or the memory of a voyage to the Venice of our dreams.

WILLIAM HOGARTH (1697-1764)

The Marriage Settlement about 1743

Oil on canvas, 70 x 91 cm NG 113

Controversial and quarrelsome, Hogarth is one of the most attractive and innovative British artists. Born in London, he trained as an engraver, later studying painting at a private academy, but was frustrated in his ambition to become an English 'history painter'. He blamed this on the vogue for Old Masters and competition from Continental contemporaries. His vociferous patriotism, however, cannot disguise his own indebtedness to French art; nor did he hesitate to advertise his use of 'the best Masters in Paris' to engrave the series *Marriage A-la-Mode*, of which this picture is the first.

Since he could not earn a living as a portraitist or monumental painter, Hogarth conceived the notion of 'modern moral subjects' to be sold as engravings on subscription, as well as in their original painted state. In the spirit of the 'comic epics' of Henry Fielding, whom Hogarth influenced and who was later to influence him, these 'comic history paintings' are the works by which we best remember the artist and which most clearly express his own moral certitudes. They are related to sixteenth-century broadsheets, and to the 'conversation pieces' (see pages 335–6) and theatrical subjects which Hogarth himself helped to popularise.

Marriage A-la-Mode, 'representing a Variety of Modern Occurrences in High-Life', was advertised for subscription in April 1743. The theme, an unhappy marriage between the daughter of a rich, miserly alderman merchant and the son of an impoverished earl, was suggested by current events but also indebted to Dryden's comedy of the same name, and by a recent play of Garrick's. As the pictures were designed to be engraved – each print a mirror image of the composition incised on a copper plate – the sequence of events in every painting is reversed.

The series thus begins with the proud Earl pointing to his family tree rooted in William the Conqueror; he rests his gouty foot – a sign of degeneracy – on a footstool decorated with his coronet. Behind him is a lavish building in the new classical style, unfinished for lack of money; a creditor is thrusting bills at him. But on the table in front of him is a pile of gold: the bride's dowry just handed him by the bespectacled alderman, who holds the marriage contract. Silvertongue, an ingratiating lawyer, whispers in the ear of the alderman's daughter listlessly twirling her wedding ring on a handkerchief. Turning away from her to take snuff and admire himself in the glass – and, in the engraving, to lead our eye into the next tableau – is the foppish bridegroom. At his feet, symbolic of the couple's plight, are a dog and a bitch chained to each other. From the walls horrid Italian Old Master martyrdoms presage tragedy, and a Gorgon's head screams from an oval frame above the pair.

The rest of the series follows the pathetic adventures of the ill-assorted pair: he frequents a child prostitute and contracts venereal disease; she incurs debts in fashionable pursuits and takes Silvertongue as her lover. Discovered in a house of assignation, the lawyer kills the husband and is arrested and executed. The Countess, back in the alderman's mean house (where the 'low-life' paintings on the walls are Dutch and the dog is starving), swallows poison; her father strips her wedding ring from her hand; a servant takes her weeping child, whose crippled leg in a brace recalls his tainted inheritance.

JEAN-AUGUSTE-DOMINIQUE INGRES (1780-1867)

Madame Moitessier 1856

Oil on canvas, 120 x 92 cm NG 4821

It is often said that while Delacroix (page 284) was the great proponent of French Romanticism, his older contemporary Ingres was the champion of the classical tradition: obsessed with Raphael (page 148) and antiquity, upholder of 'drawing' versus 'colour'. Real life being less tidy, however, we find that Delacroix was a more calculating artist than the hyperemotional Ingres, who did not hesitate to break academic rules for expressive ends. Both painted subjects from literature and history, and as visitors to the Gallery can see in Ingres's small version of Angelica saved by Ruggiero, his response to the female nude is as charged with erotic longing and scarcely sublimated violence as Delacroix's. Nor did Ingres invariably emulate Raphael or Poussin (page 230). Throughout his long career he tried to match style to subject, looking in turn to Greek vase painting, to the Early Renaissance, even to the Dutch seventeenth-century painters of everyday life.

It is, however, true that drawing was of primary importance to him. Forced to support himself and his wife in Rome in 1814 by drawing the English tourists who flocked back to the city liberated from French rule, he developed a wonderfully spare, yet lively and descriptive line. Although he despised portraiture as a lower form of art, like his teacher David (page 279) Ingres came to excel in it. Few of his painted portraits are more sumptuous than *Madame Moitessier*, begun in 1847 but completed only in 1856 when the artist, as he tells us in his signature, was 76.

He had originally refused to paint this wealthy banker's wife, but when he met her he was so captivated by her beauty that he agreed, asking her to bring her small daughter, 'la charmante Catherine', whose head is visible under her mother's arm in a preparatory drawing in the Ingres Museum in Montauban. The doubtless bored and wriggling child was soon banished as Ingres wrestled with the picture, requiring long hours of immobility from his model. The sitter's dress was changed more than once.

Ingres is recorded as still working on the portrait in 1847. The death of his wife in 1849 left him in despair and unable to paint for many months. In 1851 he began sittings anew and completed a standing likeness of Inès Moitessier in black (now in Washington). He returned to the seated version in 1852.

When he had finished, four years later, the sitter was 35. Ageless like a goddess – with her Grecian profile impossibly reflected in a mirror parallel to the back of her head – but dressed with Second Empire opulence in aniline-dyed flowered silk from Lyons, *Madame Moitessier* exemplifies the ambiguities of Ingres's art. The firm contour of her shoulders, arms and face defines flesh perfectly rounded – though barely modelled – and as poreless, smooth and luminous as polished alabaster, yet paradoxically soft to the touch. In contrast to the resiliently buxom horsehair settee, it arouses fantasies and fears of bruising. The pose, with head resting against the right forefinger,

derives from an ancient wall painting, excavated in 1739, of an enthroned Arcadian goddess, which Ingres has seen in Naples and of which he owned several copies. But 'classicising' devices are offset by the minutely realistic transcription of the surfaces of fabrics, the fashionable parure of jewels, ormolu frames, Oriental porcelain. The mixture of the general with the particular, timeless grandeur with bourgeois ostentation, languor with pictorial rigour, is unique to Ingres and far from bloodlessly Neo-classical.

THOMAS LAWRENCE (1769-1830)

Queen Charlotte 1789

Oil on canvas, 240 × 147 cm NG 4257

The youngest of five children of somewhat improvident parents, Lawrence was an infant prodigy. At ten he was drawing profile likenesses of the clients of his father's inn at Devizes, and it was assumed early on that his talent for portraiture would support

his family. Around 1787 he was brought to London by his father, began to paint in oils and to show at the Royal Academy. His fame as a painter of full-length portraits in oil was sealed at the Academy exhibition of 1790, which included, among a varied group of a dozen pictures by him, this masterly likeness of Queen Charlotte. Praised outside the royal family, the picture was never acquired by them, perhaps because the king (George III) was upset by the queen having posed bareheaded after Lawrence disliked the bonnet and hat she had chosen to wear. The queen herself found the twenty-year-old artist 'rather presuming' when he asked her to talk during the sitting, in an effort to animate her features. Eventually it was the Assistant Keeper of her Wardrobe who completed the sittings for such details as the bracelets bearing a portrait miniature of the king and his cipher.

Lawrence, a draughtsman of extreme precision, worked very hard at the 'appearance of facility'. His dazzling brushwork, inspired by Rubens, Van Dyck, Rembrandt and Titian (pages 242, 200, 235, 163), enabled him to enjoy painting draperies, unlike his ageing 'rival' Reynolds (page 328), who often left them to assistants. But there is more to admire here beside the rustling shimmer of the queen's silks, gauzes and laces. Queen Charlotte had been shocked and saddened by the onset of George III's illness shortly before the portrait was painted. X-rays show that Lawrence modified the careworn expression he had first observed. Yet even in the final portrait, so formal in conception, so grand in execution, something of the queen's malaise remains touchingly evident.

The landscape background shows a view of Eton College as seen from Windsor Castle. The trees are turning red – as they might well have been in late September when the queen posed for Lawrence, but also so that the colour contrasts of carpet and dress may be echoed in the russet foliage against a blue sky. Although she cannot see the view behind her, the direction of the queen's glance draws our own eyes to these vivid yet melancholy harbingers of winter.

EDOUARD MANET (1832-1883)

The Execution of Maximilian 1867-8

Oil on canvas, four fragments on a single support, 193 x 284 cm NG 3294

Contemporary critics castigated Manet, a man of independent means and a member of fashionable Paris society, for his detachment and 'indifference'. In the early part of the twentieth century the artist was still thought to have been motivated solely by formal concerns. Later he was viewed as attempting to depict modern life in a way informed by the great works of the past, which he studied at the Louvre and during his visit to Spain in 1865. Only latterly has the political, Republican edge of some of Manet's urban scenes from the 1860s also been noted. But there was never much doubt as to the politically contentious nature, under the Second Empire of Napoleon III, of the Execution of Maximilian.

The thirty-two-year-old Archduke Maximilian, younger brother of the Emperor Franz Joseph of Austria, had been installed as Emperor of Mexico by a French expeditionary force, then betrayed by Napoleon III's withdrawal of his troops. Captured by the victorious Republican army of Benito Juárez, Maximilian and his two faithful generals, Miramón and Mejía, were tried and condemned to death. They were executed by a firing squad on 19 June 1867.

The impact of Maximilian's death, in Europe generally and on Manet in particular, was tremendous. The event provided the only kind of theme – tragic, yet contemporary

and political – which could inspire the artist to create a 'history painting', the most highly prized category in the Salon but one he had hitherto disdained. Between July 1867 and early 1869 he produced three very large pictures showing Maximilian, Mejía and Miramón facing a firing squad commanded by an officer with a sergeant standing by to deliver the *coup de grâce*. The first version, never finished, was a largely imaginative composition. It is now in Boston.

As detailed accounts of the execution and photographs of victims and firing squad began to filter back to France, Manet began a more 'authentic' second version, painted with the help of live models, perhaps a squad of soldiers sent to his studio through the offices of a family friend, Commandant Lejosne. The mutilated fragments of this version, now in the National Gallery, were rescued by Degas (page 281) and have been reassembled on a canvas roughly the size of the original. Although the figures of Mejía and Maximilian are missing on the left, we can see that the victims stand forward in a flat simplified landscape on a level with the executioners, very close to the spectator. The soldiers are armed with French infantry muskets and wear uniforms which, as was reported of the Mexican squad, resemble those of the French army. In the final version, now in Mannheim, these provocative details are preserved, although the figures stand further back, against a wall above which spectators watch in horror. Maximilian wears a sombrero that evokes a halo around his head, Mejía staggers back as the bullets are fired. But the sun shines equally on all and the soldiers still obey their orders with the same matter-of-fact detachment.

Manet's 'indifference', his refusal of expressive rhetoric, must have seemed especially offensive in these brilliantly painted works. For if the executioners are not villains, and Maximilian is a victim but not a hero, guilt resides solely with Napoleon III, whose squalid policies led to the débâcle. The authorities banned the final painting from the Salon exhibition of 1869, and Manet's lithograph of the scene was never published in his lifetime.

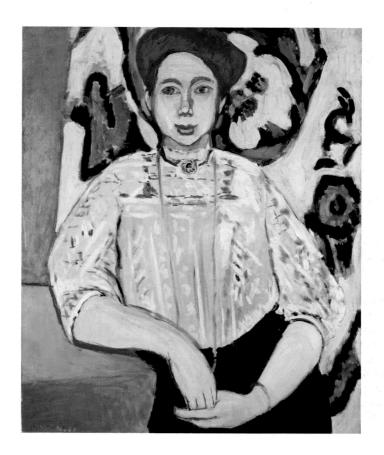

HENRI MATISSE (1869-1954)

Portrait of Greta Moll 1908

Oil on canvas, 93×74 cm NG 6450 On loan to the Tate Gallery, London

Matisse and the painters of his generation sought to preserve the intensity of colour of Impressionism, but to different ends. Like Gauguin and Van Gogh before them (pages 295, 298), they rejected Monet and Renoir's depiction of the fleeting effects of changing natural light (pages 315, 327) for a sense of constant overall brightness emanating from the painting itself. Abandoning accurate description of 'reality', they placed pure colours in a seemingly arbitrary way across the canvas, to create dazzling vibrations through the interplay between contrasting hues. When Matisse and his associates exhibited their paintings in this mode at the Salon d'Automne in Paris in 1905, so great was the shock to the art-viewing public that they were dubbed *Les Fauves* ('the wild beasts').

Three years later, when Matisse offered to paint this portrait of his pupil, the painter and sculptor Greta Moll, he was in retreat from certain implications of Fauvist method. In particular, he mistrusted the disruption of line and form which resulted from building up a picture from scattered strokes and patches of colour. With his strong commitment to ideals of order and wholeness, he especially feared the fragmentation of

the human figure. At the same time, he still wished to create a luminous painting, to find 'the kind of light that could be depended on to last'. Light radiates from the whole composition of *Greta Moll*, not primarily through Matisse's avoidance of dark shadows or even his extensive use of white, but because of the way colours are made to intensify each other. The bold blue pattern of the flowered cotton print behind the sitter – a favourite studio prop – enhances the warm red gleam in her hair and her fresh colouring. A green line above her right forearm, and a dark red line beneath it, make the flesh tones pinker and bolder. Touches of pink under the mint green of the blouse not only suggest transparency but also sparkle.

The radiant and joyful effect was achieved only after intense labour. Greta Moll posed for Matisse for ten sessions of three hours each. He kept altering the colour scheme: her blouse was at one time lavender-white and the skirt green. The painting also testifies to Matisse's study of earlier artists. He admired the 'sensual and deliberately determined line of Ingres', and the portrait almost invites comparison with the latter's Madame Moitessier (page 309), which sets volume and line off against pattern. Greta Moll's forthright pose is not unlike that of Titian's full-face Portrait of a Lady ('La Schiavona') in the West Wing. According to the sitter's own recollections Matisse, in a final attempt to arrive at a grand and monumental composition, made her arms fuller and emphasised her eyebrows – to her initial dismay – under the influence of a Veronese in the Louvre.

LUIS MELÉNDEZ (1716-1780)

Still Life with Oranges and Walnuts 1772

Oil on canvas, 61 × 81 cm NG 6505

Judged the most talented student in the Spanish Royal Academy in 1745, Meléndez was expelled in 1748 as a result of a public dispute between the Academy and his father,

also a painter. The expulsion prevented the artist from receiving commissions for altarpieces or large narrative pictures. In the last twenty years of his life he executed a hundred or so still lifes, for which he has now become famous. Although nearly half were first recorded in the Spanish royal residence at Aranjuez, they may not have been commissioned by the king directly from the painter, who died in poverty.

This picture is one of a group of the artist's largest and finest works, perhaps made in connection with his second petition to the king to become court painter. Like most of Meléndez's still lifes, it focuses attention simultaneously on the geometrical forms of the homely and characteristically Spanish objects depicted – oranges, walnuts, a melon, wooden sweet boxes and barrel, terracotta jugs – and on their surface texture, and both shape and texture are revealed through the strong light falling from the upper left of the painting. The colours are restricted to black, white and a range of earth tones, relieved only by the brilliant orange. The spectator's viewpoint, so close to the picture surface, is located just above the smaller of the two jugs. Only the cracked walnuts allow us a glimpse of their edible flesh, among the unpeeled fruit and the sealed containers of sweetmeats, olives and oil, tantalisingly displayed – humble products of Spanish soil and industry, ennobled by the artist's brush.

CLAUDE MONET (1840-1926)

The Beach at Trouville 1870

Oil on canvas, 38 × 46 cm NG 3951

With his friends Pissarro, Renoir, Degas (pages 321, 327, 281) and about twelve others, Monet was a founder member of an artists' cooperative which was to hold its first group exhibition in 1874, in defiance of the official Paris Salon. One of the paintings shown at this time, Monet's sketch-like Impression, Sunrise (1872, now in the Musée Marmottan in Paris), helped earn them the name Impressionists, under which they have become famous. Dedicated to painting modern pictures based on contemporary life and utilising newly synthesised pigments - which extended and complemented the traditional artist's palette - they sought especially to capture the fleeting effects of natural light. Although most of their works in fact evolved in distinct stages, and were often finished in the studio, the Beach at Trouville was evidently as spontaneous as it looks, executed in a single session outdoors at the fashionable resort to which Monet took his first wife, Camille, soon after their marriage in June 1870. The surface of the painting is peppered with grains of real sand (see fig. 8 overleaf), blown there by the very wind Monet has depicted in the scudding clouds. Thick impastoed brushstrokes of white paint have been flattened by the imprint of another canvas, indicating that the picture was stacked with others immediately after it was painted.

Camille, wearing a pale dress and flowered hat with a short veil, is probably accompanied by Madame Boudin, the wife of the artist Eugène Boudin, best remembered for his pictures of the beach at Trouville painted in the 1860s. What looks like a child's beach shoe hanging on the empty chair between them may suggest the presence of little Jean, the Monets' three-year-old son. The informal arrangement, with both figures close to the viewer yet cropped at the edges of the picture, adds to its extraordinary immediacy, as does the lack of traditional modelling and the use of flat, broad patches of paint.

The painting's fresh, airy luminosity, however, is largely the result of Monet using the ground colour, laid on the canvas to make it ready for painting, as a key component

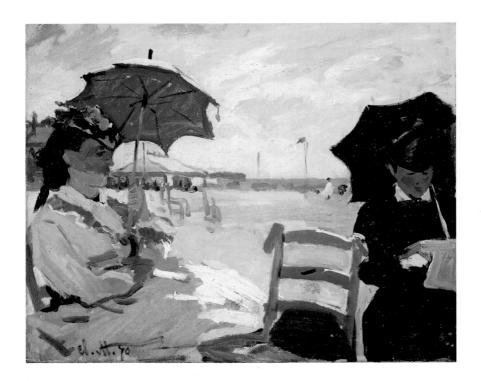

of the finished design. It is seen in many parts of the sky, around the chair, as a high-light among the flowers of Camille's hat, as the unpainted hand of Madame Boudin, and as a bare patch at the very centre of the composition. In these improvised effects the surrounding colours modify the warm pale grey of the ground so that it takes on colder, or darker, or lighter tones – turning almost mauve among the greenish-blue brushstrokes in the sky. As Monet's loaded brushes raced through or across the wet paint already on the canvas, later brushstrokes dragged and blended with earlier ones to produce colour mixtures on the picture surface. When he mixed paints on his palette – such as the complex blacks modified with a whole range of other pigments – more sand found its way onto the canvas.

The picture has been called a 'bold experiment', but perhaps what makes it most enchanting is the quality of playfulness it demonstrates in its confident disregard of professional disciplines. Boudin was to write to Monet nearly thirty years later, recalling that summer, 'Little Jean plays on the sand and his papa is seated on the ground, a sketchbook in his hand...' It is tempting to add, 'or at his painting box, turning out the most delectable sand pictures'.

Fig. 8 Monet, The Beach at Trouville. Macro detail of grains of sand near the bottom of the painting.

CLAUDE MONET (1840-1926)

The Water-Lily Pond 1899

Oil on canvas, 88 x 92 cm NG 4240

Until the late 1870s, Monet had devoted himself to painting modern subjects: Paris, its surrounding suburbs, the resorts frequented by holidaymakers from the metropolis, and the banks and bridges of the Thames in London, where he took refuge during the Franco-Prussian War. With the break-up of the Impressionist group in the 1880s, but wishing to stay loyal to the style which he, perhaps more than anyone, had created, Monet began to travel throughout France, painting series of a limited number of land-scape motifs in various sites under different light and atmospheric conditions. Many of these works excluded all traces of civilisation, focusing directly on the artist's response to nature.

The importance of this heroic enterprise was soon recognised by critics, who acclaimed Monet as 'the most significant landscape painter of modern times'. More particularly, he was now viewed as the supreme interpreter of his native land in its most essential aspects: sometimes untamed, as at Belle Isle in Brittany; sometimes entirely man-made, like Rouen Cathedral; at other times, as in the *Grainstack* and *Poplar* series of the late 1880s and early 1890s, shaped jointly by nature and human toil.

The latter series were both painted near Giverny, a rural community where Monet settled in 1883. He had always been a passionate lover of gardens. In the 1890s, when

he was not only famous but also rich, he had bought the estate on which he lived and created two complementary gardens: a Western one filled with flowers near the house, and across the road and railway tracks an Oriental water garden with a Japanese bridge, copied from a print that hung in his dining room. Monet admired the Japanese, 'a profoundly artistic people' whose love of nature and beauty he felt the French would do well to emulate. In 1899, when the vegetation of the water garden was at its most luxuriant, he began a series of views looking across the pond to the arching bridge. Of the eighteen finally painted, twelve, including the National Gallery's were exhibited at his dealer's in 1900. This version is one of the more tranquil.

The garden is shown in slanting summer afternoon light, in cool harmonies of green and mauve balanced by bright yellow reflections and vivid red and white water lilies. The sides of the nearly square canvas are divided vertically in half by the bridge, in places dark against sunlit willows, elsewhere light against shadow. Under its rising arch the pond forms an irregular triangle as if receding into the distance towards an invisible vanishing point. Flicks, patches and smears of colour serve not only to describe what is depicted but to ensure the coherence of the whole, contradicting spatial recession by a dense vibrant texture across the entire surface of the picture. It is a scene at once static and humming with energy, yet without the playful feel of the sketches of modern life of earlier decades. As early as 1890 Monet had written to his future biographer: 'I am grinding away, bent on a series of different effects... I am becoming a very slow worker...[but] it is imperative to work a great deal to achieve what I seek: "instantaneity", above all...the same light present everywhere...'

CLAUDE MONET (1840-1926)

Bathers at La Grenouillère 1869

Oil on canvas, 73 x 92 cm NG 6456

During the summer of 1869 Monet worked side by side with Renoir (page 327) at La Grenouillère, a raffish resort on the Seine not far from Paris. Both men wanted to produce large paintings of this ultra-modern subject for the Salon exhibition of 1869, but by September of that year Monet had so far only made 'a few bad sketches' (mauvaises pochades), as he wrote to his friend, the painter Bazille. One of these is the picture in the National Gallery showing bathing cabins, boats for rent and a narrow wooden walkway leading to a round islet called the 'camembert', which appears in the centre of the composition in Monet's second sketch, now in the Metropolitan Museum, New York. A third, smaller pochade shows two rowing boats (Bremen, Kunsthalle). A more elaborate composition of the motif is now known only through old photographs.

One of Monet's most famous 'Impressionist' pictures is thus revealed to have been no more than a preliminary to a more finished painting. Yet the experiments on which he embarked here were to prove seminal for his later work, in which the distinction between *pochade* – rapidly produced outdoors in front of the motif – and *tableau* – based on sketches but carefully worked up in the studio – was ostensibly abolished.

The process had been greatly facilitated by two nineteenth-century inventions: the collapsible metal paint tube and the metal ferrule for paintbrushes. The new tubes enabled oil paints (now made and sold by specialist paint manufacturers) to be stored while keeping them soft and ready for use, outdoors as well as in the studio. Metal

ferrules allowed the production of flat, as opposed to round, brushes, permitting a new kind of brushstroke: the *tache*, or coloured patch – a broad, flat, evenly loaded stroke which is the key to Monet's rapid and direct technique in *Bathers at La Grenouillère*. Thickly dabbed clusters of fluid but opaque paint form the pale green sunlit trees at the upper left; the illusion of reflections in restlessly moving water is rendered in broken horizontal slabs; long continuous outlines shape the boats and the catwalk. The human figures are given similarly summary treatment: patches of paint capture the Parisian man-about-town in dark jacket and light trousers as he accosts two women on the walkway, and in their daring bathing costumes and the hand-on-hip pose of one of them we can see that they are 'no better than they ought to be'. Here at last the traditional problem of 'drawing' versus 'colour' is overcome as the coloured *taches* swiftly fly over the canvas recording form and substance as well as light; the material nature of the paint itself overwhelms the details of the scene depicted and imposes pictorial unity.

Yet even this apparently instantaneous image was not achieved without significant revisions. X-rays reveal that Monet had made a false start, and perhaps turned his canvas upside down to begin again. With the naked eye we can see red gunwales of boats in different positions beneath the final paint layer. As Berthe Morisot, working from a boat off the Isle of Wight in 1875, was to record: 'Everything sways, there is an infernal lapping of water...the boats change position every minute...' In Monet's mauvaise pochade these difficulties were transcended, and the end results seem as fresh as a dip in the Seine.

PABLO PICASSO (1881-1973)

Bowl of Fruit, Bottle and Violin about 1914

Oil and sand on canvas, 92×73 cm NG 6449 On loan to the Tate Gallery, London

For centuries, Western paintings simulated windows through which could be seen three-dimensional forms set in space. By the end of the nineteenth century this convention had come under attack. The illusion of three-dimensionality could be produced by mechanical means through photography. In painting, not only perspective but even true-to-life fugitive effects of light had been mastered. Many artists felt that to be 'sincere' and 'authentic', painting should now be true to itself: an arrangement of lines, tones, textures and colours on a flat support. Insofar as it was representational, it

must *re*-present the world in a new idiom, and not rely on the outworn language of art as taught in the academies and studios.

Between about 1910 and 1913 Picasso and Braque had forged a novel kind of painting called 'analytical' Cubism. Objects were splintered into faceted shapes, which were not descriptive in themselves but when rearranged on the canvas could evoke the things depicted as if seen from several points of view. Light became an arbitrary pictorial element directed to any point or points in the painting. At this stage the two friends restricted their palette to neutral tones, mainly broken shades of white, grey and tan and black, thus ensuring the structural unity of each composition and minimising the illusion of space. Since the effect of this kind of art relied on the viewer being able to identify the forms being abstracted, their subject range was narrowed down to the most familiar and traditional, and thus the most easily recognisable: predominantly domestic still life and portraiture.

By about 1912–13 the limits of analytical Cubism seemed to have been reached. To revitalise their work, Braque invented *papier collé*, cutting out paper shapes and pasting them onto the canvas. So-called 'synthetic' Cubism, to which this painting by Picasso belongs, grew out of this technique. Inverting the procedure of 'analysing' a figure or object into fragments, the purely pictorial elements – shapes and coloured planes – are first synthesised into a composition. Resemblance to the real-life object evolves at a later stage in the process. Here, strong decorative colours and 'real' textures of sand and bare canvas are built up into a complex whole which contrives to maintain the optical flatness of the picture surface. (If you have ever set a colour against white, or a dark shape against a pale one, you will know how difficult it is not to see the one as 'object' and the other as 'background'.)

By turning this book on its side, you will see more readily how successful the composition of *Bowl of Fruit*, *Bottle and Violin* is, how the black line is carried through by the green to divide the painting nearly in half; how the shapes echo and rhyme, from the large curves to the smallest. Upside down, it is as varied, stable and pleasing as before. No one area is subsidiary to another, whether pale or strong in colour or texture, and each energises the rest. Right side up again, the picture gives the viewer the additional pleasure of recognising a tablecloth and table, a newspaper, grapes, a violin. Although monumental and bold, it is – and is meant to be – playful, not difficult. Its message is that art has no message beyond its own ability to create.

CAMILLE PISSARRO (1830–1903) **The Avenue, Sydenham** 1871

Oil on canvas, 48 × 73 cm NG 6493

Pissarro, the oldest of the Impressionist painters, rejected the business career his father wished for him and, leaving his native West Indies, settled in Paris in 1855 to become an artist. At this time the most 'progressive' painters were turning to land-scape, which seemed to provide the opportunity to paint truthfully from nature rather than to follow the outworn conventions of the French Academy. Pissarro particularly admired Corot (page 278) and sought his advice on painting out of doors. From 1859 some of his landscapes were accepted for exhibition at the Salon, although he and his wife and child were still living in extreme poverty. In 1870 they fled before the German invasion of France to London, where Pissarro's younger friend Monet had preceded them (see page 317).

During his stay in the city Pissarro painted twelve pictures; this springtime scene must have been completed shortly before his return to France in June 1871. Although it records a view still recognisable today, its composition may have been influenced by Hobbema's Avenue, Middelharnis (page 213), which had gone on show at the National Gallery a month before. The traditional format, the subject – a fashionable residential area – the comparatively large size and the high degree of finish may all have been intended to make the picture attractive to a buyer, and indeed Pissarro succeeded in selling it to the dealer Durand-Ruel, whom he met in London.

The Avenue, Sydenham at first sight seems to typify the freshness of spontaneous outdoor painting, but this is not quite how it was produced. Pissarro first made a preparatory study in watercolour (now in the Louvre, Paris). The picture itself was painted in two stages, following a preliminary drawing on the canvas establishing the

Fig. 9 Infra-red reflectogram of Pissarro's *Avenue, Sydenham*. Detail showing the painted-out figure of a woman.

lines of the composition. X-rays reveal that the main areas were first laid in with blocks of colour, which do not quite touch. In the next phase Pissarro used wet-in-wet brushwork to unify the composition - laying down one colour next to or on top of another before the first had dried, so that some intermixing occurred. Like Corot, he painted much of the picture with complex mixtures of paint lightened with white pigment to achieve an overall light tonality - in contrast to the undiluted pure pigments of great intensity used by Renoir some ten years later in Boating on the Seine (page 328). Smaller trees and branches were then painted over the sky. The figures were painted last, over dry paint, therefore most likely indoors in the studio. At a very late stage, a figure of a woman walking towards us on the right-hand pavement below the church was painted out, and a more distant group of people added to her right. The woman is partly visible with the naked eye, and very apparent in an infra-red reflectogram (see fig. 9). As Pissarro was to say later, painting directly out of doors was indispensable for études (sketches, studies), but 'the unity that the human spirit gives to vision can be found only in the studio. It is there that our impressions, previously scattered, are co-ordinated and enhance each other's value to create [a] true poem...'

PIERRE-CÉCILE PUVIS DE CHAVANNES (1824-1898)

The Beheading of Saint John the Baptist about 1865-9,

reworked probably in the later 1870s

Oil on canvas, 240 × 316 cm NG 3266

In the very years when Monet and Renoir (pages 315, 327) were seeking to capture in paint fugitive glimpses of modern life, an engineer-manqué from Lyon was working to virtually opposite ends. Son of a mining engineer, Puvis fell seriously ill a few days before his entrance examination to the Ecole Polytechnique in Paris. After two years' rest he went to Italy, and on his return decided to abandon technology and become a painter. He opened his own studio in Paris, and in 1861, when he was 37, he won a medal at his third Salon exhibition for allegories of *Peace* and *War*, which were bought by the state. From that time his career is a steady chronicle of public commissions, not only in France: in 1896 he decorated the Boston Public Library.

The Beheading of Saint John the Baptist exemplifies Puvis's ideals and methods. While the picture is almost certainly unfinished, its lean paint surface is characteristic of the artist. During his travels he had fallen in love with 'Italian Primitive' frescoes, and it was their flat, matt surfaces that he tried to imitate. His admiration of fresco, however, had broader implications. As early as 1848, discussions about state support for art and about the future of the Gobelins tapestry works had defined profound differences between easel and mural painting. The chemist Chevreul, then Director of Dyeing at the Gobelins, warned against the reproduction of easel paintings, with their 'half-tones', in tapestries 'for the furnishing of public monuments'. The argument presupposed that art on the walls of public buildings has a higher duty than illusionistic easel painting, essentially a domestic commodity. It was this nobler aim of 'simplicity and truthfulness' that Puvis pursued, aspiring to a 'mural' style. The smaller version of the Beheading (now in Birmingham), exhibited at the 1870 Salon, was praised by critics and officials for its 'very real elevation', but many visitors found it ludicrous and reminiscent of the crude French popular prints called *images d'Epinal*.

The beheading of Saint John the Baptist is one of the staple subjects of Christian art. The story's folk version, however, in which a *femme fatale* has the saint killed because of

her desire for him, had from the sixteenth century informed erotic pictures depicting Salome carrying the Baptist's severed head, often the artist's self portrait. This theme was revived in 1841 by Heinrich Heine in his exotic poem *Atta Troll*, and quickly became fashionable in all the arts. Perhaps unconsciously, Puvis seems to be drawing on both traditions: the wan Salome is said to resemble his mistress, the Romanian Princess Cantacuzène, and Heine's influence is particularly apparent in the 'Moorish' executioner. But the 'austere simplification of form' and 'love of the wall' are derived from church frescoes. Bodies – like the Moor's muscular back – are distorted to appear parallel to the picture surface, or at right angles to it in strict profile. Perspective is suppressed, and space behind the fig tree is patterned by its branches into two-dimensional shapes. 'Silence of colours' is assured through nearly flat expanses of hues, like the brooding courtier's sombre red cloak, unaffected by reverberating shadows or reflections.

HENRY RAEBURN (1756-1823)

Robert Ferguson of Raith 1770–1840 and Lieutenant-General Sir Ronald Ferguson 1773–1841: 'The Archers'

about 1789-90

Oil on canvas, 110.5 x 123.6 cm NG 6589

Raeburn, the supreme portraitist of the Scottish Enlightenment, was the first artist of international stature to gain a living in his native Scotland. George IV knighted him in 1822, and shortly before his death he was appointed 'His Majesty's Painter and Limner for Scotland'.

Born in Edinburgh of Edinburgh-born parents, Raeburn was orphaned young, educated at a philanthropic foundation for the sons of poor burgesses and apprenticed to a silversmith. He first acquired a reputation as a painter of miniature portraits. In 1770 or 1780 he married a wealthy widow some eleven years his senior. Although the match was a loving and happy one, it was his wife's money which, in 1784, enabled Raeburn to make an extended trip to Rome. En route, or on his return in 1786, or possibly both, he may have visited Reynolds (page 328) in London; it is clear that during his absence from Scotland he studied the work of leading contemporary portraitists as well as that of Old Masters. Either directly from the latter or through Reynolds's agency he learned, for example, to use a twill weave canvas, whose texture of diagonal lines shows through the paint, softening transitions, enlivening and unifying the picture surface. However acquired, his technique, at first experimental and changeable, became boldly assured, with much use of 'wet-in-wet' painting, scoring in the wet paint with a brush handle, and varying the consistency and density of paint and the brush size and size of brushstroke. The Scottish painter David Wilkie was to remark on his highly original 'square touch'. He seems to have worked directly on the canvas, with little pre-planning of the composition other than brush-drawn indications of placing, making changes at every stage of painting.

So free is the handling in this picture, and so subdued the colour, that at first sight it appears unfinished. The informal technique belies the work's strict geometry – the unreleased arrow divides the canvas in half horizontally, while the dark outline of the archer's torso bisects it vertically – but underscores the intimacy between the sitters and the artist (who painted them more than once), and between the sitters and the viewer. Raeburn adapts Van Dyck's formula for double portraits, making radical changes in the process. As befits 'two admirable Scotch Whigs', the Ferguson brothers are barely differentiated by costume, nor is one set above the other. Shown in the pure

profile of a Roman medal, the elder Robert is brightly lit; the younger Ronald stands within the pale shadow of the tree, Robert's ochre-grey sleeve cutting across his plumbrown coat. As in Van Dyck's portrait of the Stuart brothers (page 204), it is the younger sibling who holds the viewer in his gaze; the older brother's attention is on some more abstract goal outside the painting – here, the arrow's target.

Archery had recently been revived as a fashionable sport, though Robert and Ronald Ferguson only became members of the Royal Company of Archers after this portrait had been painted. But besides serving as a compositional device linking, yet distinguishing, the first-born heir and the younger son, the theme also expresses the ideals of the Scottish élite that Raeburn portrayed throughout his career. Robert is practising skills and exercising the self-command essential to a useful life. Ronald displays the serenity which, in the words of a contemporary essayist, 'make[s] us contented with ourselves, our friends, and our situation, and expand[s] the heart to all the interests of humanity'.

ODILON REDON (1840-1916)

Ophelia among the Flowers about 1905-8

Pastel on paper, 64×91 cm NG 6438On loan to the Tate Gallery, London

Redon first intended to study architecture, not painting. He abandoned his training, however, for a brief spell in the Paris studio of the academic painter Gérôme. After a mental breakdown he returned to his native Bordeaux, where he received informal instruction from a local watercolourist and from the etcher and engraver Rodolphe Bresdin. Between 1879 and 1899 he worked predominantly in monochrome on paper, producing charcoal drawings and series of lithographs that were acclaimed by the

literary avant-garde and came to influence younger artists. Many of his lithograph series illustrate, or more accurately freely interpret, literary works – by Baudelaire, Flaubert, Edgar Allan Poe. Like these poets, he was less interested in decoding external appearances than in interpreting dream, 'raising the spirit into the realms of mystery, into the anxiety of the unresolved, and into the delicious world of uncertainty'. Although he continued to paint landscape studies and flower pieces from the life and executed portraits in pastels, he castigated the Impressionist painters for being 'parasites of the object'.

In 1897 Redon's childhood home near Bordeaux was sold, and he appears to have been released from the bitter early memories which had haunted his black and white works. He moved to Paris, where, under the influence of the younger Gauguin (page 295), he turned increasingly to colour. In glowing flower pieces, he attempted to capture the radiance which emanates from 'the essence of the object', endowing it 'with the light of spirituality'.

Ophelia among the Flowers is one of the very few works by Redon in British public collections. The myth has grown up that the asymmetrical composition began as a vertical flower piece – a blue-green vase on a brown table – and that the profile of Ophelia was added later. There is, however, no evidence to support this and Redon made numerous compositions of this kind. The soft pastel crayons, stroked, hatched, blended, translucent over the white paper or forming dense blocks of opaque colour, inspired him to see Shakespeare's Ophelia – a favourite subject – as the visionary poet of flowers, crowned with 'fantastic garlands', who, before she drowned, floated in the brook chanting 'snatches of old lays,/ As one incapable of her own distress'.

PIERRE-AUGUSTE RENOIR (1841-1919)

Boating on the Seine about 1879–80

Oil on canvas, 71 x 92 cm NG 6478

Renoir's two young women, rowing lazily on the Seine in the haze of a hot summer's day, are the very evocation of suburban leisure, which provided the Impressionists with their best-known and best-loved subject. The painting technique also demonstrates, with almost textbook clarity, the theories of colour which most fascinated these artists. Renoir was later to abandon the 'formless spontaneity' which Boating on the Seine seems to exemplify for a more traditional style based on the discipline of drawing. At this date, however, he was still vying with his friends Monet (page 315), Pissarro (page 321), Sisley and others to paint truly 'modern' pictures, based on modern life, using modern pigments to capture fleeting effects of natural light.

Artists had sketched out of doors since at least the seventeenth century, but it was customary to complete paintings in the studio, under carefully controlled conditions. The Impressionists, however, nurtured the legend that their works were executed on the spot, in front of the motif, in a single session. Although they simulated this effect, it was rarely, if ever, true of the pictures they intended for sale (the one painting in the National Gallery in which the legend is substantiated is Monet's small, hastily executed *Beach at Trouville*, page 316). This little painting of rowers on the Seine, despite its appearance of spontaneity, evolved in distinct stages, as scientific analysis has demonstrated.

A few alterations to the composition are visible in X-ray photographs. The image was constructed with a variety of textures and consistencies of paint, the barely primed canvas constantly shows through and is responsible for the overall light tonality. But

the dazzle and shimmer which are the glory of the picture were created by paint applied on the very surface. Here Renoir juxtaposed unblended bright colours directly from the tube, having restricted himself to just lead white and seven intense pigments, most of them of recent invention. No black pigment and no earth colours appear. By setting the bright chrome orange of the skiff and its reflections against the expanse of cobalt blue of the river, he was testing out the key principle of the colour theory proposed by the French chemist Chevreul in 1839, the law of simultaneous contrast. On Chevreul's colour circle, orange and blue are placed opposite one another and, according to the theory, when they are seen as adjacent colours the intensity of each is mutually enhanced. No better demonstration of the validity of a theory could be imagined than Renoir's vivid picture.

SIR JOSHUA REYNOLDS (1723-1792)

Captain Robert Orme 1756

Oil on canvas, 239 x 147 cm NG 681

Joshua Reynolds, third son and seventh child of the Reverend Samuel Reynolds, was apprenticed at seventeen in London to the portrait painter Thomas Hudson, a Devonshire man like himself. Despite the uninspired example of Hudson, Reynolds succeeded in his ambition to become no 'ordinary' craftsman-painter: he established himself as a fashionable portrait painter, became friends with the most eminent men of letters in England, first president of the newly formed Royal Academy in 1768, and was knighted in 1769. Although he did not achieve greatness as a 'history painter', he invested his innumerable portraits of the privileged men and women of English society

with the wit, poetic resonance and nobility of heroic narrative. His fifteen *Discourses on Art*, delivered at the Academy between 1769 and 1790, remain the most cogent and most moving tribute in English to the ideals of Western art grounded in the Italian Renaissance.

We now tend to prefer the fresher brush of his rival Gainsborough (page 291) to Reynolds's contrivances. A restless and indiscriminate experimenter with media and pigments, imitating the surface effects of Old Master paintings without an understanding of their methods, he saw his pictures fade, flake and crack, so that portraits 'died' before their sitters. Even his contemporaries protested at his technical shortcomings. Yet the more we look at Reynolds, in the prodigious variety which Gainsborough rightly envied, the more we see that he indeed achieved what he defined as 'that one great idea, which gives to painting its true dignity. . . of speaking to the heart'. More than any

English painter before him, in the 'great design' of 'captivating the imagination', Reynolds participated in 'that friendly intercourse which ought to exist among Artists, of receiving from the dead and giving to the living, and perhaps to those who are yet unborn' (Discourse Twelve).

Captain Robert Orme is one of the great romantic military portraits, painted soon after Reynolds established his London practice. When it was exhibited in 1761 at the Society of Artists, a visitor described it as 'an officer of the [Coldstream] Guards with a letter in his hand, ready to mount his horse with all that fire mixed with rage that war and the love of his country can give'. The sitter, Robert Orme (1725–90), served in America as aide-de-camp to General Braddock. When Braddock was killed in 1755 in an ambush by the French, Orme returned to England and resigned from the army. Sometime in 1756 he sat for Reynolds.

Orme never purchased the portrait from the artist, in whose studio it attracted much notice 'by its boldness and singularity'. The composition may be freely adapted from drawings of Italian frescoes and Roman sculpture brought back by Reynolds from his journey to Italy in 1750–2; it may also allude to a portrait of Charles I by Van Dyck (page 200), now in Paris. But the effect is splendidly dramatic and immediate: the thunderous sky and extravagant lighting, Orme's windswept hair, the highlighted dispatches in his hand, his foaming steed, the red coat pushed open by the ready sword – all suggest a heroic and transient moment in the life of the young officer.

SIR JOSHUA REYNOLDS (1723-1792)

Lady Cockburn and her Three Eldest Sons 1773

Oil on canvas, 142 × 113 cm NG 2077

In his seventh *Discourse on Art*, delivered at the Royal Academy in 1776, Reynolds proclaimed:

He...who in his practice of portrait-painting wishes to dignify his subject, which we will suppose to be a lady, will not paint her in the modern dress, the familiarity of which alone is sufficient to destroy all dignity... [he] dresses his figure something with the general air of the antique for the sake of dignity, and preserves something of the modern for the sake of likeness.

In his fourth *Discourse* of 1771 he had recommended the 'historical Painter' never to to 'debase his conceptions with minute attention to the discriminations of Drapery... With him, the clothing is neither woolen, nor linen, nor silk, satin, or velvet: it is drapery; it is nothing more.'

Reynolds was not alone in worrying about the way portraits began to look ridiculous as fashions changed. The dress of ancient Greeks and Romans belonged to that period in European history which, educated people then thought, set civilised standards for all time; it was also believed to be closer to nature than modern dress – especially the 'straight lacing of English ladies', 'destructive...to health and long life'. But not all sitters wished to be depicted in mythical charades, and the results could sometimes be even more risible than an outmoded bodice – as when Lady Sarah Bunbury, who 'liked eating beefsteaks and playing cricket', was painted by Reynolds sacrificing to the Three Graces.

Lady Cockburn's portrait demonstrates the halfway mode most successfully adopted by the artist, and his pleasure in it is reflected by his signing it on the hem of her robe:

a wonderfully majestic gold 'drapery'. According to the newly fashionable exaltation of maternity, Augusta Anne, Sir James Cockburn's second wife, is posed with her three children (although separate sittings are recorded for the elder boys). James, the cherub kneeling on the left, born in 1771, became a general; George, born in 1772 and clambering around his mother's neck, grew up to be the admiral whose ship conveyed Napoleon to exile on St Helena; the baby, William, born that June, entered the Church and became Dean of York. The commission must have reminded Reynolds of the traditional allegorical image of Charity as a woman with three children; he probably knew Van Dyck's painting (now in the National Gallery, but then in an English private collection) or the famous engraving after it, for his composition resembles it in many details.

Where Van Dyck's Charity gazes up to Heaven, however, Lady Cockburn turns her profile to us and looks lovingly at her eldest son. Despite George's mischievous

address to the viewer – probably to be imagined as his Papa – the composition echoes Michelangelo's grand and severe sibyls on the Sistine Chapel ceiling. The colour accent of the brilliant macaw, a favourite pet in Reynolds's household recorded as having perched on the hand of Dr Johnson, was an afterthought, recalling Rubens's use of a similar device. So well did Reynolds succeed in lending Lady Cockburn 'the general air of the antique', however, that when the painting was etched for publication, and Sir James objected to his wife's name being exposed in public, the print was entitled *Cornelia and her Children* after the Roman matron who boasted that her children were her only jewels.

HENRI ROUSSEAU (1844-1910)

Tiger in a Tropical Storm (Surprised!) 1891

Oil on canvas, 130 x 162 cm NG 6421

In 1885, a year after Seurat had completed the *Bathers at Asnières* (page 334), an obscure ex-Regimental bandsman retired from his post as gatekeeper with the Paris Municipal Toll Service (in spite of his famous nickname, he never reached the rank of *Douanier* – Customs Officer) and began seriously to dedicate himself to the arts. He performed and composed music, wrote poems and plays; above all, he painted pictures. These amateur paintings, mocked by many, came to be admired by a few; in 1908 Picasso (page 320) gave a dinner in his studio in Rousseau's honour.

Rousseau's large canvases have a haunting dreamlike quality, and they have been influential on various currents in twentieth-century painting. While he claimed to

have had technical advice from the academicians Gérôme and Clement, like much untutored art his works favour pattern over 'correct' representation. Certain recurring motifs, however, such as branches silhouetted against the sky, combine calligraphy with observation. Rousseau claimed that he had served in Mexico with the French army (see Manet, page 311), but it is most likely that his foreign scenes were copied from popular prints. This composition, the first of his twenty or so jungle pictures, bears some resemblance to a pastel by Delacroix (page 284). In addition to prints and illustrated books, Rousseau also studied the exotic plants and animals at the Jardin des Plantes in Paris. Some of his most magical effects are created through the enlargement in scale of ornamental houseplants, such as the sansevierias – or 'mother-in-law's tongue' – along the foreground of this picture, and the rubber plant on the bottom right.

Tiger in a Tropical Storm was first shown in 1891 at the jury-free Salon des Indépendants, an annual exhibition organised in rebellion against the official Salon, under the title Surpris! Rousseau later described it as representing a tiger pursuing explorers, but he may originally have intended the 'surprise' to be the sudden storm breaking above the tiger. Long streaks of lightning wriggle across the sky and we can imagine the roll of thunder. It is an adventurous painting. Stripes govern the whole design; the streaks of rain were created with delicate transparent glazes of grey and white. Reversing normal expectations of bright foreground and duller background, patches of scarlet glow from behind the green and tawny foliage, echoing the fainter red snarl on the startled face of the tiger.

GEORGES-PIERRE SEURAT (1859-1891)

Bathers at Asnières 1884

Oil on canvas, 201 × 300 cm NG 3908

Like Degas (page 281), Seurat studied in Paris under a pupil of Ingres (page 308) and was deeply committed to drawing as a discipline. The beautiful conté crayon drawings which he produced rely on contrasts of tone rather than on the line so dear to Degas and to Ingres, but he fully shared with both these artists a disciplined approach to pictorial organisation.

For this, his first large-scale canvas, Seurat made over twenty preparatory studies in both conté crayon and oil, some of them executed out of doors. The setting of Bathers at Asnières and of Seurat's second monumental picture, Sunday Afternoon on the Island of La Grande Jatte, now in Chicago, is a stretch of the River Seine in north-west Paris, between the bridges at Asnières and Courbevoie. In the distance are the large factories at Clichy; in the foreground industrial workers relax on their day of rest. Seurat's theme of proletarian recreation was topical, a concern of radical politicians and of the Realist writers of the day. Ostensibly, Seurat's treatment carries no overt social comment. When the picture is seen in the original, however, its size conveys a powerful message. As Seurat well knew, paintings of everyday life were compared in academic theories of art with comedy: the depiction of 'people like ourselves or lower than ourselves'. The monumental scale was reserved for 'history painting', analogous with tragedy or epic: the noble deeds of 'people better than ourselves'. By using the traditional idiom of the higher genre for lower subject matter, Seurat threatened subversion, as the jury at the Salon of 1884, who rejected the canvas, must have understood.

The artist is best remembered for adapting Impressionist colour theory to develop *pointillisme*, painting by means of spots of pure colour fused by the eye at a distance.

Seurat later reworked parts of the *Bathers* using this technique: it is apparent in the orange hat, modified with spots of blue and yellow, and in areas of the water. The original handling varied, from thick Impressionist brushstrokes in the river to a crisscross of pink, orange, yellow and green lines in the grass. As in his conté crayon drawings, figures are irradiated by manipulating background tone with no regard to optical reality. This is especially noticeable where the water turns dark behind highlighted flesh and appears light behind flesh in shadow. Sharp contours are thus created without the use of line and with a minimum of modelling, enhancing the impression of hazy yet brilliant sunlight.

From bowler hat, vest and perky dog, to the boots, slouch and retreating chin of the adenoidal seated boy, everything places these men and boys 'among the lower orders' (with the exception of the child on the right, who plays Triton, the classical water god blowing his conch). In the same way, the stilted poses of the parasoled and top-hatted couple being ferried across the river, under the *tricolore* flag of the Third Republic, identify them as bourgeois. But it is the 'lower orders' that Seurat elevates to the ranks of monarchs and angels, like those painted with geometric grandeur by Piero della Francesca (page 82) in his Arezzo frescoes, which Seurat could have studied in replica in the chapel of the Ecole des Beaux-Arts in Paris.

GEORGE STUBBS (1724-1806)

The Milbanke and Melbourne Families about 1769

Oil on canvas, 97 × 147 cm NG 6429

Stubbs was born in Liverpool, the son of a currier, and it is tempting to imagine that it was among the tack and harness in his father's shop that he first came into contact with that English world of hunting, racing and horse breeding of which he became the quintessential interpreter. It was a world in which dukes metaphorically rubbed shoulders with stable lads, great landowners with Smithfield meat salesmen, society ladies with Newmarket jockeys, and men and women of all degrees with horses and dogs. 'Master of the art of class distinction', as the art historian Judy Egerton has remarked, he neither flattered nor mocked, but painted with profound 'acceptance of things more or less as they are'. In the words of Mary Spencer, his common-law wife for some fifty years, 'every object in the picture was a Portrait'.

In his effort to paint people truthfully Stubbs studied anatomy at a medical school. The better to portray horses he dissected them, teaching himself engraving to publish *The Anatomy of the Horse.* Although he may have wished to establish himself as a 'history painter' in the academic mould, he seems to have retained from his trip to Rome in 1754–6 only the memory of an antique marble of a lion attacking a horse. This subject preoccupied him for over thirty years and is the one theme in his work that comes nearest to evoking the 'pity and terror' of epic narrative. Stubbs's gifts of invention had to do not with storytelling but with abstract design.

The poetic effect of Stubbs's combination of dispassionate observation with pattern-making is beautifully demonstrated in this small full-length group portrait of (from left to right) the seventeen-year-old Elizabeth Milbanke, her father Sir Ralph Milbanke, her brother John Milbanke, and her husband Sir Peniston Lamb, the future

Viscount Melbourne. Although this kind of picture, popular in England in the eighteenth century, was called a 'conversation piece', the human sitters here converse no more than do the light tim-whisky carriage, the horses or Sir Peniston's spaniel. This failing must be the result of Stubbs having studied each figure group separately from the others, and from a different angle. We may be meant to imagine that the grander Milbankes are welcoming the ineffectual parvenu Sir Peniston. (His promotion to a viscountcy in 1784 was a result of his wife's affair with the Prince of Wales.)

Complete in itself, each vignette – as precise in its delineation of character as it is accurate about costume, complexion, coat, harness, or curvature of wheels seen in perspective – is carefully placed alongside the others to suggest a gracefully meandering yet uninflected line across the painting, along which each person and animal is given equal stress. The frieze is contained within the canvas, turning inwards at the edges. Stubbs often added an imaginary landscape backdrop only after he had satisfactorily deployed his figures, and I think this is what he must have done here, arranging masses of foliage and cliff, voids of sky, contrapuntally to the figural melody. And that 'vital but endlessly silent' communication among them (in David Piper's beautiful phrase) is forged in the shapes and tones of the spaces around them, the rhythms created by the curving necks and croups of horses, the legs of men and beasts, the sharp accents of tricorn hats, of rose, blue, buff, bay, grey.

GEORGE STUBBS (1724-1806)

Whistlejacket 1762

Oil on canvas, 292 × 246.4 cm NG 6569

In 1762 Stubbs spent several months at Wentworth House (now known as Wentworth Woodhouse) in South Yorkshire, the seat of Charles Watson-Wentworth, 2nd Marquess of Rockingham. With the new-found assurance gained through his study of horse anatomy (see previous page), he painted portraits of horses and dogs in Rockingham's stud farm. Five pictures were paid for in August of that year. In December Stubbs received a further 80 guineas for one of his imaginary compositions, a Wild Horse attacked by a Lion, and this painting of 'a Horse as Large as Life' – his masterpiece, the portrait of Rockingham's Arabian stallion Whistlejacket.

As well as being a passionate racing man and a gambler, Rockingham was a connoisseur and collector of sculpture, who had been to Italy as a Grand Tourist. It may be that his appreciation of sculpture motivated him to let Stubbs first omit the backgrounds in two of the earlier pictures, the 'friezes' of Mares and Foals Without a Background and Joshua (or Simon) Cobb with Whistlejacket and Two Other Stallions. And it may be that Whistlejacket's exceptional beauty – for he was only a moderately successful racehorse and had been at stud since 1759 – as captured by Stubbs in the group portrait inspired this unprecedented composition. Its dramatic air, however, also relates it to Stubbs's horse-and-lion pictures derived from an antique Roman marble (see previous page). Rockingham's Wild Horse attacked by a Lion was one of the artist's earliest paintings in this genre, and remains by far the largest. In conceiving Whistlejacket, patron and painter may have wished to endow a native English genre, horse portraiture, with Italianate grandeur and panache.

Whatever its genesis, there can be little doubt that Whistlejacket is a finished painting which exalts the fiery stallion in a state of nature. Because of the lack of background, he appears both as a live individual horse and as a monument to the horse; in a sense, the picture fits within a long tradition of the paragone, the contest between painting

and sculpture. But because it was unprecedented to show a horse as the hero of such a monument, the legend grew up that Rockingham had originally intended a life-size equestrian portrait of George III, changing his mind when he went into (political) opposition. Whistlejacket's pose – balanced on his bent hind legs, his forelegs drawn in – indeed resembles the difficult *levade*, a position in *haute-école* dressage, used in royal portraits to symbolise the ruler's power to govern. But there is nothing else to support this unlikely story.

A curious anecdote, however, further links this most modern-looking painting to classical antiquity. In his history of ancient art, the Latin writer Pliny the Elder recounts how birds came to peck at a lifelike picture of grapes. Painting outdoors while a stable boy was leading Whistlejacket backwards and forwards, Stubbs removed the picture from his easel and placed it against the stable wall. Catching sight for the first time of his own image, Whistlejacket supposedly began to 'stare and look wildly at the picture, endeavouring to get at it, to fight and to kick it'. Pummelling the horse 'with his palette and Mahl stick', Stubbs might nonetheless have relished this ultimate tribute to the realism of his art: its recognition by an animal.

GIOVANNI BATTISTA TIEPOLO (1696-1770)

An Allegory with Venus and Time about 1754-8

Oil on canvas, 292 x 190 cm NG 6387

To enter fully the radiant world of Tiepolo, we must travel – to Venice, his native city, then back to the mainland to Udine and Vicenza, across the Alps to Würzburg in Bavaria, finally to Madrid in Spain, where, fearing the shift of taste in his homeland, he elected to spend the last years of his life. The greatest decorative painter of his century, he was happiest working in fresco where his 'rapid and resolute' manner was a technical necessity. Under his virtuoso brush airy spaces, shimmering with light, opened on walls and ceilings to admit heroic beings – Christian, mythological, allegorical, historic

or poetic – dazzling to mortal viewers. He has been called the last Renaissance painter, and borrowed much from Veronese (page 170). But Tiepolo, even more than Veronese, was never wholly serious when painting epic. He can be majestic but not solemn; poignant rather than tragic. In the century which discovered feminine sensibility, he introduced a note of tenderness into the sternest and loftiest imagery.

Luckily for us, something of the freshness of Tiepolo's mural decorations is preserved in his oil sketches and in this canvas, painted to be inserted into the ceiling of a room in one of the many Venetian palaces of the Contarini family. It is designed to be seen from below, but at an angle, as we step through the door. From infinitely luminous skies, Venus, sumptuous in her white, gold and pink nudity, has swooped down in her chariot; her team of doves, released from harness flutter lovingly above her, and from a dawn-tinted cloud the Three Graces strew roses. Below, winged Cupid, her divine son, hovers with his quiverful of arrows. Venus has come to consign her newly born child, freshly washed with water from an earthenware amphora, to Father Time. Having set down his scythe. Time here signifies eternity rather than mortality. The child - wideeyed, thick-lipped and with a precocious widow's peak in his hairline - resembles page boys frescoed by Tiepolo shortly before on the staircase of the prince-bishop's palace in Würzburg. He is clearly meant to be a real baby. Venus' only human child, born to a mortal father, was Aeneas the founder of Rome. The Contarini, one of the oldest families in Venice, had fabricated for themselves a lineage from ancient Rome; the reference to Aeneas thus suggests that the ceiling may have been commissioned to proclaim the birth of a son. Through august parentage and his own heroic deeds, a Contarini boy might be expected, like Aeneas, to win eternal fame.

JOSEPH MALLORD WILLIAM TURNER (1775-1851)

The Fighting Temeraire tugged to her Last Berth to be broken up, 1838 1838-9

Oil on canvas, 91 x 122 cm NG 524

While the Suffolk-born Constable (page 275) wished to become a natural painter, Turner, son of a modest barber in Covent Garden, yearned for sublimity. Trained as a topographical draughtsman, he achieved his ambition through mastering the idioms of Claude (page 191) and of the grander Dutch seventeenth-century marine and land-scape painters (see pages 185, 248), as well as the melodramatic effects of the scene designer Jacques Philippe de Loutherbourg. Now nearly forgotten, this Alsatian-born member of the French Academy delighted the London public, and influenced artists from Gainsborough (page 291) to Turner and Joseph Wright of Derby, by staging panoramic peepshows in which painted landscapes, theatrical lighting and sound were combined to simulate natural phenomena and tragic catastrophes.

In search of the Sublime, Turner travelled widely, sketching grandiose scenery and extreme weather conditions, which he translated into canvases exhibited with poetic quotations. He considered *Dido building Carthage, or the Rise of the Carthaginian Empire* (1815) his masterpiece, bequeathing it together with the *Sun rising through Vapour* to the National Gallery on condition that they be hung beside Claude's *Seaport with the Embarkation of the Queen of Sheba* (page 192) and *Landscape with the Marriage of Isaac and Rebekah*. (This bequest is now honoured in Room 15.)

Turner's emulation of Baroque painting, however, did not exclude modern references, rather transmuting them into 'high' art. In this way he competed with both historic and contemporary masters. The *Fighting Temeraire* was exhibited at the Royal Academy in 1839

339

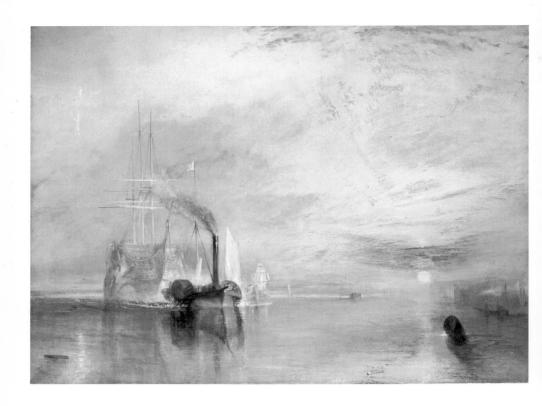

with a quotation from Thomas Campbell's poem Ye Mariners of England: 'The flag which braved the battle and the breeze/ No longer owns her.' The Temeraire had distinguished herself at the Battle of Trafalgar in 1805, but by the 1830s the veteran warships of the Napoleonic wars were being replaced by steamships. Turner, on an excursion on the Thames, encountered the old ship, sold out of the service, being towed from Sheerness to Rotherhithe to be scrapped. In his painting topography and shipbuilding alike are manipulated to symbolic and pictorial ends. Turner conceives the scene as a modern Claude: a ghostly Temeraire and the squat black tug, belching fire and soot, against a lurid sunset. His technique is very different from Claude's, as thick impastoed rays and reflections contrast with thinly painted areas, and colours swoop abruptly from light to dark. A heroic and graceful age is passing, a petty age of steam and money bustles to hasten its demise. The dying sun signals the end of the one, a pale reflecting moon the rise of the other. But just as Claude's sunrises and sunsets enlist the viewer's own sense of journey, so does the last berth of the Fighting Temeraire recall the breaking up of every human life.

JOSEPH MALLORD WILLIAM TURNER (1775-1851)

Rain, Steam and Speed – The Great Western Railway before 1844

Oil on canvas, 91 x 122 cm NG 538

While in the Fighting Temeraire Turner seemed to deplore the Industrial Revolution, his attitude in this, one of his last great works, is much more ambiguous. The 1840s

was the period of 'railway mania' and the restless Turner appreciated the speed and comfort of this form of travel. An unreliable anecdote by Turner's champion, Ruskin, records the origins of this picture in a train ride through a rainstorm, during which the artist is supposed to have stuck his head out of the window. Excited as ever by strong sensations, Turner replicates the experience in paint, although the viewer is imagined as seeing the approaching train from a high vantage point.

The bridge was, and is, recognisable as Maidenhead Viaduct across the Thames between Taplow and Maidenhead, on the newly laid Great Western line to Bristol and Exeter. Begun on Brunel's design in 1837 and finished in 1839, the viaduct was the subject of controversy, critics of the GWR saying that it would fall down. The view is towards London; the bridge seen at the left is Taylor's road bridge, of which the foundation stone was laid in 1772.

Once again Turner relies on Claude (page 191) for the diagonal recession from foreground to a vanishing point at the centre of the picture. The aims of the two artists, however, are very different. The exaggeratedly steep foreshortening of the viaduct along which our eye hurtles to the horizon is used to suggest the speed at which the locomotive irrupts into view through the driving rain, headlight blazing. Ahead of it, disproportionately large, a hare – proverbially swiftest of all animals – bounds across the tracks; we doubt if it will win the race and escape with its life. A skiff is on the river far beneath, and in the distance a ploughman stoically turns his furrow. Virtuoso swirls and slashes, and smears and sprays of paint, simulate rain, steam and speed to blur these figures of the old countryside. Exhilaration and regret are mingled with alarm; in a second we must leap aside to let the iron horse roar by.

ELIZABETH LOUISE VIGÉE LE BRUN (1755–1842) Self Portrait in a Straw Hat after 1782

Oil on canvas, 98 x 70 cm NG 1653

The daughter and pupil of a minor Parisian painter, Louis Vigée, Madame Vigée Le Brun was an attractive and charming woman, who specialised in the attractive and charming portrayal of women and children while remaining a competent portraitist of men. Eighteenth-century notions of graceful spontaneity may strike twenty-first-century viewers as arch or sentimental; nevertheless, she pioneered a new style. Her fashionable portraits in the simplified dress called à la grecque dispense with Baroque props of columns or curtains to demonstrate 'natural' manners and feelings, anticipating the Neo-classical portraits of David (page 279).

Madame Vigée Le Brun fled the French Revolution in 1789, avoiding the fate of her most illustrious patron, Queen Marie-Antoinette, to become an international success in the capitals of Europe. She returned to her native city after the Restoration in 1814

and gave an account of her early life and later tribulations and triumphs in the highly readable, if unreliable, *Memoirs* published in 1835.

The painter Claude-Joseph Vernet, she recalls, advised her to study the Italian and Flemish masters, but above all to follow nature. This picture is an autograph replica of a self portrait painted in Brussels in 1782 which wittily records her admiration of a famous Flemish masterpiece, Rubens's Portrait of Susanna Lunden, known as the 'Chapeau de Paille' (page 245). '[Its] great effect', she wrote, 'resides in the two different kinds of illumination which simple daylight and the light of the sun create... This painting... has inspired me to the point that I made my own portrait... in search of the same effect.'

The bright gleam and the general radiance of direct and reflected outdoor light as represented in Rubens's picture are indeed carefully noted, but Madame Vigée Le Brun takes care also to record her debt to nature. She shows herself in the open against a cloud-flecked sky, and – not surprisingly since she is both sitter and painter – as almost a personification of the art of painting. For this fictitious excursion into the fields, but also to demonstrate her powers of observation, she wears a genuine *chapeau de paille*, unlike Rubens's sitter, whose hat is actually made of beaver felt. To the dashing ostrich feather she has added a wreath of freshly picked rustic flowers. Her hair is her own, not a wig, and is left unpowdered. Where Susanna Lunden modestly crosses her arms above her waist and peers out from below her hat, Madame Vigée Le Brun extends her unaffected friendship to the viewer. Most natural of all, however, is her charming bosom. For unlike Rubens's beauty, whose breasts are moulded by her tight corset, Madame Vigée Le Brun lets it plainly be seen in her low *décolletage* that she has no need of such artifice.

JOSEPH WRIGHT OF DERBY (1734-1797)

An Experiment on a Bird in the Air Pump 1768

Oil on canvas, 183 × 244 cm NG 725

Born in Derby, near the site of England's first large manufactory, Joseph Wright fittingly became the first painter of the Industrial Revolution, a portraitist and friend of manufacturers, engineers and those early scientists who were still called 'natural philosophers'. Trained in London by Thomas Hudson, teacher of his older contemporary Reynolds (page 328), Wright, like Reynolds, desired to be more than an 'ordinary' craftsman. In the enquiring spirit of his Derby acquaintances, and emulating the Dutch followers of Caravaggio (page 187) – 'candlelight' masters such as Honthorst (page 214) and Godfried Schalcken (1643–1706) who had worked at the English court – Wright turned to ceaseless pictorial experiments in the effects of light, notably in nocturnal views of industrial scenes – blacksmiths' shops, iron forges, glass-blowing houses, blast furnaces, cotton mills – and of volcanic eruptions, which he depicted repeatedly after witnessing Vesuvius in action during a visit to Italy in 1773–5. All were painted with a new, Romantic fervour, in which, like the scientist and poet Dr Erasmus Darwin, grandfather of Charles, Wright was able to 'Inlist Imagination under the banner of Science'.

Darwin's tag fittingly describes this large painting, at once modern genre, 'history painting', vanitas (see pages 210–12 and 255–6) and portrait. It depicts not so much an experiment as a science-based home entertainment of the kind which Josiah Wedgwood was to arrange in 1779, when he summoned an assistant of the chemist Joseph Priestley to instruct his children and his friends. In Wright's picture a charismatic natural philosopher demonstrates the effects of a vacuum and the necessity of air for

living creatures. The air has been pumped out of the flask at the top of the large apparatus on the table with the air pump, invented by the German physicist Otto von Guericke in about 1650. Another of his inventions, a pair of Magdeburg spheres, is lying nearby; when they are placed together, and the air pumped out from between them, the resultant vacuum makes the spheres inseparable. In the flask a valuable white cockatoo is struggling for air and appears near to death. Only the scientist - white-haired and direct of gaze and gesture like God the Father in religious imagery can save it by releasing the valve at the top of the flask. The boy at the window lowers the bird's cage in hope of its imminent release; his two sisters react with grief and horror to their pet's agony, as their father adduces the chilly comforts of reason. The elderly man on the right meditates on death - a theme whose universal application is made even plainer by the human skull preserved in the large glass, from behind which shines a single candle. Another traditional motif of transience is introduced in the watch with which the man on the left times the demonstration. Behind him a boy watches with fascination. The youthful couple are alone in ignoring the central action, their eyes locked in love, their thoughts only of life. They are Mary Barlow and Thomas Coltman, who were to marry in 1769; their double portrait as a married couple, painted by Wright in 1771, is also in the Gallery.

A fainter secondary source of light is the moon outside the window – a Gothick touch reminding us that in the late eighteenth century science and the occult were sometimes confused, and equally enthralling. In a few years, Dr Mesmer would demonstrate 'animal magnetism' in Paris, while in England Erasmus Darwin's Lunar Society would meet every Monday nearest the full moon to discuss advances in science and technology.

Index

INDEX

Acciaiuoli, Margherita 146

Aertsen, Pieter 104-5

Artists' names and page numbers in \boldsymbol{bold} type refer to the main entries.

Aldobrandini, Cardinal Pietro	The Agony in the Garden 22-3	Bronzino 106–7, 147
188, 198	The Coronation of the Virgin 20	An Allegory with Venus and Cupid
altarpieces 16-17, 18, 23, 29, 32-3,	Doge Leonardo Loredan 20-1, 167	106–7 , 113
34, 37, 38, 40, 41-2, 43-4, 49,	The Feast of the Gods 165	Brouwer, Adriaen 182-4
51-2, 55-6, 60, 61-2, 63, 67-8,	Bellini, Jacopo 20	Tavern Scene 182-4
69, 71, 72-3, 76-80, 87-9, 95-7,	Bellini workshop 64, 164	Browning, Robert 153
119, 120-1, 126, 133-4, 134-6,	Bentivoglio family 35	Bruegel the Elder, Pieter 108-9,
143-4, 149-51, 156-7, 159-60,	Berchem, Nicolaes 180-1	179, 183
229, 264, 268	Peasants with Four Oxen and a	The Adoration of the Kings 108–9
Altdorfer, Albrecht 102-3, 126	Goat at a Ford by a Ruined	Bruges 40, 79, 118
Christ taking Leave of his Mother	Aqueduct 180-1	St Donatian's 40
102-3	Bergamo 128, 140	Brugghen, Hendrick ter 184-5,
Landscape with a Footbridge 102	Bermejo, Bartolomé 23-4	214
Amsterdam 168, 181, 183, 186,	Saint Michael triumphant over	The Concert 184-5, 212, 215
198, 212–13, 216, 217–18, 219,	the Devil with the Donor	Brunelleschi, Filippo 68
221, 224, 237, 248, 255	Antonio Juan 23–4	Bufolina, Maria 143
Andrews, Mr and Mrs Robert	Beuckelaer, Joachim 104-6	
292-3	The Four Elements: Earth.	Caffarelli, Bishop Prospero 38
Anne of Bohemia 95	A Fruit and Vegetable Market	Campen, Jacob van 251
Anquetin, Louis 300	with the Flight into Egypt in	Campin, Robert 30-2, 49, 94
Ansidei, Bernardino 149	the Background 104–6	Portraits of a Man and a Woman
Antonello da Messina 18–19	Bicknell, Maria 277	30-1
Saint Jerome in his Study 18–19	Blauw, Jacobus 279–80	The Virgin and Child before a
Antwerp 40, 94, 105, 109, 118, 132,	Bloemaert, Abraham 184-5, 214	Firescreen 31
145, 159, 183, 200, 203, 244,	Bologna 35, 152, 188, 197, 209-10,	Workshop of:
246-7, 298	239-40	The Virgin and Child in an Interior
Aretino, Pietro 164	San Petronio 240	31-2
Arezzo 82, 88	Bonington, Richard 285	Canaletto 271-2, 305
Ariosto, Ludovico 237, 242	Borch, Gerard ter 181-2	'The Stonemason's Yard' 271–2
Ascoli Piceno 38–9	An Officer dictating a Letter while	Cappelle, Jan van de 185-6
Augsburg 122	a Trumpeter waits 181	A Dutch Yacht firing a Salute as
Aved, Joseph 274	A Woman playing a Theorbo to	a Barge pulls away, and Many
Avercamp, Hendrick 179–80	Two Men 181-2	Small Vessels at Anchor 185-6
A Scene on the Ice near a Town	Borgherini, Pierfrancesco 146, 157	Caravaggio 184-5, 187-8, 188,
179-80	Borgherini, Salvi 146	197, 209, 258, 264
Winter Scene with Skaters near	Borgo San Sepolcro 82, 88	Boy bitten by a Lizard 187
a Castle 179	Bosch, Hieronymus 25-6, 109	Salome receives the Head of Saint
Avogadro, Gerolamo II 139	Christ Mocked (The Crowning	John the Baptist 188
	with Thorns) 25-6	The Supper at Emmaus 187-8
Baburen, Dirck, The Procuress 262	Both, Jan 180	Carpio 260-1
Bacchiacca 146	Botticelli, Sandro 26-8	Carracci, Agostino 188
Baldovinetti, Alesso 19	'Mystic Nativity' 27–8	Carracci, Annibale 188-9, 197,
Portrait of a Lady in Yellow	Venus and Mars 26-7	226, 231, 276
19–20 , 21	Boucher, François 288-9	Christ appearing to Saint Peter
Bartolommeo, Fra 165	Boudin, Eugène 315–16	on the Appian Way ('Domine,
Basle 122-3	Bouillon, Duc de 192	Quo Vadis?') 188-9
Bassano, Jacopo 103-4	Bouts, Dirk 29-30	Carracci family firm 188, 197, 209
The Way to Calvary 103-4	The Entombment 29-30	Carracci, Ludovico 188
Baudelaire, Charles 327	Bramante, Donato 152	Castelfranco 116
Bazille, Frédéric 318	Brant, Isabella 244, 245	Catullus 165
Bellini, Gentile 20, 169	Braque, Georges 272, 321	Cavallino, Bernardo 177

Bellini, Giovanni 20-3, 32, 46,

64, 116, 128

Brescia 138-40, 141, 154

Bresdin, Rodolphe 326

Corot, Jean-Baptiste Camille Delft 133, 205, 216-17, 261-2 Cézanne, Paul 272-4 della Robbia, Luca 85 Bathers 272-3 278-q. 282, 321 Avianon from the West 279 della Torre, Giovanni Agostino The Stove in the Studio 273-4 Champaigne, Philippe de 190-1 Peasants under the Trees at Dawn 128, 129 Cardinal de Richelieu 190-1 della Torre, Niccolò 128, 129 Devis, Arthur 203 Chardin, Jean Siméon 273, Correggio 109-12, 143-4, 159, Diderot, Denis 274 274-5 Dinteville, Jean de 123-4 The Madonna of the Basket 111-12 The Copper Cistern 273 The House of Cards 274-5 Venus with Mercury and Cupid Dolci, Carlo 177, 105-6, 252 ('The School of Love') 101, The Adoration of the Kings 195-6 Charles I, King of England 202-3, The Virgin and Child with Flowers 100-11 214, 242 Charles II, King of England 198 Cortona, Pietro da 206 105 Domenichino 197-8, 226, 230 Charles V (Habsburg), Holy Cosimo Rosselli 81 Apollo killing the Cyclops 197-8 Roman Emperor 125, 143, 203 Costa, Lorenzo 35-6 Domenico Veneziano 82 Charles VI. King of France 78 A Concert 35-6 Charles the Bald, King of the Cozens, Alexander 278 Donatello 54, 68, 93 Cranach, Hans 112 Donne, Sir John 78-9 Franks 77 Charles the Bold, Duke of Cranach the Elder, Lucas Dordrecht 194, 224 Burgundy 70 112-15, 138 Dou, Gerrit 198-200 A Poulterer's Shop 198-200 Cupid complaining to Venus Charles Martel, King of the Franks 77, 78 112-14 Drouais, François-Hubert 287-8 Portraits of Johann the Steadfast Madame de Pompadour at her Charlotte, Oueen 310-11 and Johann Friedrich the Tambour Frame 287-8 Chevreul, Michel Eugène 323, Duccio di Buoninsegna 41-5, 54 Maananimous 114-15 The Annunciation 43-5 Chigi, Agostino 155 Cranach the Younger, Lucas 112 Christian II, King of Denmark 125 Jesus opens the Eyes of a Man born Crivelli, Carlo 37-40 The Annunciation, with Saint Blind 43 Christian IV, King of Denmark Emidius 38-40 Maestà 43-4, 88 The Rucellai Madonna 41 Christina of Denmark, Duchess of La Madonna della Rondine ('The Madonna of the Swallow') The Transfiguration 43 Milan 125-6 The Virgin and Child with Saints Cima da Conegliano, Giovanni 37-8 Cuyp, Aelbert 194-5 41-3 Battista 32-4 Dunthorne, John 276 The Incredulity of Saint Thomas River Landscape with Horseman Duquesnoy, François 199 and Peasants 194-5 32-4 Dürer, Albrecht 45-6, 61, 64, Cimabue 34-5 103, 120, 126, 131, 145, 240, 252 The Flagellation 34 Dante Alighieri, The Divine Comedy Saint Jerome 45-6 The Virgin and Child enthroned (quoted) 34 Dyck, Anthony van 168, 183, 190, with Two Angels 34-5 Daret, Jacques 31-2 200-5, 228, 291, 325, 330, 331 Darwin, Erasmus 343-4 The Virgin in Majesty 34 The Earl of Pembroke and his David, Gerard 40-1 Claude Lorrain 180-1, 191-4, The Virgin and Child with Saints Family 170 279, 339-40 The Emperor Theodosius is Hagar and the Angel 276 and Donor 40-1 forbidden by Saint Ambrose to Landscape with Aeneas at Delos David, Jacques-Louis 279-80, enter Milan Cathedral 200-1 288-9, 308, 342 193-4 Eauestrian Portrait of Charles I Landscape with the Marriage of Jacobus Blauw 279-80 202-3 Isaac and Rebekah ('The Mill') Portrait of the Vicomtesse Vilain Lord John and Lord Bernard Stuart 176, 192, 339 XIIII and her Daughter 279 Degas, Hilaire-Germain-Edgar 203-5 Seaport with the Embarkation of Portrait of Viscountess 28, 281-3, 296, 312, 315, 333 the Queen of Sheba 176, After the Bath, Woman drying Andover and Ladv 191-2, 339 Thimbelby 203 herself 281-2 Clement VIII (Aldobrandini), Pope 143, 188 Hélène Rouart in her Father's Study Eitner, Lorenz, quoted 284 Cockburn, Lady 330-2 de la Chapelle, Richard de Visch Elliot, William 195 Cologne 61, 75 Elsheimer, Adam 101, 115-16, Constable, John 245, 249, 259, 40.41 Delacroix, Ferdinand-Victor-275-8, 278, 283, 325 Saint Paul on Malta 115-16 The Hay-Wain 275-7, 285 Eugène 171, 284-5, 308, 333 Louis-Auguste Schwiter 284-5 Erasmus 123, 132-3, 183 Weymouth Bay: Bowleaze Cove

Massacre of Chios 285

The Execution of Lady Jane Grey

Delaroche, Paul 285-6

285-6

and Jordon Hill 277-8

conversation pieces 269, 307, 336

Contarini family 339

Cornaro, Francesco 64

Este, Alfonso d' 164-5 Este, Borso d' 91

Este, Ercole d' 01

Este, Isabella d' 56

Faa Iheihe 207-8 Este, Lionello d' 91-2 A Vase of Flowers 295-6 'everyday life' 178, 181, 198, 210, Geertgen tot Sint Jans 49-50 261, 260 The Nativity, at Night 49-50 Evck, Jan van 19, 23, 40, 46-9, genre 269; see also 'everyday life' 118, 132 Gentile da Fabriano 50-2, 85 A Man in a Turban 48-9 The Virgin and Child (The The Portrait of Giovanni (?) Arnolfini and his Wife ('The Quaratesi Madonna) 50-2 George IV, King of England 324 Arnolfini Portrait') 46-8 Gerbier, Balthasar 243 Fabritius, Carel 205-6, 216 Gérôme, Jean-Léon 332-3 View of Delft 205 Ghiberti, Lorenzo 54, 71 A Young Man in a Fur Cap Giordano, Luca 195, 206-7, 288 Death of Jezebel 207 and a Cuirass (probably a Self Portrait) 205-6 Perseus turning Phineas and his Fantin-Latour, Henri 206 Followers to Stone 206-7 Ferguson, Robert 324-6 Rape of the Sabine Women 207 Ferguson, Lt-General Sir Ronald Giorgione 110, 116-17, 139, 154, 155, 164, 167 324-6 Ferrara 35, 92, 164 Villa Belfiore 92 Giotto di Bondone 34, 52-3, 89 Fielding, Henry 307 Giovanni di Paolo 54-5, 89 Fielding, Thales 285 Fildes, Luke 300 Fisher, Revd John 277 Desert 54-5 Flaubert, Gustave 327 Florence 23, 26-7, 34, 51-2, 55-6, Baptist 54 60, 80, 81, 82, 86-7, 92-3, 105, Girtin, Thomas 276 Giulio Romano 233 106, 134-6, 149, 153-4, 195, Giustiniani, Marchese Vincenzo 206, 242 Brancacci Chapel 68 Cathedral 85 Gogh, Vincent van 296, 298-301 Oratory of Saint Sebastian 87 Portrait of Mme Roulin 300 San Benedetto fuori della auote 211 Porta Pinti 63 Sunflowers 300-1 Van Gogh's Chair 298-300 San Niccolò Oltrarno 52 San Pier Maggiore 55-6 Golden Leaend, The 77, 146, 162 Santa Maria degli Angeli 62 Gonzaga, Federigo II, Lord of Santa Maria del Carmine 60 Mantua 100 Fontainebleau 220 Gossaert, Jan 118-20 Fourment, Daniel 245 Fourment, Helen 244, 245 An Elderly Couple 118 Fragonard, Jean-Honoré 288-9 Goya, Francisco de 302-5 Psyche showing her Sisters her Gifts Don Andrés del Peral 303 from Cupid 288-9 Doña Isabel de Porcel 302-3 Frederik Hendrik, Prince of The Duke of Wellington 304-5 Orange 186, 214, 219 The Naked Maja 260 A Picnic 303 Friedrich, Caspar David 290-1 Winter Landscape 290-1 Goya, Francisco Javier de 304 Friedrich the Wise, Elector Goven, Jan van 249 Granacci, Francesco 146 of Saxonv 112 Fuseli, Henry (quoted) 278 Greco, El 208-9 Christ driving the Traders from Gainsborough, Thomas 227, 276, the Temple 208-9 Grey, Lady Jane 285-6 201-3, 320, 330 Mr and Mrs Andrews 292-3 grulli 183 Mr and Mrs William Hallett Guardi, Francesco 305-6

212-13 history painting 116, 146, 171, 177, The Sunset (Il Tramonto) 116-17 214, 221, 225, 231, 235, 251, 261, The Pentecost (attributed) 52-3 268-9, 281, 291, 307, 312, 328, 333, 335, 343 Hobbema, Meindert 213-14 Saint John the Baptist retiring to the The Avenue, Middelharnis Scenes from the Life of Saint John the **213-14**, 322 Hofer family 90 Hogarth, William 226, 307-8 Marriage A-la-mode 307 The Marriage Settlement 307-8 Holbein, Hans the Elder 122 Holbein, Hans the Younger 75, 122-6 Christina of Denmark, Duchess of Milan 125-6 Iean de Dinteville and Georges de Selve ('The Ambassadors') 123-4 A Lady with a Squirrel and a Starling 122-3 Portrait of Henry VIII 123 The Adoration of the Kings 119-20 Honthorst, Gerrit van 184, 214-16, 261, 343 Christ before the High Priest 214-16 Hooch, Pieter de 216-17, 224 The Courtyard of a House in Delft 216-17 Huber, Wolf 126-7 Christ taking Leave of his Mother 126-7 Hudson, Thomas 328, 343 Huet, Paul 285 Huygens, Constantijn 219-20 An Architectural Caprice 305-6 Guardi, Giovanni Antonio 305 Guercino 209-10 Cumaean Sibyl with a Putto 210 The Dead Christ mourned by Two

Ingres, Jean-Auguste-Dominique 281, 308-10, 314, 333 Angelica saved by Ruggiero 308 Madame Moitessier 308-10 Innocent VIII (Cibo), Pope 38, 87

Jacopo di Cione 55-6

Angels 209-10

Haarlem 49, 120, 181, 183, 185,

Hallett, William and Elizabeth

Young Man holding a Skull

(Vanitas) 210-12

Heine, Heinrich 324

126, 285

Hals, Frans 183, 210-12, 254, 298

Heemskerck, Martin van 120-1

Mary Magdalene 120-1

Henry VIII, King of England 123,

View of the Westerkerk, Amsterdam

Heyden, Jan van der 212-13

Evangelist, the Donor and Saint

The Virgin and Saint John the

210, 212, 248, 249-50, 251, 254

('The Morning Walk') 291-2

Gallen-Kallela, Akseli 293-5

Gauguin, Paul 294, 295-8,

Lake Keitele 293-5

299-300, 327

The Coronation of the Virgin with
Adoring Saints (The San Pier
Maggiore Altarpiece)
(attributed) 55-6
James I, King of England 202-3,
219
Jansen, Cornelis 190-1
Joannes de Broeder 119
Johann Friedrich, Elector of
Saxony 112, 114-15
Johann the Steadfast, Elector of
Saxony 112, 114-15
Juárez, Benito 311
Julius II (della Rovere), Pope 149,
151-2

Kalenala, 204

Kalevala 294

Kalf, Willem 217-18

Still Life with the Drinking-Horn of the Saint Sebastian Archers' Guild, Lobster and Glasses 217–18

Keyser, Thomas de 219-20
Portrait of Constantijn Huygens
and his Clerk(?) 219-20
Keyser the elder, Thomas de 213
Koninck, Philips 248

La Hyre, Laurent de 220–1 Allegory of Grammar 220–1 Lamb, Sir Peniston 335–6 landscape 22, 29, 55, 79, 88, 101, 102–3, 108–9, 115–16, 116–17, 126–7, 145, 149, 157, 165, 167, 176, 179, 180–1, 191–4, 194–5, 213–14, 242, 244–5, 248–9, 250, 268, 276–9, 290, 292–3, 294, 311, 317, 321–2

Lanfranco 109

Lastman, Pieter 221-2

Juno discovering Jupiter with Io

Lawrence, Thomas 285, 310–11

Queen Charlotte 310–11

Lebrun, Charles 226

Le Nain, Antoine, Louis and Mathieu 222-4

Four Figures at Table 222–4 Three Men and a Boy 222

Leo X (de' Medici), Pope 149, 156 Leonardo da Vinci 56–60, 68,

82, 100, 110, 111, 122, 132–3, 149, 153 Christ among the Doctors 188 The Last Supper 58, 188 Mona Lisa 56

The Virgin and Child with Saint Anne and Saint John the Baptist (the Leonardo cartoon) 58–60

The Virgin of the Rocks 56–8 Leslie, C.R. (quoted) 277 Lippi, Filippino 26, 58 Lippi, Fra Filippo 26, 60–1

The Annunciation 60–1

Seven Saints 61

Lo Spagna 252

Lochner, Stephan 61-2

The Adoration of the Magi 61
Saints Matthew, Catherine of
Alexandria and John the
Evangelist 61–2

London 123, 126, 203, 219, 242–3, 276–7, 285, 291, 311, 317, 321–2, 328, 330, 343

Westminster Abbey 124 Lönnrot, Elias 294

Lonnrot, Elias 294 Lopez, Alfonso 237

Loredan, Doge Leonardo 20–21

Lorenzo Monaco 62–3, 71

The Coronation of the Virgin and
Adoring Saints 62–3

Lotto, Lorenzo 128–30, 139

Portrait of a Lady inspired by

Lucretia 129–30

The Physician Giovanni Agostino della Torre and his Son, Niccolò 128–9

Louis XII, King of France 60 Louis XIII, King of France 190, 220

Louis XIV, King of France 223, 226

Louis XV, King of France 287, 288 Loutherbourg, Jacques Philippe de 339

Louvain 29 Lucas van Leyden 146 Lunden, Susanna **245–6**, 343

Luther, Martin 75, 112, 124

Mabuse: see Gossaert, Jan MacGregor, Neil 191, 227 Maes. Nicolaes 224-5

Christ blessing the Children 224-5 Mander, Karel van (quoted) 185, 250

Manet, Edouard 303, 311–12 The Execution of Maximilian 311–12

Mannerism 153, 159

Mantegna, Andrea 20, 22, 35, 39,

46, **64–7**, 91, 110

The Agony in the Garden **66–7**The Introduction of the Cult of

Cybele at Rome **64–5**The Virgin and Child 66

Mantua 35, 64, 109, 129

Margaret of Austria, Regent of

the Netherlands 125 Margaret of York 79

Margarito of Arezzo 41, 42, 67–8 The Virgin and Child Enthroned, with Scenes of the Nativity and the Lives of Saints 67–8 Marinus van Reymerswaele

130-1, 133

Two Tax Gatherers 130-1 Mary of Hungary, Regent of the

Netherlands 125 **Masaccio** 51–2, 60–1, **68–70**, 71–2 Saints Jerome and John the Baptist

71–2
The Virgin and Child 52, **68–70**,
72

Masolino 60, 68, 71-2

The Assumption of the Virgin 72 The Foundation of Santa Maria Maggiore ('The Miracle of the Snow') 72

A Pope (Saint Gregory?) and Saint Matthias 71–2

Massys, Quinten 40, 132–3 A Grotesque Old Woman (attributed) 132–3

Master of Delft 133-4

Scenes from the Passion 133–4 Master of Flémalle: see Campin, Robert

Master of Liesborn 72–4 The Annunciation 72–4

Master of the Mornauer Portrait

Portrait of Alexander Mornauer

Master of the Saint
Bartholomew Altarpiece 75-6
The Deposition 75-6

Master of Saint Giles 76-8

The Mass of Saint Giles 76-8

Saint Giles and the Hind 76

Saint Giles and the Hind 76

Matisse, Henri 313–14

Portrait of Greta Moll 313–14

Maximilian, Emperor of Mexico 311–12

Medici family 60–1, 242 Medici, Cosimo de' 106 Medici, Cosimo III de' 253 Medici, Giulio de', Cardinal 156, 157

Medici, Lorenzo de' 93 Medici, Marie de' 190 Mejía, General Tomás 311–12

Meléndez, Luis 314-15

Still Life with Oranges and Walnuts 314–15

Melzi, Giovanni Francesco 57

Memling, Hans 40, 78–9 The Virgin and Child with Saints and Donors (The Donne

Triptych) 78–9

Menasseh ben Israel 238 Mengs, Anton Raffaël (quoted) 111 Meyer, Caspar 280

Michelangelo 52, 68, 80, **134–8**, 143, 144, 146, 148–9, 152, 155–7, 163, 209

Doni Tondo 135 Paris 76-7, 190, 218, 220-1, 223, Porcel, Doña Isabel de 302-3 portraits 19-20, 20-21, 30-31, The Entombment 100, 134-6 230, 273, 274, 277, 284-5, The Last Judgement 188, 208 287-8, 288-9, 294, 295, 296, 46-8, 48-9, 74-5, 90, 114-15, Leda and Night 248 118, 122-3, 125-6, 128-9, 298, 300, 311, 313, 315, 321, 323, The Madonna and Child with 129-30, 138-40, 140-1, 141-3, 326-7, 332 Saint Iohn and Angels ('The Ecole des Beaux-Arts 82, 334 153-4, 167-8, 168-70, 190-1, Manchester Madonna') 100, Parma 109, 143, 208 202-3, 203-5, 205-6, 219-20, 137-8 Parmigianino 143-4, 159, 208 226-7, 236-8, 241-2, 245-6, The Madonna and Child with 256-8, 279-80, 282-3, 284-5, The Madonna of the Stairs 138 Mignard, Pierre 226-7, 252 Saints John the Baptist and 287-8, 291-2, 292-3, 302-3, The Marquise de Seignelay and Jerome 143-4 304-5, 308-10, 310-11, 313-14, Two of her Sons 226-7 Patinir, Joachim 117, 145-6 324-6, 328-30, 330-2, 335-6, Milbanke family 335-6 Saint Jerome in a Rocky Landscape 342-3 Millet, Jean François 282 (workshop, attributed) portraiture 101, 106, 112, 131, The Winnower 269 145-6 132, 133, 143, 159, 177, 198, 200, 223-4, 225, 236, 242-3, 269, Miramón, General Miguel 311-12 Perugino, Pietro 23, 79, 80-1, Moll, Greta 313-14 148, 150 336-7 Post, Pieter 220 Monet, Claude 281-2, 313, The Virgin and Child with an Poussin, Nicolas 177, 226, 230-4, Angel, the Archangel Michael 315-19, 321, 327 Bathers at La Grenouillère 318-19 and the Archangel Raphael 278-0 The Beach at Trouville 268, with Tobias 80-1 The Adoration of the Golden Calf 315-16, 327 Philip II, King of Spain 208, 261 Impression, Sunrise 315 Philip IV, King of Spain 256-8 Bacchanalian Revel 231 The Water-Lily Pond 317-18 Philip of Burgundy, Bishop of Christ healing the Blind Men 234 Monfreid, Daniel de 296 Utrecht 118 The Crossing of the Red Sea 231 Monticelli, Adolphe 300 Philip the Good, Duke of The Finding of Moses 233-4 More, Sir Thomas 123 Burgundy 118 The Triumph of Pan 232-3 Preti, Mattia 206 Moretto da Brescia 138-40, Picasso, Pablo 272, 320-1, 332 Bowl of Fruit, Bottle and Violin Pucci family 88 Portrait of a Gentleman 138-40 Puvis de Chavannes, Pierre-Morisot, Berthe (quoted) 319 Piero di Cosimo 81-2, 153 Cécile 323-4 Mornauer, Alexander 74-5 Fight between the Lapiths and the The Beheading of Saint John Moroni, Giovanni Battista 138, Centaurs 81 the Baptist 323-4 A Satyr mourning over a Nymph Peace and War 323 140-3 Portrait of a Gentleman 81-2 ('Il Cavaliere dal Piede Ferito') Piero della Francesca 82-5, 334 Quaratesi family 52 139-40, 141-3 The Baptism of Christ 82-3 Portrait of a Man ('The Tailor') The Nativity 36, 84-5 Raeburn, Henry 324-6 140-1 Piper, David 336 Robert Ferauson of Raith 1770-1840 Pirckheimer, Willibald 46 and Lieutenant-General Sir Moses 234 Murillo, Bartolomé Esteban Ronald Ferguson 1773-1841: Pisa 85 227-30, 264 Santa Maria del Carmine 69 'The Archers' 324-6 Self Portrait 229-30 Pisanello 85-6 Raffaellino del Garbo 153 The Two Trinities 227-9 The Vision of Saint Eustace 85-6 Raphael 80, 103, 128, 143, 148-52, Pisano, Nicola and Giovanni 41 155, 165, 197, 198, 227, 230, 233, Napoleon Bonaparte 279, 331 Pissarro, Camille 273, 278, 315, 240, 252, 308 Napoleon III, Emperor of France The Madonna and Child with Saint **321-3**, 327 311-12 The Avenue, Sydenham 321-3 John the Baptist and Saint Nashe, Thomas (quoted) 117 Pliny the Elder 101, 105, 115 Nicholas of Bari ('The Ansidei Madonna') 149-51 Niccolini family 242 Poe, Edgar Allan 327 Niccolò di Pietro Gerini 56 Poel, Egbert van der 205 The Madonna of Foligno 144 Niccolò da Prato, Cardinal Bishop Pollaiuolo, Antonio and Piero The Madonna della Seggiola 158 of Ostia 42 del 86-8, 92, 100 The Marriage of the Virgin 151 Niccolò da Tolentino 92-3 The Battle of Ten Nudes 87, 88 Pope Julius II 151-2 The Martyrdom of Saint Sebastian Portrait of Baldassare Orme, Robert 328-30 86-8 Castiglione 236-7 Ovid 165 Pompadour, Madame de 287-8 Saint Catherine of Alexandria The Metamorphoses 81-2, 193, Pontormo, Jacopo 106, 146-7, 148-9 207, 221-2, 226-7 Saint John the Baptist Preaching 146, 153, 157 Joseph with Jacob in Egypt 106, Pacheco, Francisco 256, 258 146-7 Saint Nicholas savina the Lives

Porcel, Don Antonio de 303

of Seafarers 151

Padua 52, 64, 155

The Transfiguration 156, 157 ('Peace and War') 242-3 Luke 61 Redon, Odilon 326-7 Margaret of Antioch 48, 67, Portrait of Susanna Lunden(?) Ophelia among the Flowers 326-7 ('Le Chapeau de Paille') 206, 263-4 Rembrandt 168, 183, 185, 186, 245-6, 343 Mark 61 198, 205-6, 213, 219, 221, 224, Samson and Delilah 200, 247, Martin 72 **235-9**, 242 246-8 Mary Magdalene 30, 41, 52, 75, Belshazzar's Feast 238-9 Rudolph II (Habsburg), Emperor **94**–**5**, 103, 120, 134, **154**–**5**, The Hundred Guilder Print 224 165-7 159, 172 Self Portrait at the Age of 34 Ruisdael, Jacob van 248-9, 276 Matthew 61, 63 236-8 An Extensive Landscape with a Matthias 72 A Woman bathing in a Stream Ruined Castle and a Village Michael, Archangel 23-4, 80 Church 248-9 Nicholas of Bari 52, 67, 149 Reni, Guido 209-10, 230, 239-41, An Extensive Landscape with Ruins Paul 72, 116 252, 253 248 Peter 22, 56, 63, 66, 67, 72, 103, Lot and his Daughters leaving Ruskin, John 242, 341 138, 162, 188-9, 225 Sodom 239-41 Ruysdael, Salomon van 186, 248, Raphael, Archangel 80-1 Renoir, Pierre-Auguste 313, 315, 249-50 Roch 117 318, 327-8 A View of Deventer seen from the Romuald 63 Boating on the Seine 323, 327-8 North-West 249-50 Sebastian 38.88 Reynolds, Sir Joshua 227, 269, Stephen 56 311, 325, **328–32**, 343 Saarinen, Eliel 294 Thomas 32 Captain Robert Orme 328-30 sacra conversazione 149 Veronica 103 Lady Cockburn and her Three Saenredam, Pieter 251-2 Sandrart, Joachim von 191 Eldest Sons 330-2 The Interior of the Buurkerk Santi, Giovanni 148 Richard II, King of England 95-6 at Utrecht 251-2 Sarto, Andrea del 146, 153-4 Richelieu, Cardinal 190-1, 232 Saints: Portrait of a Young Man 153-4 Riley, Bridget 209, 273 Ambrose 200-1 Sassetta 54, 88-9 Rockingham, 2nd Marquess of Anne 58 Saint Francis Triumphant 88 336 Anthony Abbot 41, 79, 117 The Stigmatisation of Saint Francis Rockocx, Nicolaas 200, 247 Aurea 41-2 Romanino, Girolamo 138 Barbara 41, 61, 79 Sassoferrato 252-4 The Virgin in Prayer 252–4 Rome 34, 51, 64, 66, 82, 86-7, Benedict 63, 67 109-10, 116, 120, 143, 149, 157, Bridget of Sweden 49,84 Savoldo, Gian Girolamo 129, 184-5, 187, 188, 191, 194, 197, Catherine of Alexandria 38, 138, 154-5 206, 208, 209, 214, 226, 230, 40-1, 61, 67, 79, 149 Saint Mary Magdalene 232, 239-40, 242, 252, 288, 308, Christopher 79 approaching the Sepulchre 325, 335 Dominic 41 154-5 San Pietro in Montorio 157 Edmund 95 Schiavone, Andrea 170 Sant'Agostino 135 Edward the Confessor 95 Schwiter, Louis-Auguste 284-5 Santa Maria in Aracoeli 144 Eloy 77-8 Sebastiano del Piombo 155-9 Santa Maria Maggiore 71-2 Emidius 38 The Madonna and Child with Santa Sabina 253 Eustace 85-6 Saints Joseph and John the Vatican 128, 149, 198 Francis 88-0 Baptist and a Donor 146, Sistine Chapel 26, 80, 135, Gabriel, Archangel 38, 44-5, 157-9 61, 72-4, 80 The Raising of Lazarus 155-7 Villa Farnesina 155 George 38, 52, 116-17, 162 Seignelay, Jean-Baptiste-Antoine Rosa, Salvator 241-2 Giles 77 Colbert de 226 Self Portrait 241-2 Gregory the Great 72 Seignelay, Marquise de 226-7 Rosso Fiorentino 23 Hubert 86 Selve, Georges de 123-4 Rouart, Hélène 282-3 Jerome 18-19, 38, 45-6, Seurat, Georges-Pierre 82, Rouart, Henri 282-3 143-4, 145-6 Rousseau, Henri 332-3 John the Baptist 27, 52, 54, 58, Bathers at Asnières 269, 332, Tiger in a Tropical Storm 60, 63, 79, 82, 95, 137-8, 143, (Surprised!) 332-3 149-51, 158, 323-4 Sunday Afternoon on the Island of Rubens, Peter Paul 116, 129, 146, John the Evangelist 30, 61, 63, La Grande Jatte 333 183, 190, 200, 228, **242-8**, 257, 67, 72, 75, 79, 95, 121, 134, Seville 227, 228, 230, 256, 258, 276, 285, 289, 311 136 263, 264 An Autumn Landscape with a View Shakespeare, William 129, 185, Joseph 49, 85, 95, 108, 111, 120, of Het Steen in the Early 158-60, 160, 229 211-12, 327 Morning 244-5, 248 Joseph of Arimathea 30, 75 Sibelius, Jean 294 Landscape with a Rainbow 244 Lawrence 56 Siena 41, 43, 44, 50-1, 54, 88-9, Minerva protects Pax from Mars Liberius 72 93, 95

The Toilet of Venus ('The Rokeby Sisley, Alfred 327 Titian 100-1, 116, 128, 139, 155, Venus') 260-1 Sixtus IV (della Rovere), Pope 38, 161, 163-70, 171, 188, 202, 206, Velde, Adriaen van de 249 208, 226, 230, 231, 238, 257, 258, Sophia of Mecklenburg 114 260, 261, 273, 311 Vendramin family 168-70 Spencer, Mary (quoted) 335 Bacchus and Ariadne 101, 157. Venice 18, 20, 32, 34, 37, 46, 100, 109, 116, 117, 126, 129, 138, 154, Spranger, Bartholomaeus 163-5, 230, 233 The Death of Actaeon 100, 101 155, 162, 164, 169, 170-2, 206, 159-60 208, 219, 226, 271-2, 305-6, The Adoration of the Kings 159-60 A Man with a Quilted Sleeve Squarcione, Francesco 64 167-8, 236-7 Vermeer, Johannes 261-2 'Noli Me Tangere' 165-7 Steen, Jan 254-5 The Effects of Intemperance 254-5 Portrait of Emperor Charles V A Young Woman standing at a Virginal 261-2 Skittle Players outside an Inn 254 Vernet, Claude-Joseph 343 Two Men and a Young Woman Portrait of a Lady ('La Schiavona') Veronese, Paolo 170-3, 188, 206, making Music on a Terrace 314 The Vendramin Family venerating 254 314, 339 Allegory of Love, II ('Scorn') 172-3 Steenwyck, Harmen a Relic of the True Cross The Family of Darius before Allegory of the Vanities of Human 168-70 Alexander 170-2 Life 255 Venus and Adonis 101 Verrocchio, Andrea del 80 Tournai 31 still life 104-6, 184, 187, 195, Vespucci family 26 217-18, 233, 249, 255, 255-6, Treck, Jan Jansz. 255-6 Still Life with a Pewter Flagon 255 Vigée Le Brun, Elizabeth Louise 258-9, 264-5, 269, 272, 273-4, 274, 295-6, 298-300, 300-1, Vanitas Still Life 255-6 245, 342-3 Tura, Cosimo 35, 91-2 Self Portrait in a Straw Hat 342-3 314-15, 320-1 Stoffels, Hendrickie 236 An Allegorical Figure 17, 91-2 Virgil (quoted) 206 Turner, Joseph Mallord William The Aeneid 193 Stuart, Elisabeth, Queen of Voltaire 288 Bohemia 214 176, 339-41 Vouet, Simon 220 Stuart, Lords John and Bernard Dido building Carthage 176, 339 The Fighting Temeraire tugged to Vroom, Hendrick 185 203-5 her Last Berth to be broken up, Stubbs, George 335-7 Walpole, Horace (quoted) 242 Joshua (or Simon) Cobb with 1838 339-40 Waterhouse, Ellis (quoted) 293 Whistlejacket and Two Rain, Steam and Speed - The Great Watson-Wentworth, Charles: see Other Stallions 336 Western Railway 340-1 Mares and Foals Without Sun rising through Vapour 176, Rockingham Watteau, Jean-Antoine 254, 289 a Background 336 339 The Milbanke and Melbourne Wellington, Duke of 304-5 Uccello, Paolo 82, 92-3 West, Benjamin, PRA 276 Families 269, 335-6 The Battle of San Romano 16, 92-3 Weyden, Rogier van der 40, 91, Whistlejacket 336-7 Wild Horse attacked by a Lion 336 Ulm 90 92, 94-5, 118, 132 The Magdalen Reading 94-5 Swabian School, unknown artist Urbino 82, 148 26, 90 Utrecht 184-5, 214, 251-2, 261, Whistler, James Abbot McNeill Portrait of a Woman of the Hofer (quoted) 212 Wierix brothers 229 Family 90 Wilkie, David 325 vanitas 210-12, 255-6, 275, 343 Tallemant, Gédéon 220 Wilson, Richard 276 Vasari, Giorgio (quoted) 64, 68, Wilton Diptych, The 95-7 Tenniel, Sir John 133 81, 87, 92, 135, 143, 146, 147, Witz, Konrad 82-3 Tiepolo, Giovanni Battista 171, 151, 153, 159 268, 288, 305, 338-9 Vatican: see Rome Wright of Derby, Joseph 339, An Allegory with Venus and Time Velázquez, Diego 227, 256-61, 343-4 268, 338-9 263, 265, 273, 303 An Experiment on a Bird in the

Kitchen Scene with Christ in the

House of Martha and Mary

258–9

Maids of Honour (Las Meninas)

265

Philip IV of Spain in Brown and
Silver 256–8

Saint Margaret of Antioch 263–4

Air Pump 343-4

Tintoretto, Jacopo 160–3, 170, 208, 252, 258, 261

Saint George and the Dragon

162–3 The Last Supper 162

Christ washing his Disciples' Feet